HOW TO PHOTOGRAPH
WORKS OF ART

HOW TO PHOTOGRAPH
WORKS OF ART

Sheldan Collins

AMPHOTO/WATSON-GUPTILL PUBLICATIONS
New York

Library of Congress Cataloging in Publication Data

Collins, Sheldan
 How to photograph works of art/Sheldan Collins.
Originally published: Nashville, Tenn.: AASLH Press, © 1986.
Includes bibliographical references and index.
1. Photography of art. I. Title.
[TR657.C65 1992] 91-46021
778.9'97—dc20 CIP

ISBN 0-8174-4019-4 (paper)

Manufactured in U.S.A.

1 2 3 4 5 6 7 8 9/00 99 98 97 96 95 94 93 92

Contents

Color Plates and Notes

Following Page 79

Dedicated
to Dr. Horace Day, surgeon,
who, in 1845,
invented pressure-sensitive tape.

Preface

I get paid to do something that I enjoy immensely, and I get a layman's art education through direct contact with outstanding artifacts reflecting the spectrum of mankind's cultural activity.

Wanting to share these fruits with other photographers, I decided against dividing the money and instead wrote this book, which contains a wealth of practical photographic information and a smattering of unorthodox advice on sharpening your perception of art while shooting.

To get the greatest benefit from this book, the reader should already have a minimal competency with a camera: If you can't remember how to load film, a better approach for now may be to browse through some of the works in the suggested reading list at the back of the book, or to enroll in a good general course in photography.

Even if you are adept at composing the upside-down image on the groundglass of a view camera, so that what you see there no longer makes you dizzy, you will find tips and shortcuts throughout the book.

Satisfying though it is, photographing art is not easy. Often, it is plain hard work. At times, some photographic problems were so difficult that I doubted a successful image could be made; I spent more effort on making excuses than on solving the problems. Ultimately, I had to aim my complaints at my own lack of skill, ingenuity, and determination because a useful image had to be made with the tools at hand and the art before me. And quickly.

Early on, I realized that in order to cope with a diversity of media—pigment, paper, wood, glass, ceramic, stone, metal—I had to organize my trials and errors into a cogent, methodical technique. I began a journal for noting lighting diagrams, filtration and exposure information, reactions to my work by curators, and most important, my evaluations of mistakes that required reshoots. Using these notes I could double-check my thinking, track down errors, and build a repertoire of lighting solutions for the future.

I have accumulated seven volumes of journals, overflowing with the history of my failures and successes in photographing art. It is from these journals that the present book has evolved.

Did this meticulous method of going about things sap the fun from photography? To the contrary. It allowed me greater enjoyment, through the reduction of unpredictable factors that interrupt the flow of

perception of each work of art while lighting and shooting. With predictability comes certainty, which in turn nurtures confidence, a crucial ingredient in any creative endeavor.

To create a useful photo of any work of art, one must learn to handle the required tools effectively and to control the lighting on a subject, analyzing one's actions in terms of the photographic process: how the lens will form a sharp image, how the film will record tonalities and colors, and how the darkroom and reproduction steps will interpret the film image. This aspect of our work is *photographic vision*, and is the main topic of this book.

But with three-dimensional works of art, the serious photographer will have the opportunity to go beyond simply making "clear shots," and may experiment with creating superior images that both serve utilitarian functions *and* move a viewer with a profound sense of the art's immediacy. To achieve that, you don't always need a masterpiece as subject, although that *does* help. What helps more, however, is for you to develop a visual acumen that penetrates beneath the surface of a subject to deeper levels, wherein lies the significance of the subject as a unique expression of the artist's idea. By nurturing your imagination and feeling for your subjects, you will develop a receptive attunement I call *inner vision*. By coordinating technical skills with inner vision, you will soon evolve the means to *see* art and show it to others.

A note of caution. Some works illustrated in this book are of a quality, rarity, and price not readily available anywhere else, but *do not fool yourself that, without marvels of art, you cannot make exciting photos.* The solutions developed here, through trial and error, will help you find and accent the "suchness" of almost any object, however mundane it may seem at first glance. On the other hand, it is also quite possible to botch a shot of a great work of art; just ask my critics.

My photographic knowledge and style have been deeply influenced by former employers and coworkers, whose generous instruction during my formative years in the commercial catalog and advertising illustration fields was of special benefit. In addition, I received invaluable support and technical advice from my colleagues at the Metropolitan Museum of Art when I was a staffer there. I hope that this book will, in a small way, repay their kindness.

Over the years, I have pestered curators about the art I have photographed: what was its origin, use, date, medium, technique of construction. Who made it, what were the influences and intentions? Was it a singular example, and why? For my inquisitiveness, I ask their indulgence. My motivation was to provide a more useful image through better knowledge of the subject.

SHELDAN COLLINS

1
Why Photograph Art?

THE explosion, during the past century, of that noble contest called art collecting has taken place in large part because people generally agree that certain objects are of such outstanding quality and uniqueness that they must be saved from the inexorable process of decay. Apart from their value as "instruments of investment," works of art maintain an honored position among the vast realm of material phenomena simply because they reflect remarkable achievements in thought, perception, and dexterity.

Of course, in the opinions of experts, diverse and often startling objects qualify as art; and it doesn't matter whether the source of such objects is King Tut's workshop or a cluttered loft in New York City's Soho district. Consequently, private and public collections have become attics of human evolution, crammed with works ranging from the mundane to the opulent, from the passionate to the sublime. An American Shaker chair, for example, is a stark solution to the old problem of where to sit, while the bejeweled gold-and-mink cap of Peter the Great is a grand solution to the equally perplexing problem of what to wear to the coronation. Edward Munch's expressionist painting *The Scream* shudders with the intensities of personal despair, while the sculptured form of a Tang Dynasty Chinese Buddha radiates the

confident vibration of a mind in deep equipoise.

Art has been rightly called a mirror of humanity's experience, because, by studying art, we can analyze past techniques of construction and methods of craftsmanship; we can understand the motivations and values of ancient cultures; we can follow developments of perception and the evolution of ideas; we may react to art emotionally, even spiritually, intensifying our personal experience. In short, *we learn*. As an educational process, this study becomes an open channel through which flow understanding and harmony among various cultures, races, and individuals. In order to educate ourselves efficiently, of course, we need tools.

One unique tool for the study of art is photography, which responds to a wide range of needs in gathering and transmitting art information among experts and nonexperts alike. Common to those needs is the obvious but little-considered fact that photographs can supplant direct visual perception of a work of art itself. Historians, relying heavily on evidence supplied by photographs, make complex studies, postulate theories, and draw conclusions that have a profound effect on our understanding of art. The man on the street forms conscious and subliminal opinions of alien cultures, more from

looking at *images* of art than from actual encounters with the original works. Moreover, photographs are used by curators researching stylistic developments for dating and attribution of art; by conservators exploring and documenting restoration techniques; by museum registrars making file records; by artists selling their wares; and by educators and publishers disseminating knowledge through scholarly publications.

But making images of art is not so clear-cut an operation as I once thought it was. Due to photography's dualistic nature, the ideal image of art is elusive.

The Photographer as Documentarian

To make valid images of art, one must abide by certain formalities in using photographic "language." Proprieties of syntax and grammar, as well as amenities of vocabulary, should be observed if one is to communicate as clearly as possible with today's sophisticated viewer of photographs. To put it another way: using red and green gels over your lights when shooting an Egyptian head of Queen Nefertiti for a scholarly publication would be as inappropriate as creating a kazoo orchestration of Bach's Brandenburg Concertos for a command performance at the White House. While the exercise of such options might be considered

acceptable—even ingenious—in other circumstances, they are clearly out of place when they do not fulfill the rather narrow and justifiably predictable needs and expectations of the audience. You can anticipate that your audience will want the answers to fundamental questions concerning the shape, medium, texture, condition, and color of a work of art, in order to help assess, quickly and accurately, the object's identity, understand the producer's technique of craftsmanship, make historical comparisons, put a price on the work itself, or simply "get the idea."

Seen in that light, the discipline of photographing art—like cabinetry and the designing of fishing lures—wears the cloak of a technical craft. That is not to say that images of art need to be commonplace while fulfilling their utilitarian function. A simple record shot of a Matisse bronze can be accurate and insipid—or it can be accurate and exciting: the photographer's skill and sensitivity are the deciding factors. Ultimately, however, the choice of approach for each subject must conform to the goal of inducing in a viewer of the envisioned photograph a profound impression of the work before the camera.

The Photographer as Mythmaker

Thanks to its limiting nature, the camera can, to some degree, suppress or hide, accent or even exaggerate factual information. Simply by choice of lens perspective, lighting ambience, contrast range, and color balance, the photographer can either show or eliminate flaws in an object, degrade or enhance its desirableness, and diminish or emphasize its emotional and graphic impact. By printing a negative of a bronze object too light, for example, one can make the work appear to be pewter. By turning a ceramic vase so that a gaping hole is hidden, one can make

the object appear more valuable than is actually true. *Photographic technique easily blurs the distinction between the beauty of the subject and the beauty of its image.* Although it has long been known that the camera does not always tell the truth, that is a point worth underlining here.

Insofar as the photo-documentation of works of art necessarily involves distorting and abstracting—lying and beautifying—it partakes of the nature of those higher art forms that comment on reality. Here we have a neat paradox: one potential art form—photography—remarking on another. It is like holding two mirrors face-to-face.

But unlike a static mirror reflection, the photographic process has a dynamic mind controlling it, editing and selecting which "truths" about a work of art will be formed in the camera's ground-glass. Because a photograph is an abstraction, and because different photographers see individualistically, some degree of interpretation of each subject is unavoidable. I once heard several photographers arguing over the name of the predominant color in a necktie one of them wore; imagine the subjectivity influencing evaluation of an image of a work of art! Contrary to most critics' assumptions, the camera is not a cloning device that churns out little duplicate works of art, even when the original subject is two-dimensional.

Thus the thinking photographer's unique responsibility is to fuse the two natures of photography—the objective recording and the subjective abstracting—in the creation of a unified "documentary myth" that conveys both the form and the spirit of each work of art.

Getting at the spirit of a work is a topic for another book, but I can suggest possible routes that have been helpful to me. I read about art and cultures that interest me, ask

questions of curators, and try to concentrate on each subject. If I have an especially bland or vehement reaction to a work, I analyze possible reasons for it, and try to modify my opinions and keep an open mind. It is a safe bet that no artist ever wanted his or her work to be considered banal; so, in order to do justice to what I assume to be the artist's wishes, I must sometimes set aside my personal opinions.

The Photographer as Messenger

From the mundane point of view, a photograph is a physical object produced on a flat, level plane—an object whose patterns of tone or color symbolize the surface qualities of a work of art. As such, it is an instrument for the transmission of superficial knowledge from the art to the viewer's eye. From the transcendental point of view, a photo-image is an instrument for the transmission of inner experience, leaping across time from the mind of the artist to the mind of an image viewer.

Between the time of its inception on the abstract plane and its manifestation on the material plane, the idea for a work of art is molded by the artist's personality within the context of his or her cultural influences. That holds true for objects as functional as a doorknob or as ethereal as a Kandinsky painting. Depending both on the imagination, motivation, and dexterity of the creator, and on the skill and attunement of the photographer, a photo-image of this "physical representation of an idea" can, within definite limitations, allude to the emotional, mental, and spiritual attitude of the artist. A viewer looking at such a photograph with a few moments' concentrated attention should begin to experience a sympathetic vibration corresponding to the nature and quality of energy

that went into the original work of art.

If that seems a presumptuously mystical notion, bear in mind that this sort of awareness may lie at the very core of directly *experiencing* art. All the information gathered about the historical context of particular works, along with intellectual theories, helps us to sharpen our understanding; but in the end, it is visual perception of art that triggers the deepest response. This is not to imply that looking at art should cause a religious reaction; sometimes we may believe we are enthralled by a work of art, when we are actually just being emotional; and emotionalism may be not only unsuitable, in most cases, but may also cloud true photographic vision as one shoots.

Yet we can never be sure that our own experience of a work of art is what the artist intended, because of our cultural distance and individuality. (So-called primitive works of art probably come closest to striking responsive chords deep in our psyches—when we suspend our modern rationality—but, then, those creators weren't making "art.") Especially with contemporary art, the viewer is often asked—even required—to participate in interpreting the work, because the motives and reasons for creating may not have been fully understood even by the artist. Of that process, Marcel Duchamp said,

Art has absolutely no existence as veracity, as truth. People always speak of it with this great, religious reverence, but why should it be so revered? It's a drug, that's all. . . . The onlooker is as important as the artist. In spite of what the artist thinks he is doing, something stays on that is completely independent of what he intended, and that something is grabbed by society—if he's lucky. . . . The work of art is always based on these two poles of the maker and the onlooker, and the spark that comes from this bipolar action gives birth to something, like electricity. But the artist shouldn't concern himself with this because it has nothing to do with him—it's the onlooker who has the last word. Fifty years later there will be another generation and another critical language, an entirely different approach. . . . I'm afraid I'm an agnostic in art. I just don't believe in it with all the mystical trimmings. As a drug it's probably very useful for a number of people, very sedative, but as religion, it's not even as good as God.[1]

Considered in that way, one's work as photographer is to be a messenger who suggests with honesty, shaping and coloring a viewer's experience of the artist's mind while interpreting each creation in private, direct communion with it.

The dangers inherent in such a privileged position are worth mentioning: if one's technical skill is not equal to the task, neither the detailed surface qualities nor the full emotive impact will be conveyed; if one is not concious of any vapid or negative reaction to the work, the image will probably be bland or flawed; if one's ego grows beyond acceptable limits, the art may become a mere vehicle for a prejudiced statement or a display of boastful virtuosity in camera-work.

Clearly, ours is a delicate but exciting job, full of surprise discoveries and personal fulfillment in the performance of a service. Though the photographer's vision must remain true to the integrity of each subject, there will be ample opportunities as your photographic skills and sensitivities broaden, to imply how you feel about art.

NOTES

1. Calvin Tomkins, *The Bride and the Bachelors* (New York: Penguin Books, 1978), pp. 16–17.

2
Space and Energy

The Studio

SINCE the mid-nineteenth century, photographers have built studios in virtually every conceivable type of space. Some studios were dragged around the country by horses, as their owners looked for fresh subjects and ripe markets, but most were constructed on a permanent basis by photographers in search of an ideal environment where they could control light.

For light sources, early photographers had to rely on daylight and flash powder, both of them restrictive and undependable. The invention of the electric lamp enabled photographers to manipulate a constant light source, giving them enormous creative freedom: they could now move light, change its shape and quality, attenuate or increase it at will, affecting the textural and emotional aspects of their subjects.

To say that compelling, useful photographs can be made only in a studio would be foolish and untrue; but when accurate, technically perfect images need to be made *repeatedly,* the studio is the place to make them. Whenever possible, photograph art in a controlled environment, and you'll be more likely to get results that you like.

Whether the controlled environment you use for photography is in a corner of your basement at home or in a large area of a museum, the concept of a photograph studio includes not only the camera room, but also those affiliated spaces needed for varied activities that, in total, are more aptly termed a *photography department.* The list of spaces and functions below separates these activities, but in your installation you may need to combine or even eliminate some of them because of spatial and budgetary restrictions. The list below is keyed by letter to the drawing in figure 2.1 and serves as its legend.

The sizes and relative locations of these work areas are important to consider when designing a studio.

Also, the installation of electrical service, plumbing, shelves, work tables, and storage facilities must be well organized for work to proceed in a comfortable and efficient manner. Having worked in studios so chaotic that they might have been dragged around by wild horses, I can say without exaggeration that nothing insures good, fast photography more than a well-planned and orderly workspace.

Camera Room

The largest type of art that you photograph often should fit into the camera room conveniently.

Space		Function
A.	Entry to studio	Double doors allow access for large objects.
B.	Art storeroom	Temporary storage of art and color-correcting transparencies.
C.	Camera room (studio)	Photography.
D.	Film-loading room	Loading of sheet film for view cameras.
E.	Film-process darkroom	Processing and washing of black-and-white films.
F.	Film-drying cabinet	Dust-free drying of processed film.
G.	Print-process darkroom	Processing and washing of black-and-white prints.
H.	Finishing room	Final washing and drying of black-and-white prints; order fulfillment.
I.	Archives	Numbering and filing of black-and-white negatives and prints; storage of slides and transparencies.
J.	Office	Communications center.
K.	Storeroom	Photographic equipment storage.
L.	Storeroom	Film, paper, and chemical storage.

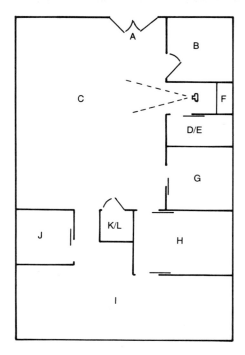

Fig. 2.1. *Plan for a dream studio, organized for efficient work flow.*

Photography of very small objects—such as jewelry, seals and impressions, and potsherds, as well as unmounted flat art—usually requires a vertical camera set-up that needs very little space. An area of about 50 square feet (6 square meters) is often adequate for the art, tripod, and lights. Small tabletop sets can easily gobble up twice that much space, because they demand more light stands, reflectors, and a pedestal. Many sculptural and decorative objects, as well as paintings up to about 4 by 4 feet (1.5 by 1.5 meters), need about 200 square feet (20 square meters). Larger paintings, furniture, folding screens, and lifesize figural sculpture require a shooting area of 300 to 400 square feet (30 to 40 square meters). In addition, you might want to make room for a camera cart (for keeping lenses, exposure tools, film, tapes, etc.), a storage table for art,

cabinets, a desk, and a few erected stands.

To economize space needs, try to keep the camera room floor as clear as possible by mounting pegboards for lights, accessories, and cables. Arrange office furniture in two corners, away from the door, where it won't block art in transit. The camera room floor should be level and free of cracks and projections that might snag equipment and send it tumbling. At the Met, we installed smooth industrial carpeting in one studio on a trial basis, but removed it when tripod and stand legs caught on the fibers. The best floor is of neutral-colored asphalt tile or linoleum; but beware of such a floor's reflecting a false color into art under unusual circumstances. And, when shooting downward, you may need to lay black cardboard on asphalt tile or linoleum flooring outside the image area, to prevent lens flare from the glaring reflections those floorings can make.

Reserve at least one clear wall of your camera room for hanging background paper when shooting three-dimensional art. Paintings can also be hung here, or can be put on an easel pushed against the wall. Homosote is an ideal studio wall covering; it will accept pushpins for holding backgrounds, or for holding mats without disfiguring them, by being pressed against, instead of pinned through, the mat's perimeter. All camera room walls should be painted either white, neutral gray, or black, to preserve purity of color in the art. The wall against which paintings are shot should be painted black or covered with black paper, to reduce lens flare. If many works framed under glass are shot here, the wall *behind* the camera should be black as well, to keep the glass free of reflections.

Subject contrast of three-dimensional objects is controlled best

in a studio with all walls black, but working in such a cavelike place is very oppressive. I've found that a studio whose walls are painted a flat neutral gray up to a height of eight to ten feet is much more cheerful, and it provides a minimal risk of flare. The upper walls and ceiling can be painted pure white, which does not affect photography adversely, but does give the photographer psychic relief from the necessary drab gray or black of walls at working levels. If you elect to keep studio walls white, have on hand a couple of large rolling flats that are black on one side, to help control contrast on large sets.

Windows in the camera room need to be more or less sealed, depending on your light source. Since electronic flash is color-balanced to match daylight, the problem of extraneous window light with that source is not too severe; but the tungsten lights more commonly used in the studio are very warm in color, relative to daylight, and a significant amount of light streaming through a window will play havoc with tungsten-balanced color films.

Permanently sealed windows provide the greatest barrier against uncontrolled light, of course, but I would reserve them for a room meant for full-time shooting. Having spent the greater part of my work days for twenty years in windowless rooms, I can vouch for the unfortunate effect it has on one's state of mind.

Ceilings should be as high as possible. An 8-foot (2.5-meter) ceiling is adequate for photographing most small paintings and tabletop objects, but it is quite restrictive when you want to shoot a large cupboard, or light an object from above with a boomlight. A 12-foot ceiling is much preferred.

Climate control in the camera room is critical, especially if you use hot tungsten lights. Plenty of cool, fresh

air will keep both you and the art healthy at an ideal temperature of 68 degrees to 72 degrees Fahrenheit (20 degrees to 22 degrees Centigrade). Relative humidity must be maintained at 40 to 50 percent for those objects susceptible to warping, shrinking, and cracking (wood, ivory, silk paintings, etc.). If winter heating or your studio lights dry the air below this humidity level, install a room humidifier near the set when photographing sensitive works of art.

Darkrooms

Locate darkrooms near the camera room if you make many trips back and forth. If you work alone, one darkroom will suffice for all needs— film loading, film processing, and print processing. If several workers perform two of these activities simultaneously, more than one darkroom is necessary. A room for loading sheet film into holders and for boxing exposed color film to be sent to an outside lab will need no sink. Such a room can be made from a closet with a light-tight door, a clean shelf for handling film, and storage shelves. If traffic and space permit, this loading area can be part of the film processing darkroom, but two or more workers sharing it will often find such an arrangement time-wasting: one may need light to examine processed film while the other needs darkness to load holders.

Archives

The conservation of art is a primary concern for anyone who owns art or is charged with its care. While the photographer's role in an art conservation program is comparatively small, it still is important, because each time any work of art is photographed, that work is subject to some degree of potential damage, either through mishandling, or from exposure to intense heat and ultraviolet light. For that reason, no work of art should be photographed more often than is necessary.

To minimize the number of times a given work is photographed, one must exercize control over all phases of photography, in order to reduce the "goof factor" that would require re-shooting. This means getting correct instructions before photographing, applying technical and artistic intelligence in the camera room, processing film and prints as accurately and cleanly as possible, and keeping photographic materials meticulously safe before and after they are exposed and processed.

Rough handling, sloppy processing, and improper storing of films and papers will have serious detrimental effects and, sooner or later, will render the materials useless as documents of art. Consequently, the art will have to be rephotographed. If the art is inaccessible or no longer exists, even re-shooting will be impossible, and there will be no documentation.

The kinds of problems that curtail the useful life of photographic materials are numerous. Experts in the field of photographic archives have scientifically researched this area thoroughly, and publications of their findings are listed in the bibliography. Below is a brief summary of some considerations that will help to capture the desired photographic image well and prolong the life of each photograph.

Emulsion Decay

The light-sensitive emulsions of films and papers are chemical compounds whose stability lies somewhere between granite and baker's yeast. In other words, favorable circumstances will allow emulsions to "capture" images and hold them relatively stable for many years; but unfavorable circumstances will accelerate the emulsion's predisposition to decay.

At the time of manufacturing, photographic films and papers are given an expiration date, which is marked on the package. When exposed and processed before expiration, the materials yield predictable results. After that date, changes in emulsion characteristics will gradually make materials untrustworthy because of decreased sensitivity, contrast changes, and loss of color balance.

However, the rated life of any emulsion, depends on proper storage. In general, films should be kept in a refrigerator until a few hours before they are loaded into the camera. Freezing will further postpone the expiration date for films, just as it will for turkey. Store papers in a cool, dry place, such as a closet; but keep in the darkroom only those papers currently in use to reduce atmospheric and chemical contamination.

Process exposed film and papers as soon as possible, to avoid contrast and color changes. If you keep an unfinished roll of color film in your camera for several weeks, store the camera in a cool place. Better yet, use the short rolls for occasional shooting.

Use care with films in the studio, too, because heat and light may cause premature chemical changes or fogging of emulsions. Load and unload cameras in subdued light, and don't leave film on radiators, light boxes, or other sources of heat. A colleague once had a repeated color shift in his sheet film for several successive days, for no obvious reason. Invariably, two or three sheets within a large batch of film were drastically redder than the others. After much investigation, we traced the cause to his large, vacuum-tube radio, on which he routinely

stacked film holders as he exposed them. The bottom holders "cooked" for several hours, decomposing the delicate stability of the emulsion, and the film turned red.

Processing for Permanence

If you process your own film or prints, be sure to follow the manufacturer's recommendation for correct procedure. Careful, consistent procedures not only lengthen the life of your negatives and prints, but they also yield predictable results.

The normal temperature range for processing films is between 65 degrees F and 75 degrees F. You may be tempted to use the higher temperatures to reduce developing time, but that can cause the gelatin in the emulsion to swell and soften more than is necessary for solutions to impregnate them. Soft gelatin is very susceptible to abrasion, and warm, swollen gelatin is liable to reticulate, or wrinkle.

Reticulation, either visible or microscopic, occurs when film is moved from a relatively warm solution to a relatively cool one, and the condition will eventually cause the emulsion to flake and separate from its base. All solutions, including wash water, must be within a temperature tolerance of plus or minus 2 degrees F, to safeguard against that problem.

Perhaps the biggest cause of film deterioration is the slow but relentless activity of residual chemicals left in films and papers after incomplete processing. Such residues alone will attack the photographic materials, or they can combine with other contaminants that may be present in storage envelopes, cabinets, or the atmosphere. In any event, the results are complex chemical changes in the material that, if undetected for too long, may be irreversible. To insure their long-range integrity, films and papers must be processed with fresh,

uncontaminated solutions for the prescribed times.

Proper fixing of the photographed image is especially needed to dissolve all *unexposed* silver in the material. Over-used or exhausted fixer (hypo) contains complex silver salts that are virtually impossible to wash out of conventional fiber-base prints. For that reason, I recommend the two-bath fixing method as outlined in Eastman Kodak's publication F-30, *Preservation of Photographs.* The two-bath method is also advisable for films, but don't overfix them, as that will reduce the silver image and destroy subtle shadow detail.

Since thorough fixing requires that the hypo permeate the materials, complete washing of films and prints is necessarily difficult. Proper wash tank design and adequate changes of fresh water are requisites for removal of the sulfurous compounds and silver salts present in residual fixer. Films and prints must be separated during the washing, to allow fresh water to flow continuously over all surfaces. Kostiner Products, Inc., is one company that makes excellent washing devices for processing small batches of film and papers.

To accelerate removal of chemicals from films and prints, use an alkaline washing aid such as Heico's Perma-Wash, Eastman Kodak's Hypo Clearing Agent, or Hypo Eliminator HE-1. These aids will shorten washing time dramatically—and save water.

The only way to know whether your final wash is sufficient for archival purposes is to test a sample film or print. You can do this yourself, with a test kit packaged by Eastman Kodak called the Hypo Test Solution HT-2, which must be used in conjunction with a Kodak Hypo Estimator. The procedure is simple and inexpensive, but as the name implies, it is only an estimate of residual fixer. Precise testing would

have to be done by a professional testing lab.

Resin-Coated Prints

Resin-coated papers enjoy a special advantage over conventional fiber-based papers because of their reduced fixing, washing, and drying times. The sandwiching of two resin coats around a thin fiber support keeps solutions from impregnating the base, a design that, theoretically, should curtail the problem of residual chemical retention. However, debate on the archival quality of resin-coated paper still rages between manufacturers and archivists. *It seems prudent to use resin-coated papers only in those situations in which long print life is not a prime concern: quick reference, immediate publication, etc.*

When you print on resin-coated stock, follow the manufacturer's specifications for processing and washing times. If you exceed the prescribed times, contaminants will seep into the edges of the fiber support, where they will cling tenaciously.

Storage of Processed Materials

High heat and humidity are the enemies of photographic materials. A safe temperature range—one that is also practical for maintaining proper relative humidity—is between 50 degrees F and 70 degrees F. Although lower temperatures contribute to greater stability, a given volume of air will increase in relative humidity as the temperature drops, thus promoting the growth of fungus on film and prints. The safest limits for relative humidity are 25 percent to 50 percent. If the air in your storage area exceeds those limits, install the appropriate control equipment.

Storage envelopes for negatives should be chemically stable, free of acids and peroxides, and made with a surface texture that does not promote ferrotying (glazing) of the emulsion.

High-quality paper envelopes, cellulose acetate sleeves, and polyethylene sleeves make satisfactory enclosures, but each has specific drawbacks that you should investigate before setting up your archives. Glassine envelopes are fine for temporary storage and handling, but they decompose with age and dampness.

Transparencies can also be stored safely in polyethylene preservers that are clear, for quick viewing. Avoid enclosures that contain polyvinylchloride (PVC), because PVC can cause traces of acid gas to form in a closed cabinet when relative humidity is high.

Always handle negatives and transparencies in their storage sleeves until you need them for printing or projection. When you remove an article from its sleeve, handle it by its outer edges, with clean hands, or—better yet—wear cotton gloves. When these materials are not in use, put them away in a dust-free metal cabinet. Grit has an uncanny way of crawling into film preservers left on a desk, and if it gets imbedded into the emulsion by applied pressure, the need for a re-shoot will be certain.

Color prints and films should be stored in special acid-free envelopes or boxes and kept in the dark, except when needed. Color-print and color-film materials are both notoriously susceptible to dye fading and stain formation, which are usually exacerbated by light. Accelerated aging tests show that dye fading and stain formation characteristics vary widely with different materials. For the latest word on color film and paper ratings for longevity based on years of rigorous testing of dozens of products, see Wilhelm's *The Permanence and Care of Color Photographs: Prints, Negatives, Slides, and Motion Pictures* (see Suggested Reading, page 201).

Cellulose Nitrate Films

Eastman Kodak discontinued its nitrate-based films in the early 1950s, although it had phased out some of them as early as 1933. If your archives contain any nitrate-based films, it is imperative that you seek them out and isolate them. Not only did they begin to decompose from the moment they were processed, but they also constitute a growing fire hazard.

In a closed cabinet, nitro-cellulose negatives release traces of nitrogen dioxide; in the presence of high humidity, nitrogren dioxide forms nitric acid that attacks all envelopes, negatives, and prints in the vicinity. Nitrate-based film also contains oxygen in its chemical make-up, and consequently will burn without any additional air, if a fire should start.

In the late 1970s, the Metropolitan Museum of Art Photograph Studio undertook a massive search for tens of thousands of nitrate-based films in its archives. These films were isolated, copy negatives were made on safety film, and the original negatives were destroyed. At the same time, the old, deteriorating envelopes, which contained acids and hygroscopic glues, were replaced with buffered envelopes sealed with nonreactive glues. The project cost was immense, but the expense was justified in comparison to the alternative loss of precious documents and the toll on the art, had re-shooting been necessary.

Electrical Service

Photographic lights require a studio that has ample and safe electrical service. The design, capacity and installation of basic service must meet both national and local electrical codes. In addition, all lighting equipment and extension cables should be of a high grade and in good working condition to insure safety.

Since a haphazard attitude toward this potent energy can have serious consequences, the following section outlines basic information for understanding and handling electrical equipment.

The Service Panel

All buildings wired for electricity have at least one service panel, which is a small substation for controlling the distribution of power within the building. In homes and apartment buildings, the panels are usually located in the basement; in institutional buildings, they are often put in special closets. The function of a service panel is twofold: it divides gross power into several small circuits, and it gives basic protection against fire hazard and shock by interrupting power to a faulty circuit through means of a circuit breaker or a fuse. Access to the service panel may be necessary in unusual circumstances.

Should power to a circuit in use be interrupted, the fuse or circuit breaker that regulates that circuit is signaling that something is wrong. One must first find the cause of the interruption and correct it before restoring power by replacing the fuse or resetting the breaker. If the problem is not corrected first, it will merely blow another fuse or trip the breaker again.

An *overloaded circuit* is most often the cause of power interruptions on individual circuits, and further along is some discussion about ways to avoid it. Another reason for interrupted power, somewhat less likely than overloading, is a *short circuit,* which is caused by two bare electrical wires touching each other, or a bare wire touching metal in the light fixture, light stand, or a "spider box" (a multiple-outlet box on a heavy-duty extension cable, with a circuit-breaker for each outlet). A short circuit

condition is very hazardous and could be a source of shock or even electrocution for someone touching anything metal (or any conductive substance) within the circuit at the moment when it "shorts." Periodically, examine all light fixtures, switches, plugs, and cables for signs of frayed insulation or bare wires, and repair or replace damaged ones immediately.

Locating Circuits

You can eliminate the potential nuisance and danger of an overloaded circuit if you know two things: the location of each circuit—that is, which outlets are fed by a common wire—and the rating for maximum current that each circuit can carry. Both these things are easy to determine if one has access to the service panel governing a studio's power.

To locate camera room circuits and their respective outlets, switch off power to all circuits except one at the service panel. In the camera room, plug a lamp into each outlet; if the lamp goes on, that outlet is connected to the remaining hot circuit. Mark all hot outlets with the same designation, e.g., "Circuit A." In turn, switch on each remaining circuit at the service panel and locate its outlets in the same manner. Mark each circuit and its outlets with a different designation, because each circuit must be treated as a separate source of power when you plug in lights. In general, the best practice is to distribute the demand for power for your lights among two or more circuits, to prevent an overload.

Circuit Breakers and Fuses

Circuit breakers and fuses are protective devices matched to the electrical capacity of the wires in a circuit. This capacity is governed by the wire diameter. The bigger the

wire, the more current it can safely carry. Wires and protective devices are both rated in amps (amperes), the basic unit of electrical current. The smallest circuit wires in the United States are rated for a 15-amp capacity, but installations since the 1960s increasingly used larger wires that can safely carry 20 amps. In practical terms, this means that you can plug in more, or brighter, lamps into a 20-amp circuit.

Never replace a 15-amp breaker or fuse installed by a licensed electrician with a device rated for 20 amps. Such a change will not increase the safe capacity of the wires, and even though it will allow more current through the circuit without "blowing," the wires in the wall could overheat and cause a fire.

To determine the maximum number and size of photographic lamps that can be plugged into a circuit of given capacity, consult Table 2.1. When the number of lights in use on one circuit consumes that circuit's capacity, any additional lights needed should be plugged into another circuit. In your calculations, be sure to add the wattage of household lamps or appliances that are on the same circuit.

In certain instances, access to the service panel is not possible or feasible. When shooting on location, for example, that possibility makes it doubly necessary to be conservative in estimating available current. Assume that each circuit is rated for 15 amps, and that one circuit may serve the outlets in adjacent rooms. If you need several high-wattage lamps, as you would when shooting a large painting or an entire room, take along enough extension cables so that you can plug some of your lights into outlets two rooms away from the set.

To find out how many lights can be plugged into a circuit of known capacity, use the following equation:

$$\text{Volts} \times \text{Amps} = \text{Watts}$$

For example, how many 1000-watt lamps can be plugged into a 15-amp circuit without blowing the fuse or tripping the breaker?

Transposing the terms of the equation above to determine the number of amps a 1000-watt lamp requires, we get:

$$\frac{\text{Watts}}{\text{Volts}} = \text{Amps}$$

Substituting the known values, then—

$$^{1000}\!/_{120} = 8.33 \text{ amps}$$

—or one 1000-watt lamp requires 8.33 amps. Therefore, two 1000-watt lamps will draw 16.6 amps, too much for a 15-amp circuit.

Cables

All electrical conductors, including the copper wire used in circuit wiring, have a resistance to the transmission of power. Using a wire too small for the demand on it creates intense heat due to this resistance. Therefore it is imperative to use wire of the proper gauge—or size—for lights and extension cables, to avoid the hazard of fire.

Wires with higher gauge numbers have small diameters; for example, an 18-gauge wire is much smaller than a 12-gauge wire. Common household lamps use 18-gauge wire, while small appliances and cheaply made photographic lights up to 250 watts often use 16-gauge wire. Neither 18-gauge nor 16-gauge wire is suitable as an extension cable.

In general, an extension cable should be at least the same gauge as the electrical wiring for the lights that will be plugged into it. Since most photo lights up to 1000 watts use 14-gauge wire, this is a safe size for most extension cables up to a length of 25 feet. However, if you have a light with a 12-gauge cord, use a matching extension cable.

Never plug a light cable into an extension line of smaller gauge than

Table 2.1
Lamp Wattage Relative to Circuit Capacity

15-Amp Circuit (1725-Watt Capacity)	
Lamps	*Demand*
Six 250-watt lamps	= 1500 watts
or	
Two 250-watt lamps *and* two 500-watt lamps	= Same
or	
Three 500-watt lamps	= Same
or	
One 500-watt lamp *and* one 1000-watt lamp	= Same
20-Amp Circuit (2300-Watt Capacity)	
Lamps	*Demand*
Eight 250 watt lamps	= 2000 watts
or	
Four 250-watt lamps *and* two 500-watt lamps	= Same
or	
Two 500-watt lamps *and* one 1000-watt lamp	= Same
or	
One 2000-watt lamp	= Same

Note: Listed above are some of the combinations of photo lamps of various capacity that can safely be plugged into a 15-amp and a 20-amp circuit. Any combination of lamps can be used, so long as their total wattage (demand) does not exceed the capacity of the circuit. Note that in all instances the total demand is a few hundred watts short of capacity, to allow for a safety factor that could, in practice, be used up by work lights, voltage fluctuation, or increased heat caused by resistance in long extension cables.

the light wiring. I once witnessed a photographer plug a hefty 10-gauge cord from a 2000-watt light into a 14-gauge extension cable. Within a few minutes, the two neoprene plugs were melting and smoking from heat. He had first inserted a 20-amp fuse into a circuit wired for a 15-amp fuse, and consequently the fuse sensed nothing wrong, and therefore did not interrupt power. Luckily, we noticed the problem in time and avoided misfortune.

Another factor affecting electrical wire capacity is its length. The resistance built up in a 50- or 100-foot extension cable can cause a voltage drop that shifts light color and raises heat. As a precaution, use 12-gauge or even 10-gauge wire for those very long extensions.

Adapters. Most new electrical cables have a three-prong plug. Never cut off the grounding pin because it's there to protect you from possible shock. Use an adapter when plugging a three-prong plug into a two-prong receptacle. Keep several adapters in your location kit—you may find yourself unable to photograph if you don't have a few with you—another suggestion courtesy of the Voice of Experience.

Spider Boxes. Extension cables are more versatile when they have either a duplex or a four-gang outlet box. When plugging two or more lights into such a cable, be sure that you don't overload its rated capacity.

Strictly speaking, a *spider box*—as we mentioned above—is a multiple-outlet box at the end of a heavy-duty extension cable, in which each outlet has a circuit breaker. Spider boxes are especially useful in a camera room some distance from the service panel. In case of an overloaded circuit, the breaker in the spider box will switch off, saving you a trip to the service panel. However, these boxes are unwieldy to take on location.

Fire Extinguishers

Because electrical problems are the greatest hazard in a studio, it's a good idea to equip your studio with a dry chemical fire extinguisher, as a safety measure: the dry chemical extinguisher is approved for use on fires of classes A, B, and C, which means that it is effective for fighting fires of wood and paper, as well as those caused by electrical devices. Know the instructions for using your extinguisher and keep the units fully charged.

Electrical Installation Design

If you have the opportunity to renovate old wiring, or to install original wiring in a new studio, keep in mind the following points.

Put the service panel in the camera room near the main shooting area, but not on a wall where you plan to hang paper or photograph paintings. The amount of power to be provided through the service panel depends on the size and number of lights you plan to use, as well as the number of photographers who will be drawing power. In any event, calculate your maximum needs and add 50 percent more power for future expansion. The minimum for each photographer is 30 amps; 40 to 60 amps each would not be a luxury for a busy studio that handles large works of art requiring many bright lights.

Service from the panel to wall outlets should be divided into two or three circuits per photographer. Group those outlets on a common circuit at each side of the shooting area, at four-foot intervals. In addition, you might want a ten-gauge cable from the panel to serve a spider box or a single outlet for a 1500-watt light. Make this cable of sufficient

length to reach both sides of the studio. If steel conduit must be fixed directly on walls, keep it near floor level where background paper will hang, to prevent paper bulge.

Plan the installation or renovation thoroughly with the building contractor and discuss your particular needs with the electrician who will actually do the work. Check the work as it progresses, because your requirements will be dramatically different from those of the ordinary commercial building installation.

3
Care and Handling of Art

ART is precious. Whether you or I *like* a particular work is immaterial, so far as its safety is concerned. And whether the work is commonplace or rare, is solid or fragile, whether it costs a hundred dollars or a cool million, it merits—and needs—our kindest care if it is to remain intact for future generations to study and appreciate.

From the conservator's point of view, photography exposes art to very high risks. Both in the studio and in the gallery, works of art are subject to damage from breakage, heat, ultraviolet radiation, and abrupt humidity changes when photographic equipment (and careless photographers) are near.

Certain types of damage, such as the unexpected encounter of a porcelain vase with a concrete floor, are often complete and always immediately obvious. But other kinds of injury are more insidious, because they remain invisible for a long time and may not show up until irreversible changes have taken place deep within the fiber of the work of art. The effects of tarnish on metals, food or chemical stains on textiles, ultraviolet radiation on fugitive color, and quick humidity changes on ivories or woods, may not become known for months or years after the unwary photographer set in motion the subtle but inexorable process of deterioration.

Below are some guidelines based on information in *The Care and Handling of Art Objects*, by Marjorie Shelley (New York: Metropolitan Museum of Art, 1987).

Rules, however, must sometimes be broken—and not always through carelessness on the photographer's part. Surprisingly, I have been asked by curators and art directors to shoot objects in a manner that seems to jeopardize the art. Typically, these situations involve the propping up of a fragile, top-heavy object, such as a large ceramic plate, to be stood on edge for a view into the plate's flat surface. (This *can* be done by leaning the plate gently against a heavy weight and taping the two objects together. A narrow block of scrap iron, as tall at least as three-quarters of the plate's diameter, will not show in the camera, but will give ample support.) Although a unique stand or mount may have been custom-fitted for displaying such a fragile object in a gallery, neither the mount nor any other prop is allowed to be visible in the photograph.

If you are asked to levitate a work of art in an unusual circumstance that seems unsafe, your ingenuity must be tempered by caution. If you think that the method indicated jeopardizes the work, don't do it.

Attitude, Awareness, and Housekeeping

Underlying a good photographer's habitual sense of caution there must be a solid confidence that quells all nervousness. If you can juggle three eggs while blindfolded, but cringe at having to carry a century-old teapot across the room, you can overcome the fear by being certain of your abilities and surroundings. Move slowly, with deliberation and forethought.

Forgetfulness when handling art is simply not allowable. Studios abound with stands, tripods, electrical cables, and overhead booms whose positions are continually changing. It takes practice and concentration to develop the peripheral vision necessary for skirting collision when moving art. Orderly housekeeping not only improves one's sanity and efficiency, but it also keeps a clear path for getting the art to the set. Because studio work promotes an industrial atmosphere, I often remind myself of the difference between the strength needed to hoist a twenty-five-pound spotlight, and the delicate touch needed for lifting a half-pound vase. Switching procedures requires consciously changing my dexterity gears.

Support and Environmental Control

Risk to art work can be minimized by reducing hand-carrying. Rolling tables, baskets, and dollies, properly lined with felt, foam rubber, or carpeting, should be used for everything from glassware to books to paintings. Carry small objects, such

as coins or tableware, in an open box with handles and tissue or cotton padding. *By every doorway, there should be a table for setting art while you open the door—with your hand, not your toe.*

When moving heavy art brings out the machismo in you, remember that no one has ever been favorably impressed by a shattered marble sculpture. *Get help. If you have doubts, get more help, or let an expert handler or rigger move it.*

The art storeroom should be clean and free of things not art (except for a light box for color-correcting). In the camera room, away from the set, provide ample shelves or tables reserved for art. Both temperature and humidity in storage areas must be monitored and controlled to avoid the abrupt changes in range that are detrimental to most art. Compare often these environmental factors in storage spaces with those on the set, and take steps to make the temperature and humidity of the two areas match as closely as possible, to prevent shrinking, expanding, warping, and cracking of art objects.

Some Dos and Don'ts in Handling Art

• Before picking up any art object, examine it carefully for breaks or weak repairs: a seemingly intact pre-Columbian copper mask I once tried to move crumbled in my hands because I did not notice a hairline crack that had been "repaired" from the back with ordinary transparent tape.
• Always use two hands when picking up an object.
• Support the heaviest part of an object from underneath with your stronger hand, and steady the upper

portion with the other.
• Move separate parts of an object separately—for example, carry a covered dish in two trips, not in one.
• Make sure that tall objects are stable after setting them down. If they are top-heavy or wobbly, they could teeter and fall.
• Prop off-balance objects with a wedge that will not harm the art's surface. Wood slivers, slices of gum eraser, beeswax, pencils, plastic lids from film cassettes, and coins are all useful props.
• Secure all photographic equipment in place before moving the art to the set. If a risky change is to be made, such as switching backgrounds or changing lenses above the art, first remove the art from the set.
• Don't let pens, cigarette packs, or other small personal items fall out of your shirt pocket onto art in a vertical set.
• Don't use plasticene or other oily substances as props for porous stone and low-fired pottery, because the oil may be soaked up by the art, causing stains.
• Wash your hands often to remove the grit that clings to them from electrical cables and traces of chemicals from the darkroom. *Textiles and works on paper are especially susceptible.*
• Wear clean cotton gloves when handling glass or any metal that tarnishes easily. Silver, gold, firearms, delicate bronzes, and painted wood or stone require glove handling. However, gloves reduce one's grip and tactile control, so bare hands may be better on heavier objects.
• Do not pick up objects by any projections or fragile parts. Teacup handles, glass stems, and chair arms are obvious examples.

• Do not use tape of any kind near paintings, silver works, paper, textiles, ivory, or wood. Besides lifting pigments and tearing surfaces, glue from tapes is notoriously damaging to these media. Tape can be safely used on certain glazed ceramics (but not on low-heat-fired pottery), on glass, and possibly on some bronzes whose surfaces are in prime condition—but only as a last resort for support. (A bronze that is patinated or crusty or diseased may be damaged by tape lifting off some of the metal.)
• Do not lift paper objects by the corners. Carefully slide under the art a thin, stiff ragboard as a support.
• Carry paintings by the frames or stretchers, and keep fingers off the pigments. Oils from your hands can cause long-term damage.
• Do not consume food or beverages in the camera room or in art storage areas. Food and drink may cause direct stain damage to the art, and they attract vermin that can infest furniture and textiles.
• Move heavy books or stacks of smaller ones on a rolling cart. When photographing bookplates, do not force the book open fully, or you might break the spine or tear out pages. Opening the book much farther than a hundred degrees might make the page being photographed bulge, yielding a distorted image.
• Support the opened section of a book with lead weight from behind it when copying in a vertical set. Turn pages carefully, using two hands.
• In instances where you suspect damage to a work of art to be recent, even though not caused by you, notify the curator-in-charge or a conservator. Your alertness and honesty will be appreciated.

4
Equipment and Tools

MAN Ray, celebrated for his experimental work in both painting and photography early in this century, once stated that

Until now [the photographer] has relied too implicitly on the short-sighted scientists who have furnished him the materials for his medium. His concern with *how* the thing is to be done, instead of *what* is to be done, is a repetition of the spirit that held in the early days of painting, when painters went about smelling each other's oils.[1]

In spite of Mr. Ray's spunky exhortation, we must detour through the enticing land of equipment to examine some bizarre but intriguing technology before continuing to the actual methods of photographing art. After all, *what* we will photograph is given; we need to know *how* to proceed by choosing the right tools and mastering their use.

Several pitfalls lie before us. The first may trap the novices among us who become fainthearted at the prospect of coping with mechanical gadgets. They may decide to skip these pages and go to the section on lighting. But much of the later material is built on the terms and explanations presented next; if something in the last half of the book puzzles you, it may be because you missed reading about it here. If you can drive a car or cook your own dinner—not a frozen one—you can certainly learn the basics of photo technology.

A second ambuscade is one that might ensnare even the professional in our midst, who may also be tempted to skip this material. If you are at ease with the tools and methods that have served you well for many years, you may be justified in ignoring this chapter; do be aware, however, that, although new technology is developed with an eye to profits for the manufacturer, we often benefit from updated equipment when it makes our work easier and our photographs better. While some "advancements" in 35mm cameras geared for the amateur market have eclipsed the professional's needs, recent developments in lens design, for example, make these newer tools optically superior to older lenses you may be using.

The third possible entrapment can distract those who, like myself, regard encyclopedic knowledge of equipment or the ownership of many cameras and lenses as an end in itself. In the first instance, such thinking will erode your time; in the second, your wallet. *You can do a wealth of fine work with one camera body and two or three lenses for each format you shoot. Likewise, a few well-chosen lights can serve a variety of needs.* Many photographic suppliers rent equipment at a modest cost, so that you can keep a trim ship. Renting a thousand-dollar wide-angle lens for one use, for example, is far more sensible than buying it. If you want to purchase a new camera, rent it for a weekend, to find out whether you like it.

Camera and lens designs have evolved within a mystique of advertising claims and testimonials that can complicate rather than clarify a sensible choice. When shopping for a camera, set a budget, ask opinions of other photographers, read magazine articles, and handle as many different brands as you can before you buy. Once a "scientific" examination of the market has been made, follow your intuition, because this mass-produced instrument is your primary tool, and it will become as personal as your favorite chair.

Formats

Cameras can be categorized according to the size, or format, of film they use. The format directly relates to image quality, cost of film and processing, and the amount of space needed for archival storage. It is also closely linked to the cost of camera equipment, the speed with which that equipment can be handled, and its suitability for location work. But the chief criterion for selecting one format over another is the end use of the photograph.

Small format. If you want to save time and money, choose a camera

that uses 35mm film, which yields 24 x 36mm images. With fine-grain black-and-white film and fine optics, you can make high-quality enlargements up to an 8 x 10 print. However, the grain structure inherent in such enlargements is definitely noticeable, when compared to a print made from a medium-format or large-format negative. If your needs are primarily small record prints for registration files, occasional 8 x 10 enlargements for publication, and color slides for lectures, the 35mm format should be more than satisfactory.

Medium format. Medium-format equipment is heavier and generally costlier than 35mm cameras, but it's a good compromise between small and large format, if you cannot afford both.

The standard roll film required for medium-format cameras is designated 120 size, which will yield negatives or transparencies of various dimensions, depending on the particular camera design. Available formats are 6 x 4½ cm (2¼ x 1⅝ inches), 6 x 6cm (2¼ x 2¼ inches), and 6 x 7cm (2¼ x 2¾ inches), resulting in sixteen, twelve, or ten frames per roll, respectively.

Enlargements up to 11 x 14 inches, made from fine-grain black-and-white film in medium format are difficult to distinguish from those made with 4 x 5-inch format. Small record prints can be contact-printed quickly and trimmed to size. However, the odd size requires a special projector in order to use color transparencies for lectures. Generally speaking, small color reproductions made from medium format are similar to those made from 35mm Kodachrome transparencies.

Specific reference to medium-format equipment throughout this book will be meager, because I suspect that it is less frequently used than other formats, although many

medium-format brands are very fine tools and are a joy to use.

Large format. For maximum image fidelity, large-format film is without peer. The grain structure is barely noticeable in enlargements up to 11 x 14 inches, and the large film withstands repeated handling with more grace—and durability—than its little brothers. The finest color reproductions are normally made from large-format transparencies. Also, black-and-white negatives can be processed individually for optimum contrast control, something not possible with roll films. However, big film requires a big storage area, and the cost per shot is significant.

A major advantage of large format cameras is that the larger ground-glass image affords greater attention to composition and lighting details with less eye fatigue than small- and medium-format equipment do. Large format is for the serious photographer who has the time, money, and enthusiasm necessary for mastering its image controls.

View camera formats are 4 x 5 inches, 5 x 7 inches, 8 x 10 inches, and 11 x 14 inches. All but the 4 x 5 and 8 x 10 are slowly becoming bastard sizes, although film for all formats should continue to be available for many years.

35mm Cameras

There are two basic types of focusing 35mm cameras: the range finder and the single lens reflex. With the range finder, viewing and focusing are performed via a framing window that closely approximates the view seen by the lens. But since the view the photographer sees is not exactly the same view that the lens sees, errors in composition can easily occur. This displacement, called *parallax error,* is automatically corrected, to some extent, in better cameras; but residual error is unavoidable, and the error gets worse

as the lens is focused closer. Consequently, range-finder cameras should be left to the photojournalist and others who need a quickly focusing, quiet camera.

By contrast, the single lens reflex (SLR) type has a viewing and focusing system that allows the photographer to see exactly what the lens sees, even when one changes lenses. This feature is indispensable for the precision necessary to compose a shot of a complex sculpture from the desired perspective, or to center a painting accurately in the viewfinder.

TTL meters. Most current 35mm SLRs have a built-in meter that reads through the lens (TTL) that light reflected from the subject field. TTL meters automatically compensate for different angles of view seen by different lenses, as well as for reduction of transmitted light caused by filters, or by bellows extension when making close-ups. Although use of a TTL meter is convenient, it is not essential, because you can use a hand-held meter instead.

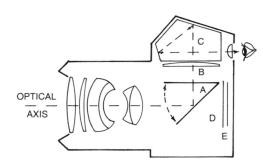

Fig. 4.1. *In this diagram of a 35mm single-lens reflex (SLR) camera, light entering the lens is reflected by a mirror* (A) *through the camera's ground-glass* (B) *and into the camera's pentaprism* (C), *producing, at the eyepiece, an erect image that looks exactly the way the lens frames the view. Upon exposure, the mirror at A swings upward, allowing the imaged light to pass to the shutter* (D), *which opens to expose the film* (E).

TTL meter sensitivity patterns vary from model to model. Some extend uniformly across the field of view, while others are center-weighted. A few cameras offer a concentrated spot-reading of a few degrees. It is important for you to know your camera's sensitivity pattern if you are to assess intelligently the information it gives you.

More specific tips on using TTL meters appear in the section on exposure control.

Automatic cameras. A plague of automatic and programmed cameras has invaded the 35mm market in recent years. The shutter-priority and aperture-priority models let you pick the shutter speed or the aperture, respectively, while the camera's computer picks the other variable to get a good exposure. Programmed cameras automatically control both shutter speed and aperture at settings that are a compromise of action-stopping ability and depth of field. Multi-mode models offer two or three configurations. Usually, any of these cameras also has a manual mode.

Automatic cameras are fine for many general picture-taking situations; but when used in the automatic mode, they are less than ideal for studio and gallery work. The reason is that they choose an exposure based on a "normal," uniform distribution of bright and dark areas in the scene. Many paintings, tabletop sets, and gallery cases, however, have an unusual distribution of tonal values that might fool an automatic camera into rendering a poor exposure. *Consequently, the automatic camera you use should also have a manual mode to allow "bracketing" exposures above and below the setting recommended by the camera's meter.*

Shutters. Earlier cameras had mechanically timed focal-plane shutters, but the trend today is to use electronic means. While the

mechanical type is subject to timing error with age, the electronic type is battery-dependent. If your battery goes dead with most models, you will have only one mechanical back-up speed (usually about $\frac{1}{90}$th of a second). The necessity of always carrying a spare battery is obvious.

Autofocus lenses. Manufacturers have been phasing out manual-focus lenses because the buying public wants autofocus lenses. Some newer autofocus lenses on less expensive cameras are autofocus *only*, while better lenses have both autofocus and manual override. Developments in engineering have made autofocus lenses highly reliable, and they will prove useful for photographing flat art or objects on display in galleries. But certain conditions can cause some types of autofocus lenses to make unsharp photographs. Vitrines surrounding objects can fool the autofocus mechanism, causing the lens to focus several inches in front of the art, at the surface of the vitrine. In this instance, and for subjects such as furniture, sculptural and decorative objects, and gallery views, you will want to override the automatic function to focus manually for the best depth of field (see pages 33–34).

Viewfinders. Most viewfinders display the selected shutter speed, or the aperture, or both. The configuration of this information can take different forms: numbers silhouetted within or outside the picture area, light-emitting diodes, or a liquid crystal display. A preference for the nature and position of these displays is largely personal. I dislike those that impinge on the picture area, because they can't be read easily on all kinds of scenes; but I use such a camera, because it has other advantages that offset that problem.

Nikon is the only current camera manufacturer to construct a viewfinder whose frame coincides precisely with the image recorded on

film. That feature is standard only with the models F, F2, and F3. Contax, Canon, and a few others show more than 95 percent of the recorded image in the viewfinder. All other cameras, at present, allow the dubious benefit of giving one much more image on film than can be seen in the viewfinder, so that framing becomes a matter of estimation. As if this weren't trouble enough, the extra image may be offset more in the vertical dimension than the horizontal, or vice-versa. Extra image is no problem in black-and-white work, where it can be cropped in printing, but that bonus area in a slide may just reveal the corner of a reflector card, or the edge of the background paper that you did not see in the viewfinder. Fortunately, a slide mount will often crop the processed image by an amount corresponding to the field seen in the viewfinder. Only framing tests will reveal how much bonus image a given camera will yield, and whether the image is centered.

Other features. Focusing screens are interchangeable in some cameras, allowing a selection of different patterns for focusing, or better viewing for special lenses. The preferred screen for our work is a uniform matte field with etched vertical and horizontal lines similar to those on the ground glass of view cameras. Such a screen is especially good for framing flat art parallel to the film's edges, for aligning the vertical axis of three-dimensional objects, and for architectural subjects. Being matte, the screen allows focusing of the image at any point across the field of view.

Interchangeable lenses provide some flexibility in choosing perspective. Virtually all SLRs now accept different lenses, and the type of mount is important to consider only if you intend to adapt to your camera a lens made by a different manufacturer. Some brands are inter-

adaptable; others are not.

Power winders for automatic film advance are convenient only for art that moves very fast or for multiple slide frames of one view (different from multiple exposures on one frame). When exposing multiple frames, use of a power winder precludes camera movement and misframing that might occur when advancing film manually, even though the camera is tripod-mounted. Your money could be better spent on lights and stands.

Medium-Format Cameras

Equipment in the medium-format category falls naturally into the division of SLR cameras, with viewing/focusing systems similar to their 35mm counterparts, and twin-lens-reflex cameras. The latter type, such as the famous early Rollieflex, permits viewing and focusing through an auxiliary lens mounted just above the picture-taking lens. Unlike the viewing and focusing system of the SLR, this arrangement allows continuous viewing during the exposure. But, like the range-finder system, this configuration suffers from parallax error, a problem that renders the twin-lens reflex inappropriate for photographing art.

Many SLR camera designs incorporate a film chamber that is a module separate from the body proper. If you own two modules, you can change from black-and-white to color film in mid-roll, without moving the camera or wasting film.

TTL meters and automatic cameras. Fortunately, the automatic exposure craze has not yet overcome the medium-format camera. In fact, the basic camera from most manufacturers has no meter, but a TTL type is usually available as an expensive accessory. However, automatic exposure models are being added to each line of cameras, at premium prices.

Shutters. Medium format SLRs use either a focal-plane shutter mounted in the camera body or a diaphragm shutter mounted in the lens. The latter type can be synchronized with electronic flash at all speeds up to $\frac{1}{500}$th of a second. This is an advantage if you use strobe often in areas of bright, existing light, because you have the option of using a slow shutter to capture ambient light in addition to your flash, or you can use a fast shutter to eliminate the ambient light and still synch with your flash. On the other hand, the focal-plane shutter's fastest flash synch speed is about $\frac{1}{60}$th of a second, which may be slow enough to allow ambient light to register on color film in addition to flash. If that existing light is tungsten or fluorescent, as it might be in a gallery, the mix of variously colored sources will look peculiar on film.

Viewfinders. The standard viewfinder yields an image that is erect (right-side-up) but virtual (reversed left for right). You can overcome this disconcerting feature with experience, or you can purchase an optional (and expensive) prism viewfinder that gives an erect, normal image like that in a 35mm SLR.

Large-Format Systems (View Cameras)

Large-format camera systems include a complex and expensive category of equipment that one should research thoroughly before buying. While a modest but useful 4 x 5 set-up can be bought for about the same money as one of the better 35mm cameras and several lenses, you may have to spend several thousand dollars for a more versatile view camera, three lenses and accessories. The camera itself is only the heart of a system that could include interchangeable backs, film holders, lens boards, lenses, compendium lens shade, plus a heavy-duty tripod. In addition, you will need special equipment if you plan to

process black-and-white film yourself.

An appealing feature is that all large-format lenses of any brand will fit on any large-format camera. Such versatility allows you to tailor a system to your specific taste and requirements.

View camera design. A view camera may look formidable and complex, yet it is basically composed of four main parts whose functions are utter simplicity:

1. Front standard: a mount for the lens (and auxiliary shutter, if needed).
2. Rear standard: a mount for the ground glass (used for composing and focusing) and for the film holder, which displaces the ground glass for picture-taking.
3. Bellows: a flexible, hollow compartment that makes a dark space between the lens and the film.
4. A bed or rail that supports the front and rear standards.

The front and rear standards can move independently in various ways that affect the shape and focus of the image. These movements are the optical controls that give the view camera another distinct advantage over cameras of smaller format.

There are four basic movements that can be designed into either standard. Their description appears in Appendix 2, "View Camera Movements," along with some basic examples of ways in which they are used. Better view cameras incorporate all four movements into both front and rear standards.

When shopping for a view camera, check the position and alignment of all optical controls. Are they logically positioned? Can they be unlocked inadvertently? Is there a detent in each control that allows easy centering? Do the gross and fine focus adjustments move smoothly? Some cameras have a single lock for both horizontal shift and swing

movements. This is a cleverly crafted but frustrating design that is tedious to use, because you must carefully align both movements each time you want to set only one of them.

Viewing systems. Since the ground-glass image in a view camera is formed directly from the lens, it is the simplest viewing system of all cameras. However, the image is *inverted*, a feature that is disconcerting for beginners. With practice, judging view camera composition and lighting becomes second nature.

Several 4 x 5 brands offer an accessory reflex viewer that clips over the ground-glass and eliminates the need for a focusing cloth. Its image is erect but remains reversed, left for right.

Flatbed view cameras. Flatbed view cameras are considered more stable than the monorail type, especially when used vertically. Other advantages are its light weight and its compactness when folded for

Fig. 4.2. *Schematic drawing illustrating the front section of a typical monorail view camera:* A, *lensboard;* B, *lateral shift movement;* C, *vertical shift movement;* D, *swing movement— rotation of the standard about a vertical axis;* E, *tilt movement— rotation of the standard about a horizontal axis. The bellows for such a camera—not shown here—would attach to the back of the lensboard.*

transport. However, many flatbed view cameras have limited optical controls in the rear standard, and most controls are not geared, as they are on many monorail types. Also, the short bellows common to most flatbed cameras makes close-ups difficult, and restricts the use of longer focal length lenses, which are preferred for the majority of art objects. The only way around this last problem is to buy an expensive, specially-designed telephoto lens which yields an image that is magnified larger than its focal length would suggest. (For details, see the section on telephoto lenses.)

Monorail view cameras. Monorail view cameras range in cost from the modest to the ridiculous. The most basic models suffer from grossly designed optical controls that subvert aspirations to finesse, a fixed bellows of restrictive length, and a small selection of accessories that can limit their versatility. Better models have all four optical movements built into both front and rear standards, and they operate smoothly and positively. Such features as interchangeable bellows, center standards (used with double bellows), extension rails, rotating ground glass backs, multi-format backs, and copying frames make these modular systems extraordinarily versatile.

At the top of the line is the Sinar-P, designed with the care of a Mercedes-Benz— and priced like one, too. It includes such sublime features as "asymmetrical axis" for tilt and swing movements, and self-locking controls. Many other cameras may seem like Volkswagens in comparison, but they'll get you to the same beach, if not in the same style.

Copy Cameras and Stands

The equipment under this heading is distinguished by the fact that the copy board, camera stand, and lights form an integral unit with the camera for the sole purpose of copying two-

dimensional works of art. Studios, libraries, and museum departments that do a lot of copying can benefit from having a permanent copy set-up that is ready for work with minimum adjustment.

Copy stands for 35mm cameras are designed much as enlarger stands are, except that, in place of an enlarger head, there is a mount for a camera, which points downward at copy placed on an easel. Two lights fixed to brackets provide illumination. To use such a stand, make sure your camera is level and square with the art or bookplate; load the correct film (usually Type B color, to match the lights); focus carefully; and meter the subject accurately.

An expensive but useful copying accessory for your camera is a magnifying waist-level viewfinder that allows one to see easily into the camera when it is on a copy stand; otherwise, you may have to tiptoe and crane your neck.

Large-format copying on an occasional basis is most simply done by placing the copy on an easel, illuminating it evenly with two lights, and sliding a tripod-mounted camera along an axis perpendicular to the copy to compose (see below, "Photographing Flat Art"). An alternative for busier studios is to make a horizontal stand, something like the one sketched in figure 4.3. Although the sketched design shows a 35mm camera, any format could be adapted. Simply mount a firmly anchored, stationary plywood copy board at one end of a smooth-topped table, exactly parallel to the film plane of the camera. To make the camera stable, mount it on a tripod head slipped over a spud that is screwed to a wooden box. Sliding the box between wooden guide rails allows gross image sizing, while exact focus is achieved in the normal way. Make the height of the lens above the tabletop half the height of the visible

Fig. 4.3. *An old table makes a good base for a homemade copy stand. Attach a plywood copyboard covered with homosote firmly to one end of the tabletop. Mount a camera—any format will work—on a box by means of a tripod head and aim the camera horizontally at the copyboard. Gross image sizing is done by sliding the box forward or backward between wooden guide rails screwed to the tabletop. Height of the camera lens above the tabletop should be half the height of the copyboard.*

portion of the copy board. If homosote is nailed to the copy board, you can hold mats in place with pushpins whose heads gently but firmly hold down the perimeter of the mat. Or you can use glass to hold the copy flat (use discretion with delicate surfaces like charcoal drawings or pastels). Keep the glass in place with a length of clothesline wrapped around the board and connected behind the board with a heavy strip of rubber, to make the line flexible but taut. Another method that works for unmatted, lightweight art is to cover the board with Velcro loop material, and hold the copy with Velcro hook tabs at the corners. The tabs may cover the artwork if there is no

border, but this approach is usually acceptable for condition documentation photos.

Accessories

Any photographer trying to keep up with the vast array of accessories available today would go mad—and go broke, at about the same speed. A few accessories are *essential*; some are *useful*; a great many are superfluous gadgets.

Some essential accessories are these:

1. A lens shade, which prevents light from striking the lens and causing flare.

2. A cable release, which prevents camera shake during exposure by permitting the photographer to trip the shutter from a safe distance.

3. A focusing cloth, for clearer viewing of a large-format camera's ground glass.

4. A magnifying loupe, for critical focus with a view camera.

5. A small spirit level, for aligning the camera parallel to architectural subjects and two-dimensional art.

The Lens: Its Function and Design

To anyone who has thought about it for a couple of minutes, the apparent similarities between the human eye/brain combination and a camera/lens/film system are, in reality, quite few. Of course, both use a lens and a light-sensitive medium to focus an image for analysis; but in the case of us humans, our storage capability—our memory—is limited and undependable, compared to photographs.

In addition, our eyes see a panorama of over 125 degrees horizontally, so that we are seldom conscious of any abrupt perimeter of vision, even if we wear eyeglasses. Our wide field of view gives us an enormous sense of freedom of sight. However, because of the unique

construction of our eyes, with their retinal nerves feeding information to the brain, well over 95 percent of our *attention* is focused in about 1 percent of the panorama. In other words, when someone says, "Look at the girl's face in that Renoir painting," you swivel your eyes in their sockets and direct a highly concentrated gaze toward a very small physical area. In order to evaluate the entire painting, you must *scan* it, perceptually integrating a series of tiny isolated images, because peripheral vision is too unqualified to give the best input.

Not so with photographic lenses. Whether you use a lens with a wide or a narrow field of view, the parameter of its vision is cut off by a black frame that can be seen inside the camera's viewfinder. Of course, this frame corresponds to the outer edges of the image recorded on film which, in turn, corresponds to the maximum image in a print or a slide. You can later crop that image to include less area, but you cannot expand it to include more area than the lens saw when you fired the shutter. Embarrassingly basic as this point is, I emphasize it *because the frame is a primary factor in photographic composition.* Lenses also lack the ability to reason. Being passive, they absorb all light rays, indiscriminately, and cannot scan a scene or an art object and make sense of it, the way you can. Consequently, if your photographs are to be what you'd like them to be, you must learn to *be responsible for all the input that a lens gathers*—in terms of the relative position of all subject points within the frame—before you expose film.

Other major differences in the two systems lie in their function and construction. On the one hand, human eyes automatically accommodate to both varying distances of focus and fluctuating levels of light; on the other, cameras and lenses—at least,

the manual ones we mostly use for shooting art—must be controlled by us to perform these functions. Also, the remarkably efficient eye/brain construction gives excellent vision with a minimum of flaws and, with healthy eyes, the human viewer can, with the help of a simple corrective lens, alleviate most flaws. By contrast, photographic lenses must be designed to meet a variety of criteria that are often at cross-purposes, with the correction of various flaws requiring from three to eighteen separate glass elements, grouped into components whose shape, thickness, composition, and curvature control light in a quantum ballet.

"Just what I *don't* need," you say, "a bunch of charts and diagrams and technical jargon that will send me running back to my Instamatic."

I hope not. What follows is a truly nontechnical overview of photographic lenses, designed to present a clear statement of the way lenses work— at the direction of keen personal vision.

An Optics Primer

Angle of view. An easy way to understand a camera lens is to think of it as an optical system that "collects" a cone of light reflecting from a subject, and then "projects" an inverted cone of rays inside the camera, where it is "deposited" on the film as a focused image. Although the projected cone is round, the film gate in the camera crops and shapes the sharp, useful portion of the deposited image to a square or rectangular *image field*. This corresponds to our earlier mention of the viewfinder image of the *subject field* outside the camera. A quick method of classifying a lens is to know its *angle of view,* which is the angular measurement across the diagonal of the subject field, telling you how much the lens "sees,"out there. (See figures 4.4 and 4.5.)

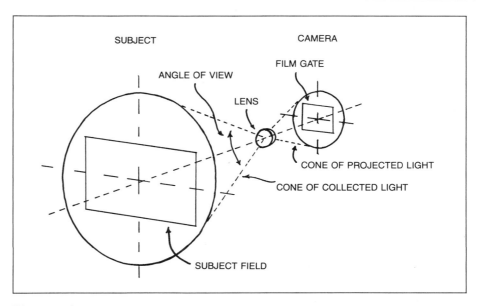

Fig. 4.4. *Convention in optical diagrams puts the subject to the left of the lens, and the camera and film to the right.*

Lenses with an angle of view wider than about 60 degrees are called *wide-angle lenses,* and they are useful for shooting sweeping views of rooms where space is cramped. Depth of subject space is exaggerated, with nearby objects looming large, and distant ones seeming diminutive.

Conversely, lenses with a *narrow* angle—less than 40 degrees—are called *telephotos,* and are necessary, for example, to magnify the image of a stained-glass clerestory window shot from the floor of a cathedral.

In between 40 degrees and 60 degrees are the so-called *normal lenses.* Curiously, to me, this angle is nowhere near the panoramic 180 degrees our eyes see, so why are these lenses "normal?" I've an opinion about that, just a bit further on.

Focal length. The main design property of a lens that makes it either wide, normal, or telephoto is its focal length—which, for most lenses, is the distance between the lens center and the film plane when the lens is focused on infinity. A lens designer creating a normal lens will make the

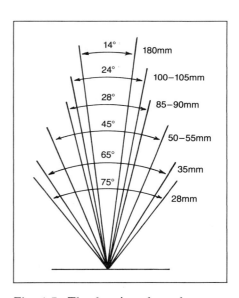

Fig. 4.5. *The drawing above shows approximate angles of view for standard focal lengths of selected lenses for the 24 x 36mm format.*

focal length about equal to the distance across the diagonal of the format; for a wide-angle lens, he will make it shorter; and for a telephoto, longer.

"All very interesting," you say, "but why bother me with this?"

For two reasons: first, the only way to identify a lens is to look at the lens barrel, which is stamped with the focal length—not the angle of view. But since these two properties are always interrelated, if you know the focal length, you can estimate the angle of view. Figure 4.5 illustrates this point.

Second, the focal length is an important value that must be used in calculating exposure compensation when shooting close-ups with a camera that does *not* have a TTL meter. Appendix 5 gives details.

Interformat relationship of focal lengths. More, now, on focal lengths. Take a look at Table 4.1. Reading across, note that *lenses classified similarly, such as the normal lenses, have different values of focal lengths for different formats.* Why? Because the diagonal measurement of each format is different. Yet all the normal lenses for their respective formats will give an equivalent angle of view and degree of magnification. Likewise, each lens from a wide or a tele group will be alike in these respects. This is valuable information if you want to shoot a 35mm slide and 4-by-5-inch negative of an object from the same point of view and hope to get a similar image size on both films. If your 35mm slide is shot with an 85mm lens, for instance, you would want to use a 210mm or 240mm focal length for the 4 by 5-inch format.

Although some focal lengths occur in two or more formats, they can seldom be interchanged between formats.

Magnification and reproduction ratio. Magnifying power is not a popular way to compare lenses, but if

Table 4.1
Comparative Table of Focal Lengths and Formats

Classification	35mm (24 x 36mm)	6 cm x 6 cm	4" x 5"	8" x 10"	Approximate Angle of view
Very Wide-Angle	20mm	40mm	65mm	125mm	90°
Semi- Wide-Angle	28mm	50mm	90mm	165mm	75°
	35mm	65mm	135mm	210mm	65°
Normal	50mm	80mm	150mm	305mm	50°
		100mm	180mm	360mm	40°
Semi- Long-Focus (Short Tele)		120mm	210mm	420mm	35°
	85mm	150mm	240mm	480mm	30°
	105mm		305mm	610mm	25°
Very Long-Focus (Tele)	135mm	250mm	360mm		20°
	180mm				15°

Note: An exact comparison of focal lengths is not possible between two formats whose aspect ratios (vertical versus horizontal dimensions) are not proportionate, viz. 24 x 36mm and 6 x 6cm. Direct proportional comparison *is* possible between 4 x 5 inches and 8 x 10 inches.

Example 1. A normal 50mm lens used on 35mm format yields approximately the same angle of view as an 80mm lens on 6 x 6cm format.

Example 2. A 210mm lens on 4 x 5-1 inch format will yield exactly the same angle of view as a 420mm lens on 8 x 10-inch format.

you are thinking of buying a new lens for increased flexibility, it is helpful to remember that *each doubling of focal length (within the same format) will double magnification and halve the angle of view. And vice-versa, when halving the focal length.* But such a big jump in magnifying power is sometimes restrictive on perspective; first, then, consider increasing focal length by 50 percent or decreasing it 25 percent from normal before you buy a super-tele or an ultra-wide lens. Of course, any lens will magnify the image when moved closer to the subject—which brings us to the next point.

Reproduction ratio refers to the size of the in-camera image compared to the size of the actual object being photographed. If, for example, the *image* of an ivory comb in your viewfinder is half the size of the *real* comb, you can describe that

relationship in various ways: the image is half life-size, or the image is 50 percent, or the image ratio is 1:2 (spoken "one-to-two"). I prefer the last notation, in which the first number always represents the *image size*, and the second, *object size*.

To get an idea of the difference in subject area that various formats yield at 1:1 ("one-to-one," or life-size magnification), imagine that you could comfortably fit the image of an extended hand and wrist on 8 x 10-inch format; the image of an orange on 4 x 5-inch format; and the image of an average coin on 35mm format. Looking at it another way: that extended hand, which would fit at 1:1 on 8 x 10 format, would have to be reduced to 1:2 for 4 x 5 format, and reduced to about 1:10 for 35mm format.

Now, *you* may not care what repro ratio a given image is, but *your lens*

does, because it will give you the best results when used at or near its *designed optimum repro ratio,* or focused distance. Since the bulk of our work requires repro ratios in the range between 1:15 (¹⁄₁₅th life-size) down to 1:1, we will be looking for lenses for each format that fit that requirement. Generally, small formats will be used at lower repro ratios (around 1:10) than larger formats.

The Aperture

Varying the size of the aperture in a lens does two things. First, it changes the amount of light transmitted to the film, just as turning the valve on a faucet controls water flow. In order to calculate the effect of aperture size on exposure it must, of course, be calibrated in some orderly fashion. Lens designers could have used any notation to calibrate settings (such as A, B, C, etc.), but in a moment of inspiration, they gave us the actual sequence of numbers derived from comparing the diameter of the opening at each setting relative to the focal length. Thus the term *relative aperture.* That is why two lenses with different focal lengths have different sizes of aperture openings at the same f/number. If you set f/8 on both lenses, they will transmit exactly the same amount of light. If you are less than excited by this, I can see why, because this sequence is as hard to memorize as your dentist's phone number.

Relative apertures (f/numbers). 1.4, 2, 2.8, 4, 5.6, 8, 11, 16, 22, 32, 45, 64, 90.

It may seem random, but being a geometric progression, it is quite logical: each successively *larger* number *cuts* light transmission by 50 percent, while going the other direction on the scale, each successively *smaller* number *doubles* light transmission. A simple mnemonic device that may help keep this mathematical quirk in mind is

thinking, "Little number, big hole — big number, little hole."

Changing the aperture toward higher numerical values is called "stopping down," while changing it toward lower values is called "opening up." Details on using the aperture in controlling exposure are given in chapter 7, "Exposure Control."

The range of apertures varies with lens type and format. Typical parameters on lenses you will use (medium wide, normal, and short tele) include these:

Small format
Maximum f/number
1.4, 2, or 2.8
Minimum f/number
16 or 22

Medium format
Maximum f/number
2.8, or 4
Minimum f/number
22 or 32

Large format
Maximum f/number
5.6, 8, or 11
Minimum f/number
45, 64, or 90

Lens nomenclature always includes the camera name, lens name, focal length, and maximum aperture, e.g., *Olympus Zuiko 85/2.*

Optics with a very large maximum apertures ("fast" lenses) are handy for indoor low-light-level work because the viewfinder image is bright, and the precise point of focus can easily be seen. However, these lenses are expensive and are usually designed to give the best results when focused on distant objects. In fact, some of the better lenses for photographing art do not, as we shall see, have very fast maximum apertures.

Depth of field. The second thing the aperture does is influence certain optical qualities in the image.

To understand how, think of the *plane of critical focus* as an imaginary

plane in subject space that lies along those points most sharply focused. When you focus on a painting, it becomes obvious that this plane coincides with the surface of the canvas and is parallel to the film plane, but when you focus on a three-dimensional object, such as a chair, you have to imagine that the plane of focus is slicing through space and the chair at the place where you most critically focus. Now, if you shoot one negative at maximum aperture and one at minimum aperture, the chair's image will be mostly fuzzy in the former shot and sharp in the latter. Why?

Because of an optical property common to all lenses, *object points before and behind the plane of focus will appear unsharp at larger apertures, but sharper at smaller ones.* This zone of acceptable sharpness extending in space on *both* sides of the plane of critical focus is the *depth of field,* whose limits expand as you stop down the aperture. The rule of thumb is to use smaller apertures to render images of deep objects sharply from front to back, but soon we'll see that there is a qualifier to this rule.

How do you know how much to stop down for a given subject? Just to get an overview, consult the depth-of-field table packed with each new lens. This table gives near and far distance values for depth-of-field zones at various subject distances and aperture settings. However, you can choose the best aperture just as well either by using the depth-of-field estimator engraved on the barrels of small- and medium-format lenses, or by using the camera's depth-of-field preview button and checking visually before you shoot. The latter method requires some practice to perfect, since the image darkens considerably.

The tables packed with lenses imply that all subject points within the depth-of-field (DOF) zone are equally sharp and that points immediately

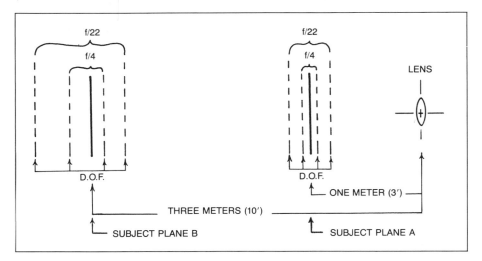

Fig. 4.6 *When a lens is focused on a nearby object (see Subject Plan A, at right, above), depth of field is shallow at a wide aperture (f/4) and is increased at a small aperture (f/22). Note that the depth of field (DOF) zone is divided almost equally on either side of the plane of critical focus. When the same lens is focused on a more distant object (see Subject Plane B, left, above), the DOF zone at these respective apertures is much larger. The zone beyond the plane of focus increases at a faster rate than the zone on the near side of the plane of focus, as the subject distance becomes greater—useful knowledge when you want to place the plane of focus at the optimum position for the greatest depth of field at the widest possible aperture.*

Fig. 4.7. *Typical of small-format lenses is the 100mm f/4 Canon macro lens shown here. Lens parts include:*

Knurled focusing ring (A), for adjusting the plane of focus.

Yellow "reminder" line (B), a reminder that ring A has been set to engage friction drag to prevent it from slipping out of focus when camera is vertical (unique to Canon).

Reproduction scale (C), found only on macro lenses. Here, value to left of colon is image size; value to right of colon is actual-object size. This lens is focused at 1:7, giving an image one-seventh of life size.

Distance scale (D), measured in feet and meters; here, lens is focused at three feet (0.9 meters).

Depth-of-field scale (E), showing approximate DOF at various apertures, automatically compensating for all subject distances. At three feet, f/32 DOF ranges from 2.8 to 3.2 feet;

Aperture scale (F), for adjusting aperture size; and

Auxiliary repro ratio scale (G), used only when extension ring is between camera and lens (not shown), to give repro ratios from 1:2 down to 1:1.

outside the zone are blurred, but actually the transition from "sharpness" to "blurriness" is gradual for each part of your subject. Depending on a subject point's distance from the plane of focus and also on your tolerance for slightly blurred subject points at the zone's limits, the *apparent* depth-of-field zone will shrink or expand. In addition, the zone's size is dependent on the degree of image enlargement (print size) and the distance from which the print is viewed. Our chair may look sharp from front to back in a small print, but its near and far points may look quite fuzzy in a large print that you scrutinize from a close distance.

Another thing to remember is that, as you focus closer, as you would for small objects, and the repro ratio increases—from, say, 1:10 to 1:5—

the depth of field shrinks if you keep the aperture constant. For this reason, you must often stop down more for close-ups than you would for distant shots.

Contrary to popular belief, wide-angle lenses will not yield an appreciably greater DOF than telephoto lenses, unless the repro ratio is about 1:5 or higher. But at such high magnifications, a wide-angle lens will be so close to the subject that your lights may cast the lens's shadow on the art, so you would do better here to use a normal or long-focus lens.

Diffraction, resolving power, and critical aperture. "If stopping down insures that the depth of field will increase to render a subject sharply," you may ask, "why not always use the minimum aperture?"

In general, stopping down *does* increase sharpness, but at very small apertures, the *overall* image quality becomes degraded because of *diffraction*. The cause of diffraction is the bending of light rays as they pass the edge of the aperture iris; the result is that each ray of light striking the film—rays that should each record as a point of light—will record as concentric ripples of light, much the way the surface of a calm pool of water behaves when a stone is dropped into it. Since, at small apertures, a large percentage of rays are deflected by the iris, the lens resolving power is disrupted.

Resolving power is a measure of a lens's ability to record closely adjacent subject points as distinctly separate image points. The better the resolving power, the better a lens will render the art's texture, which is important for conveying a sense of the subject's medium and condition, as well as knowledge about the artist's method of working the surface. (Lens designers test resolving power by photographing a chart that contains many fine lines, and then counting the number of lines per millimeter recorded on film. Higher values, in the range of fifty to sixty lines per millimeter, indicate a good lens, but values will always be lower in the image corners and at both maximum and minimum apertures.)

If it seems that I have introduced two opposing optical phenomena, both caused by the aperture stop, you are right; when the aperture is stopped down, depth of field is great, but resolution is low; when the aperture is open, depth of field is shallow, but resolution—at least, theoretically—is high.

In practice, photos shot with the iris "wide open" have blurred and vignetted (darkened) corners—the result of residual lens aberrations—even if the subject is a painting,

which has no depth. These inherent flaws can be corrected by stopping down. As the aperture is closed, eventually a setting is reached beyond which no further improvement in image definition or evenness of illumination can be detected and, as far as resolution is concerned, the image is now "diffraction limited." This *critical aperture* is generally between two and five stops closed from maximum, and will give you the best overall image quality. For this reason, always use the *largest* aperture that will give just enough depth of field to include your subject's depth. Better lenses become diffraction limited at wider apertures. If you cannot find this information for your lens in test reports, and if you really want to know your lens's critical aperture, conduct your own test, shooting a newspaper page at all apertures. When I made such a test for a very good lens, I concluded that the critical aperture for that lens was, after all, not so critical, since I could not detect any difference in the four middle apertures until I examined the negative with a powerful 50x loupe.

Focusing Tips

If you have trouble seeing the viewfinder image clearly and getting sharp focus, perhaps you should change focusing screens and use one more suitable for your lenses, your eyes, and your chief application. The standard split-image screen, which is helpful if the subject has straight lines, may be useless or even a nuisance in other circumstances. Try a clear matte fresnel screen, either with no supplementary aid or with a central microprism; for flat copy work and architectural subjects, the addition of superimposed reference lines helps you align the art within the frame.

Focusing the image of flat art is straightforward, but focusing on a

deep three-dimensional subject, like a big pot in profile, can be tricky. Since depth of field is about equally divided on both sides of your plane of critical focus at medium and close subject distances, you can focus half-way between the *visible* near and far points of the pot and then stop down to increase depth of field. If your subject is a desk in three-quarter view and even the minimum aperture won't carry depth of field for sharpness throughout the image, sacrifice the least important part of the subject—in this case, the rear leg—and let it be slightly fuzzy.

If practical, choose an aperture in the middle range to keep resolution high and prevent an unnecessarily long exposure that could adversely affect contrast and color balance. After focusing a small-format lens, put a bit of tape on the collar to prevent it from moving, especially if the camera is pointing downward.

Occasionally you may encounter a lens whose basic design or individual idiosyncracies cause a noticeable shift in the plane of focus as the aperture is stopped down. This is not uncommon with some view camera lenses. To test for this problem, focus carefully on the brilliant highlight of a metallic object while the aperture is stopped down half-way; then open the aperture all the way and see if the highlight is still in focus. If it is not, the lens has a *focus shift*. Usually, the plane of critical focus moves away from you as you stop down. This is not a lens flaw, per se, since a great many optics of fine reputation have had it, but it can lead to image flaws if not counteracted. Should you have such a "shifty" lens, use the maximum aperture only for composing, and then stop down three stops to focus.

And don't rush the job of focusing. The art isn't going anywhere.

Figure 4.8

Figure 4.9

Figure 4.10

Figs. 4.8, 4.9, and 4.10. *The gracious lady in figures 4.8, 4.9, and 4.10 was a patient model for these three shots illustrating the effect of aperture size on image quality. Fig. 4.8 was shot at maximum aperture, and only the eyes are in focus. Fig. 4.9, shot with the aperture stopped down half-way, makes the near elbow and the distant flowers sharp, through increased depth of field. Fig. 4.10 was shot at minimum aperture, and although depth of field is further increased, diffraction makes the image so blurred that Daguerre would have been ashamed of it.*

Distortion and Curvature of Field

One purpose of the multiple elements in a lens is to control light rays in a way that minimizes aberrations (astigmatism, coma, spherical and chromatic aberrations, and so on,) to create a clear image. For you to detect the distinction among most aberrations is no more useful or interesting than being able to tell the proportions of cumin and coriander in Vindaloo Curried Mutton, but you will be able to see clearly in your photographs the *cumulative* effect of aberrations in an inferior lens that cause poor resolution—even when you shoot at the critical aperture.

Two aberrations that are especially bothersome when shooting paintings are distortion and curvature of field. Distortion is an obvious flaw that warps the perimeter of the image of any flat art (see figure 4.11) but has no effect on sharpness. Since the problem derives from the *placement* of the aperture stop—not its size— in relation to the glass elements, stopping down will not improve distortion. The only way to avoid it is to use a lens whose stop is located near the center of the elements, like the symmetrical apochromatic lenses for view cameras and macro lenses for smaller formats. Wide-angle and telephoto lenses often have negative and positive distortion, respectively, yet even here recent advances in design have minimized the fault in certain models. If you shoot many paintings, use a lens reputed to have less than 1 percent distortion. Lens manufacturers sometimes publish aberration figures, as do periodicals in their test reports. For a comprehensive guide to selecting and using lenses for every format, see *The Complete Book of Photographic Lenses*, by Joseph Meehan (New York: Amphoto, 1991). This reference includes detailed information on angle of view, film formats, aspect ratio, depth of field, and more.

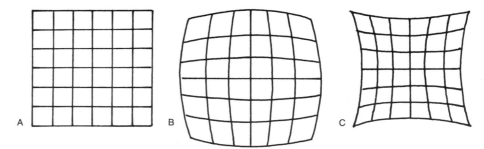

Fig. 4.11. *Exaggerated diagrams showing the kinds of image-distortion that can result from use of three different kinds of lenses, in photographing a grid. Diagram* A *is made with a rectilinear (nondistorting) lens, the type preferred for photographing flat art.* B *shows negative (barrel) distortion; and* C *shows positive (pincushion) distortion.*

depth of field, and more.

Curvature of field causes the image of a flat subject to be curved at the film plane, so that the photo will be sharp in the center and fuzzy in the corners, or vice-versa. (The simple lens in the healthy human eye casts a curved image too, although here it is not a problem, because the image lies exactly along the curve of the retina, producing sharp vision.) Again, apochromatic and macro lenses, sometimes called "flat-field lenses,"

minimize or even eliminate the problem. As with distortion, many wide-angle and telephoto lenses suffer from terminal field curvature. If you must use such a lens, reduce the possibility of an unsharp photo by focusing on the art at a point one-half the distance between the painting's center and corner, and stop down three or four stops to let depth of field "pull into focus" the entire image.

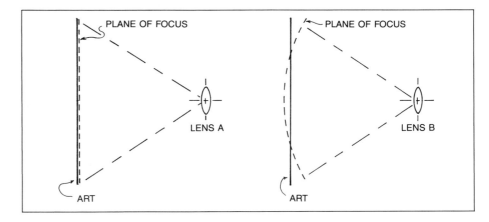

Fig. 4.12. *Lens* A, *above, either a symmetrical type or a macro, will render a relatively sharp image from corner to corner, no matter where you focus on the painting. Lens* B, *a wide-angle uncorrected for curvature of field, must be focused halfway between the center and a corner of the painting and then stopped down, to get the entire image sharp.*

Light Transmission and Lens Flare

Light passing through a lens with many glass elements is subject to partial absorption and reflection at every glass-air interface. Without corrective measures, a typical lens with eight such interfaces would suffer a loss of transmittance at the film plane of about 30 percent. To make matters worse, some of the reflected light bouncing around among the elements does reach the film, causing either image "ghosts" or non-image veiling flare that lowers contrast. Flared photographs look as if they were shot through a sun-struck dirty window.

Since 1935, lenses have been made with various chemical coatings bonded to glass faces to increase transmittance and improve image contrast. Today, most lenses have multiple coatings to give balanced color to a series of lenses from each manufacturer, but standards vary from company to company. If you are critical about your color photography, and wish to simplify life, stick to lenses made by one company, to keep color balance uniform from shot to shot.

This practice is not always feasible, however, for view camera users, who have the freedom—almost the necessity—of mounting lenses of unlike origin for particular applications. These photographers may have to use a pale color-compensating filter for certain aberrant lenses to get matching color balance for all their optical tools. For example, I have an old Goerz Dagor whose single coating helps reduce flare, but it also gives a pale yellow cast, compared to my newer, multi-coated Japanese lenses. Since I do not want to part with this superb old hunk of glass, I simply use a CC05 blue filter in the filter pack, over the lens, when shooting color film with this lens. Details on testing for and adjusting a lens's spectral characteristics appear in the sections on color-compensating filters and color-correcting.

Even though multi-coated optics will reduce flare in situations of high contrast, as when photographing a dark object on a light-toned background, image "crispness" will be ruined if the lens surfaces are laden with dust, fingerprints, jam, and scratches. (Remember that nuisance, the lens cap?) Filters over the lens must be clean, too, or a "dirty-window" effect will result. *Always clean your optics according to the manufacturer's instructions:* rubbing a lens with your shirttail, for instance, will surely mar the delicate coatings.

With any lens, I strongly recommend a lens shade, because oblique light rays originating outside the subject field can cause flare. The most efficient shade is a rectangular accordion matte box, available for all formats, that can be adjusted to different angles of view.

Selecting the Right Lens

With a sharper awareness of optical concepts, we should now examine some factors to keep in mind while looking for the best lenses within the glitter of the glass managerie. These pertinent factors include the type of art to be photographed, its size, and its reproduction ratio; your perspective and lighting requirements; and the distance from which the final photo will be seen. Let's take the last point first.

As indicated earlier, the normal lenses' 40-to-60 degree angle of view is quite a bit less than our human panoramic vision. The reason these lenses are called *normal* lenses is *not* because of their angular view, but because they produce a relative magnification of objects at various distances within a scene that is akin to the way our eyes magnify—provided that photos made by these lenses are viewed from the normal, or "correct," distance.

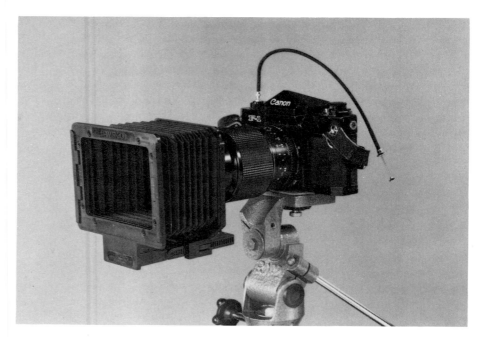

Fig. 4.13. *The accordion matte box, a telescoping lens shade that screws onto small- and medium-format lenses or clips onto the front of a view camera, is sold as an accessory, but I recommend it as standard equipment.*

Photography's magic is its ability to induce in a viewer the sensation of seeing three-dimensional space while looking at a two-dimensional print. That effect is strongest when the distance between the viewer's eyes and the print is proportional to the distance between the lens and the film when the photo was made.

For example, suppose you shoot an 8 x 10-inch negative using a lens of fourteen-inch focal length—a normal lens for the 8 x 10-inch format. Next, you contact print the negative and view the 8 x 10-inch photo from a distance of about fourteen inches (35 centimeters). What happens? Your mind's eye accepts three-dimensional space in the photo because your perspective on the print coincides with the film's perspective on the art as "seen" through the fourteen-inch lens. If you hold the print too close, the image will seem *diminished* in perspective (telephoto effect), causing apparent compression of subject space. If you hold it too far away, the image will have *exaggerated* perspective (wide-angle effect), causing an apparent expansion of space. For simplicity, I've illustrated with large format, here, but the rule holds for all formats, because *enlargement* of the image will keep the normal viewing distance proportional to the focal length. For example, shoot 35mm format (1 x 1.5 inches) with 50mm lens (2-inch focal length), enlarge the negative seven times, to a 7 x 10.5-inch print, and view it from fourteen inches—seven times the focal length.

These errors in print-viewing distance induce an *apparent perspective distortion* that may be mistaken for a lens flaw, a common observation made by people looking at photos taken with wide-angle lenses, which have a very short focal length. For an 8 x 10-inch print, the correct viewing distance becomes an eye-straining three or four inches! Holding the print

a normal fourteen inches (thirty-five centimeters) away, you can easily focus on it, but you also see the apparent distortion for which wide-angle lenses are so often maligned. In truth, wide-angle lenses record scenes in "correct" perspective, just as normal and telephoto lenses do; wide-angles simply include more of a scene.

Obviously, some perspective distortions are going to occur, because you will not always be able to use the exact focal length that will correspond to the distance from which the photo will ultimately be seen. But the problem can be minimized by anticipating that most photos will be viewed from a distance that corresponds to the short telephoto effect. Small book reproductions of photos and 8 x 10-inch enlargements are usually viewed from a distance of ten inches to twenty inches. Larger prints and wall posters are commonly seen from three feet away, or farther. In all these instances, a normal or short telephoto lens will probably induce the sensation of three-dimensional perspective.

Photographing art often allows room for personal interpretation, but our opinions must always be subordinate to the demand for an accurate document in terms of perspective. Rarely are finer aesthetics or scholarship served through wide-angle photographs that will appear distorted unless held within three inches of the viewer's nose.

Fortunately, the remaining factors to review in lens selection are not complex. The preceding discussion assumes that you have enough space to shoot with a normal or short telephoto lens, yet many situations are so cramped that that is just not possible: you obviously need a wide-angle lens, for instance, when photographing a cabinet in a crowded

storeroom. Still, a good rule of thumb is to use the *longest* focal length practical. If you do much wide-angle photography—tapestries, large furniture, and architectural subjects—you may need several focal lengths from medium-wide to very wide, equivalent to 35mm, 28mm, and 24mm lenses in the 24 x 36mm format. For *occasional* wide-angle work, you could either use a zoom of variable focal length (discussed further on), or use one fairly wide focal length for every big subject, cropping out the unwanted portion of your negative in the darkroom when the view is greater than you need from your chosen perspective.

Perspective is another fundamental criterion for selecting a particular lens for a given three-dimensional shot. Since the lens takes the place of a viewer looking at a work of art from an ideal viewpoint, you must have the right lenses to give you freedom to shoot from any of an infinite number of places. (In reality, the number is not quite infinite, since space and print-viewing distance will limit your choice.)

For example, say you want to photograph a life-sized bronze statue. As you move through space, analyzing the sculpture from various angles, your *visual perspective* is changing. Once you decide "The bronze looks best from this spot," you position the camera at that point in space where your eyes were. Doing so determines *lens perspective*. Ideally, your lens focal length (with its concomitant angle of view and magnification) will form a fairly large image of the bronze so that, when the image is enlarged or reproduced in a book, film grain will be minimal. If your first lens' choice either produces a tiny image or crops part of the statue, you would have to change lenses to achieve the ideal image size from your chosen perspective. Of course, you could use your first choice and move toward or

Figure 4.14

Figure 4.15

Figure 4.16

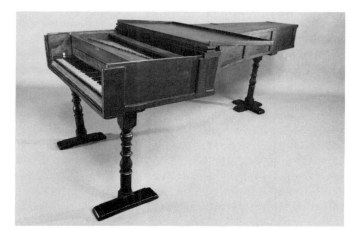

Figure 4.17

Figs. 4.14., 4.15, 4.16, and 4.17. *Perspective is a function of the lens position relative to the subject and is not dependent on lens focal length or angle of view. Illustrating this principle are photographs of a Cristofori piano, (figs. 4.14-4.17), currently the world's oldest functioning pianoforte. Fig. 4.14 was shot with a short telephoto lens, from a distance of 20 feet (6 meters), to yield a frame-filling image. Fig. 4.15 was shot with an extreme wide-angle lens from the same position. Fig. 4.16 is an enlargement of negative 4.15, so that the piano's size matches that in Fig. 4.14, showing that the perspectives are identical. Fig. 4.17 was shot with the same wide-angle lens, but from a point about three feet away from the piano, so that its image filled the frame. Here, the shape of the instrument is changed so dramatically that it is misleading—unless you can view it from a distance of about four inches, a distance proportional to the wide-angle's focal length.*

away from the subject, but that would change perspective. If you own just one lens, your perspective on three-dimensional objects is at the mercy of its focal length.

If you are now reaching for your wallet to see if you can buy all the lenses described here and still pay your rent, take heart: *with just two or three lenses, you can create a wealth of fine work, and with only minor adjustments in perspective.* And even if you are a "one-lens photographer," the majority of people looking at your photos will never suspect the limitations of your tools.

However, another reason to have flexibility in lens choice is the problem of lighting. Sometimes your ideal perspective will put the lens so close to the subject that you can't light the art properly without the camera casting its shadow on the subject. A telephoto will allow you to move back far enough to light the art properly and still maintain a larger viewfinder image.

A rarer and reverse problem arises when the lens-to-subject distance is quite long, and the lights near the subject shine into the lens, possibly causing flare or "ghost" smudges of amorphous blobs of light on the film. You can curb this by checking to see whether your lights reflect small specular highlights on the front lens element. If you cannot shade the lens with a hood or a gobo, you had better use a lens with a shorter focal length and move slightly closer to the art.

The last points to consider in lens selection are the type of subject matter to be photographed and the reproduction ratio. If your work in the 35mm format includes flat art smaller than about 4 x 6 feet (1.2 x 2 meters), the fixed-focal-length macro or micro lens is perfect, because it has a fairly flat field and little or no distortion. (Larger works, I'm assuming, will require a wide-angle lens, unless your studio is the size of

Grand Central Station.) Also, the macro lens type is usually designed to give optimum image quality at a reproduction ratio of between 1:10 and 1:5, making it ideal for most three-dimensional art. For example, while a shot of the head of a figural sculpture will have the finest resolution, you can also get more than adequate results when you back up to include the whole sculpture or move in close to magnify the mouth at one-half life-size. By inserting an extension tube between the camera and the lens, you can focus a macro all the way to 1:1. Macros are made in both a normal 50mm and a 100mm focal length, to give you an option in choosing perspective and working distance from your subject. Unfortunately for photographers shooting in available darkness, maximum apertures are f/2.8 or slower.

For that extra freedom, there are "portrait" lenses of 85mm focal length; and although they are computed for medium distances, their nearest focus of about three feet restricts their use, unless you have the appropriate extension tube. However, since many lenses of this type retain high residual aberrations at larger apertures, to give a flattering softness to aging faces, you should stop down to at least f/8 to improve resolution.

Most medium-format companies offer a macro lens in only one focal length, around 120mm or 140mm. This is a good compromise, versatile for many smaller works of art, but a normal focal length macro would be useful for shooting paintings where space is tight. Close-up photography in this format with a non-macro lens must be done with a supplementary lens (see below), except with special camera models by Mamiya and Rolleiflex, which accept their lenses mounted in reverse for life-size and larger magnification.

View camera lenses, a rather

complex and esoteric subject, are discussed in Appendix 3.

Zoom lenses. Those of us who depend heavily on 35mm equipment will note that we are woefully deprived of lenses in the 60-to-80mm focal length category—a potentially useful range. Before you shed tears, however, consider a variable-focal length lens, called a *zoom.* To use a zoom lens, first pick an ideal perspective, focus, and then operate the focal length control to change the angle of view for composing the picture you want. (With some models, you may have to refocus, after zooming.) Choices of focal lengths are infinite, within the limits of a given lens's zoom range, expressed with the shortest focal length first, e.g., 35 to 70mm.

Zooms are difficult to make so that performance is uniformly excellent throughout the entire zoom range. Although many of the problems that plagued early zooms are being overcome—distortion, flare, poor transmission, mushy resolution—the fact remains that most zooms are inferior to fixed-focal-length lenses. The better zoom lenses are, naturally, quite costly.

Many zooms have a handy close-focus range, erroneously termed a *macro range.* Since zoom lens design is a compromise—involving about as tricky a balancing act as a political platform—this close-focus range does not give nearly the degree of resolution that "true" macro lenses do. And if this close-up ability comes into play only at the wide-angle setting, the lens-to-subject distance may be a scant few inches, making it hard to light the subject. A better choice is a zoom that focuses closely at all focal-length settings or, at least, at the longest one.

When shopping for a zoom, determine the focal length range you need most and then review the characteristics of models available.

For traveling light, pick one that supplants no more than two or three fixed-focal-length lenses. The 35–70mm, the 28–80mm, and the 35–105mm are ranges flexible enough to shoot many different types of art under various circumstances.

The greatest drawback to a typical zoom in this category is the usual barrel distortion at wide-angle settings and the pinchushion distortion at telephoto settings. Were more manufacturers to incorporate aspherical elements in zooms, as Canon has done with their 24–35mm and 20–35mm "L" series, we would have truly useful (but expensive) optics with minimal distortion and curvature of field. Another serious problem is the typical "slow" maximum aperture that makes focusing in low light levels difficult.

Perspective control lenses. When we look up at buildings and down at desks, we usually don't notice that the vertical components of these objects—window frames, desk legs—are not parallel, but convergent. Yet, when a tall building is photographed by tilting the camera upward to include the entire structure, the convergence is often upsetting, especially if a wide-angle lens was used. Wide at the bottom and narrow at the top, the building will seem to fall backwards when its image is surrounded by a rectangular frame. Now, in spite of the fact that the lens recorded reality the way we see it, we "know" that the parallel sides of a stout building cannot possible converge, and we insist that in a photo the building's sides become parallel to the sides of the frame. How is it done?

By keeping the camera back (film plane) vertical and using a perspective control wide-angle lens, you can maintain parallel verticals and frame the entire subject (within limits) by shifting the lens barrel so that the large image circled projected onto the film

shifts in relation to the film gate. The barrel of a perspective control lens (sometimes called a "shift" lens) rotates, too, allowing you to look up or down, or from side to side, without tilting the camera.

If you ever photographed a large textile as it lay on the floor, you probably had trouble composing the image because the camera had to be centered over the art to prevent keystoning and to crop out tripod legs. With a PC lens, the camera does not have to be centered over the art, making it easy to compose your image as you balance on a ladder.

The PC lenses are a little bit slower to use than conventional lenses, because the aperture is not automatic. For the extra price, however, they are a worthwhile investment, since they will do anything that a conventional wide-angle lens will do, and more. Currently, the "big five" camera makers (Canon, Minolta, Nikon, Olympus, and Pentax) and Zeiss make PC types. All make 35mm focal lengths; a few make 28mm and 24mm as well. The Nikon 28mm PC lens is shown in figure 4.18.

Supplementary close-up lenses. If you are happy with your non-macro lens, but need to shoot an occasional close-up, you can use a supplementary close-up lens, which screws onto your prime lens like a filter. Depending on the maker, results range from adequate to superb, with cost reflecting quality. Being designed for particular prime lenses, supplementary close-up lenses are not interchangeable by brand. No increase in exposure is needed for this technique of close-up work. Supplementary lenses are made in various magnification powers, measured in diopters, which give overlapping narrow ranges of magnification.

Photomacrography lenses. Strictly speaking, *photomacrography* refers to

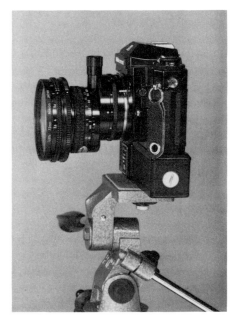

Fig. 4.18. *Nikon's 28mm PC (perspective control) lens is shifted downward, here, to get a wide view of a period room from a high camera position while maintaining parallel verticals and cropping unwanted ceiling. (See also chapter 9, figure 9.10.)*

images made by special lenses designed for reproduction ratios ranging from 1:1 up 20:1 (20 times life-size). Magnifications lower than 1:1 are technically known as close-ups and are (confusingly) best made with macro or micro lenses. Magnifications greater than 20:1 require use of a two-lens apparatus (a microscope), and fall into the category of *photomicrography.*

Few applications outside the concern of conservation of art call for images larger than life-size to be made in the camera; usually, an 8 x 10-inch enlargement of a life-size image will sufficiently reveal details. But when great magnifications in-camera must be made repeatedly, consider using a photomacrography lens.

Canon, Leitz, and Zeiss are among manufacturers who make a matched series of photomacrography lenses, each of which is suited to a limited magnification range. A special bellows mount, necessary to get the lens away from the camera so that it can work in its optimum range, can be the same brand as your camera, while an adapter for the lens gives you the freedom to mount the optics you want.

With close-up or photomacrography work, try using an adjustable focusing stage (a tiny platform on a scissors jack) for holding small, delicate objects as you shoot them when the camera is vertical. Set the magnification you want by adjusting the camera's lens-to-film distance, and keep that relationship constant as you fine-focus by raising or lowering the stage so that the desired portion of the subject is coincident with the plane of critical focus. Depth of field is virtually nonexistent at high magnifications, even at small apertures, so focus carefully.

Independent Lens Brands (All Designs)

Independent lens makers thrive on the interadaptability of their products with a wide range of cameras. Many are quite good and are less expensive than name brands. With lenses, as with most other things, more money will probably buy you a better product: superior optics and precise signal-pin-couplings for automated functions. Before you choose, check the direction of rotation for the focusing and aperture collars; if the direction is opposite to that of your regular lenses, confusion may arise each time you switch lenses.

Tripods and Camera Stands

I have probably discarded enough blurred 35mm slides to fill Catherine the Great's swimming pool. Either I was too tense to hand-hold the

camera steadily for a short exposure, or I was too lazy to use a tripod for a long one, but there was no excuse for blurred shots when shooting art, because a tripod would have saved every photograph.

How long is a short or a long exposure? I use the following rule of thumb to decide when to switch from hands to a tripod: I hand-hold the camera when the denominator of the shutter speed is equal to or larger than the focal length of the lens, but when it is smaller than that, I use a tripod. For example:

Hand-hold
28mm (wide angle)
 1/30, 1/60, 1/125, etc.
50 mm (normal)
 1/60 and shorter
100 mm (telephoto)
 1/125 and shorter

Tripod
28mm (wide angle)
 1/15 and longer
55 mm (normal)
 1/30 and longer
100 mm (telephoto)
 1/60 and longer

Depending on light intensity and lens aperture, your shutter speed will vary, but with slow-speed color films, shutter speeds of 1/8 of a second and longer are common in gallery and studio work.

When shopping for a tripod for 35mm gear, your first inclination may be to buy a two-pound lightweight that collapses to eighteen inches and fits into an attache case. Fully extended, it will be about sixty inches high, and it will wobble slightly as you compose. You will save yourself untold aggravation and film if you skip all that and *begin* with a *sturdy* tripod of adequate height. Sturdiness in tripods for any format is, of course, related to weight, but a poorly designed heavy one won't be as stable as a well-designed lighter one. To measure stability, fully extend the legs

and column, screw your camera onto the head, and jiggle the camera. Even the heaviest tripods may wobble at *maximum* extension, so lower the column and legs until the tripod is steady when you touch the camera. This is the maximum height for safely using this tripod; if it's too low, test another brand or a larger size.

Some tripods will not telescope down low enough for the camera to achieve ideal perspective on objects such as chairs. You may need a column that accepts the head at its bottom for low viewpoints, but that requires mounting the camera upside-down—a rather awkward procedure. A few models allow the legs to splay at a very wide angle, which lowers the camera sufficiently in its normal upright mode, although you may need a second, short column that will not bang the floor in order to take advantage of this feature.

Quick-release columns that raise and lower the camera by brute strength are fine for small cameras; however, you will not regret the extra cost of a tripod with a gear drive for lifing heavy cameras without strain.

Some tripods include the head as standard equipment. If your choice does not, select a head that has metal hefty enough to support the camera, and knobs or levers that tighten sufficiently to keep the camera from drifting—especially when it is aimed downward. Ball heads are compact but difficult to set for precise composition because the camera wobbles in all directions until you tighten the single clamp. The double-tilt design, with two independent controls for tilting the camera on two axes, is much easier to use.

The tripod platform for 35mm cameras should be small enough to allow depression of the film rewind button which is usually found on the camera's base plate. If the platform covers the rewind button, you will have to move the camera to rewind

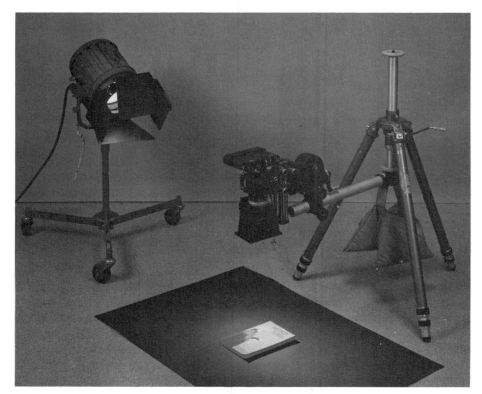

Fig. 4.19. A Gitzo tripod with a side-arm holds a 35mm camera for copying flat art in a vertical set. The Majestic tripod head, chosen for its geared action that gives precise control in composition, must be adapted via a special plug from the Majestic Company, of Chicago. A fifteen-pound (seven-kilo) sandbag counterweight prevents the tripod from tipping over. The evenly flooded beam from the single focusing Fresnel spotlight gives a raking light for defining the raised edges of the embossed book cover, while the black card eliminates glare from the shiny floor.

Photographic Lighting

Daylight

The French impressionist painter Claude Monet had such a keen sense of the way daylight gradually changes direction and color in the course of a few minutes that, to sustain a particular light mood in his outdoor paintings, he would work on a given canvas on site for only a few minutes at the same time each day when weather conditions were identical. In much the same manner, a photographer needs a constant light source to get predictable, repeatable results, especially when using color film. Black-and-white film is more forgiving of subtle daylight shifts than color film is; but even so, daylight can be tricky with *it,* too.

Once when I was shooting an oak bureau detail under a skylight, the combination of factors involved (dark wood, long lens extension, small aperture) created a calculated exposure time of ninety seconds. During exposure, small clouds racing by above the skylight caused the light level to drop and to intensify at fluctuating intervals. Since I had to guess the effect of all that on exposure, I shot five sheets of black-and-white film, of which only one was usable.

Yet, in spite of daylight's unpredictable intensity and color balance, you can use it when artificial lights are inconvenient. The qualities of "north light"—that soft, indirect daylight found near a window with a northern exposure free of the sun's glare—have long been valued by painters, and it is easy to see why, if you photograph an object by it.

To use north light (or any window light not facing direct sunlight), place the art on a table or a pedestal, so that the object is lit from the side or three-quarters frontally. Use white or silver reflector cards to bounce light

and reload film. For view cameras, get a head with a platform small enough to collapse the bellows sufficiently for focusing your shortest focal length lens on infinity.

Camera Stands

Although it is a stable support, the time-honored tripod is a dinosaur of technology compared to a camera stand. Especially quick to use when raising or lowering a heavy 8 x 10 camera, such stands consist of a three-wheeled dolly upon which is mounted a vertical column with a sliding horizontal arm for holding the camera. Since the arm travels from a height of one foot to the top of the column, typically eight feet, intermediate camera perspectives are easy to set. And because of the absence of tripod legs, it is easy to light and shoot objects laid on the floor with the camera pointing downward. A small tray for holding exposure tools, mounted on the arm, saves steps. At several hundred dollars apiece, camera stands are a wise investment only for photographers using large-format equipment daily.

into the shadow side of the object, adjusting the contrast ratio between *main light* (the window) and *fill light* (the reflector) by simply moving the reflector closer to or farther from the object. If your only window allows direct sunlight into the room, diffuse it with a translucent white lucite sheet cut to fit the window, or simply tack a white bedsheet or a white shower curtain over the window.

The soft quality of north light is so ideal for the photography of three-dimensional art that several methods to achieve it artificially are described below in the section "Incandescent (Tungsten) Lights."

There are several drawbacks to natural window light:

1. The light source has a fixed position, thus limiting control and variety.

2. The light source is uneven— i.e., its brightness "falls off" considerably with greater distance from the window; thus it is not useful for photographing large, flat art.

3. The color balance of the light source varies too much during the course of a day and under different weather conditions; thus predicting and correcting color balance is impossible.

Outdoors, daylight (and daylight film) must be used, of course, when photographing architecture and garden sculpture. The best sunlight direction must be predicted well beforehand, so that you will have ample time to set up the camera, compose, focus, and calculate exposure. Passing clouds may delay your shooting (if you prefer direct sunlight), so allow time for waiting. When possible, visit the site before you actually shoot, and make notes regarding angle of sun relative to the subject, time of day, obstructing shadows from nearby buildings or trees, and so on.

Electronic Flash (for the Studio)

Art subject to damage from photographic lamps should be treated in a special way. Color pigments susceptible to fading (fugitive color) are those used in paintings of all kinds—watercolors, works on paper, painted statuary, and textiles. Sustained ultraviolet radiation found in daylight and in most artifical lamp light is the worst culprit, although visible and infrared radiation has some detrimental effect. Works of art susceptible to warping, cracking, and weakening at the joints include all objects made of ivory or wood— carvings, panel paintings, furniture, musical instruments, and sculpture. The chief sources of these problems are quick and extreme changes in temperature and/or humidity within the immediate environment of the object. Hot, intense tungsten lamps can cause both temperature and humidity to change by dangerous levels if the photographer does not use discretion.

Ultraviolet light and heat damage can be minimized through use of electronic flash lamps (strobes). The heat produced by even the most powerful strobe lights is so slow that at ordinary working distances there is no risk to the art. Flashtube casings that absorb ultraviolet radiation are available for most brands of strobe, and special UV-absorbing filters placed over the reflectors of flash heads cancel residual radiation. In addition, these filters reduce an overall blue bias in the light emitted by most strobes, and protect both you and the art from an exploding bulb (a very rare occurrence).

Extensive tests using strobe lights were conducted in 1970 by Dr. J. F. Hanlan, senior research chemist at the National Conservation Research Laboratory in the National Gallery of Canada. Sample pigment patches and textile swatches were subjected to

25,000 flashes of a typical studio strobe at a distance of three feet. For most pigments, the fading was considered negligible.

Another advantage to the use of strobes is the virtually constant color temperature throughout the life of the bulb, roughly 50,000 flashes. This attribute eliminates one variable in getting good color shots. Because the color temperature of electronic flashlamps closely matches the color temperature of sunlight on a clear day (between 10:00 A.M. and 2:00 P.M.), it is used with daylight-type color film. Therefore, strobe light is the best choice for shooting color film in a gallery that has a skylight or windows, since the two light sources usually mix well.

Tungsten light does not blend well with daylight, because of the great difference in color temperature between the two sources.

There is a wide range of attachments and accessories for studio strobes, making them almost as versatile as tungsten light sources.

However, there are several disadvantages to using electronic flash. Such lights can be dangerous if mishandled. A large power supply can be very heavy for location use, outside the studio. Switches on the electronic flash generator can be damaged easily through misue, and capacitors and bulbs can overheat if fired repeatedly in too rapid a sequence. Either problem causes malfunction and expensive repair; meanwhile, you're in the dark, unless you have a back-up unit.

But the biggest drawback to using strobes is their high cost. A basic, medium-priced outfit, versatile enough for both small paintings and three-dimensional works, can cost five to ten times as much as a comparable tungsten light outfit. Larger works of art and large-format cameras require additional power supplies and flash

heads to achieve full lighting coverage and small apertures.

A full commitment to electronic flash means a large financial investment, but the cost is justified, when one compares it to the cost of possible permanent damage to art that can be caused by hot tungsten lights used unwisely. Future generations will be able to see and study art only so long as sensible conservation procedures are used every time a photographer turns on photographic lights.

Incandescent (Tungsten) Lights

After reading the foregoing testimonial in praise of strobes, you may be surprised to learn that only a dozen photos in this book were made with them. More examples made by tungsten were chosen because tungsten is what you will most likely use. But because of the similarities between lighting techniques with either type of source, the procedures and tips outlined further on can be useful, regardless of your equipment.

When using tungsten lights, you can minimize potential damage to art by applying common sense—and the following general guidelines:

• Never aim an undiffused lamp directly at art when diffused or indirect light will do the job as well.
• When direct lamps must be used, reduce to an absolute minimum the time the art is exposed to the light.
• Never use tungsten lights so close to the art that it becomes warm. Check the temperature often and shut off lights as necessary to keep the art cool.
• Install a humidifier, if necessary, to maintain a safe relative humidity level above 35 percent.

For a great many works of art—those made of metal, stone, and glass—incandescent lamps pose no known threat. Even so, following

these safety tips is responsible practice.

Spotlights

An adjustable spotlight produces a rather harsh light whose beam circle is variable in size between a concentrated spot of light and a wide flood of light. The undiffused spotlight is raw light that sharply chisels an object and creates the highest saturation and contrast levels of any source. When used as a main light for three-dimensional objects, the undiffused spot should have plenty of fill light added, to avoid deep, harsh shadows within the hollows of the art.

A glass lens called a *Fresnel* pronounced *fray-nell*), fitted over a spotlight softens the light, producing a more even beam and making the spot a more versatile tool than it would be if left undiffused. In addition, the Fresnel lens absorbs some heat that could damage art. However, both the raw spot and the Fresnel spot produce specular highlights (small, harsh dots of glare) on the reflective or rounded surfaces of works such as metal and glazed pottery. For these objects, a softer light, or even a polarized light source, is necessary.

Some photographers still use bright spotlights as main lights, but the trend lately is toward larger, softer sources, for easier contrast control and a more pleasant mood. In general, my preference for a main light is an umbrella light or softlight (see below), but I sometimes use a miniature focusing Fresnel (fondly known as a *dinky*) as an accent light for skimming the surface of a crusty bronze, for example, to "draw" the texture crisply, or to brighten a dark, recessed area in an object's surface without disturbing the general mood set by the main light.

Floodlights

The small parabolic reflector light, referred to throughout this book as a

pan light, because of its resemblance to a gold-prospector's pan, is among the cheaper, more versatile floodlights. Most likely, a pan light will be your first photographic luminaire. When properly designed and fitted with the right shape of lamp, this light creates a smooth flood of illumination that is more or less diffuse, depending on the reflector's size and interior finish. The smaller sizes, eight inches to fifteen inches in diameter, normally carry a 250- or 500-watt bulb and are handy for copying large paintings, for lighting furniture, and for main or fill lights when bounced off white reflectors for photographing sculpture. Normally, I diffuse them with tracing paper when aiming them at the art, but use them raw when bouncing them.

Known as *scoops* or *broads,* larger reflector floods carrying bulbs up to 1500 watts are useful main lights on big objects lit from a great distance. These large reflector floods can be round, square, or rectangular, and units several feet long may hold multiple bulbs for throwing an enormous "wash" of illumination on the set. Full-scale studios shooting pianos, large furniture, or oriental screens sometimes have such multi-lamped "window lights" or "bank-lights" hanging from the ceiling; but unless such arrangements are diffused with spun glass, tissue, or cloth, their multiple shadows can be very distracting.

High-Intensity Luminaires

As a conventional lamp glows, the tungsten filament in the bulb slowly evaporates, leaving deposits on the inner bulb wall and causing a blackening. Although this blackening on the bulb may not be noticeable, it can gradually curtail the lamp's brightness by as much as 40 percent and shift color temperature by 8 percent. Translated into practical

terms, this means that your work will need longer exposures, produce higher electric bills, inaccurate color, and require more reshoots.

Halogen gas added to the partial vacuum inside a lamp retards tungsten evaporation through chemical rejuvenation, thus keeping the filament whole much longer. Consequently, halogen lamps last longer, burn brighter, and maintain a more constant color temperature than conventional tungsten lamps. The drawback is that halogen bulbs must burn at 600 degrees Centigrade— much hotter than regular bulbs—and that intense heat must be efficiently dissipated, to prolong the life of the electrical socket and the wiring in the fixture. Inexpensive units may be poorly designed in this respect, so beware. Also, 600 degrees C of heat poses a danger to art and to your fingers, requiring caution when you handle these lights. Incidentally, these high-intensity bulbs are also called *quartz lamps,* because of the glass casing used for them, to withstand the heat.

Several varieties of lighting equipment are designed for halogen bulbs, and although the initial cost is high, the long-term savings make high-intensity luminaires a good buy.

The standard focusing spotlight type, when equipped with a halogen lamp, throws a lot of heat toward the subject and may have to be diffused for safety when the light is close to the art (see below). A safer— and costlier—unit is the halogen-lamped spotlight with a Fresnel lens. Ross Lowel, a film-maker who revolutionized location lighting design, makes two other types of units that are lightweight and work equally well in the studio or in travel photography. The folding Tota-light, when used direct and in pairs, gives a fairly even flood of illumination that is ideal for copying flat art. With an umbrella mounted on the unit, the light is

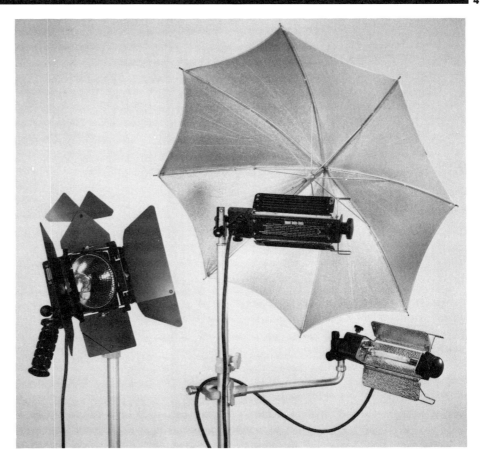

Fig. 4.20. *Quartz lights.* Left to right: *Light* A *is a Lowel Omni, 600-watt, high-intensity ("quartz") variable-focus spotlight with barndoor. Lights* B *and* C *are both Lowel Totas, 500/1000-watt quartz "broads," with built-in barndoors. Light* B *is reflecting into an umbrella; Light* C *is direct. Both* stands *are Lowels, but the side-arm extension is by Mole-Richardson. The steel side-arm, intended for a steel stand, must be clamped onto the soft aluminum stand very carefully, or the stand's riser will be dented and will not telescope.*

softened considerably for use as a versatile main light on three-dimensional objects. In this configuration, the art is protected from excess heat, since the light is aimed away from the subject. The compact but bright Omni-light has a high spot-to-flood ratio whose irregular pattern of illumination makes it less desirable as a direct source than as an umbrella mainlight.

Umbrellas and Softlights

You can duplicate the fine qualities of natural north light in several ways. While broad and directional, the light resulting from the devices mentioned below produces a modeling of three-dimensional subjects that enhances their plastic qualities without making harsh, ugly shadows. If a raw spotlight can be said to sear a sculpture with light, then these sources will tenderly caress it.

A photographic umbrella's parabolic shape makes an efficient and soft source that creates diffuse shadows and highlights, provided this lighting arrangement is placed fairly close to the subject. Umbrellas of metallic fiber, required with high-intensity bulbs, to avoid fire, yield an illumination that is slightly harsher and spottier than that obtained with umbrellas of standard white cloth or plastic, but I have shot countless objects of wood, stone, bronze, and terra cotta by using a metallic umbrella source, with a white card reflector for fill. However, highly reflective surfaces like glass or glazed ceramic will cause umbrella-shaped highlights that are distracting. For these objects, I use a large rectangular source for a more natural, window-shaped reflection on the object: the softlight.

Softlight sources are of two types: ready-made units with self-contained lamps, and kits that adapt to existing luminaires, such as a focusing spotlight or an electronic flash head.

Rigid metal studio softlights, whose "windows" of light measure from 8 x 18 inches (20 x 45 centimeters) up to 36 x 48 inches (90 x 120 centimeters), are often lamped with halogen bulbs of 750 to 8000 watts. The quality of light can be varied from severe to sensual, depending on the window size, the light's proximity to the subject, and the strength of fill light. Placed near a little object, a small unit envelopes the art with diffuse illumination, rendering broad, transparent highlights and open shadows with soft edges. I use Mole-Richardson's small *zip light* on a twelve-inch stand to shoot seals and impressions, jewelry, and other tiny subjects as they lie under a vertical camera. M-R's larger *softlite* is ideal for a wide variety of tabletop sets. Lowel makes a lightweight twenty-four-inch (sixty centimeter) square unit that produces a healthy 1500

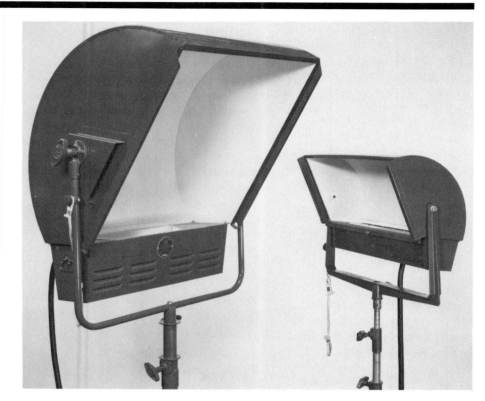

Fig. 4.21. *Two steel softlights by Mole-Richardson, each containing two independently switched lamps of 500 to 1000 watts located in the bottom vented section. On the left is a 24-by-24-inch brute that requires a special stand. The smaller "zip" light on the right will fit on any conventional stand of appropriate stability.*

watts of illumination and packs neatly into a small box for portability.

Softlight kits attach to your existing spotlight or flashhead via a frame, so that the light is beamed through a large diffuser. Cheaper and lighter than rigid softlights, these kits are most flexible when mounted on a sturdy, counterweighted boom for maneuverability, either as a top light or sidelight.

Support Equipment for Lighting

Photographers I know have been very inventive in seeking the perfect diffuser for raw lights, stripping their beds of sheets and cutting up their old sails, in hopes of finding one that gives just the right quality of illumination without reducing brilliance beyond practicality.

Spun fiberglass works well and is slow to scorch, but it frays easily into tiny, sharp fragments that too readily get into human skin and lungs. Tracing paper clamped to a pan light by clothespins is an inexpensive way to get a soft light, but paper ignites easily unless it is curved *generously* away from the bulb. If you use it, watch out. *Frosted acetate is an excellent diffuser, being safe and adaptable.* Available in small sheets or long rolls, the 45-mil thickness works best for reducing a spotlight's harshness without absorbing too much intensity. I buy the fifty-foot roll, cut sheets to size, and staple them to open stretchers made of 1 x 2-inch pine. Since the frames must be

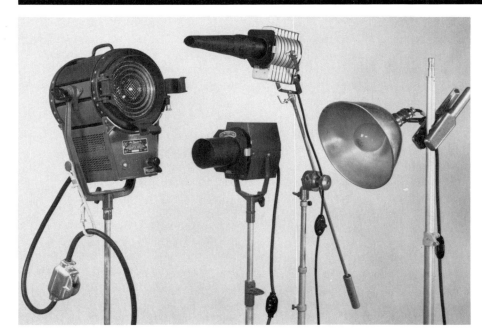

Fig. 4.22. *A gaggle of lights and stands.* Left to right: A, *a Mole-Richardson 2000-watt variable-focus spotlight with Fresnel lens. Three frame members adjacent to the lens accept the accessory barndoors, snoots, and diffusers. The stand is a heavy-duty steel rolling type by Mole-Richardson.*

B, *a Mole-Richardson 200-watt variable focus "dinky" spotlight wearing a large snoot for a moderately narrow beam of light. Stand is the same as for Light A.*

C, *Photogenic's version of the Fresnel "dinky-with-a-snoot," to which has been taped a piece of cardboard shaped to produce a narrow pencil-beam of light. Aluminum stand is by Photographic Instrument Corporation (generically, a "Pic" stand). The mini-boom allows manipulation of the light unit for high and low placement.*

D, *Mole-Richardson's version of a gator-grip-and-socket assembly with a ten-inch reflector (pan light). Bulb is a simple photo flood. This unit can be clamped anywhere on the aluminum stand shown, made by Lowel.*

clamped to two stands for placement in front of the light, cost and space factors escalate. However, it is an easy way to get a 3 x 6-foot banklight by using several pan units behind the screen. An alternate method is to clamp a one-eighth-inch-thick sheet of translucent white plastic between two stands and shine light through it. Although this thick plastic is unwieldy and quite absorbent, its quality of illumination is sumptuous.

A material for diffusing that is new to me is a polyester web, such as Pelon, available in sheets and rolls from archival supply stores. Since such webbing melts easily, use it with caution by placing it several inches away from bare bulbs.

Reflectors

I often use reflectors for fill light where other photographers might be tempted to use small luminaires, because the effect is more pleasing and natural. Flexible double-weight cards measuring 28 x 42 inches (70 x 105 centimeters), which are ideal for larger works, can be cut to size for smaller objects. Many art supply stores sell three kinds that you may find helpful. Pure white reflects the softest quality of light, dull silver reflects a slightly spotty, harsher light, and shiny silver reflects nearly as much as a mirror. I use the shiny silver, sprayed with Crescent Matton, a permanent dulling spray that will not rub off onto the art, to modulate reflectance variably. This card's reverse side is white, making it versatile. Colored reflectors are unsuitable, since they add a color not present in art as viewed under standard white light.

Another useful reflector is the 11 x 14-inch doubleweight Cole card. You can use the black side as a gobo (see below), or its reverse white side as a soft reflector. And very large objects requiring a broad fill can benefit from a sheet of white seamless paper suspended between two stands and placed near the art on its shadow side. If you have enough space, consider building a theatrical-type rolling flat of 4 x 8-foot plywood, Masonite, or homosote. Paint one side white, for use as a reflector, and the other side black or dark gray, to double as a movable copy board or giant gobo. Finally, small mirrors are efficient light reflectors for photographing tiny objects like jewelry. I've never used them, but one might, under some conditions, find them handy.

Gobos, Barndoors, and Snoots

The articles named in this menagerie of devices make it possible for photographers to fine-tune lighting by masking the beam from specific areas of the set or object. When shooting three-dimensional art, it is essential to separate the outline of the subject from the background tone, and that can usually be done through adding light to—or, more often, subtracting it from—the background,

after the object is satisfactorily lighted.

A *gobo* is any opaque material that is placed in front of a light to prevent the beam from spilling onto unwanted areas. Usually made of black cardboard, a gobo can be clamped to a stand and adjusted independently of the beam to shade light off the paper, or to keep it from shining in the lens. It is unnecessary to buy gobos, since you can make better ones by cutting scraps of card to the shapes you need.

A cousin of the free-standing gobo is the *barndoor*, a metal assembly of two, four, or more "leaves" that attach to the front frame of a spotlight. Independently adjustable, these "leaves" can shape the light beam dramatically, changing it from a large square down to a thin sliver, for a carefully placed highlight on an object.

A *snoot* is a rigid, hollow, metal tube that mounts on a spotlight, like a barndoor, and is usually available in two or three different diameters that regulate a round beam. A snooted and diffused dinky on a boom aimed at a background will give a soft glow around an object that enhances visual depth in the image and helps to separate the object from the background. Both barndoors and snoots are manufactured for specific spotlights, and though they are sold as accessories, they should be considered standard equipment.

Two other accessories that I find helpful are a small base plate with a two-inch spud, and a right-angle sidearm adapter with a spud. With the first one, you can mount a dinky in a tight place where a stand won't fit, such as on the edge of a tabletop set, or you can put a light on the floor and still control it. With the second, you can clamp an additional luminaire onto a stand when space is tight.

Buying Lights

If you think that you will have to skip your next vacation or win a grant in order to afford the kind of lights you'd like to have, don't worry. With inventiveness and experience, *you can make a few well-chosen units do a lot of work.* As proof, consider that *many photographs in this book were made with one light and a reflector (sculpture), or with two lights (paintings).*

You can narrow your selection by matching the alternatives with the nature of your work:

1. Type of art most photographed (flat or three-dimensional or both)
2. Size of art most photographed (small or large or both)
3. Budget
4. Durability of equipment (how frequently will you use it?)
5. Portability (for location use)
6. Total brightness needed (small format generally requires less wattage than large format)

For example, if you specialize in documenting paintings on location, your needs are different from someone who shoots furniture in a studio. Four folding high-intensity floodlights would equip you adequately; but the other person would require an overhead scoop or a bright boom-light, as well as several Fresnel spotlights and pan lights for full coverage of big objects.

Obviously, no formula for best lighting can be given, because personal taste in lights and lighting procedure vary too much among photographers for anyone to set foolproof guidelines. However, if I were restricted to one type of luminaire, I should pick the high-intensity spotlights, such as those by Lowel, because of their versatility as direct, bounced, or umbrella sources for paintings and sculpture. Being

compact and portable, they make a small, manageable set in the studio or on location while producing brilliant and controllable illumination. For studio work on medium-sized objects, I prefer a medium-sized softlight, 24 x 24 inches (60 x 60 centimeters).

Stands for Lights

Many manufacturers of lights make specific stands for their different units. Following their recommendation is wise, because if you use a stand that is too small, the light could topple. However, most lights will fit on, or adapt to, many different stands, so if a particular stable stand appeals to you, buy it. Just remember that adapters "walk away" when you need them.

I prefer stands capped by a spud with a collar that keeps the light from sliding down the riser. This design helps to prevent breakage or damage to bulbs or fingers.

Within the categories listed below are stands of various minimum and maximum heights. You will mostly use those that telescope from three feet to eight feet, but don't overlook very low (one foot to three feet) and very tall (five feet to fifteen feet) stands for special applications.

Lightweight folding stands. Suitable for small luminaires up to 5 pounds (2.2 kilograms), lightweight folding stands can double as studio or location supports, since they can be collapsed easily for packing. You might be lured to those with many telescoping sections for compactness, but *when this type is erect, it may not be stable.* Better stick with the three- and four-section models, which do not bend as readily. Some giants extend to 15 feet (4.5 meters) for putting light into inaccessible places. *When using them at their upper reaches, sandbag the bases to keep the rig steady.*

Most stands are made of unpainted

aluminum. Such stands are fine for most work, but they may reflect in the surface of shiny objects or glass. In those instances, use a stand painted black (available from a few companies) or put black tape or black cardboard over the reflecting section. I don't use black stands, because they are hard to see against a dark floor, and they're easily tripped over.

For safety reasons, the telescoping sections of most stands will not come apart as you extend them. There are a couple of models that *will* separate, and I find them useful nearly every day in the capacity of a mini-boom for holding reflector cards.

Century stands. For extra strength, to hold heavier lights, the century stand is a compromise between mobility and cost. At eight to twelve pounds, it can safely hold a one-thousand-watt Fresnel, but since it has no castors, a bit of muscle is needed to move it. Because of the leg configuration, it does not pack easily for location work or storage. Another small drawback is its minimum height of three feet; but compared to the next group, the price is right.

Rolling stands. Because the weight of rolling stands ranges from ten to forty-five pounds, I consider them heavy-duty stands for studio use, even though they can be folded for portability. *For sheer strength, durability, and safety, the rolling stand is best.* The tallest of them, at full extension, do not sway with a properly matched light unit; and if accidentally bumped, they tend to roll, rather than tip over. The low leg profile permits maneuverability in tight places and between the legs of folding stands. Naturally, the price of a steel stand with brass fittings and ball-bearing castors is high; but such a stand will be reliable for many years of daily use.

Booms. In lighting three-dimensional objects, you will often find that the ideal position of the luminaire is somewhere over the art. If your skill in levitating lights is as underdeveloped as mine, you will use a boom for getting the light exactly where you want it. This calls for caution and the correct equipment.

Unless you like to flirt with danger, don't try to make a boom out of a broom handle and masking tape. There are some very stable commercial booms available, and although they are expensive, they are more kind to fragile art than any cheap makeshift. Also, boom kits can

Fig. 4.23. *A double-swivel clamp like this one by Fisher Scientific for laboratory use is one of my standard tools. Various uses for it include holding reflector cards, such as the shiny silver card here; holding cardboard gobos; and serving as part of a stick-stand-and-clamp assembly for erecting a tent of white paper when photographing shiny objects. Fisher Scientific also makes a three-fingered "claw" clamp, which can hold a small mirror for reflecting light.*

save you money and be as safe as readymade types.

Make sure that the stand and boom are hefty enough to hold your heaviest light, without sagging near the breaking point, by checking the manufacturer's rating. If you have cash to spare, consider a boom that has a windlass near the counterweight for controlling the angle of the spud, so that you can adjust the light when it is out of reach. To go first class, get castors on the stand, too.

A typical kit consists of a heavy-duty stand, a clamp, a pole, and a counterweight. This weight can be a sandbag, or a lead cleat, or a plastic waterbag—but if you use the latter, watch out for leaks. Whether you buy a kit or a ready-made boom, assemble the rig *away from the set,* and make sure it is secure before putting the light over the art.

First, sandbag the stand legs; then clamp the pole tightly to the stand in a vertical position. Attach the counterweight, then the luminaire, and tape the cable to the pole. Adjust the pole's horizontal balance by moving the weight or changing the pivot point in the clamp, so that when the clamp is loose, the pole tips slowly downward *at the counterweight end.* This insures that, should the clamp be mistakenly loosened while the boom is over the art, the light will *lift, away from the object.* Leave slack cable near the base, to prevent toppling the whole thing if someone trips over the wire, and raise the pole to the desired height. Double-check all knobs and fittings before moving the boom to the set.

Background Materials

It seems unlikely that any artist of any era—except, perhaps, that maverick, Marcel Duchamp, who had startling ideas most of us never bother having—ever created a work of art that was intended for display on

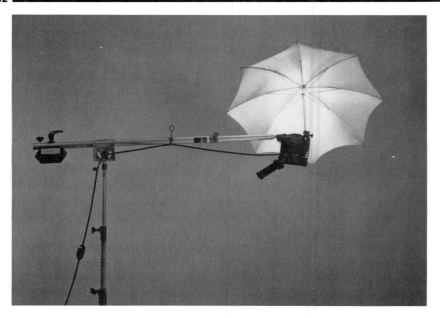

Fig. 4.24. *A versatile but inexpensive boomlight: a Mole-Richardson rolling stand, sandbagged for security, is capped by a Lowel grip-and-pole assembly. The Lowel Omni-light with umbrella is counterbalanced by a fifteen-pound lead weight from Larson.*

a sheet of seamless paper. Yet today we accept without question photographs showing church censers and fertility masks floating on a sea of uniform tone. When considered from this point of view, our treatment of images of art may seem odd; nevertheless, the practice is useful and appropriate. Imagine the confusion and implications of showing those same objects on Astro-turf, or on lace, or on stainless steel. A generation from now, the fashion in backgrounds will probably change, just as it will in lighting taste; but for now, the state of the art of shooting art requires simple materials for clarity's sake.

The clearest background is one that simply is not there. By that, I mean that all background tone is eliminated, usually through photomechanical masking in the reproduction stage, so

that the object pictured hovers on the page in silhouette. Of course, you can silhouette two-dimensional works with rectangular borders by cropping the background out with enlarger easel blades in the darkroom, as is usually done when printing negatives of paintings. But to cancel the distracting surround for a sculpture you shot in a crowded storeroom would require either extensive print retouching or photomechanical masking. Because of the cost of silhouetting and the discomposure many viewers feel when seeing three-dimensional objects float on a page without a sense of place, the technique is falling out of favor.

Paper backgrounds. Paper is still the best background material for object photography, simply because paper makes lighting art for a clean silhouette of form so easy, and paper

is available in a wide variety of colors and gray shades (although many hues are unsuitable for shelf liners, let alone for art backgrounds). While it is still relatively inexpensive, paper is steadily increasing in price, presumably to keep forests from going on strike. Long rolls of seamless paper, typically 12 yards (11 meters) in length, are the overwhelming choice for shooting art of all sizes, except for tiny objects at high magnification, wherein the paper texture is distracting. The full roll is 107 inches wide (267 centimeters); the half-roll for tabletop work, is 54 inches wide (135 centimeters). If you specialize in shooting harpsichords, you *might* save money by using jumbo rolls, which are 50 yards (or 46 meters) long; but before you buy one, picture yourself standing alone on a tall ladder trying to press 45 pounds of paper up onto the wall brackets.

When shooting jewelry and other small things, try silkscreened papers, which have a very smooth finish with a low luster. The largest size from Coloraid is 24 x 37 inches (60 x 92 centimeters), big enough for vases and life-size sculptural heads. You can even make a larger area by *carefully* trimming the white border of one sheet, taping the edge with double-faced tape, and overlapping a second sheet to make a nearly invisible seam. If you cannot make the seam disappear through lighting alone, have an assistant gently move the paper during a time exposure. Coloraid brand silkscreened papers are widely sold in art supply stores, and offer more than 140 hues and shades of gray.

An alternative here is a paper that has the color *printed* onto it, such as that sold by the Pantone company. The surface is slightly more durable than silkscreening, and the hues are less saturated; but the paper is smaller—18 x 28 inches (45 x 70 centimeters). With this or any other

paper, you have to develop dexterity in handling, to prevent creases and smudges that may show up in a photo.

Formica and plastic. For high volume tabletop work, consider a 4 x 8 foot (120 x 240 centimeter) sheet of Formica, clamped or nailed to a table or jig so that it curves gently from horizontal to a nearly vertical slope. Since Formica is flexible, make sure that the sheet is secure, so that a procelain figure, for example, is not catapulted suddenly off the table by an unexpectedly active background. Accumulated dirt and faint marring, which would make paper unusable, can be washed off Formica with mild soap and water.

Translucent plastic makes an ideal background for glass objects, which often require lighting from *below*. If you buy a commercial plastic table, spend the extra money to get one that is a quarter-inch (or 6 millimeters) thick and has a horizontal table area (between the front and back curves) at least 15 inches (38 centimeters) deep, to accept large heavy glass without bending. Keep hot lights away from the table, or your investment will melt and buckle before your eyes.

The poor man's light table is made of two sawhorses, a sheet of plate glass about three feet square, and a sheet of thick, frosted acetate draped from a pole behind and above the table so that it makes a sweeping curve over the glass. With the right lighting, the rear edge of glass disappears, but the front edge always shows as a shadow line, making very low angle shots difficult. Plastic and acetate sometimes add a pale yellow or pink cast to color shots, so if you plan to use either, experiment first with either a CC025 blue or green filter over the lens to neutralize unwanted background contributions to the color.

Shadowless backgrounds. Objects

with perforations, such as jewelry, masks, and implements, require special techniques to show the perforations clearly. Normally, you would lay these objects on a horizontal background and shoot from above, but if no light gets through the perforations to the paper, the holes may appear as solid black areas in the subject's surface. The easiest way to achieve clarity is to lay the art on a sheet of non-glare glass (regular glass may cause reflections of camera parts) that is safely supported a few inches above the background, so that some mainlight spills on the paper to delineate the perforations. If you want a brighter background, or one that has absolutely no shadows, raise the glass a little more and add a second light on the background.

A more sophisticated method is to construct a light box similar to a transparency illuminator. Make it as large as you like, but leave ample space inside to wire a series of 25-watt bulbs, six inches apart, so that there are no "hot spots" on the surface, which can be translucent white plastic or ground-glass (expensive). For finesse in balancing the mainlight and backlight intensities, add a rheostat to the box wiring, making sure that the device is rated to accept the total wattage. One drawback to dimming tungsten lights is that the color temperature changes radically as power is reduced, turning the background orange. Unless you want to break new ground in color photography, limit the light box use to black and white.

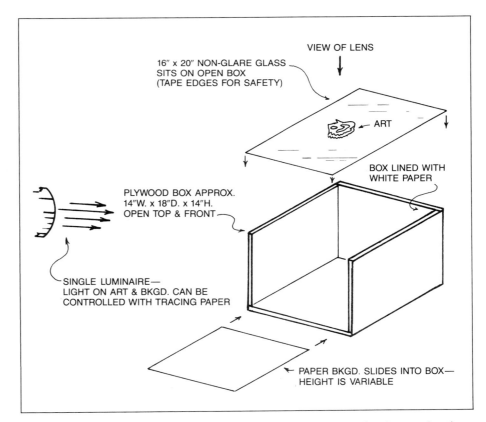

Fig. 4.25. *A simple, homemade light-box for shooting any art that has perforations or any small object requiring a shadowless background.*

Methods for hanging paper. The simplest way to hang a paper background is to tape or pushpin one end of the paper sheet to a wall, then drape the descending end over a pedestal so that it forms a gentle curve between the vertical and horizontal sections. If the curve's radius is too small, your lights may cause a bright horizontal band of glare at the apex of the curve; if the radius is too great, there may be tension that creates an unsafe condition for the art when it is placed on the paper. Fix the paper to the pedestal with tape or pushpins for security, taking care not to crimp the background where it hangs over the front edge of the pedestal, since this area may be the foreground of the photograph.

Only after the paper is secure should you put the art on it.

Adjusting the position of a heavy bronze by twisting it in place may tear the paper; to avoid doing that, therefore, put two pieces of corrugated cardboard under the object and slide the cardboard around until you get the art positioned. With a little (or maybe not so little) effort, you can tilt the object to remove the cards while keeping the paper intact.

Permanent hardware mounted high on a wall for supporting rolls of "seamless" make life easier when you have to change colors frequently. An aluminum pole, which is inserted through the core of the paper roll, nestles in two brackets that can hold one or more rolls of paper. Some assemblies have a chain and pulley for unrolling the paper while you stand on the floor, to save your climbing a ladder.

When you shoot in a home or a gallery, a wall may not be convenient for attaching paper, so you must erect a free-standing set. Two light stands topped with special clamps, such as those by Lowel, will hold the pole and paper, but be careful not to kick the stands, or the art may become airborne. To get extra height for tall objects, use extension poles that mount on the stands, and be sure to sandbag. One great advantage of a free-standing set is the open space behind the paper, which can be used for putting up a high backlight or boomlight. If you're thinking about using expandable springloaded poles with rubber cups to hold up the paper, like the versatile Polecat brand extension poles that can be wedged upright and stationary between the floor and ceiling by friction—*don't.* It is one thing to use this sort of device for a toaster shot; but it is quite another to submit a Rodin plaster model to such a rig which, under extraordinary circumstances, may collapse.

NOTES

1. Man Ray, from article in *Art in Transition* 2, no. 14 (March 1966): 41.

5
Films

General Considerations

The Eastman Kodak Company has so pervasively dominated the photographic market that most of us think of the Great Yellow Father when we think of film. To the astonishment of few, I should remind us all that other brands of film are available. In fact, many photographers consider certain Ilford, Agfa, Fuji, and 3M films to be as good as, if not better than, Kodak films.

Refereeing a contest among films, however, is not my interest here. My point, rather, is to discuss certain films, with the understanding that my preferences are based on greater experience with Kodak films than with other brands. If other films get the results you want, in your work, it makes very good sense for you to go on using them.

I cannot too strongly recommend that experimentation with various films be kept to a minimum. Although early efforts with different films may suggest that they are all pretty much the same, you will find, with experience, that each film type has a unique identity, with strong points and limitations. In a sense, film and light together are the photographer's canvas, brush, and palette. Bold graphic gestures, subtle tonal nuances, and predictable emotional effects within the context of an accurate document, when appropriate, can be at your fingertips only after many attempts with one kind of film.

With that in mind, try limiting your choices to one black-and-white and one color film for each format. Once you have learned the idiosyncracies of those two, a change of film will not mystify you.

General Characteristics

Physical Make-Up

Upon close inspection, film appears to be constructed somewhat like an open-face sandwich with a spread of cream cheese and ground nuts. Corresponding to the bread is the film base, which functions as a support for the emulsion, composed of minuscule grains of silver halide (ground nuts) suspended in gelatin (cream cheese). Of course, getting to know film is more complex—and less nutritious—than that, but the everyday model will serve, for now.

The "sandwich" is loaded into a camera so that the emulsion faces the lens. When an image of focused light strikes the emulsion, a *latent* image is recorded; and in the presence of a chemical developing agent in the darkroom, that latent image mysteriously becomes a relatively stable, visible image, made of metallic silver.

Negative materials produce a negative image that must be transformed into a positive print through contact with or enlargement on sensitized paper. Transparency materials magically become a transparent positive image (European term: *diapositive*) upon completion of the initial processing cycle, ready for display, projection, or reproduction.

Sensitivity

The relative sensitivity ("speed") of a film is a measure of its response to light. For a given light level and scene reflectance, a very sensitive (high-speed or fast) film requires less exposure in the camera than one of low sensitivity (low-speed or slow film). Any light meter, to be used, must be calibrated to the speed of the film in use before exposure readings are taken.

You'll find that film-speed calibration in light meters is made easy through an index system that is now standard worldwide, the International Standards Organization (ISO) index. This index replaces the American Standards Association (ASA) index that was previously used in North America and the Deutsche Industrie Norm (DIN) index used in Europe. The change presents no problems because the numerical values used in the ISO index are identical to the older numbers.

Table 5.1 compares ISO with DIN values. Memorizing the ISO sequence will help you to make quick judgments about any film's sensitivity and other related characteristics. I find the ISO system simple because I can think

Table 5.1
ISO Film Speeds

Film "Speed"	ISO ("Old" ASA)	"Old" DIN
Low	20	14
(Slow)	25	15
	32	16
	40	17
	50	18
Medium	64	19
	80	20
	100	21
	125	22
High	160	23
(Fast)	200	24
	250	25
	320	26
	400	27
	500	28
	640	29

easily in its arithmetical terms.

Within each film-speed scale, sequential values represent one-third stop increments. For example, in the ISO system, 64 is one-third of a stop faster than 50. Similarly, 80 is two-thirds of a stop faster than 50, and ISO 100 is one stop faster. In arithmetical terms, ISO 100 is twice as fast as ISO 50, and therefore requires half the exposure of the slower film for a particular situation.

Current 35mm films are also marked "DX," which means that those perforations in the film leader will signal information about the film's ISO index to many of today's sophisticated cameras, automatically calibrating the built-in meter. The DX films can also be used in manual cameras.

In addition to these nominal ISO values, professional-grade film data sheets include an EI (Exposure Index) value, which relates directly to the ISO value. This EI value informs the user that a particular emulsion's speed may vary from the nominal ISO rating, often by one-third stop or more. All this is a reminder that any system of speed evaluation is only an approximation, and that many factors can affect the *actual* speed index of the film. (See Chapter 7, on exposure

control, for further discussion of these factors.) For now, be aware that if your photos from a particular film are *consistently* too dark or too light, it is because of one or more of these variable factors. To solve the problem, all you have to do is to re-rate the speed of the film when you calibrate your meter: use a lower EI to get lighter pictures, or use a higher EI to get darker ones.

Film Grain

If the characteristics of all films were similar, we could always use a high-speed film and eliminate the bother of tripods, except in extreme circumstances. However, the image structure of high-speed film is generally less desirable than that of low-speed film for making photographs with fine detail and tangible texture.

One reason for those differences in the two film types is that film speed is directly linked with the size of the particles, or grains, of silver in the emulsion. For most films, the greater the sensitivity, the larger the grains must be. And the larger the grains are, the fewer there can be in a given area of film. Since these grains in total comprise the photographic representation of an art object, it follows that a more technically faithful and aesthetically pleasing rendition is achieved through spreading the "information" among as many silver grains as possible.

Format and degree of enlargement also affect grain structure. For example, contact prints made from a high-speed film, such as Kodak's Tri-X Pan in 8 x 10 format, have a lustrous, silky tonality, with virtually no grain structure visible from an ordinary viewing distance; but that same film, enlarged from a 35mm negative to an 8 x 10 print, reveals the truth about current silver emulsions: the image is comprised of many tiny dots, much

like a painting produced through pointillism.

Film Resolving Power (Resolution)

If you paid a premium price for a fine lens and then made photos using an extremely high-speed film, you would probably be disappointed in the results. The very high resolution of which your lens is capable would be stifled by the poor resolution of the film. As with lenses, film resolving power is a measure of its ability to pick up and discriminate among fine details. High resolution means high visual sharpness in the image, and this emphasizes the immediacy of the art. In general, resolution of low-speed films is better than that of high-speed films. However, fast films are necessary when shooting in dim light without a tripod.

The point to remember, when trying to achieve high sharpness, is that that quality is dependent on a combination of factors: camera lens, film type, enlarging lens, printing paper surface, and reproduction screen size. Choosing the best materials will keep quality high.

Tonal Response to Contrast

According to textbook definition, an "average" photographic subject is composed of brightness values distributed evenly among light, medium, and dark tones. Looking out on a pastoral scene under a morning sun, one could see such an average subject with different brightness values reflecting from various areas— the delicate highlight shadings of clouds, the mass of medium tones in the grass, and the subtle shadow details within tree bark. A film for recording such a high ratio of contrast values must have a tonal response capable of registering all the tonal shadings as discrete steps in silver density. If the film does not have a long tonal scale, the negative or transparency will record deep shadow

tones as black and faint highlight tones as white. Likewise, a representational painting of this scene would require a similar film for a faithful photographic record.

General-purpose (or pictorial) films, when properly exposed and processed, have the long-scale tonal response necessary for capturing the essential tonal information within most works of art. Such films will fully satisfy requirements of record-keeping and curatorial study, as well as of scholarly and trade publications.

High-speed films usually render a given scene with slightly more shadow and highlight detail than slow films.

Very few special-purpose and scientific films are applicable to our work, because of their recording characteristics, which are designed to meet stringent and unusual circumstances. Some special-purpose films of limited interest are mentioned further along.

Exposure Latitude

Film tolerance to under- or over-exposure is called the *latitude of exposure.* This nontechnical term is a loose measure of the extent to which the exposure can vary from optimum and still yield a usable photograph. Of course, an ideal photo is made by using the ideal exposure; but—to a limited extent—special techniques in processing and printing can be applied in black-and-white work, to salvage a slightly under- or over-exposed shot or roll. But the same problems in color transparencies can be corrected only through delicate and expensive manipulations in retouching and color reproduction.

A rule of thumb is that the more sensitive films—those of "higher" speed—have a greater exposure latitude than do slower films.

Summary of Film Characteristics

As with most things in life, gains in certain film characteristics are offset

by the loss of others.

In general, low-speed films:

- have extremely fine grain;
- have high resolution;
- have a slightly compressed tonal scale (are "contrasty");
- have a narrow latitude of exposure.

In general, high-speed films:

- have a noticeable grain pattern with enlargement;
- have moderate resolution;
- have a long tonal scale (are "flat" or "soft" in contrast);
- have a wide latitude of exposure.

Attaining a workable balance among the characteristics needed most involves several factors: film format, degree of enlargement, availability of a tripod, etc. Choosing a medium-speed film may be the best course if what's needed is a film fast enough for hand-holding the camera at times, along with moderately fine grain and good resolution.

Black and White Films

General Purpose Films

For black-and-white film to give a meaningful rendition of a colorful work of art, the film's sensitivity to various colors must match the human eye's sensitivity to the color spectrum. Most pictorial films are *panchromatic,*

which means that they translate colors into gray values whose relative brightnesses are fairly close to what we would see if we were totally color-blind. Panchromatic film is the film to use in photographing most works of art, regardless of light source. Professional films, in comparison with regular films, have increased shadow sensitivity to boost the brightness of the dark areas of an image, and thus are preferred for studio use, because "contrasty" lighting and long exposure may cause a loss of shadow information.

Special-Purpose Films

Continuous-tone copy film. In copying black-and-white full-toned originals, faint highlight tones often "block up" into a white mass on pictorial film. If the job involves copying many photographs, consider using a special film, such as Kodak Professional Copy 4125, whose increased highlight contrast yields a close match to originals. Being orthochromatic (color-blind to red), copy films are best used for copying black-and-white art. Also, they are available only in sheets.

Line copy film. Graphic arts films enjoy only a limited place in our work. "Line films," such as Dupont's Cronar and Kodak's Kodalith, yield extremely

Table 5.2
Selected General-Purpose Panchromatic Films

Eastman Kodak	ISO Exposure Index	Available Format
Technical Pan	25	135/120/Sheets
T-Max 100	100	135/120/Sheets
Plus-X Pan	125	135
Plus-X Pan Professional	125	120/Sheets
Tri-X Pan Professional	320	120/Sheets
Tri-X Pan	400	135
T-Max 400	400	135/120/Sheets

Note: T-Max films are finer-grained but have higher contrast than other films in their respective speed classes.

Figure 5.1

Figure 5.2

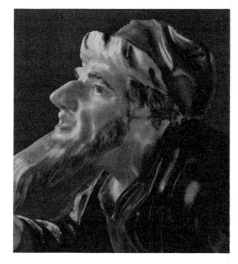

Figure 5.3

Figure 5.4

Figs. 5.1, 5.2, 5.3, and 5.4. *The four shots of this porcelain head of Pantaloon were made to compare a series of black-and-white films. Figure 5.1 was made using Kodak Tri-X, 35mm; figure 5.2, Kodak T-Max 100, 35mm; figure 5.3, Kodak Technical Pan, 35mm; and figure 5.4, Kodak Super-XX, 8 x 10. The first three photos are sections of 16x enlargements of three 35mm films; figure 5.4 is a section of a contact print from an 8 x 10 negative. Note the differences in grain structure, contrast range, and tonal rendition of colors. Technical Pan film (figure 5.3), with its extended red sensitivity, records the red cap and lips of the subject lighter than the others do. Also, its contrast range is considerably longer than the other films shown here.*

high-contrast negatives: if any gray tones are present in the original scene or work of art, line film will record all lighter grays as white and all darker grays as black. Using line films this way is rare, even in special-effect photography. Where line films excel is in copying originals that are comprised *only* of lines, as are all my strained diagrams in this book. The printer used line film as an intermediate step in reproduction.

It might seem natural to use a line film for photographing high-contrast drawings, prints, and etchings, but the results are often unsatisfactory. The reason is that the line *density* (not the width) of many works varies from light gray to black, and unless the exposure of the line film is precisely on target, some of these lines will not record properly in the negative.

See figures 5.5 and 5.6 for a comparison of a subject shot with a line film and a regular film.

Duplicating film. Duplicating film is for making direct *film* duplicates of black-and-white positives (prints or glass plates) or negatives (such as nitrate-based films). Using Kodak's Professional Duplicating Film SO-015, which requires only one camera exposure and normal processing, I once copied a thousand glass plates for classroom projection. This film made the job simple by eliminating the internegative that would have resulted from using regular reversal black-and-white film. SO-015 is an extremely slow but very fine-grained film, available in 35mm and sheets— on special order. Its ISO value is around 2.

Kodak Technical Pan film. Kodak Technical Pan film, a special-purpose film for scientific and medical use, has been around for a few years, but only since 1982 has Kodak packaged a compatible developer, Technidol LC, specifically made for pictorial results with a long tonal scale. The grain

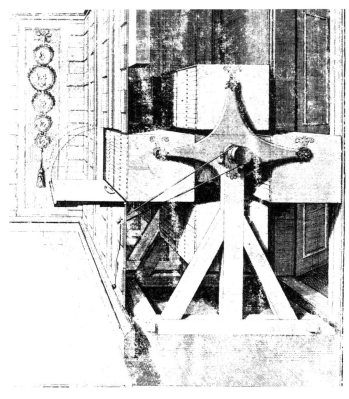

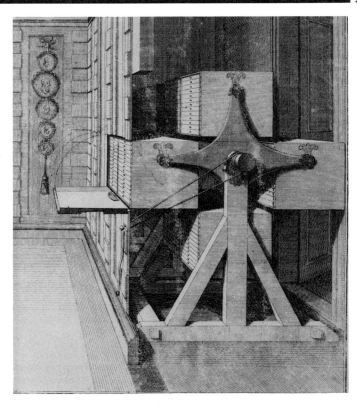

Figure 5.5 *Figure 5.6*

Figs. 5.5 and 5.6. *A bookplate showing a fatuous inventor's early method for saving space in a library serves to illustrate two different approaches to photographing line drawings. Kodalith, a graphic arts line copy film, was used for figure 5.5. Characteristic of "line films," this shot shows the elimination of all middle tones, so that gray values in the scene are relegated to obscurity in blackness or whiteness. Exposure alone determines which gray values become black or stay white, since development and printing have no effect on contrast. The exposure latitude for line films is virtually nonexistent. The film used for figure 5.5 was overexposed by less than one-quarter stop; highlight detail is "plugged," and the paper texture of the book is lost. Figure 5.6, on the other hand, was made on full-tone film, push-processed slightly to increase contrast, but not enough to obliterate paper texture. This rendition is better than that done with line film, because the full-tone film more faithfully records subtle differences in the original's line densities, ranging from faint gray to deep black.*

structure is remarkably fine, and resolution far surpasses the capability of most lenses. Enlargements from 35mm negatives equal the clarity of medium-format Panatomic-X. However, there are drawbacks. Being a type C panchromatic film, Technical Pan film is extra-sensitive to the red end of the spectrum. To neutralize that effect, use a 30cc cyan filter over the lens when shooting under tungsten illumination. This filter reduces the nominal ISO 25 to about 16. The film is highly susceptible to streaking in development, but with care that can be avoided and beautiful prints result.

Polaroid film. The advantages of using Polaroid film for test shots should be obvious: composition, lighting balance, exposure, and focus can all be checked instantly, and adjustments made, before the "real" shot is exposed on regular film. Although the cost per shot using Polaroid in testing, is significant, it is offset by the time saved in avoiding reshoots.

Currently, Polaroid film holders are made for all 4 x 5 and 8 x 10 cameras and most medium-format cameras. An expensive custom-made Polaroid film holder for 35mm cameras is available through Professional Camera Repair Service of New York City. Color film is made for all sizes, and black-and-white film is available for all except the 8 x 10 format. I prefer the black-and-white, because it tells me all I need to know without the extra expense of color. Besides, the color balance of color Polaroid is too

dissimilar to that of regular color film to be of help in predicting any filtration needed.

Color Films

Negative and Reversal Films

Of the estimated twelve billion photographs exposed each year worldwide, far more are made with color-negative materials than with color-reversal (transparency) or black-and-white films. However, color-negative films are not generally suitable for our work, for two reasons.

First, the color-negative must be printed onto color-printing paper, to get a positive image—an extra step that costs time and money and is subject to the variables of lab procedures.

Second, the chemical composition of color-negatives is of a highly unstable nature and is subject to rapid color fading—a factor that reduces the useful life of the film as an archival document.

Color-transparency films are much preferred to color-negatives, because of both the short elapsed time possible between exposure and final positive image (overnight, typically, with custom-lab processing), and the relatively better stability of the image when properly processed and stored.

Convention within the film industry denotes color-negative film with the suffix -color; for example, *Fujicolor.* Transparency films are assigned the suffix -chrome; for example, *Agfachrome.*

Emulsion Batches

Just as textile dyes are mixed in lots, so film emulsions are prepared in batches large enough to coat hundreds of rolls or sheets of film at once. Within one batch, the treated film's characteristics are *generally* uniform, but from one emulsion batch to the next, unavoidable changes in

chemistry cause variations in technical qualities. In black-and-white materials, these variations are so small as to be negligible, but in color films they can often create significant changes in speed and color balance.

To avoid disruptive exposure mistakes and unexpected color shifts, the safest thing to do is to buy large quantities of film marked with the same emulsion number—but no more rolls or sheets than you expect to use before the film's expiration date. Using film from the same emulsion batch is especially important when photographing a larger number of works for one publication, because that cuts down on reshoots and helps the printer achieve accurate color in reproduction.

Kodak film boxes are marked with a four-digit film type number, followed by a three-digit emulsion number. The final two digits are "cut" numbers within the emulsion batch; if you want to be really nit-picking about color consistency for a particular job, buy film from the same emulsion *and* cut numbers. The expiration date is marked by month and year.

Professional Films and Storage

Films categorized as *professional* boast accurate color balance and uniform contrast levels at the time they are released on the market. However, experience shows that most films—professional and regular alike—require moderate filtration where the photographer's standards are exacting. Even so, "pro" films are more predictably color-faithful than regular films, and should be refrigerated or frozen to halt emulsion ripening that is sure to happen if the film is stored at room temperature.

On the other hand, you *can* take advantage of emulsion ripening if you prefer to use regular films, which usually have a decidedly cool cast when first released. As regular film ages, on drugstore shelves or in desk

drawers, its color balance drifts to neutral; and near the expiration date, its color balance is warm. You can buy a large quantity of regular film, let it "ripen" at room temperature for a few months, and test a roll. If the balance is neutral, freeze the remainder until you need it. With freezing you can extend the expiration date by many months.

Any film that is frozen or refrigerated should be allowed to warm to room temperature before you take it from its protective wrapper or box. That way, condensation will form on the *container,* not on the film. Moisture could cause streaks, or alter color balance, or harm your camera.

Color Memory
in Human Beings and Film

Have you ever bought a shirt in a store lit by fluorescent light, only to be surprised by its "change in color" when you saw it later in sunlight or incandescent light? Of course, the dyes in the garment didn't change colors; only the light source changed. The apparent color shift that occurs in objects viewed under various lighting conditions depends partly on the chemical composition of the object in question, and partly on the color balance, or mixture of wavelengths, in the illuminating source. Whether or not we *notice* such color shifts depends largely on our awareness and our memory of color.

Color Temperature

Color temperature is a useful concept that applies to light sources and color films; it also concerns viewing conditions in which color photographs and printers' proofs are corrected with respect to original art. When used to describe a light source, *color temperature* is used to mean a gauge of color balance as compared to a known standard.

The standard used by scientists is a *carbon bar,* or a "black body

radiator."At room temperature, the bar is black; but as it is heated, it glows red, then orange, yellow, white, and—finally—blue, at a very high temperature. The color that the glowing bar emits at any given temperature is termed *the color temperature of the light.* To find the color temperature of *another* light source, such as a Type B photoflood, scientists heat the carbon bar until its color closely matches that of the photoflood, and then note on the Kelvin scale the temperature at which that happens. Thus, we have the familiar notation appended to both Type B light sources and the films that are designed for use with them: 3200K. Table 5.3 shows selected examples of light sources and their color temperatures.

Matching Film to the Light Source

In color photography, we have only four primary light sources at our disposal, because color films are balanced to match only those four sources. Other kinds of light can be used, but filtration is required.

Daylight/strobe. Daylight as a source requires daylight color film. But since daylight is unreliable because of color shifts that vary with time of day, weather, and pollution, it is not ideal. Ordinarily, daylight has a color temperature of 5000-5500K; at sunset on a clear day, that may drop as low as 3000K; and in overcast conditions,

it rises beyond 12,000K.

Electronic flash is generally balanced for 5500K and can be used with daylight film. Electronic flash is a very stable light source, maintaining color balance for more than 50,000 flashes. Often no filtration is needed, other than for ultraviolet absorption.

Tungsten. There are two types of tungsten sources—A and B. Currently, only one film—Kodachrome Professional, Type A—is made for the former. Many Type B films are available and are the overwhelming choice of most photographers.

Type A light is 3400K, while Type B is 3200K. In a pinch, you could use Type A film with a Type B source; the photos will be slightly warmer than ideal, but not objectionable. For critical color, stick with the proper film/light combination, or use a light-balancing filter.

Fluorescence. No color film is made for exclusive use with fluorescent lighting, and it's doubtful that there ever will be. The reason is that too many different kinds of fluorescent lamps are manufactured, each with a radically different color balance—cool white, warm white, daylight, and so on. In addition, two tubes with the same designation from different manufacturers will have a dissimilar spectral emission. Nearly all except "daylight" are grossly deficient in certain wavelengths, and require

heavy filtration that, at best, can only adjust the color balance to an approximation of the balance of current film color emulsions.

Daylight-type fluorescent tubes are theoretically the closest match to the color emission of a "conventional" source, but a quick visual comparison of "daylight" fluorescence with sunlight reveals an obvious discrepancy. If you must shoot under their illumination, see "Filters for Fluorescent Sources" in chapter 6.

Combination light sources. Sometimes you will have to shoot in situations where there is a mixture of different kinds of light sources. A typical situation is a gallery lit with both window light and tungsten spotlights. If you couldn't control the existing light, you could ideally bring your own light source, such as a portable flash attachment. But if that isn't possible, you have to choose a film (or a film/filter combination) that most closely matches the dominant type of existing light. To find out which of two or more sources is more prominent, you could use either your eyes and intuition or an expensive color meter. But what if the color meter tells you that the window light, which calls for daylight-balanced film, and the ceiling light, which calls for tungsten-balanced film, are about equal in intensity? You then have to choose between either a shot in which the daylight part of the scene looks right, but the tungsten part is reddish (daylight-balanced film), or a shot in which the tungsten part of the scene looks right, but the daylight part is bluish (tungsten-balanced film).

Color Transparency Film

Choosing the right color transparency film for your specific needs is a complex matter, because there are many tradeoffs you must make regarding speed, sharpness, contrast range, color saturation, and general color mood. In addition,

Table 5.3
Light Sources and Color Temperatures

Source	Color Temperature (Degrees Kelvin)	Color Name
Overcast Daylight; Twilight	12,000 - 18,000	Blue
Electronic Flash (Strobe)	5,500 - 6,000	White
"Photographic Daylight" (mid ⅔ of day)	5,000 - 5,500	White
Type A Photoflood/Quartz	3,400	Yellow
Type B Photoflood/Quartz	3,200	Yellow
Museum Gallery Tungsten (approx.)	2,800 - 3,000	Orange
Household Lights (40-100 watt)	2,600 - 2,900	Orange

each film has its own stain-forming characteristics and dye stability, which can differ according to whether the film is projected (slides) or stored in the dark.

Apart from the selective controls you have in achieving proper color balance through testing and filtration, outlined in the next chapter, each film has a characteristic "mood." This mood can strike you as neutral, cool, or warm, and seems to depend on the colors that are most emphasized. Any color film can be manipulated to yield a good color balance in terms of pure whites and neutral grays. But when you compare six different transparency films of the same subject, for instance, all of which have a "neutral" color balance derived from careful lighting and filtration, you will find some of the shots have substantial differences in mood. All of Kodak's Kodachrome films, for example, have a decidedly warm cast. Certain Ektachromes, on the other hand, seem neutral, while others have a cool mood about them. The choice is largely subjective.

While color film dye stability and resistance to fading have been concerns of photographers for a long time, recent tests reveal that stain formation (usually yellow) is as pressing a problem. If longevity of image is important for archival needs, you should use Kodachrome, still champion for dye stability and freedom from stain—as long as the slides are kept in the dark. But those same Kodachrome slides, if projected, will fade faster than any other slide film currently on the market! The obvious solution is to make duplicates for projection. By contrast, Fujichrome materials are far superior to all others for projection, but are only average with respect to dye stability and are poor with respect to stain formation. Ektachrome films are average in dye stability in both dark storage and in projection. The tendency for

Ektachrome to form stains, however, is greater than average even when stored in the dark. Agfachrome and 3M products have poor dye stability in the dark, but average stability when projected.*

If speed of processing is important, your film choice may tip in favor of Ektachrome or Fujichrome, which use the same Kodak developing process (currently E-6). There are thousands of E-6 process labs around the world, and turnaround time can be as short as two hours. Only a handful of custom labs can process Kodachrome. But there is a vast network of locations (E-6 labs, drugstores, and so on) where Kodachrome can be dropped off and picked up, with turnaround time ranging from a few hours to one week. Recently, film manufacturers have introduced several films that have increased color saturation and contrast, such as Ektachrome 100 Plus Professional

(EPP). I have not used such films, but I suspect that they are more suitable for commercial photographers who want greater graphic impact in their photographs than you want when documenting art. Likewise, I have found Kodachrome Professional Film Type A to be of too high contrast and very finicky with respect to exposure latitude.

My personal choice for transparency films is Ektachrome EPN (6122) balanced for electronic flash, simply because it seems neutral in mood, has an adequate contrast range, and is fairly fast, sharp, and reliable. A great advantage for me is that it is available in several formats, thus simplifying life when both sheets and slides of the same subject are required.

*Information on dye stability and stain characteristics is adapted from tests by Henry Wilhelm (see *Suggested Reading*).

Table 5.4
Selected Color Transparency Films

Eastman Kodak	ISO Exposure Index	Available Formats	Comments
Kodachrome (Daylight/Flash)			
KM	25	135	Fine grain; needs ripening
PKM	25	135	Fine grain; refrigerate
KR	64	135	Same as KM
PKR	64	135/120	Same as PKM
PKL	200	135	Moderate grain and sharpness; for hand-held cameras
Ektachrome (Daylight/Flash)			
EPR	64	135/120/Sheets	Ideal for flash
EPX	64	135/120	Warm balance; high saturation
EC	100	135	"Amateur"; widely available
EPN	100	135/120/Sheets	Fine gain; moderate contrast; good for difficult textiles
EPZ	100	135/120	Same as EPX
EL	400	135	Grainy; for hand-held camera
Ektachrome (Tungsten 3200K)			
EPY	50	135	Fine grain; moderate contrast
6118	64	Sheets	Fine grain; moderate contrast
ET	160	135	"Amateur"; widely available
EPT	160	135/120	Moderate grain; for hand-held camera

6
Filters

A friend, learning to photograph his own paintings, overheard a conversation about filters that prompted him to ask "Is there a particular filter that should be used for photographing art?" The answer was no; but his question, asked in all earnestness, reminded me that the topic of filters is *confusing*—even for professional photographers.

Filters exist for one reason: to change the quality of light reaching the film.

In black-and-white work, filters are rarely used for photographing art, except to change the tonal contrast between two important values that would otherwise be indistinct. In color work, filters are often employed to adjust the color balance of the light so that the film closely resembles the art. A third use for a particular kind of filter—which is actually termed a *polarizer*—is to reduce glare on the art.

Made of gelatin or glass, filters can be round or square, and they are affixed to the camera lens by use of a threaded screw-mount, a step-up ring, with tape, or even by insertion between the elements of barrel-mount view camera lenses. My preference is the dyed glass screw-in type for 35mm lenses, or the square gelatin type that slips into a slotted bellows lens shade. Whichever you choose, don't skimp on quality—*and keep it clean!*

Of the many filter systems available, I have chosen for this book the well-known Kodak Wratten system.

Because all filters absorb some light, you must usually increase the exposure, when using filters, to prevent underexposure. The amount of increase depends on the light source and the filter density. This "filter factor" is noted with instructions packed with each filter.

Types of Filters

Contrast Filters (Black-and-White Film)

Ordinarily, the gray value rendering of panchromatic film is the most desirable interpretation of art. Very rarely, increased tonal contrast is necessary between two *adjacent* colors, to reveal more information for curatorial study or conservation assessment.

Contrast filters are made in several densities of six basic colors, but I find that as few as three will suffice for most situations: No. 25 Red, No. 47 Blue, and No. 58 Green. Being highly saturated, each of these filters will transmit only that light whose color is close to its own, and will absorb (block) light of a complementary color. Thus, the *transmitted* colors will be light in the print, while the *absorbed* ones will be dark.

For instance, if you shoot a green pattern stitched on the red lining of a kimono, and the two colors are of the same brightness and saturation, they may record—without a filter—as the same gray value on black-and-white film. A No. 25 Red filter over the lens would allow the red color to transmit to the film, but would block the green (its approximate complement). The green stitching would then manifest itself in the print as dark gray tones against a light-toned background.

When a contrast filter will not sufficiently alter the tonal distinction between two similar colors (e.g., green on blue), forget the filter and

Table 6.1
Contrast Filters for Black-and-White Film

Color of Subject	Use this Filter To Make Darker	Use this Filter To Make Lighter
Red	G	R
Orange/Magenta	G or B	R
Yellow	B	R
Green	R	G
Cyan (Blue-Green)	R	G or B
Blue	R	B
Purple	G	B

rely on increased film development or high-contrast printing paper to gain separation.

Light-Balancing and Conversion Filters (Color Film)

Light-balancing and conversion filters for color film are used to make a gross adjustment in the color balance of light when you have the "wrong" type of film in the camera for the color temperature of the light. For example, if you have been shooting indoors with Type B Tungsten-balanced film and want to move outdoors and shoot under the *relatively* bluish light of the sun with the same film, you need an amber 85B filter.

Table 6.2 lists the filters that convert various light sources to match the two most popular types of color film. Series 80 and 85 are properly called *conversion filters*, because they alter the color balance of light by a greater amount than series 81 and 82, which are *light balancing filters*. Those suggested for museum galleries will help only under conventional incandescent sources— not under those spotlights that have theatrical gels to "enhance" the art.

Color-Compensating (CC) Filters (Color Film)

According to theory, the color balance of processed transparencies should be correct if the proper emulsion/light source combination is used, or if the color temperature of the light is adjusted by using a *conversion filter* or a *light-balancing filter*. In fact, however, color transparencies often do not match the art closely, even when these practices are observed. Owing to many factors—variations in emulsion batches, unavoidable changes in processing chemistry, age of bulbs— the color balance of transparencies may reveal a slight overall color cast that can be eliminated by using a

Table 6.2
Filters for Color Film

Film Type	Light Source	Filter	Approximate Exposure Increase in f/Stops
Daylight/Strobe	Daylight or Strobe	None	0
	3200K Photo	80A (blue)	+2
	3000K Museum Gallery (tungsten only)	80A and 82A (blue)	+3
Type B Tungsten	3200K Photo	None	0
	3000K Museum Gallery (tungsten only)	82A (blue)	+1/3
	Daylight or Strobe	85B (amber)	+2/3

color-compensating (CC) filter.

CC filters are made in six colors: red, green, blue, cyan, magenta, and yellow. Each color is made in several densities, for greater or lesser absorption of the dominant color cast. These densities are marked in the following increments: 025, 05, 10, 20, 30, 40, and 50. The nomenclature of each filter is abbreviated, so that a magenta color-compensating filter of 0.30 density is designated *CC30M*.

The principle to remember with CC filters is that a given color cast is absorbed, or neutralized, by a filter of the *complementary* color. For instance, a greenish color cast can be neutralized by a magenta CC filter.

Since the color cast of your transparencies will undoubtedly vary

occasionally, you should have a set of all six colors of CC filters in increments of 0.05 and 0.10, if you want the highest quality possible for publication. With experience, you may want to fine-tune your work with 0.025 densities, as well.

"Shooting for Accurate Color" (page 67) and "Photography for Publication: Some Guidelines" (Chapter 10) give detailed information on CC filters.

Filters for Fluorescent Sources

Black-and-white film exposed under fluorescent light ordinarily requires no filtration, but certain types of very cool fluorescents are so deficient in the warm wavelengths that underexposure may result if the film is rated at the normal International

Table 6.3
Kodak Color-Compensating Filters

Color of Filter	Absorbs	Approx. Exposure Increase in f/stops
CC05R	Cyan (B + G)	1/4
CC10R	Cyan (B + G)	1/3
CC05G	Magenta (B + R)	1/4
CC10G	Magenta (B + R)	1/3
CC05B	Yellow (R + G)	1/4
CC10B	Yellow (R + G)	1/3
CC05C	Red	1/4
CC10C	Red	1/3
CC05M	Green	1/4
CC10M	Green	1/3
CC05Y	Blue	-
CC10Y	Blue	1/3

Standards Organization (ISO) film speed rating. Standard light meters cannot discriminate the color balance of fluorescent light, and so will not alert you to any deficiencies. For safety, re-rate black-and-white film in your meter by cutting the ISO rating in half, to insure ample exposure.

Color films exposed under fluorescent sources show a very peculiar color balance that is caused by the uneven spectral distribution of wavelengths. There are about six classes of fluorescent lights whose color balances are quite different— and tracking down the proper filtration for each combination of color film and fluorescent source is about as much fun as changing a flat tire in the rain. Short of climbing a ladder to find out what class of bulbs are in use where you will shoot, you could use an expensive color meter that will give basic information that can be linked with a color-temperature balance dial and CC filter chart, such as those published in the *Kodak Professional Guide* (Kodak Publication R-28). Depending on the film type and the class of bulb, filtration can range from a mere CC10Y to an eye-boggling 85B + CC30M + CC10Y.

The point of this explanation is to dissuade you from shooting color film under fluorescent sources. However, there may be times when you *must* shoot under fluorescent sources, and you should be minimally prepared to help alter the color balance toward a closer resemblance to normality.

There are two types of filters made exclusively for use with fluorescent sources that help a little bit—one for daylight/strobe-balanced film, and one for Type B film. Most manufacturers designate the former as FL-D and the latter as FL-B. Tiffen, Spiratone, and others make these filters, but my favorites are made by Singh Ray.

Polarizing Filters

Lighting for many types of

materials results in a certain amount of glare, because the intensity of light reflecting from a surface is too great to record as a tone with visible detail. Featureless white areas in photographs are simply accepted as natural, specular highlights when the areas are very small; but when they are so large as to be objectionable because they hide important features, they gain the notoriety of glare. Metal works, ceramics with a high glaze, highly varnished paintings, and polished wood surfaces are some materials noted for glare potential.

I try to minimize glare through the placement and size of light sources whenever possible, but in extreme cases, the glare is so great that a *polarizer* is needed to reduce or eliminate it for a clearer look at the obscured surface.

To use a polarizer, screw it into the lens barrel while observing, through the camera, its effect on glare. At some point in turning the polarizer, you will see the glare fade, as the surface detail shows. Adjust the polarizer to the position where reduction best suits your needs, and compute the exposure, keeping in mind that full reduction of glare can reduce the amount of light at the film by two stops or more. In some instances, total elimination of glare is important; in others, only partial reduction is needed, for residual glare to impart meaningful information about the medium to add "sparkle" to the image. Where a little glare is retained, it can usually be positioned on the object by moving the light so that no decorative detail is lost.

Polarized light sources (advanced). In rare situations a polarizer will be of no value when used on the lens alone and will have to be supplemented by a polarizer over the light source.

Ordinary reflected light is not polarized, but all glare is more or less polarized, which means that one component of the light's oscillation is

limited to one plane. The degree to which glare light is polarized depends on the nature of the reflecting surface, the angle of incidence between the light and the surface, and the angle from which that glare is photographed.

Multi-faceted surfaces, and those lit by two or more sources, may have many specular highlights (glare spots) that are polarized in different planes and by different degrees. When such an object is viewed through a rotating polarizer, different glare spots will alternately become darker and lighter, but at no one position of the polarizer will *all* glare be eliminated.

The only way to eliminate all glare simultaneously is to place polarizing material (*pola-screens*) over each light source and align each pola-screen so that all glare spots consist of polarized light oscillating in the same plane as seen from the lens position. *In conjunction with a polarizer on the camera lens, pola-screens will reduce or even eliminate all glare.*

Using pola-screens. To align two or more pola-screens on light sources, turn off all lights but one. This source's pola-screen can be set at any position. Place the polarizer over the lens and rotate it so that glare is eliminated. Turn off the first light and turn on the second. Without disturbing the first pola-screen or the lens polarizer, rotate the second light's pola-screen until its glare is eliminated while you look through the lens. In turn, set each pola-screen in a similar way. When all lights are turned on, there should be no glare, even for metallic objects, because the planes of polarization are parallel for all pola-screens.

Eastman Kodak makes pola-screened lights that are handy, but expensive. You might want to make your own by constructing a foam-core box that is open on two opposite sides, covering one opening with polarizing material and aiming a

Figure 6.1

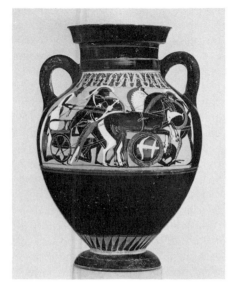

Figure 6.2

Figs. 6.1 and 6.2. *Glazed ceramics, like the Greek pot above, require polarized light sources in addition to a lens polarizer, if glare obliterates important details. The wooden block on which this vase sat is one of a series, each of different diameter, used to raise an object a few inches off the pedestal. That slight elevation allows positioning of lights low enough for even illumination of the lower portion of vases, which are sometimes deeply contoured. Black paper covers the top of the pedestal (cropped out, here) to eliminate reflection in the glaze. I used a 100mm lens on 135 format to insure a large image at a distant perspective. Also, a distant viewpoint at eye-level insures a quick grasp of each object's silhouette, which is used in stylistic grouping, dating, and attribution. Figure 6.1 was shot using conventional lights; figure 6.2 was shot using polarizers over the lights, in addition to a lens polarizer to reduce glare.*

panlight or spotlight through the other opening. Polarizing material is available from Spiratone and other distributors of 3M products at a fraction of Kodak's cost.

Because of the many drawbacks of polarized light, I avoid it like a tax audit: setting up for it is a slow procedure; the screens absorb so much light that they dictate long exposures; and the quality of light on three-dimensional subjects is often ugly, unless diffused. Also, exposure calculations with a lens polarizer are

vague. The nominal filter factor is four, meaning that exposure time must be multiped by that amount, or the aperture must be opened by two stops. Partial glare reduction on a light subject may require less exposure increase, while total reduction on a very dark subject may call for a greater increase.

But the main drawback to using polarized light sources in conjunction with a lens polarizer occurs with color film: the hue relationships and values of a multicolored subject are often

altered from those seen normally, with the unaided eye. Since no amount of CC-filtration will bring these hues back to the exact color and intensity of the original, deciding whether to use polarizers with color film becomes a matter of some philosophical importance. The choice can be determined *before* photography, however, by comparing the subject under normal illumination (as seen with the unaided eye) to the subject under polarized light (as seen through a polarizer).

Ultraviolet and Infrared Barrier Filters (Advanced)

When you want accurate color photographs for reproduction, you may have to use an ultraviolet or an infrared barrier filter—or one of each. These filters "cut off" wavelengths of light that are invisible to the eye but may be visible to color film. Paintings are especially susceptible to the ultraviolet (UV) and infrared (IR) components of photographic light sources, and sometimes a "false color" will register on the film. For example, a blue sky may photograph with tints of pink, even though all other colors in the film are faithful to the painting. An IR filter will solve the problem.

Likewise, certain papers used for watercolors may have whiteners that fluoresce under UV excitation. Where the watercolor pigment is of a certain nature, fluorescence of the paper under photographic light will cause it to change colors radically. I have seen grass green turn purplish-brown, and the effect was cancelled only by using UV-absorbing material over the light source, as well as a UV filter over the lens.

Full investigation of the subject of "false color" is far beyond the scope of this book, since it is extremely complex and represents a small

fraction of our work. But for the technical wizards among you, here are some tips for starting experimentation.

Use a UV-absorbing gel over lights, such as that made by the theatrical lighting firm Rosco, or Tedlar film by duPont. For total UV-absorption, you may have to use an optical Wratten No. 2A over the lens, in addition, as an anti-fluorescence measure. To absorb infrared radiation, try the Wratten No. 304 behind the lens. These filters will probably add an overall color cast, which must be absorbed by CC filters. A CC30B may help, if both lights and lens are filtered with yellow materials, and a CC20R will correct the bias of the No. 304. These densities and colors of CC filters are estimates only; your tests will determine the right ones, with your emulsion and processing.

Shooting for Accurate Color

Just as happiness can be found by removing the causes of suffering, so can excellent color transparencies be obtained by eliminating the causes of inaccurate color. These latter causes, although foreseeable, may go ignored; they are merely variables in your technique or changes in your photographic "system." If you can keep in harmony the many factors affecting color balance, your reshoot rate will decline, and your success rate will increase.

Obviously, a wide range of art shot over a period of time will require you to use film emulsions from different batches, alter lighting techniques, vary your exposure times, or change other factors that affect color. If you develop a standard method of working, these deviations will not cause uncertainty and reshoots. The color test outlined below is a suggested "standard method." I use it to determine the necessary

countermeasures for predicting and correcting imbalance of color when I change any significant aspect of my technique.

The Standard Color Test

Select a small group of colorful objects and place them on a neutral gray background as a tabletop set. These objects should be always accessible for any future tests, and should include a "true" white card, a neutral black object, a gray scale, and color bars. (See color plates for a series of photos made of sample test objects.)

For this and for all other tests, use your favorite lens, meter, and lighting unit. Adjust the lighting so that the main light is about 45 degrees off-axis from the camera and use appropriate reflector cards to fill in shadows.

For this first test, use no filters over the lens. Calibrate your meter to the nominal ISO of the film and load a roll of film with a color temperature matching that of the light source. If you use a view camera, load five sheets of film. Expose five frames (or the five sheets) at five different exposures—one shot at the exposure suggested by your meter, one each at + ⅓ and + ⅔, and one each at − ⅓ and − ⅔. Bracket by changing the lens aperture, so that the exposure time remains constant.

Adjust the lighting and aperture for this and all tests to yield an exposure *time* typical of actual working situations. For example, most of my 35mm slide exposures are made between one-fourth of a second and two seconds, so I use one second for my tests. Be sure to account for any lens extension or reciprocity factors (see Appendix 5). Process the film immediately, but do not break the set until you evaluate the color. Meanwhile, diagram the lighting plan

and mark the exposure calculations in a notebook for reference.

Evaluating the color test. The color test tells you two things: the speed of the emulsion, relative to your light meter; and the color balance of the emulsion, relative to your "standard method."

Examine the transparencies on a light box. If your meter is working properly and if you have used it correctly, one of the five exposures should be very close to ideal. If none is acceptable, check your exposure calculations or check your meter against one known to be working correctly.

Mark each frame or sheet with the emulsion and test numbers and the equivalent Exposure Index. For example, if your film has a nominal ISO of 50, the middle exposure would be EI 50; the shot exposed + ⅓ would be EI 40; the shot exposed − ⅓ would be EI 64, and so on. Regardless of which shot looks best, use its EI to calibrate your meter for this emulsion.

To evaluate color balance, follow the procedure outlined under "Color Correcting by the Photographer," early in chapter 10. If you need to use a CC filter, include its filter factor in calculating exposure for a second test.

If your first test produced unacceptable speed or color results, repeat the test, using the exposures and/or CC filters you think will improve the shot. If you keep the same lighting and exposure time, you should be able to zero in on the emulsion speed and color balance by the second or third test. The ideal exposure from these tests becomes this emulsion's Exposure Index, and the ideal filtration becomes this emulsion's "basic filter pack."

The following notes for a mythical emulsion test illustrate this procedure.

Table 6.4
Sample Emulsion Tests for Color

DATE:	1/1/86
EMULSION:	#176/TEST #1
FILM:	EPY-135
LENS:	55mm MICRO-NIKKOR
LIGHT:	OMNI-LIGHT/ UMBRELLA
EXPOSURE TIME:	1 SECOND

BRACKET:	EQUIVALENT EI:
f/16 2/3	80
f/16 1/3	64
f/16	50
*f/11 2/3	40
f/11 1/3	32

RESULTS: *EI 40 is best esposure but looks too red; will try CC05 Cyan at EI 32 (to compensate for filter factor.)

DATE:	1/2/86
EMULSION:	#176/Test #2

BRACKET:	EQUIVALENT EI:
f/11 2/3	40
*f/11 1/3	32
f/11	25

RESULTS: *EI 32 has OK density; color neutral.

Factors Affecting Color Balance

Once you have calibrated your system in the way just discussed, the basic filter pack should remain constant and the color acceptable for all photographs made with the tested emulsion—unless some factor changes. For relatively simple systems employing matched lenses and a few matched lights, as well as a reliable color lab, the results will be predictable. When the color does shift unexpectedly, the deviation can be corrected or avoided by following tips outlined further on. Unplanned color shifts can be and often are caused by any one or any combination of the reasons listed here:

- Emulsion batch changes
- Improper film storage prior to processing
- Color temperature of the light source not matched to the film in use (a gross color variation)
- Mixture of various brands or designs of light sources of the same color temperature (a minor color variation)

- Old bulbs
- Reflections from nearby colored objects
- Different lens coatings
- Reciprocity effects
- Color lab processing variations
- Ultraviolet fluorescence and infrared luminescence of the subject
- Voltage fluctuations
- Limitations in the sensitivity of three emulsion dyes

Emulsion-batch changes. Each color emulsion batch has a distinctive color balance. Sometimes the balance is neutral, but more often there is an overall color cast that can be cancelled with CC filters. The presence of a cast does not mean necessarily that the emulsion is flawed; although, on rare occasions, a "bad" emulsion that cannot be corrected by filters is marketed, a color cast is most likely the result of emulsion characteristics in relation to the sum of factors in your "system."

Whenever you change emulsions, you will probably have to alter your basic filter pack to fit the new emulsion into your system. The quickest and least expensive method to determine a workable new filter pack is to conduct another Standard Color Test with both the old and new emulsions. Instead of a five-shot bracket, however, a three-shot bracket should suffice.

Expose the old (current) emulsion with its appropriate filter pack, and expose the new emulsion with no filter. Process and compare the emulsions for relative speed and color balance. Shooting the old emulsion at this time will not only help you judge the color balance of the new emulsion; it will also signal any radical shifts in color that may have occurred since the first color test with the old emulsion. Such color shifts could be due to your technique or changes in processing. Select the best exposure index for the new emulsion and

conduct a second test, if necessary, using the CC filter(s) you think will correct the color.

Once you get acceptable color, maintain that basic filter pack for the duration of your use of the new emulsion.

Improper film storage. If film is subjected to heat before it is processed, the color balance will surely change. Keep film below 75 degrees F (24 degrees C), but let it warm to room temperature before exposure if it has been stored in a refrigerator or freezer.

Color temperature. As discussed earlier in the chapter on films, the gross color temperature of the light source must match that of the film. If it does not, use the appropriate conversion or light-balancing filter.

Mixture of light-source brands. In theory, all light sources of one type will emit an equivalent color temperature of illumination; but in practice, that is not true. For example, all Type B light sources are nominally 3200K, but variations in manufacturing tolerances and designs of luminaires may cause the actual color of light emitted by various sources to differ significantly. In addition, changes in the way a source is used may do the same thing. Although you may not notice a difference, in lighting an object with two different kinds of lamps, the processed transparency will reveal any discrepancy. The easiest way to avoid such surprises is to limit the illumination on each set to sources whose color temperatures are critically matched. Also, in changing the method of using a particular source—switching from direct to reflected mode—you should realize in advance that change may alter the color.

To determine the comparative color balance of different brands of lights, or the effect of switching modes, test each by the Standard Color Test method.

The source I use for testing emulsions is an Omni-Light bounced in an umbrella. For shooting certain objects, however, I prefer a Mole-Richardson Softlight. Since the M-R emits a light that is *relatively* cyanic, compared to the Omni, I must add CC05R to the basic filter pack. Please note that the color of the M-R is not "wrong," except in relation to my standard tested procedure. If I always used the M-R for testing emulsions, *its* color would naturally be programmed into the basic filter pack, and the Omni would become the aberrant source.

Similarly, if I remove the umbrellas and bounce the Omnis off the inner walls of a white paper tent, I add CC05B to the filter pack to subtract the resulting pale yellow cast of light.

Such hair-splitting attention to procedure may seem complex, but it will help to get the best results consistently. For a comparison of color balance changes caused by four different kinds of 3200K sources, see color plates.

Old bulbs. Incandescent bulbs yellow with age. The problem is more bothersome with short-lived, conventional photofloods than with tungsten-halogen (quartz) lamps. When blackening occurs on the glass of any bulb, compare its color visually to a fresh one. Throw out the old bulb when it changes color.

Reflections. Vibrant, saturated colors in backgrounds will add their own colors to that of objects sitting on them. Metallic and white objects show this most clearly, but "contamination" occurs, to some extent, in all works. Likewise, colored walls, nearby equipment, and even the photographer's clothing may reflect in the art. Where the problem is obvious, use a neutral environment—white, gray, or black.

Lens coatings. Because different antireflection coatings on lenses have been used by manufacturers over the years, older lenses with a single coating may lend to transparencies a color cast different from that obtained with newer, multicoated lenses. The lens color cast that is "right" is the one always used for your Standard Color Test.

If you suspect a problem with lens coatings, shoot a color test with the lens in question and with your standard lens. If the older lens adds, for instance, a blue cast, mark a small piece of tape on the lens with +CC05Y, to alert you to change the basic filter pack.

Reciprocity effects. Color film works best within a particular exposure range determined by the manufacturer—and noted on data sheets packaged with Kodak Professional Films. Photographs can and indeed often must be made at exposure times outside the optimum range, but the color goes awry. In fact, the exposure time chosen for your Standard Color Test may well have been outside the manufacturer's optimum range, and any color shift due to reciprocity during that test will have been accounted for when you chose a basic filter pack.

But should your exposure time for any reason be more than about two stops shorter or longer than your standard time, you may see the color shift again slightly. At three or more stops beyond the standard time, the color may change so much that you will have to reshoot with a new filter pack. That happens frequently in using low lighting levels, small apertures, long bellows extensions for close-ups, and a polarizer over the lens.

Following the manufacturer's suggested filtration may not be of much help, since that data is based on a Standard Color Test using equipment and processing different from yours.

Processing. Since most of us rely on custom labs to process our color,

selection of a reputable lab is important. Choosing the best lab involves several factors—service, cost, speed, etc.—but consistent quality of color is the chief criterion. Although color processing is largely an automatic process, the attitude of personnel is critical to quality control. A close working relationship with the lab manager will keep you abreast of information that can help you track down technical problems that may originate there.

Over a period of months, even the best lab's "color line" is subject to subtle changes in chemistry that may cause the color balance of your films to vary slightly. If you suspect such chemical changes, check with the lab. A responsible quality control manager will appreciate the feedback from your critical eye, which he should regard as a valuable adjunct to his abstract monitoring devices.

You shouldn't need to change CC filtration because of processing variations more often than about once in three months. If changes happen consistently every month or so, it's time to change labs.

Also, some labs repeatedly deliver processed films in pristine condition, while others seem to specialize in spots, streaks, and stains. These problems are due to either mechanical flaws or personnel problems, and if the manager of such a lab seems reluctant to repair equipment or train technicians, a lab change is in order.

UV and IR. Ultraviolet radiation is more prevalent a problem with electronic flash than with tungsten sources, but it can be solved in either case by placing UV-absorbing gels over the luminaire. Most flash-tubes now have UV filters incorporated within the tube's protective glass casing, but some are not very efficient. Several manufacturers make a filter that clips over the reflector and does not disturb the quality of light.

When transparencies of works such as paintings exhibit a "false color," the discrepancy may be caused by ultraviolet fluorescence or infrared luminescence of pigments responding to the light source and so recorded by film. To solve this rare problem, you should follow the procedure outlined on pages 66 and 67.

Voltage fluctuations. Seemingly insignificant, voltage "drop"—a decrease in the electromotive force received throughout your power system—can upset color balance.

Local voltage drop occurs sometimes when a nearby photographer, plugged into the same underserviced electric panel that you are using, turns on his lights. Another common cause is the use of a very long extension cable whose diameter is too small. Widespread voltage drop occurs when the regional power company lowers voltage to accommodate such unusually heavy demands for current as develop on hot summer afternoons when air conditioners are struggling.

Monitoring your electrical service occasionally with a voltmeter will alert you to changes from the norm. A 5 percent drop is not unusual, but is tolerable; greater drops may cause enough excessive warmth in your film to require a CC05B or CC05C for correction. Radio Shack makes an inexpensive meter that is suitable.

Limitations of the medium. Finally, when all other potential causes of inaccurate color have been examined and found to be under control, but a particular color in the film still does not match the work of art, we may have to admit defeat and lay the blame on one of two causes: either we don't know what we are doing, or there are definite and real limitations (at present) in color film's ability to record faithfully all colors existing in concrete reality. This latter possibility is highly probable, since there are only three film dyes that, in combination, must represent an infinite variety of hues and values existing in works of art.

When one runaway color eludes your best efforts, do not despair: make notes on a sticker on the transparency sleeve to alert the production specialist to add a little mechanical magic in the reproduction process. It may be expensive, but if a fine reproduction is wanted, the color can usually be reproduced and printed.

7
Exposure Control

THE recent development of viable, automated cameras has removed from general photography one of the most worrisome obstacles to technically acceptable images: exposure control. However, automated exposure is of scant value in our work, because we often must bracket exposures for critical control. That does not mean that, just to shoot art, you should trade in your automatic camera, if you have one. Most automatics have a manual override that will allow you, when necessary, to bracket. And even the most foolproof models, which have no manual mode, can usually be adjusted to give lighter or darker exposures than the automatic circuit would normally yield. You can make such an adjustment by changing the ISO index on the meter: use a lower value to brighten the exposure and a higher value to darken it.

Film Exposure

Film exposure is the cumulative effect of light, which builds a latent image. Because of this "accumulation" of light, there is such a thing as too little or too much light on the film for proper image density, just as there can be too little or too much sugar in coffee for best flavor. To yield a usable image, film needs *just the right amount* of light. Within the limits of a film's exposure latitude, that amount can vary, according to the photographer's taste. For a given

subject, one photographer may prefer a light exposure in a color transparency, to give a sense of buoyancy, while another may prefer a darker exposure, to give a feeling of gravity. Either effect is the result of lighting quality coupled with the amount of exposure given the film. Lighting quality is relatively easy to control, because the photographer can see what happens as the art is lit; but exposure is often a source of trepidation, because one *cannot* see the outcome of all photographic decisions until the film is processed. To remove some sources of anxiety and guessing, let's discuss what exposure is, mention some tools and means for its control, and list several factors that influence it.

For a given intensity of illumination on a work of art and a given film's sensitivity to light (its ISO speed), proper film exposure is achieved by balancing the *amount* of light passing through a lens with the *duration* of the shutter opening. This balancing act is, of course, achieved by manipulation of the lens aperture and the shutter speed. In algebraic terms, the relationship between these two controls is expressed poetically by the formula:
EXPOSURE = INTENSITY x TIME.
Known as the Law of Reciprocity, this relationship applies to most photographic situations, although there are exceptions that cause exposure to deviate from the

predictable pattern.

The calibrations on the aperture and shutter dials of a camera are marked in increments that are primary units of exposure, termed *stops*. The concept of a *stop* should not be confused with the term *f-stop*, which is jargon for the f/numbers on the aperture scale. Stop values are useful for comparing light-source intensities, lens "speeds," and film "speeds," as well as for describing filter factors and assessing the densities in processed films, prints, and transparencies. A *stop* as a primary unit of exposure is a relative measure of brightness values, in much the same sense that an octave is a relative measure of pitch interval in music. A *whole-stop* difference in brightness between two transparencies, for example, is due to one's being exposed to twice as much light as the other.

This 2:1 ratio in brightness values can also be expressed as a percentage: *a whole-stop change in exposure is a 100 percent change; a half-stop change is 50 percent, and so on.*

For any constant light level, increasing the diameter of the aperture by a factor of one stop (e.g., f/11 to f/8) *doubles* the intensity of light at the film; decreasing the aperture by one stop *halves* the intensity. Likewise, increasing the length of time the shutter is open by one stop (e.g., half a second to one

second) *doubles* the amount of time the film is exposed; decreasing shutter duration *halves* the length of time. Sometimes it's necessary to juggle these two controls to achieve a certain effect while maintaining an equivalent exposure. For instance, if you meter a New Guinean mask in a gallery case for an exposure of ¼ of a second at f/16, but you do not have a tripod, you will want a faster shutter speed. By increasing the aperture by four stops and decreasing the shutter speed by four stops, you can safely handhold the camera at ¹⁄₆₀ of a second at f/4—and get the same film exposure.

The Right Exposure

A major step in getting the "right" exposure is learning to recognize one when you see it.

A film's latitude of exposure is a rather vague term, ostensibly referring to the film's ability to accept underexposure or overexposure and still produce an acceptable image. In a very real sense, a film's latitude can be no greater than the photographer's tolerance of a photograph that is either too dark or too light.

Underexposure yields a negative or transparency whose shadow details are drowned in a pool of obscurity. Middle tones and highlight values are suppressed and "muddy"; the overall mood is depressive. Transparencies have an *underexposure latitude* of about a half-stop under optimum; virtually no corrections can be made in lithographic reproduction for brightening a transparency that is more than one stop darker than optimum. Duplicate transparencies can be made lighter than the original, but usually there is loss of color fidelity, and increase in contrast and grain. Black-and-white films can withstand about a half-stop underexposure, too, before contrast increases beyond the threshold of acceptability.

Overexposure causes films to have faint or nonexistent highlight details. All middle tones and colors seem bleached, and the mood is one of searing light. Transparencies have an *overexposure latitude* of about a half-stop above optimum. Shots brighter than that cannot be salvaged, even in reproduction, because there is simply no granular information in the highlights for an engraver to use for making color dots. Attempts to make a duplicate transparency that is darker will introduce a pale, flat tone in the empty highlight areas. On the other hand, black-and-white films can withstand a one-and-a-half-stop overexposure and still be acceptable. However, such negatives lose sharpness and contrast while gaining in grain size. In addition, overexposed negatives require long enlarger-printing times.

Correctly exposed films have all significant shadow, middletone, and highlight values in proper relationship. Their mood is "right." Transparencies will reproduce easily with all tones intact, and black-and-white negatives will print on a normal contrast grade of paper, with little need to burn in highlight areas or dodge shadows.

You can evaluate the density of transparencies as you judge their color on a light box. Choosing the best density of black-and-white films, however, is difficult for beginners who use a light box, because the brilliant, transmitted light makes overexposed negatives look acceptable, while correctly exposed ones look too thin. I prefer judging films, wet or dry, when they are illuminated by the indirect light of a 75-watt spotlight reflecting from a 3 x 3-foot white card taped to the darkroom wall, while the film is held about two feet from the card.

Light Meters

Photoelectric meters are light-sensitive instruments for measuring the relative intensity of light as an aid in determining exposure. There are two basic classes of meters, and they are used quite differently to achieve the same result.

Incident meters. All incident meters are handheld devices that measure the light impinging on a subject. The light-sensitive cell is capped by a plastic dome, or sphere, which integrates the light falling on it from all angles. In use, an incident meter is held near the subject with its integrating sphere directed toward the camera, so that this sphere "collects" the same light that the subject collects.

These meters are useful for all types of photography, but they excel in work involving very small subjects that are difficult to read with handheld reflective meters, and in reading the entire subject field for flat art, which must be evenly illuminated. Many photographers prefer incident meters for color transparency work because they favor accurate highlight exposure, which is generally the key to acceptable transparency density. Some incident meters are convertible for use as a reflective-reading meter, a design that makes them more flexible.

Reflective meters. Reflective meters read the light reflecting from a subject. The handheld types have a light-sensitive cell capped by a small lens that limits the cell's angle of acceptance to an exact field, usually about 45 degrees, but better meters have a narrower angle of about 10 degrees for more accurate readings of smaller subject areas. In use, a reflecting meter is held between the camera and the subject, and its sensor cell is pointed toward the subject so that it reads light reflecting from the art. Consequently, it accounts for the light absorbed by each subject—something an incident meter cannot do.

All TTL camera meters are

reflective-reading and can give more or less reliable readings, depending on the cell's sensitivity pattern in relation to the art as it is framed in camera. One major advantage of a TTL meter is that its angle of acceptance is limited to that of the lens in use, so that the photographer can move in close to the subject for more precise readings of small areas while seeing exactly the area being read. Like incident meters, reflective meters can be used for all kinds of art.

Spot meters. Spot meters are a professional class of reflective meters whose angle of acceptance of about one degree is for precise measurements of various subject areas when determining contrast ratios. This information tells you whether to alter the lighting balance (in three-dimensional work), and whether to compress or expand the contrast range through film development (in black-and-white work).

This esoteric approach to exposure reading presupposes at least a flirtatious familiarity with the zone system of exposure control (see chapter 8).

Meters in Use

The mechanics of using the dials of any meter are fairly simple and are detailed in the instruction manual packaged with the meter or camera. Operation varies somewhat with different meters, but the basic steps are those listed below.

Handheld Meters

1. Set the ISO value scale to match the ISO value of the film in use.

2. Make a reading of the light intensity by holding the meter near the subject.

3. Note the moving needle's position on the light-value scale.

4. Transfer this value to the rotating dial.

5. Select one of the combinations of aperture and shutter speed

indicated on the dial and use that as the base exposure.

TTL Meters

1. Same as step one, above.

2. Move the camera close enough to the subject to fill the viewfinder with its image and make a reading.

3. Set the desired aperture and rotate the shutter-speed dial until a proper exposure is indicated.

4. Use that combination as the base exposure.

As an example of a theoretical meter reading, you might get the combinations of values shown in Table 7.1 on the dial of a handheld meter—see table below.

Any of the combinations represented in any vertical column, theoretically, could be used to get an equivalent exposure. In other words, you could use a fourth of a second at f/8, or two seconds at f/22, and get the same amount of light on film. With TTL meters, no one dial displaying various combinations exists, but the principle is exactly the same: the actual aperture and shutter speed dials on the camera are used.

Factors Influencing Exposure

Those of us with experience in using a meter know that its advice should be regarded with as much caution as a politician's promises: both may tell you what is good for you, but your own intelligence should dictate your actions. This is not because meters are inaccurate—most types will give a very precise basic reading, and they are invaluable tools—but

extenuating factors that affect the light in its journey from the source to the film must be considered in computing exposures, and the advice of the meter must frequently be overridden. These variant factors include meter idiosyncracies, emulsion speed, lighting direction, subject depth, subject reflectance, subject contrast, filters, polarizers, lens extension, shutter speeds, reciprocity effect, and film development (black-and-white). They are discussed briefly on the following pages.

Meter idiosyncracies and emulsion speed. Like all mass-produced items that are supposedly identical, different meters will often give slightly different readings of the same subject because of variations in design, factory calibration, and individual quirks. For films, too, variations in speed between emulsion batches are inevitable. Before you can get predictable exposures, your meter and the film emulsion must be calibrated to each other. Follow the procedure for the Standard Color Test in "Shooting for Accurate Color" (chapter 6).

Lighting direction. When the principal light beam (or beams) on a subject are at an angle of 60 degrees or less, relative to the camera axis, readings with both types of meter are made in the normal way; but when the angle of incidence of the light approaches 75 degrees and greater—such as the raking light that might be used in lighting a stone relief—the reading made by an incident meter will usually be erroneous. Since the

Table 7.1
Typical Values, Handheld Meters

Aperture (f/#)	4	5.6	8	11	16	22	32	45	etc.
Shutter Speed (seconds)	1/15	1/8	1/4	1/2	1	2	4	8	etc.

integrating sphere of the meter collects more light than does the face of the relief, the meter "thinks" there is more light than is actually present on the art. Consequently, a straight reading will yield underexposure. To counteract that probability, increase the exposure by a factor of one-fourth to three-fourths of a stop.

Reflective meters are not subject to that type of error.

Subject depth. When the entire depth of a three-dimensional subject must be in sharp focus, the aperture may have to be very small in order to gain adequate depth of field. That circumstance necessitates a long shutter speed, but generally this is not a problem, as long as the camera is mounted on a tripod. The normal procedure is to select the aperture first, and then use whatever shutter speed is required. (See "Reciprocity Effects," below, for exceptions to that approach.) This circumstance does not, *per se*, require overriding the meter reading.

Subject reflectance. All meters "think average." Regardless of the type, each meter is calibrated to suggest proper exposures for "normal" subjects of average reflectance. When the art is predominantly light or dark, you will have to override the meter reading to avoid over- or underexposure.

To illustrate: suppose you are shooting three paintings of widely differing reflectance: a daytime scene by Edward Hopper, a predominantly black painting by Georgia O'Keeffe, and a pale canvas with very small areas of color by Morris Louis. The Hopper is of "normal" reflectance, with a mixture of light, medium, and dark tones (conventional meters "think" in gray values—not in colors). The O'Keeffe is of very low reflectance; and the Louis, of very high reflectance.

First, make a reading of each painting, under identical illumination, with an *incident* meter. Theoretically,

there should be no variation in the readings; but in fact, if you hold the meter near the canvases, there could be a difference of about a half-stop between the black O'Keeffe and the pale Louis, because the integrating sphere collects both direct light and light reflecting from the canvas. That could be a source of poor exposure if overlooked. But for our example, let's assume that the readings are identical, and you expose film. What happens?

The Hopper is correctly exposed; the O'Keeffe is underexposed (too dark); and the Louis is overexposed (too light). Why?

Because an incident meter measures the light falling on a subject, it has no way of knowing how much light is absorbed by the art and how much is reflected toward the camera. Since it is the *reflected* light that the *film* sees, you must look carefully at each work of art and judge its absorbency and reflectance, to determine whether it is "average," and adjust your exposure accordingly.

From this example, we can conclude that, *when using an incident meter, if the subject is predominantly dark, one should increase exposure by a factor of a half-stop to one-and-a-half stops; if the subject is mostly light in value, decrease the exposure, but by no more than a half-stop.*

The amount by which you overrule the meter's advice depends on how much darker or lighter than "average" a subject is, and on whether you are shooting black-and-white or color. With black-and-white, overexposing a pale original is not a big problem, since you can "print down" a dense negative when enlarging—provided that you haven't overexposed by more than one stop. But since color film's latitude is small, you will have to reduce exposure a bit. Refer to Table 7.2 as a guide for calculating exposures when using an incident meter.

To continue: next, make a reading

of the same painting with a *reflective* meter, either a handheld type or a TTL meter. The different reflectances of the paintings will cause the meter to suggest three *different* exposures. If you follow its advice, the Hopper will be correctly exposed as before; but the O'Keeffe will be overexposed and the Louis, underexposed. With the last two mentioned, this is an opposite result from that obtained with the incident meter. Why?

Again, meters are calibrated to suggest exposures suitable for subjects of "average" reflectance. Most scenes contain a range of tones that, if they could be peeled from objects, tossed into a vat, and stirred up, would become a monotonous gray tone that reflects only about 18 percent of the light falling on it. (Such a tone corresponds to that of a slice of whole wheat toast and a Kodak 18 percent Neutral Gray Test Card.) When a meter responds to a scene or a work of art that is of exceptional reflectance—such as an O'Keeffe or a Louis—it continues to "think average," and consequently suggests an exposure based on wrong assumption. For all the meter knows, it could be reading one painting under three different intensities of illumination, when in fact it is reading three very different paintings under the same illumination.

From this test we can conclude that, when using a *reflective meter*, if the subject is predominately dark, we should *decrease* the exposure by minus one-half to minus one stop; if the subject is mostly light in value, we should *increase* the exposure by plus one to plus two stops, depending on the type of film. Refer to Table 7.3 for guidelines to follow with reflective meters.

A reliable method for making reflective readings is to use the 18 percent card mentioned above, or a swatch of Coloraid Gray No. 5. Hold either one near the subject, so that it receives full illumination while turned

| *Figure 7.1* | *Figure 7.2* | *Figure 7.3* |

Figs. 7.1, 7.2, and 7.3. *A three-part series of photographs of three paintings helps to illustrate some of the complexities of subject reflectance. The subjects*—left to right, here, and in the six photos following—*are a daytime scene by Edward Hopper; a Georgia O'Keeffe work that is predominantly black; and a pale painting with very small areas of color, by Morris Louis. These three paintings are of different reflectance and will cause light meters to suggest exposures that may be erroneous. Figures 7.1, 7.2, and 7.3 show them as they appear in reality.*

| *Figure 7.4* | *Figure 7.5* | *Figure 7.6* |

Figs. 7.4, 7.5, and 7.6. *Compare these three photographs with the first three in this series. An* incident meter reading, *followed unquestioningly, may produce obvious differences in appearance when photographing paintings of very low or very high reflectance.*

| *Figure 7.7* | *Figure 7.8* | *Figure 7.9* |

Figs. 7.7, 7.8, and 7.9. *A* reflective reading meter *of the three paintings in this series will cause* these *transgressions to the original art. Note that an "average" subject like the Hopper painting will record correctly with either type of meter.*

halfway between the lens and the mainlight. Aim your meter at the card and use that reading as your base exposure.

A virtually foolproof way to get accurate exposures is to make both a reflective *and* an incident reading of a subject, and then interpolate the two values. For example, if a reflective reading of a dark subject calls for an exposure of four seconds at f/16, and an incident reading suggests one second at f/16, the best exposure would probably be two seconds at f/16 (this trick courtesy of Walter J. F. Yee).

Subject contrast. When all *important* tonal values in the art being photographed are recorded in a print or transparency as discrete steps in tonal value, the contrast range is said to be correct and faithful to the sense of the art. When a work of art has a contrast range (ratio of brightness from black to white) that is much greater than the film's capacity to record contrast, only a portion of the

subject's "tonal value scale" will record on film. That portion recorded—dark, middle, or light values—is a function of the exposure.

Contrast control, along with color balance control, is one of the most menacing technical problems in photographing art. Both are so important and so complex that they deserve further discussion. See chapters 8 and 10.

Filter factors. Each filter used over a camera lens for altering the light does so by subtracting certain wavelengths. Consequently, the intensity of light reaching the film is reduced by an amount that varies according to the filter density. To prevent underexposure, either the aperture must be opened or the shutter duration must be extended by an amount defined by the instructions packed with the filter. The nominal amount of increase is called the *filter factor.* No compensation is required for filters if your reading is made with a TTL meter, since it automatically

compensates for light loss.

Polarizer factor. Like filters, a polarizer reduces light intensity in the process of doing its job. The nominal factor is *four,* which means you must increase the aperture by two stops or multiply the time by four. Particular cases may require a change of plus or minus a stop, depending on subject reflectance.

Lens transmission. Because of the many air-to-glass interfaces of a complex lens, reflection and absorption may reduce the amount of light reaching the film. Modern multi-coated lenses transmit more than 90 percent of the incoming light, and so do not require compensation. But older, uncoated or single-coated lenses may cause a one-third to two-thirds stop loss, which you must account for in calculations.

Lens extension. The exposure suggested by any meter is based on the assumption that the lens is focused on infinity. When close-up focusing is performed by extending the lens away from the film—as it is when *not* using a supplementary close-up lens—the effective intensity of illumination at the film plane diminishes. If you don't counteract that by opening the aperture or increasing the shutter speed, your film will be underexposed. TTL meters automatically compensate for that effect, so that no additional increase beyond the direct meter reading is needed; but if you use a handheld meter, you must calculate the required increase.

A moment's reflection may well make you wonder what causes such a "light loss." According to Albert Einstein, no energy can simply disappear into the nether regions; so where does the light go? The answer lies in the Inverse Square Law, discovered by Sir Isaac Newton, and it perfectly describes the situation created by a lens "projecting" a circular image toward the film plane.

Table 7.2
Change in Exposure from Incident Meter Readings

Overall Subject Value	B&W Film	Color Transparency
Average (18% Reflectance)	None	None
Moderately Dark	+ ½ Stop	+ ½ Stop
Very Dark	+ 1½ Stops	+ 1½ Stops
Moderately Light	None	− ¼ Stop
Very Light	− ½ Stop	− ½ Stop

Table 7.3
Change in Exposure from Reflective Meter Readings

Overall Subject Value	B&W Film	Color Transparency
Average (18% Reflective)	None	None
Moderately Dark	− ½ Stop	None to − ½ Stop
Very Dark	− 1 Stop	− ½ to − 1 Stop
Moderately Light	+ 1 Stop	+ ¼ to + ¾ Stop
Very Light	+ 2 Stops	+ 1 to + 1½ Stops

As you extend the lens for a close-up, the image circle grows larger. Since the total light energy projected is constant throughout this growth, the energy becomes distributed over an increasingly larger area at the film plane. And because the film remains a constant size, it necessarily crops or cuts off a decreasing portion of the growing image circle. Consequently, the film receives only a fraction of the total light energy. In other words, no energy is lost; your film only gets a small part of the total when you extend the lens for close-ups.

Loss of intensity actually begins immediately, as the lens is shifted from infinity focus, but the loss is not usually discernible in processed film until the plane of focus in subject space is roughly ten times the focal length of the lens. Here, underexposure of about a quarter-stop occurs—an inconsequential amount in black-and-white work, but a significant one in color. And by the time the in-camera magnification reaches half-life-size, underexposure is already one full stop. The problem, then, is to know exactly how much to increase exposure at each reproduction ratio.

There are several methods for determining this factor. Close-up formulas involve more math than is entertaining, and the magnification-comparison method is a nuisance to perform with small- and medium-format cameras. An easy and fairly accurate way to determine the extent of exposure increase needed is to use the calculator dial in the *Kodak Professional Guide*. With it, you can also estimate the subject field seen by each lens and format combination at any reproduction ratio.

Appendix 5 includes a table for using the lens-extension measurement method of computing exposures for close-ups.

Shutter speeds. Faulty shutters that give imprecise times should be repaired, or they will cause trouble.

Have a competent repair person check your shutters at least annually, and at all additional times after your camera is subjected to dust. Shutters thrive with use, but not abuse; if neglected for long periods, they become sluggish. Every month or so, fire your unloaded camera several times at all speeds, to keep it peppy. Between-the-lens shutters should be stored untensioned. Focal plane shutters can be left cocked or not, since in either position one curtain will always be under tension.

Reciprocity Effects

When the exposure duration is abnormally short or long, film does not accumulate all subject tonal values in correct proportion. This phenomenon is in direct violation of the Law of Reciprocity (E = I x T), which implies that as long as the *total* exposure accumulated on film is ideal (for a given film's ISO speed), it does not matter how short or long the shutter speed is.

For most films, exposures longer than 1/10 of a second or shorter than 1/1000 of a second will alter image contrast because highlight and shadow values accumulate film density at varying rates. In addition, the color balance in transparencies will shift perceptibly. These "reciprocity effects" can be eliminated by altering normal exposure and/or development to correct the contrast in black-and-white photography and by using the appropriate CC filter to correct the color in transparency work.

Exposure times of 1/1000 of a second or less are often produced by electronic flash. If your flash fires at about this duration, expose black-and-white film in the normal way, but extend development time by 10 percent. That will check suppressed contrast. Any color shifts due to reciprocity with strobe will be corrected automatically when making the Standard Color Test.

In studio and gallery photography with tungsten sources, it is common to have 35mm exposures between 1/8 of a second and 4 seconds; with 8 x 10 format, the range may be from 5 seconds to 60 seconds, depending on lens extension and aperture, as well as on light level.

What causes reciprocity departure at long shutter speeds?

As the times exceed one second, image contrast increases because the highlight tones in the subject build film image density at a faster rate than shadow tones do. In effect, the deepest shadows begin to fall below the film's threshold of sensitivity. At very long exposure times (30 seconds or longer) even middle tones in the subject begin to fall behind the highlight tones in the race to forge image density. You can induce a similar effect in your vision by squinting at a scene: notice how shadow detail disappears. When the light intensity at the film becomes extremely weak, causing calculated exposure times of 60 minutes or more, highlight tones may not even register on film; and, as far as the film is concerned, it is dark in the studio—even though the shutter is open. It is like trying to fill a tub with a trickle of water while the drain is open, and is *not* a situation I have ever encountered when photographing art, since exposures are typically *much* shorter than sixty minutes!

This effect can be counteracted in black-and-white photography in two steps: first, *increase* the exposure, either by opening the aperture or by extending duration. This has the effect of letting the shadow values in the image "catch up" to the highlights in forming density. Second, *decrease* the development if you increase the shutter speed, so that film highlight tones do not form a "bulletproof" density of silver. This suppression of contrast by *overexposure and underdevelopment* is putting to work

Figure 7.10

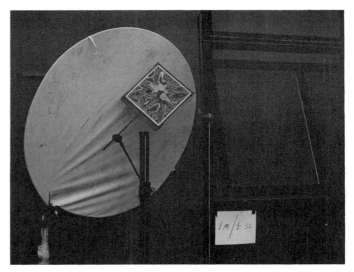

Figure 7.11

Figure 7.12

Figs. 7.10, 7.11, and 7.12. *I assembled the unlikely group of objects in these three photographs to illustrate the increase of contrast due to loss of shadow detail incurred with very long exposure ("reciprocity failure"). Each of the three sheets of film was exposed at an aperture/shutter speed combination calculated to yield an equivalent total exposure. All films were processed and printed identically on Grade 2 paper, with no darkroom manipulation.*

the adage "Expose for the shadows and develop for the highlights."

For precise exposure and processing data, refer to Appendix 5, which has a Reciprocity Time and Development Scale for revising procedures with long exposure times.

Long exposure time with color transparency film does not, in my experience, increase contrast nearly so much as with black-and-white film. Even so, you would be wise to avoid long exposures when possible by using bright, full illumination and the largest practical aperture. Keep times within a range of plus or minus two stops of your exposure time used for the Standard Color Test, and color and contrast will be predictable. If you try to use the overexpose/underdevelop technique with color film, color balance will go askew.

Rarely, a combination of factors will cause an interminably long exposure of several minutes. At such a time, it may prove sensible to sacrifice depth of field slightly, open the aperture by one stop, and recalculate. The new time will be much briefer.

Film development (black-and-white). High-energy (vigorous) developers maximize film speed and heighten contrast, while low-energy and "fine-grain" developers lower contrast and grain, but may reduce effective film speed. Consistent, gentle agitation and even temperature control are critical to predictable results. Stick with a general-purpose, long-lasting developer that gives a normal processing time of seven minutes or longer. If you need to underdevelop, a reduced time will not be so short that uniformity in development or accuracy in timing are sacrificed.

A

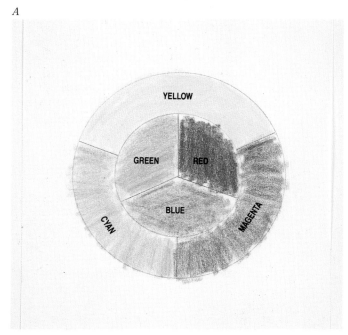

B

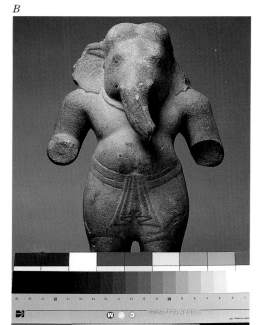

C

D

E

F

PLATE 2

EL GRECO: *VIEW OF TOLEDO. Plate 2 was shot at the same time as the black-and-white photograph of El Greco's Toledo—figure 11.8, in chapter 11. The black-and-white shot was made to illustrate some of the exposure problems photographers must consider in shooting most dark oil paintings, predominantly the necessity to interpret the painting's colors in terms of gray values, which can result in great loss of shadow detail unless exposure is increased. For the black-and-white, I increased exposure by about one full stop over the incident meter reading and reduced development time by about 10 percent. For the color transparency in Plate 2, I used the same standard four-light copy set that I had used for the black-and-white shot, but bracketed exposures in increments of ⅓-stops to insure that one shot had important tones present at each end of the brightness spectrum.*

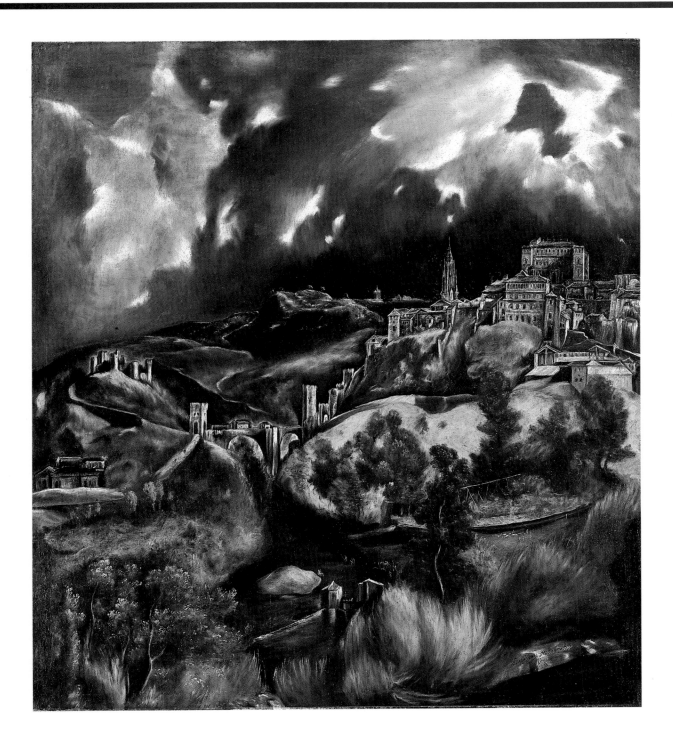

PLATE 3
METALWORK—SILVER: *BUST OF SASANIAN KING, SHAPUR II (?).* Although the curatorial preference for background colors largely limits a photographer to neutral and muted hues, I chose a dynamic red paper for a poster "beauty shot" of this life-sized silver head. This delicate artifact's mount was an expanding jig inside the crown, which was attached to a hollow rod extending below the neck for insertion into a heavy base (which I did not use). I slipped this rod over a ⅝-inch lightstand spud, taped it securely, and wrapped red paper around it to facilitate retouching. With the paper taped to a wall, I moved the subject six feet away to avoid red reflections in the silver, and then framed the image to estimate where to build the paper tent to photograph it in. I erected four stands and two poles, draped white seamless paper over them, and hung a separate sheet of seamless in front of the lens, which looked through a hole cut in this sheet. Then I set up four Omni-lights on stands, returned the object to the set, and proceeded to light it. Any change in lighting direction and intensity modified King Shapur's expression.

PLATE 4
FRANCIA: *MADONNA AND CHILD.* The upper right half of this painting was given a single, normal exposure, while the lower left half was given the same exposure plus a flash exposure to white paper for reduction of contrast. The flash exposure was made at three stops less than the main exposure, for a duration equivalent to 20 percent of the main exposure. An excessively long flash exposure was chosen to emphasize the effect: note that shadow areas are affected much more than highlight areas. Also, the subject matter selected shows the unacceptable "fog" that flashing causes in paintings with broad masses of very dark color.

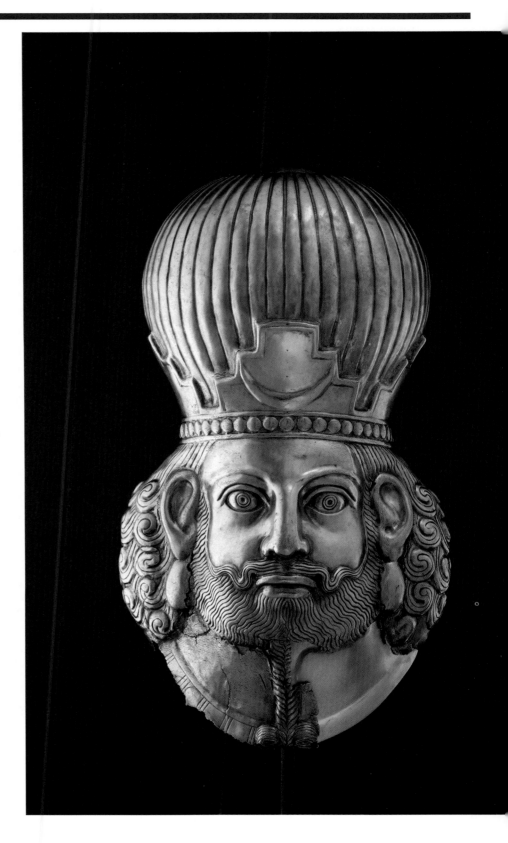

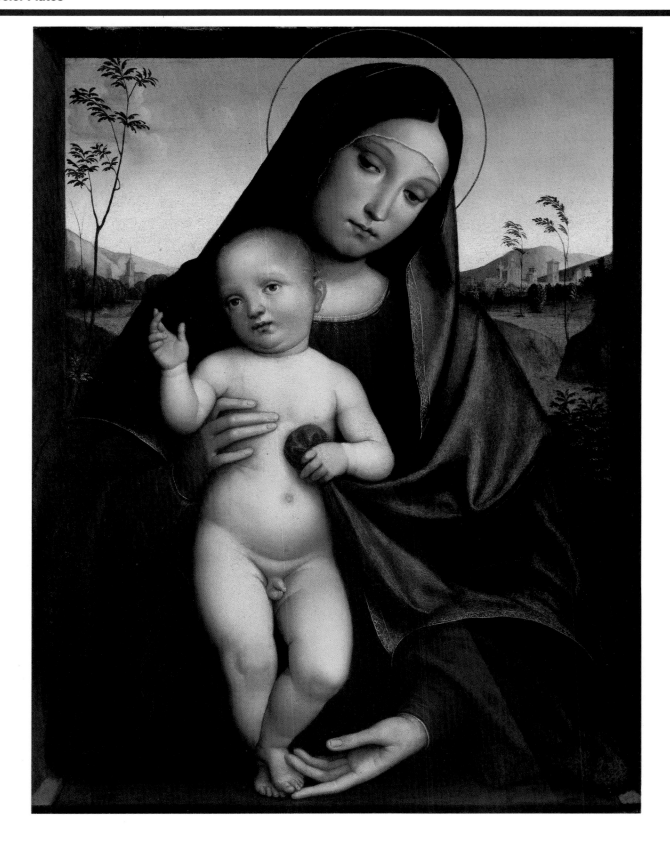

PLATE 5
VAN GOGH: *SUNFLOWERS (2 views).*
These two shots reveal the latitude of
interpretation possible in lighting
paintings. Photo A, made by Malcolm
Varon, was lit by one raking light from
camera right, to accentuate impasto.
Specular highlights on the peaks of
pigment were muted by soaking the
processed transparency in a special
solution. Photo B, by me, was made by
placing the painting on its right end on
an easel, lighting it from camera right,
"above" the work, with two 500-watt
lamps, and from camera left, "below"
the work, with one 500-watt lamp.
This 2:1 ratio kept the colors vibrant
and open, while retaining a hint of
impasto. Also, the glistening highlights
were left intact for sparkle, since they
did not interfere with legibility. The
slight difference in color balance
between the two photos was caused by
each photographer's filtration of two
different emulsions, based on
individual judgment. To choose the
"better" photograph, one would have to
judge them in comparison to the
painting, under ideal illumination.

A

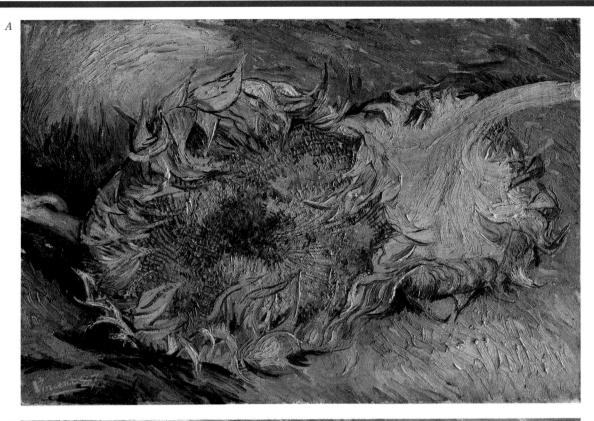

B

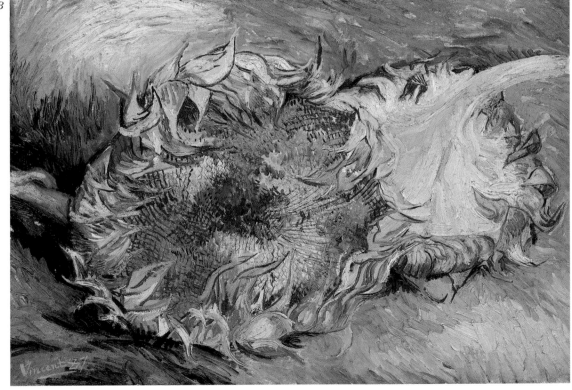

PLATE 6

LABINO: *EMERGENCE IN POLYCHROME* (Prints 6-A and 6-B). Since the early 1960s, when newly created chemical formulas put glassmaking within easy reach of artists with relatively modest means, the forms of glass have reflected the radical and fertile imaginations of artisans working with it. The novelty in these works demands that a photographer documenting new glass respond with an experimenting attitude, fresh vision, and technical skill. Prints 6-A and 6-B are two interpretations of Emergence in Polychrome, *by Dominick Labino, a pioneer in chemical research and glass artistry. My discovery of this art object's schizophrenic nature was quite accidental, when I put the glass on a sheet of white paper and played with the art by shining lights from various directions. In the first version, I top-lighted the art with a raw snooted dinky from a point just behind the subject plane. Since no light hit the paper directly behind it, the object loomed mysteriously against black, its inner core boiling with clashing lavenders, greens, and oranges. To separate the object incisively from the background and accent a sense of upward thrust, I edge-lit the subject with two additional dinkies, one at each side of the table just behind the subject plane. Putting these luminaires at a point an inch or two* below the table surface *and aiming them upward at the art let the lights add the brilliant streaks at the edges of the glass without causing the art to cast additional shadows on the background. This ingenious technique I learned from photographer Lee Boltin, a master at creating dynamic images of works of art. The technique works for any medium one might wish to illuminate with multiple primary sources without making several shadows that upset*

graphic harmony in a photograph. For print B, I moved the overhead dinky toward the camera, aiming it directly downward at the glass—note the change in the shadow; but, in addition, I added another dinky to a second boom over the art and aimed that one at the paper behind the subject, causing an intense white backlight that transformed the colors of the glass into the pure blues and purples reminiscent of a lotus blossom. Which version is "right"? Both are.

WINSLOW HOMER: *TAKING ON WET PROVISIONS (Print 6-C). Most watercolors do not require extraordinary treatment in lighting, but the paler ones usually reproduce better in color when they are* slightly underexposed. *The Winslow Homer sailboat in Plate 6 is a typical case in point. The gray scale and color bars included in this reproduction would, for a "normal" exposure to a subject of "average" reflectance, look like the originals in color and density. But here the colors are muted because of underexposure of about ⅓-stop. The tip-off is in the gray scale: the white square is not quite pure, and the last two dark tones are of equal density. The increased density of this transparency gives the printer more saturated color to work with than a pale, washed-out transparency would. What you see here, however, is about the limit for usable underexposure. Anything darker would begin to "muddy" the painting's colors irrevocably.* A note of warning: *Often, deliberate underexposure causes a noticeable color shift—usually toward green-cyan—that can be corrected by a filter of complementary color. If that happens, you may be underexposing too much. Sometimes, watercolors exhibit a gross peculiarity when one color—sky-blue, for instance, or grass-green—abandons all sense of cooperation and turns an altogether different color because of fluorescence. When that happens, vigorous measures must be taken to combat this curious turn. See Chapter 6, "UV and IR Barrier Filters" and "Factors Affecting Color Balance."*

A

B

C

PLATE 7

GLASSWARE: *TIFFANY GLASS GROUP.*
*Glass has fascinated people for
centuries. The vast array of shapes,
colors, and functions of glass presents
unique challenges to photographers
because in addition to showing an
object's form and details, the
photographic image must convey to the
viewer a sense of* glassiness. *Glass
plays with light as no other medium
does (remember your lens?), and in
such diverse ways that, if you shoot
much glass, your repertoire of lighting
solutions must be large for you to
respond with speed and skill. The
simplest way to photograph many kinds
of transparent and translucent objects
is to use a formed acrylic plastic table
that has a permanent, gentle curve
sweeping upward behind the subject.
You could force a thin, flat sheet of
plastic into a curved position and
clamp it to a jig, but it would be as
taut and as dangerous as a drawn
bow. For the Tiffany group in Plate 7,
I used a commercially made acrylic
table and a fairly standard lighting
arrangement. First, I put a 500-watt
focusing Fresnel, adjusted to a medium
flood, under the table and aimed it
straight upward. Next, I clamped two
poles between two pairs of stands
placed around the table and clamped a
28-by-42-inch silver card to the poles in
a horizontal position, for fill light
reflected from above the objects.
Finally, I moved the art—one piece at
a time—to the table. I picked a high
point of view to show the open rims of
the taller objects, set the view camera
back vertically, and lowered the lens-
board to center the subjects without
convergence. For a 35mm slide, I chose
a 105mm lens to minimize
convergence. The arrangement of the
glass artifacts was a collaborative
effort. Such complicated shots of groups
require thought and careful observation
to work out problems of lighting, depth
of field, and size relationship. The
aesthetic and curatorial challenges of
group shots are greater than with
single-object shots, since overlapping
may occur among the several subjects
in a group shot, hiding significant
parts of some objects, while the
tensions and balances of the
compositional components affect the
viewer's eye. Because the contrast ratio
was so great between the tops and
bottoms of the glass subjects in Plate
7, the exposure was critical. I followed
the incident meter's advice as I held it
facing the camera at the bottom of the
subject field, and bracketed by one-
third-stop increments over and under
the reading. Alas, the darker two
exposures were useless, telling me to
position the meter, next time, at the* top
of the subject field.

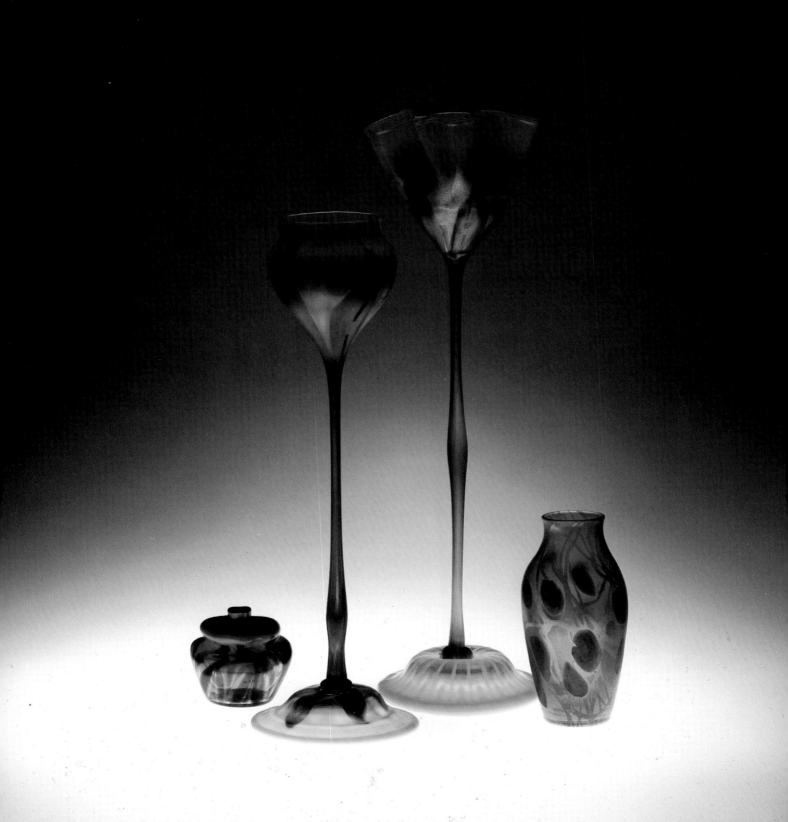

A

B

C

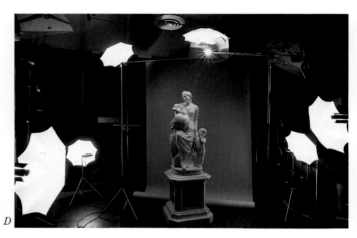

D

PLATE 8

SARRAZIN: *LEDA AND THE SWAN. The eight prints in Plate 8 show* Leda and the Swan *as interpreted in marble by the artist, and the lighting arrangement devised by me to achieve the ultimate result in photographing it. Prints E through H present the life-size* Leda *and entourage in a main frontal view, as framed for slide presentation. Set-up prints A through D show the entire lighting arrangement used for the work. Comparison of the plates shows the way the lighting was handled. I first placed the top-light to emphasize the mood of tension and tenderness between* Leda *and her lover. Next I set the two three-quarter back lights to create an "envelope" of illumination for maximum definition of the major planes. The left source was especially important, as its position and intensity affected the expression on Leda's face. Next, I turned on all three lights and made adjustments to correct the balance and maintain a sense of voluptuousness and candor in the scene. The result was dramatic—but stark in the lower half of the object, so I added soft fill to boost the shadow areas without destroying chiaroscuro and mood in the two primary actors. Note that the two umbrellas in set-up print D are turned 180 degrees from normal position, a configuration that allowed me to brighten the lower half of the sculpture without disturbing the modeling on the top half. The final lighting effect is shown in print H, which also exhibits a peculiar color shift. The slide film for this print was taken from the refrigerator and directly loaded into the camera without proper warm-up time, because I had run out of film. One point of concern to the curator for whom I was photographing this work was that* Leda *be lighted so that her repaired nose would not be obvious to the casual viewer. To have achieved that would have required such drastic changes in lighting and set-up that, although the result might have shown an apparently perfect nose, it would have sacrificed the drama and data in the rest of the sculpture. We decided to keep the drama and let the repaired nose be evident—as part of the data—if it must.*

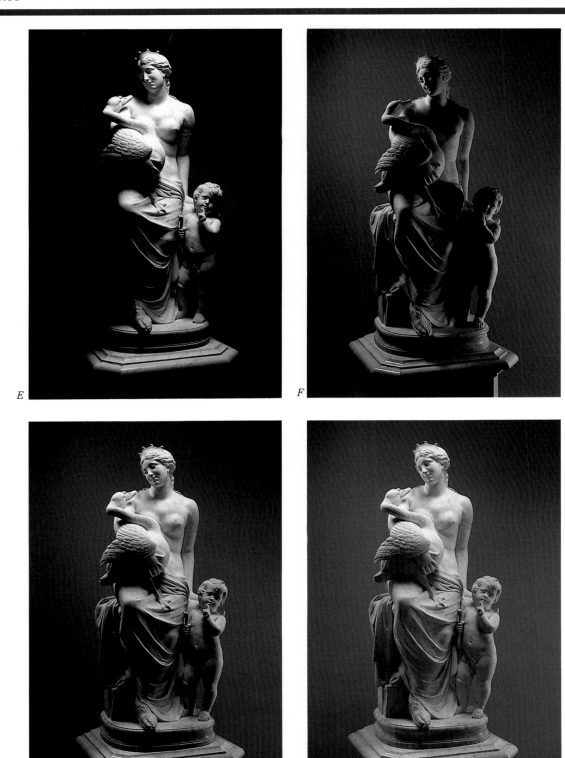

E

F

G

H

PLATE 9

*HEAD FROM A STATUE: KING AYE
(?). If photography is to depict a unique
characteristic of an object, the lighting
must be tailored for the clearest
possible communication. This often
creates unorthodox results, and the
photographs produced are often useless
for general needs. That was the
situation when I made the series of
color slides appearing as prints A
through F in Plate 9. The art
photographed was an Egyptian head,
and the work was done for Dr.
Bernard von Bothmer, former
chairman of the Brooklyn Museum's
Egyptian Art Department. The
photographs were to illustrate von
Bothmer's theory about the style of
carving. By using a high-contrast
lighting arrangement, with absolutely
no fill for shadows, I was able to
emphasize the unusually deep modeling
of the subject's cheeks and mouth. For
each camera perspective, I made two
shots, lighting the head from different
directions to show the contours on both
cheeks. Lighting throughout was a
single Tota-light/umbrella, placed five
feet above the head, near or behind the
subject plane. Metering the
backlighting was imprecise, so I
bracketed—plus-one stop and minus-
two stops, by half-stop increments—
around the reading obtained from an
incident meter placed at the nose, with
the integrating sphere turned halfway
between the light and the camera.*

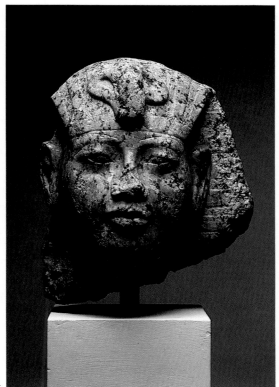

A

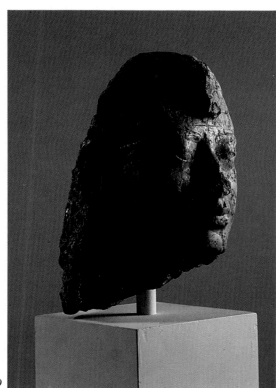

D

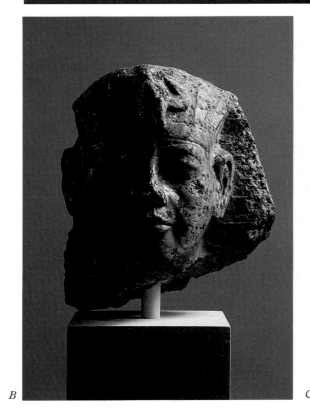

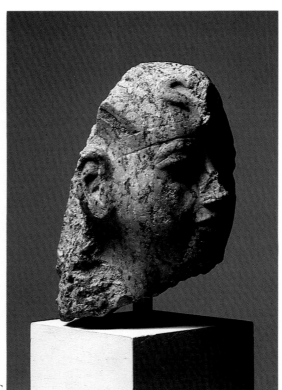

B

C

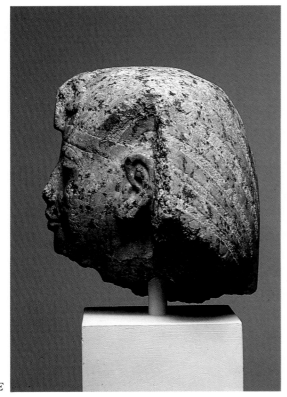

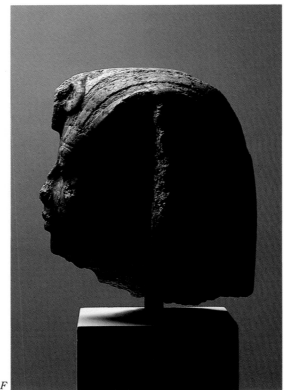

E

F

PLATE 10
TEXTILES: PATCHWORK QUILT. *The depth and texture of embossed prints and tufted textiles—such as Plate 10's Southern Appalachian quilt, made by my grandmother Pocahontas Sells— are revealed when the work is lit with directional or raking light, as is done here. With a 35mm camera mounted on a tripod side-arm, I shot this detail, using one umbrella source, set at about a 30-degree angle with respect to the art, as the quilt lay on my living room floor. When only one light is used, intensity falls off across the field of illumination, unless the source is several feet away. To modulate the degree of crispness to texture, raise or lower the light and experiment with a white card reflector on the shadow side of the subject.*

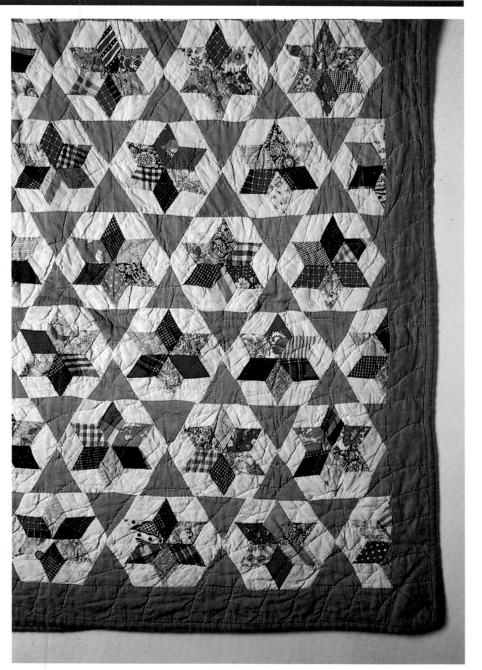

Plate 12

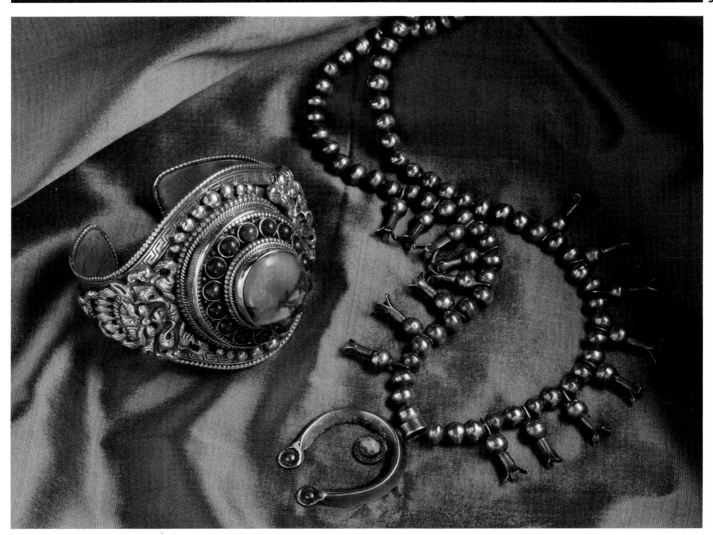

PLATE 11
ORNAMENT: TIBETAN JEWELRY. *When illustrating several groups of Oriental jewelry, I used both a variety of fabrics and slabs of marble for backgrounds. The series of photographs was made using a single Omni-light aimed through a sheet of 100% rag drafting paper suspended between two stands. This inexpensive method yields a colorless light, the quality of which can be adjusted from fairly harsh to very soft by adjusting the spotting focus. (Just be careful not to scorch the paper!) A black card at camera right caused a shadow that enhanced the mood of opulence, while a shiny silver card camera left added sparkle to the bracelet.*

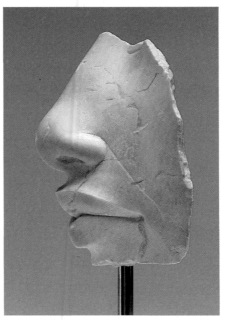

Plate 10

PLATE 12
SCULPTURE: *FRAGMENT OF ROYAL
HEAD. Scale in photographs of art is
often impossible to show. This
limestone facial fragment from a head
thought to represent Akhenaton was
actually about three-and-a-half inches
high, but it could easily be mistaken
here for a monolithic fragment. This
image of it was made both as a "beauty
shot," for a postcard, to convey the
masterful, sensual carving, and as a
curatorial lecture slide, to show the
stylistic points relating this work to
others of the same period. I have
included it here to illustrate that
successful images can be made with
minimum equipment. A single Omni-
light/umbrella source was placed above
the art for modeling the subject's
contours, and a dull silver card at
camera left provided fill. Patience and
a delicate touch are required when
positioning illuminants, because a
minute change in placement causes a
substantial shift in values and mood.*

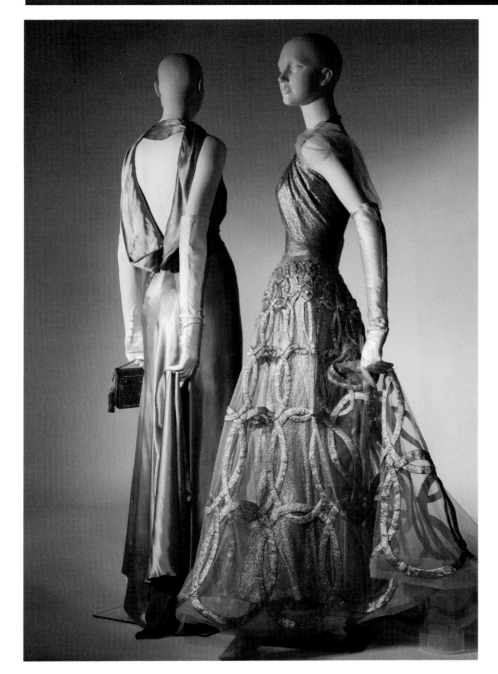

PLATE 13

COSTUMES. *These dresses from the 1930s, designed by Madeleine Vionnet, were arranged to show the most unique features of each. An important goal was to create a mood appropriate to the elegant styles, and this was achieved through the careful positioning of the mannequins' heads, arms, and hands. Lighting was from a large softlight at camera left, which was flagged by black cards to prevent excess light on the heads, the bottoms of the dresses, and the background. A large white card at camera right gave fill light to the lower part of the dress at right, which was once owned by the Duchess of Windsor. Because the white background was to have a caption surprinted on the left area, the mannequins stood about twelve feet in front of the extra-wide seamless, so that the mainlight did not spill onto it. Two dinky spotlights, diffused with window screen, were aimed at the background to give a smooth, feathered glow on the right, which enhanced depth.*

PLATE 14

TAWNEY: *UNTITLED (Prints 14-A and 14-B) and* MARIONI: *GOOSE BEAK PITCHER, (Prints 14-C and 14-D). The flag textile by Tawney was hanging in a gallery only a foot from the gray wall. Consequently, the shadow was disconcerting. Had there been a separation of six feet or more between the flag and the wall, I could have lit the wall separately, making it white, thereby avoiding a shadow and making the supports disappear. The curator asked for a reshoot, which I did against black paper for a cleaner silhouette. Marioni's red vase shows what happens when shooting a highly reflective object against a light background: the paper makes a peculiar shape in the lower third of the vase. Apart from building a white tent completely around the object to make all reflections similar (a very time-consuming proposition), nothing can be done to hide such reflections. Remembering the earlier problem with the flag (previous page), I shot a second version on the spot, against black, to give the curator a choice. The rectangular highlight is from a strobe softlight, and seems natural to me, although some people object to such things. You can possibly improve such a highlight using tungsten lamps and a long exposure, during which you (or an assistant) move the light slowly for a feathered, elongated highlight. However, you should shoot several exposures to insure getting the ideal highlight and overall balance.*

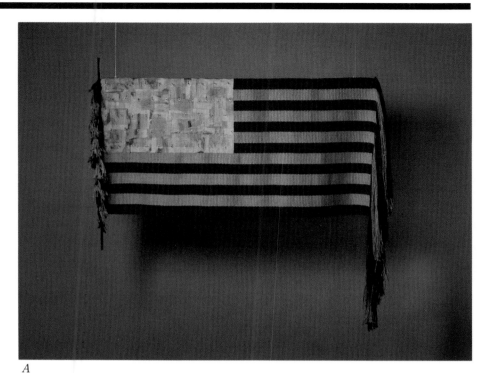

A

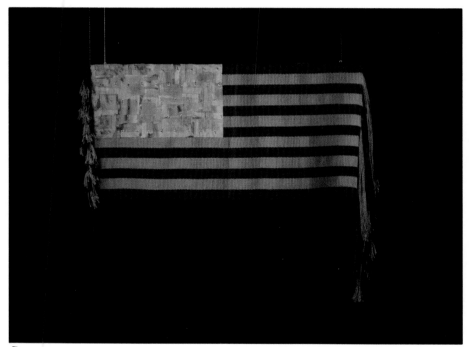

B

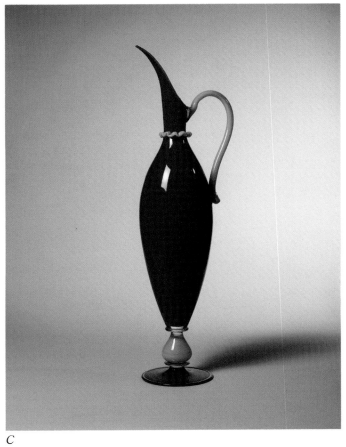

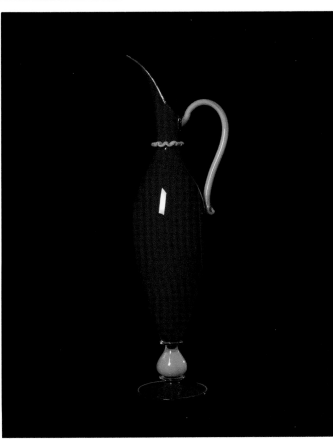

C

D

PLATE 15

SCULPTURE: JADE MASK. *The fellow of ominous appearance in Plate 15 might well be a successful artist's idea of the quintessential tax collector. Actually, the work is a jade ritual mask of the eight century B.C., from the Olmec culture in Central America. In keeping with the mood of intense, terrifying power projected by this elemental face, I tried to photograph it in a manner that underscored its awesome aspect while retaining enough surface data to keep any art historian satisfied.*

Because this heavy piece of art arrived at the studio with no mount, I had two choices for supporting it. First, I could use a tabletop set, although, if I did, the mask would then rest its chin on the background as it sat propped up from behind. Were I to use a light-toned paper, the intended mood would be lost; were I to use a dark one, the chin's outline would be lost in shadow. Second, I could shoot down *at the mask as it floated against black, a set that would allow me freedom to light for separation* and *mood. I chose the latter approach and raised the mask off the black paper onto an eight-inch, felt-covered brick. I aimed a 1500-watt focusing Fresnel, diffused with tracing paper, from "above" the mask from a distance of six feet, and tilted the light so that its beam trajectory was fifteen degrees with respect to the plane of the mask. That angle let light spill into the eye sockets, to show they were not hollow. I fine-tuned this source by moving the diffuser in the beam so that some direct light reflected off silver cards surrounding the mask, for defining the outline, cheeks, lower lip, and nostrils. Finally, I put a gobo between the diffuser and the mask, to block light from the background to keep it black. See figure 11.51 for the lighting diagram for this mask.*

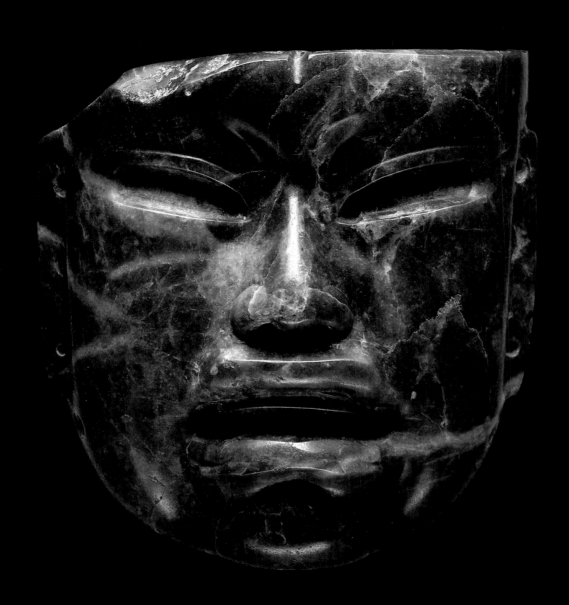

PLATE 16

DINHOFER: *COLLECTIONS (Print 16-A)
and* TOOKER: *THE SUBWAY (Print 16-
B). Both paintings on this page
required special treatment in lighting
for different reasons.* Collections *by
Dinhofer was lit by bouncing two Tota-
lights from the left ceiling to give a
gentle wash of light from above, as
supplement to two Totas placed on each
side of the painting. Because the
ceiling was not pure white, the
resultant yellowish cast seen here had
to be canceled by using a CC05 Blue
filter. The subway scene by Tooker
could not be removed from its frame,
so the lights had to be put closer to the
camera axis than normal to prevent
shadows cast by the frame from
obscuring the art. Fortunately, the
frame was not too deep, nor was the
painting highly varnished. When a deep
frame causes shadows on the art, follow
the technique outlined on page 151.*

A

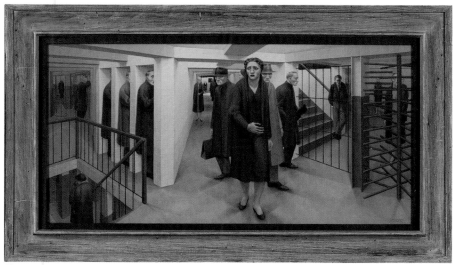

B

A

PLATE 17

CRIBBS: *FEMALI (Print 17-A)* and DEHNER: *COUPLE (Print 17-B). The mixed media sculpture* Femali *by Cribbs presented only one mildly difficult problem: the shininess of the copper medallions, which twisted in the breeze of the gallery air-conditioning. When the copper pieces turned away completely from the large softlight at camera right, they became too dark to read; when they turned completely into the light, they "blew out" featureless. A dim, diffused spotlight from camera left opened the shadow on the background. Both objects on this page were turned slightly from head on to show depth. For Dehner's corten steel sculpture, one medium-size strobe softlight was the only light needed. Since the object was of uniform color, I introduced contrast by letting the shadow side go nearly black, the only fill being a slight reflection from the adjacent light gray wall. When shooting in galleries, as was done here, be aware of the color of nearby walls or other art that may reflect unwanted into your subject. Shooting color film with strobe in such situations is ideal, as it overpowers tungsten gallery lights should they need to be on for other people's use.*

B

PLATE 18

TEXTILES: COURT ROBE OF THE
EMPRESS DOWAGER T'ZU HSI. *The robe
in Plate 18 dates from the Chinese
Manchu Dynasty and is one of many I
shot for an exhibition catalog as they
hung individually from a dowel in a
storeroom whose dimensions created
rigorous demands on my composing
and lighting. As I imagined the
catalog, each robe would float on a
uniform sea of color, which meant
hanging the subject some ten feet in
front of the seamless paper
background, to prevent shadows. The
subject illumination was provided by
three Tota-lights in umbrellas—one on
a boom above the robe, and two more
on each side—to give as broad and soft
a light as possible from close range. I
placed two more identical sources just
behind the subject plane for lighting the
paper. Because the room was so
narrow, I used a long focal length lens
to ensure that its narrow angle of view
was filled with background. (A lens of
shorter focal length, with a wider angle
of view, would have included the side
walls.) Because the lights were so close
to the optical axis, I shielded the lens
by cutting a rectangular hole, slightly
larger than the 8 x 10″ format, in a
2′-square black cardboard suspended
between two stands. Positioning of this
gobo was critical, since misalignment
could cause image cut-off or a light-
struck lens. A final task was to tape
cards over air-conditioning vents, to
prevent the garment from billowing in
the air currents during the twenty-
second exposure. I encountered no
special color problems here, but certain
modern fabrics and dyes are of a
chemical profile that causes radical,
uncontrollable color shifts: see Kodak
Data Release E-73, "Why a Color May
Not Reproduce Correctly." Lighting
plan for this robe is shown in figure
11.25.*

Plate 19

PLATE 19
FURNITURE: ENGLISH CABINET.
Floridly decorated with marquetry, this stately English cabinet on a stand had a secret panel visible only from the frontal view when the doors were open. The photograph's high color saturation and clarity of grain were products of the direct 1500-watt focusing Fresnel, hung ten feet high on a heavy-duty boom set about three feet forward of the subject at a one-o'clock position. This provided minimal shadows on the subject's face, but ample modeling to define overhang of lips. Had the light been closer to the subject plane, less glare would have resulted, but the amount of glare seen here lends a waxiness to the surface while adding sparkle without obliterating important features. The Fresnel's beam was flooded, for even illumination, and I bounced fill light from two raw Tota-lights aimed at white sheets of paper at camera left to lighten the cabinet legs. A snooted dinky near the lens axis poked light into the secret compartment. Two more Totas with umbrellas, set behind the subject plane and aimed at the background for a uniform surround, softened the cabinet's shadow. In this photograph, the mixture of different types of light sources did not cause color balance problems. Figure 11.84 is a lighting diagram for this object.

PLATE 20
KENDRICK: *RED, YELLOW, BLUE.*
Kendrick's Red, Yellow, Blue *was
complex in terms of planar reflectances
and color contrast, and was difficult to
light. One of a series of maquettes shot
for a catalog, the work had to fall into
a rather disciplined lighting
interpretation based on the desire to
convey power, motion, angularity, and
sharpness. These ideas were not very
hard to show, since they were in the
works, and could be had by using a
small softbox set some 75 degrees from
the lens axis for strong sidelighting. It
was difficult to fill shadows, so I used
small, weak spots and silver cards with
light strong enough to register color
accurately on film, but discreet enough
not to destroy the graphic impact.*

PLATE 21
MICHAEL C. ROCKEFELLER WING OF PRIMITIVE ART, METROPOLITAN MUSEUM OF ART. *The view shown in prints A through D of the Rockefeller Wing at the Metropolitan was selected for the cover of the museum's 1982 annual report. The goal was to choose a viewpoint and lighting that best displayed the collection and its new home, recently opened to the public. Among the many photographic problems to solve, in making these shots, was dealing with the mixture of three different light sources: daylight coming through the glass wall and ceiling; tungsten spotlights aimed at the art; and fluorescent case lights. The widely different color temperatures of these sources called for experimentation and tricky timing of exposure, so that the art would look naturalistic and the architecture imposing. I chose Ektachrome Type B film, since its color temperature closely matched the spotlights on the art. All told, I shot two dozen sheets of film on four occasions, to get the best balance.*

Print A was the first test, shot one hour before sunset, on an overcast day in early May. The daylight, given a peculiar color cast by the building's special glass, overwhelms the tungsten spotlights. The fluorescent case lights, meanwhile, lend the scene an unearthly green cast—obviously not acceptable. Print B, a later test, was shot around sunset on a clear day a week later. Print B was a double-exposure: shot once for the twilight/spotlight combination, using no filter, while the case lights were off, and exposed once again, after dark, for the fluorescent case lights, using a CC30 M filter, while the spotlights were off. The overall balance was improved, but the designer felt that there was too much blue twilight and that the case lights—even if further filtered for a neutral color—were distracting and should be left off. Print C was exposed to the spotlights only, fifteen minutes after sunset. Here, the art looked good, but the architectural features were lost, leaving the objects isolated in a gloomy cavern. The final

version, Print D, was made a month later, in mid-June, and by then, twilight was lingering later into each evening, so that I could not use a clock to anticipate the proper moment of exposure for the best twilight/spotlight ratio of brightness. For previous tests, I had made notes that included spot-meter readings of the sky and, using them as a guide, I waited for the right light. Since the twilight was fading fast, as I began the four-minute exposure (at f/32 for depth of field) there was too little sky-light to make a second exposure on the same evening. To compose the view, I traced in grease pencil a proportional scale of the annual report cover on clear acetate, which was taped to the view camera's ground-glass. I included on film a three-quarter inch (twenty millimeter) border beyond this scale, to give the designer some leeway in cropping and trimming on the full-bleed printed image. The bottom section of the photograph was intentionally made dark for the Metropolitan logo in reverse white type.

A

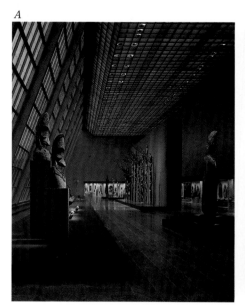

B

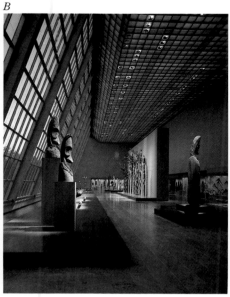

C

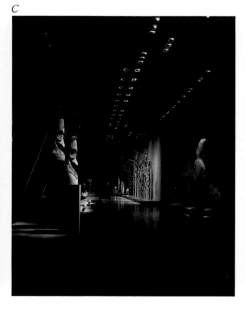

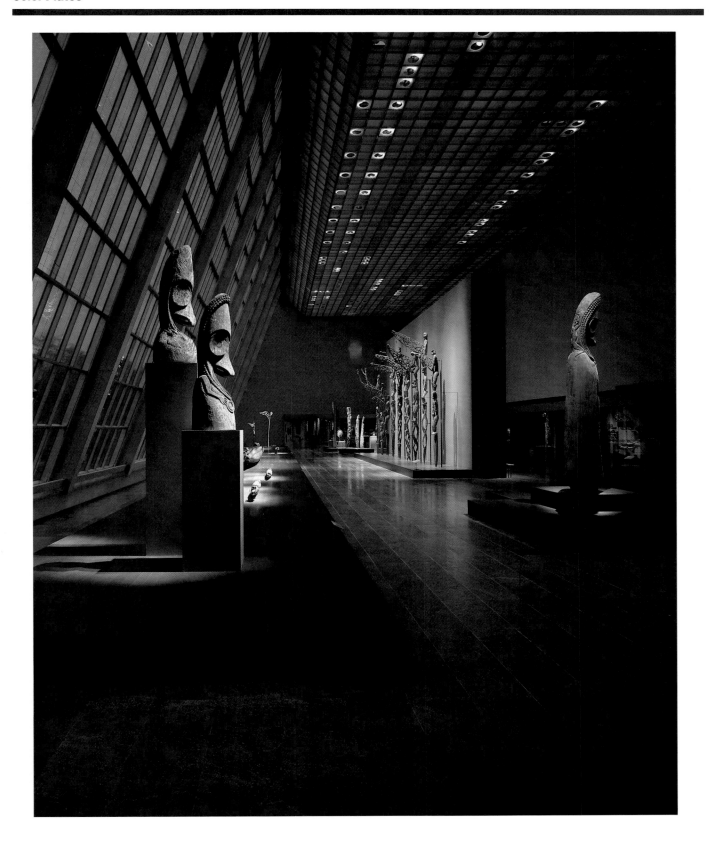

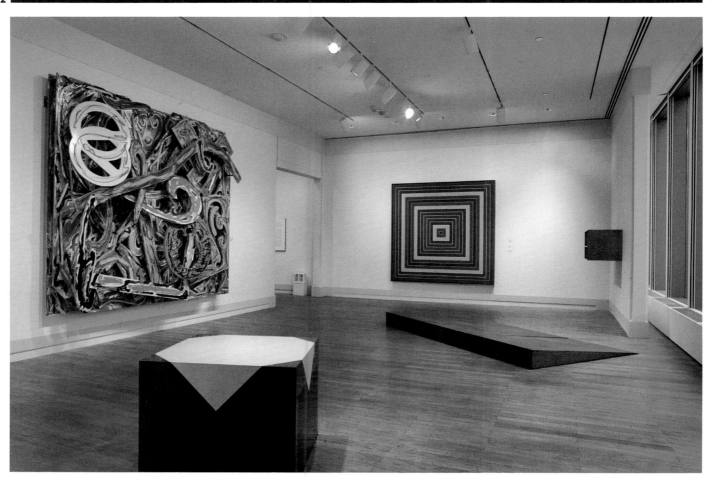

PLATE 22
INSTALLATION VIEW OF THE EXHIBITION
*EARLY/LATER: SELECTED WORKS
FROM THE PERMANENT COLLECTION
OF THE WHITNEY MUSEUM OF
AMERICAN ART.* As discussed on page
61, photographs made with mixed
lighting can look strange, because color
film is currently balanced for either
tungsten sources or daylight/strobe
sources. One might surmise that film is
flawed because of this, but I don't
agree. Most texts on color photography
state that the human eye/brain
mechanism has a mysterious ability to
"compensate" for scenes lit by mixed
color sources, as though we
automatically want to see "white" light.
This hardly seems likely. My own
theory is that we do see variances in
color sources, but usually don't have
the conscious need to register them as
such . . . until we look at color
photographs that include mixed
sources. It is easy enough to check this
out sometime when indoors: with a
tungsten light on, and daylight coming
in a nearby window, compare the color
of light sources. If you take the
tungsten lamp as white, the daylight
will look blue. If you take the daylight
as white, the tungsten lamp will look
orange. Consequently, color film is
made to work with either of the two
most prevalent sources—tungsten and
daylight/strobe—when one or the other
is taken as white. The art in this
gallery, including earlier and later
works by Artschwager, Judd, and
Stella, was lit more by the tungsten
ceiling lights than by the window light,
so I chose Ektachrome Type B Film,
and let the window light go blue (since
I couldn't do anything about it
anyway).

8
Calculating Exposures

FACTORS influencing exposure should be considered in logical order when calculating the proper aperture and shutter speed. The steps toward making such calculations follow, in sequence.

1. Make a meter reading, compensating if the light is oblique to the subject (with an incident meter) and the reflective characteristics of the subject (with either type of meter). Make sure the EI (Exposure Index) of the emulsion is set correctly on the meter.

2. Choose an aperture small enough to give adequate depth of field, but not so small as to introduce diffraction effects to the image. Note the shutter speed that the meter indicates for proper exposure at the chosen aperture. That combination is your *base exposure*.

[Users of TTL camera meters skip to step 5.]

3. If using a hand-held meter, add to the *time* any filter or polarizer factors and any factor caused by poor lens transmission.

4. Measure the lens extension (distance from center of lens to film plane) and add that factor to the time by referring to Appendix 5.

5. If shutter speed is longer than two seconds, compensate for any reciprocity factor by either extending the shutter duration or opening the lens aperture (see Appendix 5). For short times—up to five seconds—

compensate by opening the aperture a little bit, rather than by trying to increase time by a fraction. For times longer than that, extend the time accurately if a specific aperture for best depth of field must be maintained.

6. Compensate for special development (black-and-white) according to the contrast control needed: if the contrast range is to be extended, underexpose and overdevelop; if the contrast range is to be suppressed, overexpose and underdevelop. (See chapter 9 for details.)

7. Estimate a bracket of exposures (see below) and expose film. Keep notes for reference.

I always keep extensive notes (and sometimes lighting diagrams) for every color transparency shot and each tricky black-and-white shot. If I need to reshoot, then I can quickly trace the source of the problem. The notes also serve as a sourcebook for lighting solutions.

See figures 8.1, 8.2, and 8.3 for examples of exposure calculation, ranging from the simple to the sublime. I do not keep *all* notes indicated, but I have included all important factors here for illustrating the thinking process.

Bracketing Exposures

Most professional photographers of still-life subjects make several different exposures of each setup to insure a usable exposure in color.

"If so," you ask, "why bother to do such meticulous calculations? Why not just follow the meter's advice and shoot many exposures? And why not experiment with Polaroid to find the exposure?"

The main reason to calculate carefully is money; all film costs too much to burn up haphazardly. (Many photographers in the advertising field, incidentally, take pride in the large amount of film they shoot for each job. This "strength-in-numbers" approach disappears, however, on jobs where the client does not pay film costs.) There is also this consideration: if you don't begin with the discipline of these calculations, you will never develop the technical and visual skills necessary for mastery over your medium.

"If the exposure calculations are so very precise," you retort, "then why bother to bracket at all?"

Again, the reason is money: if you spend three hours lighting a complex situation, and your one exposure is too light by a half-stop, the money saved on film will be minuscule, compared to the reshoot cost. Even if that one shot *is* precisely exposed, what if it gets lost, or two people need the same image simultaneously?

```
                                        Date:  1/29/1985

Subject: Warhol pntg.: Hummingbirds in Rapture

Film: EPY 135/ Emul.: 217

EI:  40 (As tested)

Filter: CC05R

Lighting: 4 Pan lights (standard copy set)

Lens: Canon 100/4 macro

    Base Exposure: 1/2 @ f/11 (TTL meter)

    Reflectance: Average                              f/8 1/2
                                   Bracket: 1/2 sec. @ f/11
    Lens extension: Negligible                        f/11 1/2

    Reciprocity factor: Negligible
```

Figure 8.1

```
                                        Date:  1/29/1985

Subject: Egyptian Head (Green schist)

Film:  Tri-X Prof.  4x5  B&W

EI:  200 (As tested @ 1 sec.)

Filter: None

Lighting: Omni-light/umbrella + white cards

Lens: 210 Symmar-S

    Base Exposure: 4 @ f/45 (Incident meter)

    Reflectance: Dark subject--add 1/2 stop
                 exp.= 6 @ f/45
                                          Bracket: Unnecessary
    Lens Extension: 300mm = 12 @ f/45              in B&W

    Reciprocity: 21 @ f/45
```

Figure 8.2

```
Subject:  Greek Vase          Date:  1/29/1985

Film: Ekta 8 x 10  / Emul.: 782

EI:  32 (As tested @ 10 sec. with filters)

Filter:  CC05M + CC05B + Polarizer

Lighting: 6 PAR lamps w/pola-screens

Lens: 480mm Red Dot Artar

    Base Exposure: 6 @ f/64 (Incident meter)

    Reflectance: Average (after polarization)       120 sec.*
    Polarizer Factor: +2 stops = 24 @ f/64  Bracket: f/64  180 sec.*
    Lens Extension: 730mm = 56 @ f/64               270 sec.
    Reciprocity Factor: 180 sec. (3 min.)

*Bracket in time is numerically asymmetrical to account for further
reciprocity when exposing ± 1/2 stop above and below middle
exposure.
```

Figure 8.3

A sensible compromise between extravagance and miserliness—and one that accommodates human error in calculation—is to make three or four exposures of each subject shot in color. Normally, with sheet film, I shoot one exposure at the calculated settings, and one each at plus or minus one-third stop. If in doubt, I may shoot a fourth exposure for insurance, at either two-thirds plus or minus the center of the bracket—but I do not process it until the main three shots are returned from the lab. If that bracket is acceptable, I throw out the back-up shot to save processing cost.

For beginners, I'd suggest a "wider" bracket of plus or minus one stop around the calculated exposure, taken in half-stop increments, for a total of five exposures.

Contrast Control

One of the astonishing aspects of healthy vision that we take for granted is the ability to discriminate between subtle tonal values of low contrast; another is the ability to perceive fine detail in a scene encompassing a tremendous range of brightnesses. Owing to the limited nature of the photographic medium, neither aspect of human vision can be duplicated in photography.

The relatively poor resolution of films and lenses causes fine tonal distinctions in low-contrast subjects to be lost in film grain and fuzzy edges. And the relatively short contrast scale

Figs. 8.1, 8.2, and 8.3. *Concise notes taken while calculating exposure for each shot can save you time in tracking down problems, and—when they are accompanied by lighting diagrams— such notes can also serve as a fund of ideas for handling future shots. The three examples illustrate workable format and types of information to include.*

in film and paper emulsions, as well as in reproduction processes, forces detail at each end of the tonal spectrum of high-contrast subjects to be crowded into deep black and pure white. Consequently, vigorous measures are often needed to overcome these limitations so that the tones in a photograph honestly convey the sense of the art.

In making "creative" images of a nonscientific nature, photographers often employ unusual contrast control techniques for pictorial reasons—consider the later work of Bill Brandt and the nature images of Ansel Adams—so that the resulting photographs are radically different in tonality from the scene, object, or person before the camera. Many such control techniques are outlined in this chapter, but the motive for using them is somewhat modified: any enhancement of contrast in photographing works of art is commonly directed toward a representation that is aligned with the viewer's expectations. Fundamental questions concerning a work's shape, condition, style, color, medium, and texture must be answered, with no guesswork on the part of the viewer. Beyond that, there may be opportunity to make a dynamic image, through contrast manipulation, so long as those dynamics do not overwhelm the art itself.

Successful control of contrast requires the conscious unfolding of a photographic "second sight," which sees all subjects in terms of gray values, regardless of whether shooting color or black-and-white. It is not easy, and it comes only with practice and experience. Why it is necessary becomes clearer with a look at some factors affecting contrast: lighting (three-dimensional art), inherent subject contrast, exposure, development (black-and-white film), and photographic printing paper.

Contrast Control in Three-Dimensional Objects

No hard-and-fast rules for lighting three-dimensional objects need to be made, but one useful generalization is to separate conceptually those objects of inherently high contrast from those of inherently low contrast. Those works with a naturally wide range of brightnesses (including shiny metal objects) usually need a soft, broad, or omnidirectional light that acts as a counterforce to the high contrast of the art. If such objects are lit by small, sharp, directional sources, without adequate fill light, there is a multiplication of contrast beyond the recording capabilities of film.

On the other hand, a great many three-dimensional works are of one medium and—depending on the simplicity of shape—may have an inherently low contrast. When that is true, it may be relevant to introduce contrast through lighting to show form, depth, and proportion. You can do that by controlling chiaroscuro, by placing lights well away from the camera axis—toward the sides of the set or above the object—and keeping the fill light relatively weak in relation to the main light.

If either type of object has lots of modeling, convoluted bulges, appendages, depressions, or hollow spaces, these will reflect, absorb, and further modulate light and influence contrast. Analysis of an object in terms of contrast and balance requires an abstract visual sense working actively apart from, but in connection with, the scholarly information that you are trying to portray.

Plate 11, a shot of a Tibetan bracelet and ring, is an example of a complicated work of inherent high contrast, while Plate 8, a marble sculpture of *Leda and the Swan*, is an example of a complex work of inherent low contrast.

In general, black-and-white films and papers can tolerate a higher level

of contrast than color films can. When lighting for black-and-white, you don't need to fill shadows quite as much as when lighting for color; but with either material, the ratio of mainlight intensity to fill light intensity—which affects the ratio of highlight value to shadow value—must be considerably less than what you might expect. This is because film usually displays greater contrast than what you see. You may have had the disappointing experience of shooting, on color slide film, a beautifully lighted gallery object, only to find that the film interpreted the art quite starkly. In a situation like that, you must choose through exposure which portion of the subject's long-scale "brightness spectrum" is most important to record within the film's more limited brightness spectrum. An exposure great enough to show shadow detail may cause highlight areas to "burn out," or become white and featureless. Conversely, a reduced exposure suitable for rich highlight tone might cause shadow tones to be dense black. And, if the lighting is severe, even a compromise exposure midway might not successfully record both shadow and highlight tones. Rather than accept a mediocre shot, you could use a camera flash (if allowed). It would lower contrast, assure good color, and eliminate camera shake. See chapter 9, "Photographing on Location," for pointers on using camera flash.

One of the easiest ways to control contrast in black-and-white is in the printing of negatives. By choosing different printing papers, you can suppress or increase the "fixed" contrast range of a negative to salvage an imperfect exposure or fine-tune an excellent one.

Printing papers are made in two types: graded and variable-contrast. The first is packaged one grade to a box; each grade is numbered, and they range from one through five.

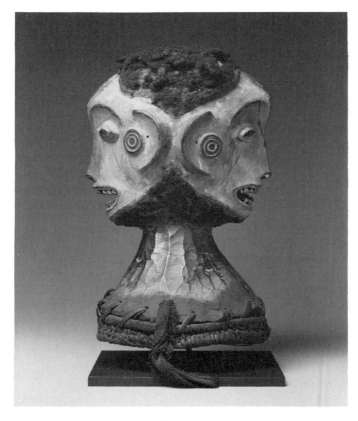

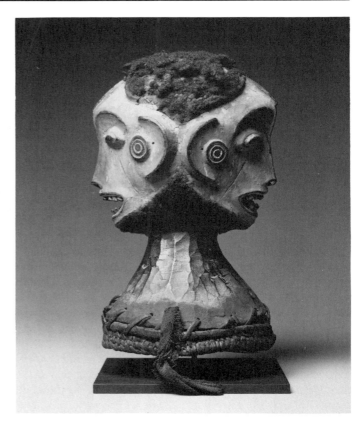

Figure 8.4

Figure 8.5

Figs. 8.4 and 8.5. *The two prints of this primitive Janus were made from negatives exposed and processed identically, then printed on paper of the same contrast grade. The only difference occurs in the lighting: the white reflector cards used for fill in figure 8.4 were removed for figure 8.5. While the stark version emits a decidedly raw and negative psychic power appropriate in an interpretive statement, it lacks the subtlety of information that makes the softer version the more useful image for a broad range of purposes.*

Printing a negative on grade one paper will lower the contrast, while printing it on grade five will increase contrast dramatically. "Normal" negatives will usually print nicely on grade two paper.

On the other hand, variable-contrast papers are manufactured with uniform characteristics, so that separate boxes for different grades are unnecessary. The variable-contrast paper has a unique emulsion that, although black-and-white, is sensitive to changes in color of the enlarging light, controlled by placing special filters over the enlarger's lens. These filters are usually numbered in the same way as the graded papers.

You would want to print on paper designed to produce a higher contrast in order to save a grossly underexposed or underdeveloped negative, increase the contrast range of a full-toned subject, or make a definite distinction between two middle-tone values in a short-scale subject. Conversely, you would print on a paper made for lower contrast to save an overdeveloped negative, or to include both subtle shadow and highlight values. Always use discretion when printing. Negatives that require the entire range of grades or filters to get good prints are signals indicating the need for more careful use of lighting, exposure, or film development.

The photographer's most effective tool in regulating the contrast of three-dimensional art is light; next in importance are exposure and development; and finally, as a means to refinement, there is the printing paper. When the first steps are secure, the last is inevitably easy.

Contrast Control in Flat Art (Advanced)

Most flat (two-dimensional) art carries an internal sense of contrast, and you can do little in lighting to

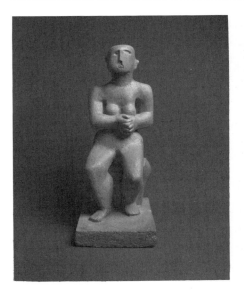

Figure 8.6

Figure 8.7

Figure 8.8

Figs. 8.6, 8.7, and 8.8. *These three photographs of a Henry Moore sculpture illustrate the wide range of interpretations made possible simply by using printing paper of various contrast grades. All three of the above photos were made from the same "normal" negative, printed on paper of contrast grades 1, 2, and 3, respectively. Choice of contrast is shaped by such objective considerations as legibility of form, separation of object from background, and ease of identification of the medium. Only after these requirements are satisfied can subjective factors such as mood be entertained when manipulating contrast.*

change that. On very large paintings with broad masses of dark area, you can increase lighting intensity locally to boost shadow detail, but that treatment is difficult. For users of small- and medium-format cameras, it is best to fall back on the printing stage to change contrast in black-and-white. However, users of large-format equipment have an advantage: they can use special manipulation of exposure and development for individual sheets of film to shift the brightness range of black-and-white work radically or subtly, as the situation demands.

For a subject of "average" contrast, use the computed normal exposure and development to print on grade two paper. You can give subjects of slightly low or high contrast normal exposure, but increase the low-contrast subjects' development by 10 percent and decrease that of the high-contrast subjects by 10 percent.

These negatives should print on grade 2 paper, also.

When the contrast in the original is very low (for example, like that of pencil on gray paper, certain textiles, pastel watercolors or oil paintings of a uniform tone) you may need to "perk up" contrast further—especially if the subject is quite dark and will be published, since dark values in publication tend to bleed into an undifferentiated mass of ink. (See figs. 8.9 and 8.10.) To keep that from happening, underexpose and overdevelop. This technique is used by photojournalists and photographers of sports and theatrical events— photographers who must shoot in dimly lit situations. The film is rated at an ISO value one to two stops faster than normal, and development· is "push-processed" to compensate for this underexposure. While such drastic techniques are useful in the photographic fields mentioned, the

resulting extreme contrast and graininess are rarely necessary or suitable for photographing works of art when using small- and medium-format film.

To make a greater increase in contrast, equivalent to roughly one contrast grade of paper, underexpose by a half-stop and extend development by 30 percent over the normal time. (For example, a ten-minute normal time would require a thirteen-minute development). That will allow you to print the negative on grade 2 paper, which usually gives a richer but more fully toned image than printing a normally exposed and normally developed negative on grade 3.

Conversely, high-contrast originals (most representational oil paintings and works with gold leaf) often require a radical suppression of contrast. To accomplish that, overexpose by one full stop and reduce development by 30 percent,

Figure 8.9

Figure 8.10

Figs. 8.9 and 8.10. *Although the print used to make figure 8.9 was an accurate representation of the tonalities and condition of the Chinese painting photographed, its reproduction here does poor justice to the painting's artistic merit. The fault is in the shortcomings of current reproduction processes. The print used to make figure 8.10 "cheats" the contrast to portray detail in publication more clearly.*

which will effect a change equivalent to one contrast grade (e.g., a ten-minute development time would be multiplied by .7 to yield a seven-minute new time). The extra exposure will allow significant shadow values to register well above the film's threshold of sensitivity, while the shorter development will reduce highlight opacities in the negative to allow enlarging light to pass through easily and register as a pale highlight tone on grade 2 paper. As before, the result is superior to a normally exposed and normally processed negative printed on contrast grade 1

paper. These suggested changes in the time from the usual timing are based on my experience, using films and developers that may differ from yours; therefore, use these observations as guides in conducting your own tests.

This method of regulating the brightness range of your films need not be confined to flat art. It works just as well for three-dimensional subjects.

Attempting this technique with color transparency film, however, is a gamble. Even though changing the timing of the first developer in color

processing will alter contrast, it will skew the color balance. Predicting the hue and degree of color shift is virtually impossible. This means that your exposure must be precise, so that the most important tones register, and that is the chief reason for bracketing exposures.

In my experience, contrast expansion with color film is rarely needed. By far, the most prevalent problem, especially when shooting paintings, is the problem of compressing the scale. Although none of them work very well, there are several tricks for compressing the

scale: use an old, uncoated lens to introduce flare; line the inner walls of the bellows with white paper; or "flash" the film. I frequently employ the last technique, for want of a better solution.

Flashing film (color)—advanced technique. Flashing with tungsten light requires double-exposing the film: once to the subject, and once to a blank sheet of paper. If you use a small- or medium-format camera, it must, of course, have double-exposure capability. First, compute the exposure for the painting in the regular way, accounting for subject reflectance, filter factors, bellows extension, and reciprocity departure. Make the exposure of the painting and keep a record of it. Remove the painting and replace it with a clean sheet of smooth white paper three feet square. Move the camera toward this paper until its image fills the viewfinder or ground-glass, but be careful not to throw shadows on the paper. Do not refocus the camera, because that will change the lens extension (which affects exposure), and may introduce faint paper texture during the flash exposure. Stop down the aperture three stops (*or* use a neutral density filter of 0.90 density at the aperture previously used for the painting exposure), and re-expose the same frame or sheet of film. For most subjects, the duration of the flash exposure should be about 10 percent of the painting exposure. William Summit, chief photographer at the National Gallery in Washington, D.C., uses a neutral gray paper instead of white for this procedure. He credits gray with better success than white in controlling color balance. Presumably, flash exposures for the gray are longer than 10 percent.

What happens is this: the flash exposure adds a thin veil of nontextured light to all areas of the film; but since highlight areas have already received a great deal of light from exposure to the painting, this veil adds perhaps only 2 percent more

light there—a negligible and invisible amount. However, the shadow areas have received very little light from the painting, and the veil of light from the flash exposure represents a much higher proportion of the total shadow exposure. Since the shadows are now lighter than they would be in a "straight" (single) exposure, and the highlights are the same as in a single, the contrast range is suppressed.

Flashing more than 15 percent of the exposure usually causes an ugly overall fog. Also, paintings with large masses of dark tone do not respond well to flashing, for the same reason (see Color Plate 4), but where a painting has many isolated and relatively small areas of color, flashing helps to soften an over-harsh image. For medium- and light-toned paintings, flashing is unnecessary.

A very advanced technique for contrast control in color is to use duplicating film in the camera and polarized lights for illumination. The very low contrast range of duplicating stock gives much more shadow detail than normal color film, as well as cleaner, more accurate colors. The naturally "contrasty" effect of polarized light sources—usually considered anathema—is an advantage here, because it counteracts the over-suppressed contrast of duping film and, at the same time, eliminates glare from varnish, impasto, and cracked surfaces.

However, the disadvantages of this procedure are numerous: duping film requires heavy filtration, and its color balance is very sensitive to changes in exposure time (reciprocity effects) and processing. Also, exposure times are quite long: for 4 x 5 format, for example, exposures are between one and five minutes, depending on aperture and lens extension. Photographer Greg Heins of Boston has shown me impressive results he has gotten with this technique, but my own initial experiments in 8 x 10 format were inconclusive: exposures

in excess of five minutes apparently caused a "cross-over" in color balance that could not be corrected by filtration.

The Zone System

If you are passionate for ultimate control over exposure and contrast with black-and-white film, see, in the reading list, suggested titles related to the zone system. The tests and procedures explained in these books are complex, and they require a sizeable investment of time and film; but the theory is useful for developing an understanding of the way film "sees."

Essentially, the zone system demands the use of a spot meter for reading reflectances from different areas of a subject. These reflected values are then compared to a brightness scale, much like the discontinued version of Kodak's Gray Scale (see color plate 1-B). Since the brightness scale is an abstract pattern representing the maximum contrast range that photographic emulsions are capable of recording, one can readily see which values in the subject will record as an equivalent gray value in the final print. Accordingly, lighting, exposure, or development can then be adjusted to suppress or expand contrast.

For the reader who may wonder why the zone system—a theory pioneered by Edward Weston, systematized by Ansel Adams, and raised to the level of a religion by Minor White—is discussed so briefly here, it's because such a system, rigorously applied to a craft as unscientific as photography, *may* lead the unwary photographer away from the easy flow so necessary for excellent work. Conceptual theories can be handy only if they are fully understood and then absorbed into the subliminal consciousness, freeing the mind for inspiration. Useful and moving images *can* be made without a lengthy—and tedious—detour through the intricacies of sensitometry.

9

Photographing on Location

FEW experiences are as rewarding as combining the pleasures of photographing art with the delights of travel. But whether you taxi across town to a gallery to shoot a vase with 35mm camera and flash for a lecture, or whether you caravan to a dozen sites in Tibet with 4 x 5 gear to produce a catalogue, the success of location work depends on thorough planning, flexibility, and ingenuity. Below, we borrow from the movie industry's grand overview, which divides location work into three phases: pre-production, production, and post-production.

Pre-production: Getting Ready

Preparation is essential. Allow ample time to gather information, check the working condition of your equipment, map a realistic itinerary, and see to your personal health and safety. If you run into photographic "white water"—and you will, eventually, when traveling a lot—you will be able to maneuver safely and bring home the shots only if you have exercised foresight. In fact, this pre-production phase is the time when you must anticipate everything that might go wrong and take steps to avoid those mistakes and snares most likely to occur. *Begin by asking questions in three categories: photographic, logistic, and personal.*

What will the photographs be used for? The answer will suggest the format to shoot; but remember that large format requires a strong back, extra time, bright lights (when using artificial sources), and bulkier film that may have to be loaded into holders inside a changing bag if there is no darkroom on site.

What is the art? Naturally, a variety of objects will call for a larger arsenal of tools than one small painting will. Try to get existing photos to help you anticipate special technical problems and identify the art. It is surprisingly easy to shoot the wrong work from a large collection if the assigned subject is incorrectly labeled or inadequately described. In lieu of photos, learn as much as possible about the art: the media, size, weight, position—if fixed—and the condition.

Do you want backgrounds? Determine the minimum size and number of sheets or rolls needed and the method of hanging. Taping paper to a wall is fine—unless your host has delicate wallpaper, or the object is fixed on a pedestal in the room center. You may need to take two extra stands, two brackets, and a pole for paper.

Can you scout the location prior to the shoot? That may save much time and irritation in the production phase, because you can spot potential trouble and circumvent it. While scouting, determine whether you will need wide-angle or telephoto lenses to get the desired perspective if the art is unusually large, cannot be moved, or is inaccessible. Altars, sculpture in niches, and stained-glass windows all require a battery of lenses or a zoom to get the desired image size on film. In extreme cases, you may need a ladder or an extra-tall tripod. It's a good idea to check the circuits for ample service and the location of outlets, test outlets with an inexpensive circuit tester, and figure how much extension cable to bring. Without first-hand knowledge, you must either take contingency equipment or risk embarrassment at not being able to do the proper job.

What is the traffic flow? Will your work interfere with the building occupants—or vice versa? You may have to bring an assistant (or borrow one on site) just to watch your equipment to prevent accidents or theft. If an attendant must accompany you throughout the shoot, find out if you must interrupt your work during his lunch and coffee breaks. By knowing this, you can plan your pace and finish on schedule. Ask whether there are rules against using flash or tripod and whether those rules can be waived for you to get the best quality.

Whom do you contact at the site? Will you need special permission to shoot? I once rented a car in a foreign country and drove three hours in 112-degree F weather to photograph a painting at a university, only to be denied permission, when I arrived, because my permit was addressed to an absent official. Although I had sent a letter *and* a telegram a week prior,

that official had not authorized a deputy to allow me to work. Consequently, I left town without the shot. This is an extreme case of bureaucratic inaction, but it shows that even the best-laid plans may go awry.

Back at the studio, make a checklist of all equipment, film, and paperwork that you will take. Figure the maximum amounts of film needed and add at least 25 percent more for contingencies. Test any equipment that has lain dormant for some time, to insure its reliability. Batteries and shutters often fail on the shelf, and lamps and switches that performed only last week can mysteriously leave you in the dark. Depending on the job's complexity, you will certainly want to take backups or alternates for key equipment, in the event of damage or failure—the location photographer's dread. Some of the spare key items I take on even the simplest of 35mm jobs are: two or three lenses in the 35-to-100mm focal length range; a handheld meter, in addition to the camera's meter; second camera body; batteries for camera, meter, and flash; and—if using artifical light—extra lamps and adapter plugs.

Packing all this gear is a minor art that never gets due attention from the critics—until a lamp or lens is mashed because of sloppy procedure. You don't need steel crates for a short drive uptown, to arrive with your equipment intact; but you *should* use more caution than a friend of mine who dumps his lights and lenses into shopping bags as he rushes out the door. All too often, he forgets something or damages a piece of prime equipment.

Pack small-format cameras and lenses separately from everything else. Of the hundreds of camera cases available for each fashion preference, I use a shoulder bag that zips closed and can be secured with a small lock to keep out dust and uninvited fingers. Thickly padded movable dividers mold the interior into a variety of shapes to fit gear snugly. You may like the metal attache type of case, which is also padded and lockable, but that kind is heavy, obvious, and may disappear quickly when set down at an airline ticket counter.

Large-format camera manufacturers usually make cases for their equipment, and these receptacles will often store camera, several lenses, meter, film holders, and accessories.

If the job is simple, you can pack two lights, two stands, cables, reflectors, and a small tripod in one large fiberboard case. For bigger jobs, you may want one case for lights and cables, a second, tubular case for the stands and tripod, and a small toolbox for set apparatus and spare bulbs. You can buy these cases through catalogues, but to get the right size and fit, take your equipment to a store and experiment with packing. For small sheets of background paper, use a mailing tube and put it inside a larger case.

Formica-clad plywood cases with reinforced steel corners give the greatest protection against shock and abusive handling on long-distance jobs. If designed to meet Airline Transportation Association specifications, they will be expensive and heavy, but will last for years of travel. To transport any kind of large cases from car to site, use a sturdy, collapsible dolly with stretchy straps ("bungee cords").

Naturally, you will want to make travel arrangements well ahead of departure. Transportation and accommodation bookings are subject to a myriad of influences, among them weather, special events, local holidays, strikes, and "computer loss." Therefore, be prepared with fall-back plans, in case the taxi really does get a flat tire on the way to the airport. Depending on your style of travel, you may need to take real money—cash. Waiters, porters, bellboys, cabbies, and just about anyone within sight of your intriguing luggage will expect tips. Excess baggage fees at airlines can soon bankrupt the unprepared photographer toting several cases. And the discreetly placed tip to the right person there may insure that your gear is handled more gently and gets on the right plane.

Foreign Travel

Assuming that you travel light and stay briefly in a foreign land, it is usually wiser to avoid bureaucratic entanglements by going as a tourist. For major shoots, however, you may have to run an obstacle course through red tape to eliminate delay upon entering and exiting from each country—including your own.

Most major cities have consulates or tourist offices of the country of your destination, and there you can get all the current official information concerning visas, immunization, and the importation of photographic equipment and film. Often the host country wants anyone coming in to register equipment with customs upon arrival at the port of entry; on leaving, visitors must remit the forms and show the registered equipment again at customs. If anything is missing, as you depart, you may be suspected of illegally selling it— unless you have a document, such as a police theft report, proving otherwise. Assuming that you travel light and stay briefly in a foreign land, it is usually wiser to avoid bureaucratic entanglements by going as a tourist. For major shoots, however, you may have to run an obstacle course through red tape to eliminate delay at customs.

Most major cities have consulates or tourist offices of the country of your destination, and there you can

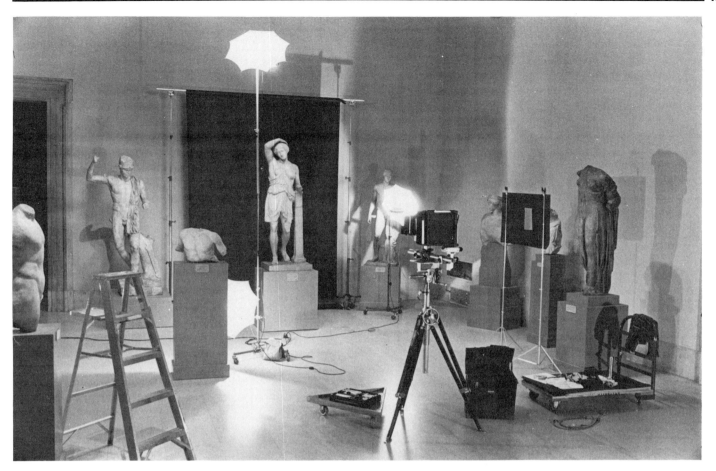

Fig. 9.1. *This view of a Greek gallery at the Metropolitan Museum of Art shows some special equipment for location work.* Left to right: *ladder, for shooting a detail of the head of the Amazon lady; fifteen-foot stands, for raising paper high; sandbags, for securing the stands; extension cables, for electricity from afar; triangular dolly, for moving the tripod; film case; gobo on two stands, for blocking light from shining in the lens—when the gobo is moved to the camera; large dolly, for moving other equipment.*

get all the current official information concerning visas, immunization, and the importation of photographic equipment and film. Often the host country wants anyone coming in to register equipment with customs upon arrival at the port of entry; on leaving, visitors must remit the forms and show the registered equipment again at customs. If anything is missing, as you depart, you may be suspected of illegally selling it— unless you have a document, such as a police theft report, proving otherwise. There is one sure-fire way

to avoid such hassles, but it takes planning, time, and money.

Well before your departure, contact the *Carnet* Department of the United States Council for International Business, located at 1212 Avenue of the Americas, New York, N.Y., 10036. For a small fee, the Council will register your equipment on an internationally honored *carnet* form, which you show to customs officials upon entering any foreign country and upon re-entering the United States. The carnet proves that you brought the equipment before entry into the

foreign country, and that you intend to bring it all home. You will have to supply to the council a list of your equipment, with serial numbers, and possibly copies of receipts.

Just in case you might sell some of your cameras abroad, the council requires that you place with them a deposit, which is held until verification from U.S. Customs that you brought home your gear.

The technical aspect of location work in foreign lands requires close attention, especially if the electrical voltage and connectors are different

Fig. 9.2. *This massive piece of Egyptian statuary bulking nearly ten feet high on the two dollies where we placed her for shooting illustrates some of the problems encountered when photographing monolithic sculpture away from the studio. This statue of Queen Hatshepsut had to be stationed on two dollies so that she could be turned by riggers for profile and back views. That required a two-piece background of re-usable seamless paper—one hanging behind her, and one on the floor. The one on the floor could be rolled up toward the camera each time the subject was turned. A notch cut in the floor paper enabled us to fit it tightly around the dolly on both sides. We left extra paper in front, as a flap to hide the dolly, and secured the two side strips over the hanging sheet with double-faced tape at a point on the floor just behind the subject, to hide the seam.*

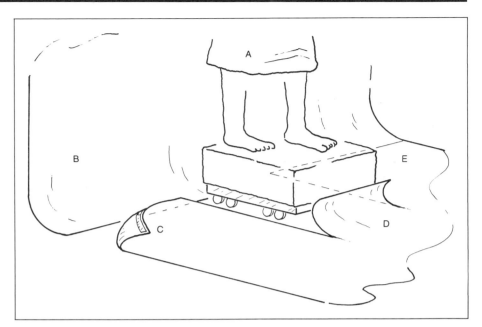

Fig. 9.3. *An isometric view of the seamless background paper around the dolly holding the Egyptian monolith in figure 9.2:* A, *the art, on wheeled dolly;* B, *seamless paper background hanging behind the subject;* C, D, *and* E: *matching sheet of seamless paper on floor, cut to surround dolly. Double-faced tape held the two sheets together.*

from those at home. Most countries outside North America have current that is nominally either 220 or 230 volts. When using tungsten film and light sources, you can simply insert into your light units lamps rated for 230-volt Type B color, and get fairly good results. But for fine-tuning the voltage to obtain consistent source color—even during summer "brownouts"—use 115-volt American lamps and plug them into a heavy-duty rheostat, which in turn you plug into a wall outlet. By checking the voltage several times a day at the rheostat outlet with a reliable voltmeter, you can monitor fluctuations and attenuate voltage accordingly to maintain constant current. Do *not* use those small dimmer switches for moody dining room lighting, because they will overheat with bright photo lamps. The appropriate rheostat, available from suppliers of electrical equipment

to contractors, is large and costly, but safe.

Strobe lighting as a source on location makes good sense, because you may have to shoot in a wide variety of conditions in which prevailing tungsten or daylight is strong. If your stobe is powerful enough, it will overwhelm these other sources, to yield accurate color. In addition, the color output under strobe lighting is consistent, regardless of minor voltage fluctuations. However, studio strobes that plug into the wall must be wired for the proper current, or they will be seriously damaged. A few brands have a built-in transformer that converts from 115 to 230 volts by switching, but for units without this feature, you must use a separate heavy-duty step-down transformer between the wall and the strobe. A transformer suitable for a 1600-watt-second generator is smaller than a

desk phone but weighs about twelve pounds (five kilos).

When traveling throughout India to more than thirty locations, I used strobe with unerring reliability, shooting in tungsten-lit galleries and even on porches in the open shade. And during the many surprise blackouts that occurred, I switched to smaller German strobes connected to powerful rechargeable batteries, which allowed me to continue using daylight-balanced color film. Since a few large objects had to be shot outdoors—including a palanquin and a cannon—daylight film worked there, too. By using the same kind of film throughout, I minimized costly or even irreversible mistakes, eliminated the need for conversion filters, and maintained accurate color.

Electrical plug and outlet designs vary widely by region, so be sure to have the right adapter for your lights. The major categories of different configurations are: North America, South America, western Europe, England/India, Austria, Australia, and Asia. The Franzus Company of New York City makes adapters for U.S. plugs to fit most countries' outlets.

Film and the Airport X-ray
The X-ray machines at airport security posts are the travel photographer's nemesis. Although many machines are quite safe for film, others will produce enough radiation to fog your film and ruin a shoot with only one pass through the apparatus. And if you put the same film through even the safest machines on more than one flight, your risk of X-ray damage is substantial, regardless of what the signs say. The best cure is prevention: get to the security post early, wait for a lull in traffic, and ask the attendant for "hand inspection" of your film and cameras. With luck, you will get it. Should he refuse, ask to see a supervisor, explaining that you cannot risk losing the film to fog, and

that you have several airports to go through. Remind him that film reacts *cumulatively* to multiple exposures of visible light and invisible X-rays, causing all sorts of interesting but absolutely unusable effects in your business. In my experience, friendliness and patience win guards over much quicker than a demanding and argumentative approach. Official documents of any sort may help. In many European airports where security is understandably zealous, however, none of these tactics will work: either your film goes into the machine, or you do not fly. In those circumstances, pack your film in lead-lined Filmshield Bags, which give minimal protection against low-dosage X-rays. Alternatively, pack film with your checked luggage; it may circumvent the problem, but I hear that some airlines even X-ray baggage before stowing it on the plane.

Personal Health and Safety
Few experiences are as depressing as falling ill or sustaining an injury while away from home. Depending on the length and location of a trip abroad, you will certainly want to take along a small first-aid kit containing basic applications for cuts and burns, and medications for relief of digestive maladies. Since I am not a medical practitioner, my suggestions should be taken only as guidelines.

Sensitive stomachs subjected to spicy or unclean foods cause most work delays when traveling. I find that yoghurt (when fresh), plain rice, capsules of lactobacillus and tablets of folic acid help sooth a troubled tummy. Milk from the green coconut, available in tropical countries, is Nature's healer. When diarrhea strikes, the prescription drug Lomotil relieves the symptoms, but not the cause. Many physicians will prescribe Lomotil to travelers.

Water supplies in many countries are—to use a kind word—

questionable. When in doubt, drink bottled mineral water or carbonated soda, and avoid ice in drinks. So-called filtered water may not have extraneous matter visibly floating in it, but what you cannot see may knock you down—permanently. Some people are tempted to drink hot tea or coffee, thinking these drinks to be safe, but only after boiling a full fifteen minutes is water free of parasites that cause dysentery, cholera, and hepatitis. Fruit juices from cans are probably safe, but juices diluted from concentrates must be considered suspect. Food that is washed in local water may be contaminated, so the safe choice is to eat only prepared foods that are cooked, and eat only those raw fruits and vegetables that you yourself peel. The truth is that even in five-star hotels, the food chain is only as pure as the least clean hands that prepare your meals.

As a rule, I refrain from introducing foreign substances into my bloodstream by means of a needle, but when traveling through lands whose hazards include a high rate of communicable diseases, I will get the recommended shots. Medical doctors and clinics administering immunizations get monthly updates on prevalent diseases in each country, and they can advise you about which medical measures to take and how many weeks will be required to administer them.

Production: The Job, on Site
Having done your pre-production homework and arrived at your destination, you are now ready to make photographs, a task that should proceed as smoothly as in your studio. If the airline accidentally sends your lights to Ouagadougou, Upper Volta, or if your equipment fails, don't panic: often improvisation will save the shot, or you can borrow or rent equipment locally. And in situations

where accurate color and ideal lighting are less important than simply getting a quick image on film, you can produce usable record shots if you carry either a small tripod or a camera flash.

Written records of each shot, with descriptions of the objects listed in the order of exposure, will save valuable time back home, when you hunch over a light box in perplexity, trying to identify the art and edit film.

It is important to keep all film— unexposed and exposed—cool until development. Better hotels offer refrigerators in their rooms; without access to one, you can minimize spoilage by keeping film out of the sun, taking with you each day only the amount you need. In humid regions, fungus may form on film, causing permanent damage. This problem, less likely with fresh, sealed boxes of unexposed film than with exposed stock, can be avoided by drying the air around stored film with a desiccant, such as silica gel. Put the desiccant in an infant's sock, to let it breathe and do its work, and seal the sock inside an airtight container (a Filmshield Bag works well) along with the exposed film. Although the desiccant's effect will dry sheet film inside light-tight boxes, you should leave roll film out of the plastic cans.

Since the procedures for shooting on location with studio lighting are virtually identical to those back home, the following discussion is limited to two easy techniques not yet discussed: shooting with flash on small- and medium-format cameras and "painting with light" (using a tungsten source for any format).

The small flash: a useful tool. A camera flash need not be large, expensive, or complex to be effective; in fact, the small, lightweight units require less effort to use than do sophisticated models. For most situations, all you will need is a flash that has two power modes and uses two or four penlight batteries. Clamped onto the camera's "hot shoe," a standard flash unit will give adequate direct coverage of the subject field when you use a normal lens. With wide-angle or telephoto lenses, you will need a flash that accepts snap-on auxiliary lenses or has a zoom head to adjust the unit's lighting field, so that it matches the lens's angle of view. A swiveling head is handy in situations where indirect light on the subject is more pleasing than direct light. For example, a heavily varnished painting that glares badly from direct flash can be shot successfully if you aim the swivel head toward the ceiling at an angle of 75 degrees, so that an even wash of light comes from above. But such a flash must have lots of power, to travel the increased distance and still give ample brightness

Virtually all of today's flash units have both manual and automatic modes. Using the manual mode requires a little math, while the automatic one frees you to concentrate on composition and focusing. Many cameras and flashes are "dedicated," which means that the flash, when charged, automatically controls certain camera functions, such as shutter speed or aperture or both. These systems are fairly accurate and foolproof, but you must switch to manual mode to bracket exposures.

Yet, with any flash, you must use your own good judgment. Since the light is not visible before the exposure, you have to anticipate its effect as you compose.

You can avoid the most common faults when using flash by remembering key points, such as these:

• Set the shutter speed at, or slower than, the maximum speed required by your camera for proper synchronization. (Usually this is $\frac{1}{60}$ of a second, but it can be higher, on some models.)

• Keep the subject within the minimum and maximum distance limits for the power mode in use. If the subject is too close, it will be overexposed; if too far, underexposed.

• Use a low power mode to increase the flash range and conserve batteries. Doing so requires a larger aperture than a high power mode.

• Use a high power mode to increase depth of field. This decreases the far range limit—and also drains batteries quickly.

• With a wide-angle camera lens, use a wide-angle adapter on the flash to increase its angular coverage of the subject. Although this eliminates a "hot spot," it reduces the maximum range.

• Do not aim the flash at a reflecting surface, like glass, which is parallel to the film plane, or you will get obliterating glare. Move the camera flash off-axis so that glare follows a path that is outside the lens's field of view.

• Use daylight-balance color film. If you have Type B film in the camera, put a salmon-colored 85B conversion snap-on filter *over the flash head* to convert the light to tungsten balance. Although this filter reduces light output slightly, the color mixes well with existing gallery lights, and the flash continues to function automatically.

Stuart Carey Welch, the eminent scholar of Islamic and Indian art, uses the following technique with admirable success when traveling. He connects the strobe light to his camera by means of a ten-foot (three-meter) synch cord, which allows him to shoot from any desired perspective while lighting the art from a point off the lens axis. In that way, he avoids troublesome reflections and introduces modeling on the subject when desired. Obviously, an assistant or a

Fig. 9.4. *Ambient gallery lights alone give adequate modeling of the relief figures on this marble sarcophagus, but their weak intensity calls for an exposure of ⅟₁₅ at f/3.5. This is too slow a speed to hand-hold the camera steadily, and too wide an aperture to give sufficient depth of field.*

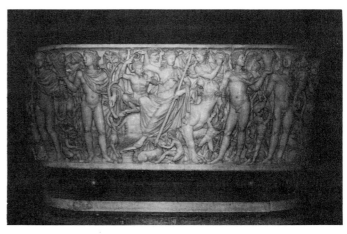

Fig. 9.5. *Although a camera flash freezes the image here sharply and increases depth of field, the frontal lighting reduces modeling—the major drawback of on-camera illumination. The "hot spot," caused by using a normal-angle flash with a 28mm lens, could be eliminated with a wide-angle diffuser over the flash head.*

stand with a clamp is required, to hold the flash.

Painting with light. The second technique, while more cumbersome than a camera flash, has the advantage of producing depth and softer modeling in the subject's image. Useful primarily when shooting rooms, "painting with light" can improve any large object, such as a sideboard, when you have too few luminaires to fully illuminate it. The camera must be tripod-mounted, because the shutter has to be set for a time exposure while you move the light around to illuminate the art evenly and eliminate sharp, dense shadows.

I shot figure 9.8, a view of the Pennsylvania German Room in the American Wing at the Met, using only the existing gallery lights. Although the moody lighting was quite pleasing to the eye, its contrast ratio was so great that, on film, the furniture details are lost in Stygian blacks, punctuated by glare. I then added a single, stationary pan light at camera left (figure 9.9), which lightened the

shadow areas for an acceptable record shot. However, I found that by *moving* the pan light during a thirty-second exposure, directional modeling was retained as the shadows' edges softened (figure 9.10). Of course, during the exposure I could see only the shadows move, and had to *imagine* the cumulative effect on film.

Figuring the exposure when "painting with light" is tricky. First, with the light stationary at its approximate position of illumination, make a reading at the center of the subject in the usual way. An incident meter is preferable, but you can use the camera meter, too. Select an aperture that yields a shutter speed of at least ten seconds to give yourself ample time to move the light evenly. Bracketing exposures is necessary, because as you sweep the beam of light across the subject field, no one part of the subject will get sufficient light during the *computed* exposure. For the Pennsylvania German Room—a dark, large subject field—I shot several frames each at two, three, and four times the

computed time, to assure one good shot that did not have "hot spots" where my motion was erratic. Obviously, a diffuse light is better than a spotlight.

Next, turn off the light, set the camera to "bulb," trip the shutter, and lock it open with a cable release. Quickly pick up the light, turn it on, and immediately move it smoothly in horizontal motions while watching the clock. (It's no harder than patting your head with one hand and rubbing your tummy with the other, all at the same time.) With each side-to-side sweep, lower the luminaire slightly for overlapping beams of light, making sure that all parts of the scene get equal time. But for very deep subjects like this one, give more light to the farther areas than to the foreground, to equalize exposure. The pattern of motion can vary from small arcs to generous swoops, depending on how diffuse you want the shadows. You can light from both sides of the camera to get balanced lighting, but beware of windows and mirrors that might reflect harsh glare into the lens.

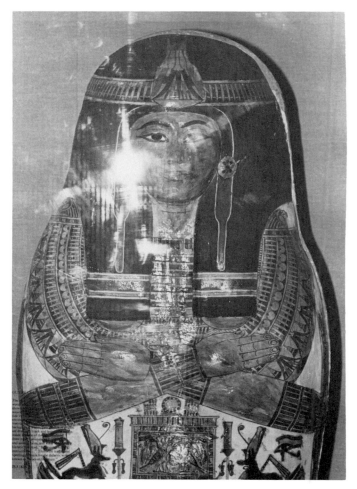

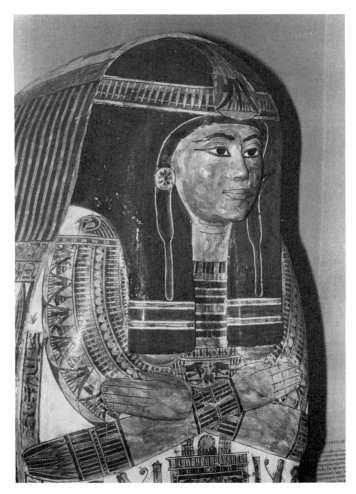

Fig. 9.6. *Here, aiming the flash directly at the subject itself, a coffin behind a glass case, creates glare. Also, the flash's automatic exposure system (a thyristor circuit) reads the reflection glare and assumes that the subject is much nearer and brighter than it actually is. Consequently, the flash cuts off too early, causing underexposure.*

Fig. 9.7. *Photographing the coffin as a three-quarter view presents it from a less desirable perspective, but the flash's reflection from this point does not impinge on the image, nor is the thyristor circuit fooled.*

(Some of my frames on this shoot had such reflection, from the far windows.)

A final note: figures 9.8 and 9.9 were shot with a conventional 28mm wide-angle lens on 35mm format from a perspective that required tilting the camera, causing verticals to converge. For figure 9.10, I used a 28mm Nikkor PC (perspective control) lens, that allowed me to set the camera back vertically (parallel to the wall) while "shifting" the lens barrel downward to obtain the proper composition from my desired point of view. The camera and lens are shown in figure 4.18.

Post-production

If you have not processed film at local labs while on location, do that as soon as possible after returning home, to insure stable images. Most labs will, if you ask, transfer your film label information from the rolls to the boxes of processed slides, so that editing will be easier. Another routine task to be done soon after returning is to check your equipment for malfunctions and have it repaired, especially if you're returning from places in which cameras have been subjected to salt air or dust. You may need to get them thoroughly cleaned and relubricated, to prevent long-term problems. Also, after a trip, before

storing cameras, meter, and flash for extended periods, remove all batteries, to prevent damage from leakage. And while the trip is fresh in mind, write yourself a concise review, noting any forgetfulness on your part and special problems you are likely to face on similar occasions in the future. By having such a report to refer to, you can reduce the pre-production effort for the next trip and smooth the way for an even more successful expedition.

Figure 9.8

Fig. 9.8. *Existing light in this period room in the American Wing of the Metropolitan Museum of Art was insufficient for delineating features of the dark furniture. A conventional wide-angle lens, tipped downward to include the near table from a high perspective, caused vertical elements to converge.*

Fig. 9.9. *Addition of a single pan light for the subject in figure 9.8 improved the legibility of furniture, but caused harsh shadows.*

Fig. 9.10. *"Painting" with a single light during a time exposure of twenty seconds diffused the shadows in this third shot of the room, rendering a more pleasing version than the stationary light source. In addition, use of a perspective control lens allowed the verticals in the room to be kept parallel, although the camera position remained high.*

Figure 9.9

Figure 9.10

10
Photography for Publication: Some Guidelines

PHOTOGRAPHS used for publication must have clarity, sharpness, good definition between object and background, and a full range of tones corresponding to those in the art photographed; they must have ample modeling for shape, texture, and detail; and they need soft shadows and faithful color. Exceptions to the rule would include interpretive photographs and those made to show special features for scholarly or conservation reasons.

The contrast range should be great enough to add vivacity when appropriate, but low enough to render important information as a definitely discernible tone. Just as there is a tendency for contrast to increase at each stage in original photography, so does contrast often become greater at each step in the photomechanical reproduction process. If important textural detail is not present as a discrete tone in the print or transparency, it cannot be restored in the reproduction process. Conversely, if an unwanted tone or textural detail is easily visible in the photograph, it will probably reproduce when published—unless it is retouched. Apart from contrast, the photograph's density must be evaluated. Photographs too light or too dark for study will probably reproduce poorly.

For the best reproduction, photographs must be in healthy condition. Finger smudges, coffee stains, cracked emulsions, and the jagged areas where mice have nibbled will all reproduce in great clarity.

In spite of the high quality of current lenses and films, the extra care that smaller films require in reproduction usually means that they are less likely to be printed as well as larger formats. However, recent technological advances in laser scanning, color matching, and fine-screen printing have improved reproduction of small formats to an astounding degree.

Papers and Film

Black and White

You can achieve consistent results in reproduction of shots made with black-and-white film by using one type of contact paper or enlarging paper for each job. A smooth, glossy surface retains the most brilliance and longest tonal scale of any paper, with the least troublesome reflections for a printer. Glossy papers can be dried matte or glossy, but glossies are more difficult to spot and retouch. Avoid papers that have a warm-toned image or cream-colored support, because their contrast ranges may be misleading to you and to the printer. A neutral black image on white stock (Kodabromide, Polycontrast, Ilfobrom, Multigrade), will give you a better idea how the reproduced image will look. Also, avoid using "exhibition" papers for reproduction purposes (Galerie, Seagull, Elite, Brovira), because their dense, Stygian blacks may not reproduce with the same effect as you see in the print.

Color

Obviously, a principal criterion in making color photographs for publications is to control colors so that they resemble those in the works of art they are intended to replicate. However, precise matching of colors is an optimistic and impossible goal. Neither the colors in the three dyes of photographic color emulsions nor the four inks in the conventional printing process can duplicate the rich palette used by artists in painting or the subtle hues appearing in natural materials. For that matter, the hues, values and tonalities that appear in a color transparency illuminated by *transmitted* light (as on a light box) cannot be duplicated in the four-color printing process, whose results are viewed under *reflected* light. Even so, the rapidly changing technology of the photographic and printing industries makes possible images that come very close to evoking in viewers an accurate impression of art. That can be achieved only when good judgment is exercised in evaluating and correcting color photographs.

Analyzing the Product

All published photographers have experienced reactions ranging from delight to dismay upon seeing their photographs reproduced in

publications—simply because the quality of reproductions runs the gamut from fine to farcical. In the worst instances, when, in reaction to an exceptionally disappointing reproduction, the photographer moans, "How could the printer do that to my beautiful shot of the Van Gogh?"—the printer in his shop may already have responded to the same reproduction by wondering, "How could a photographer make such an awful transparency of such a beautiful painting? When am I going to get photographs I can work with?"

Both photographer and printer were pursuing the same goal: a fine reproduction of a great work of art. They both believe they did the best job possible.

What went wrong?

The photographer will never know, as long as he or she silently blames the printer and avoids an objective analysis of the problem. And future work may turn out equally badly, unless the photographer learns something about the procedures and limitations of color printing.

A photograph is to a reproduction as a foundation is to a house: it is not seen directly, but its influence on the outcome is crucial. Of course, the best transparencies can be—and have been—reproduced with disastrous results by inferior printing; but even the most conscientious and skillful printer cannot transform a shoddy transparency into an accurate, affecting image of Van Gogh's *Starry Night*.

Photographic Reproduction

The brief, nontechnical outline of the photographic reproduction process below introduces the key participants and their functions. At the "creative" level of publishing are four primary functions, those of a writer, an editor, a designer, and a photographer. Ideally, the four specialists involved will be in close communication before

original photography begins, so that they reach an understanding of the publication's *raison d'être*. Only rarely, however, will most photographers be consulted for a production meeting, simply because most fine art publications are composed of both existing and original (new) photographs brought together from widespread sources. Most often the photographer will receive no guidance—or will, at best, receive a phone call or a note indicating the request for a shot and the reason it is needed, specifying which angle to choose, what color background to use, and so on. Be certain always to try to achieve the best quality possible when there is reasonable certainty that an image will be published: once a photograph leaves your hands, it is dissected, abstracted, and transformed by other experts in the printing process—all without your advice (or criticism).

At the manufacturing level of publication also several functions are performed in concert. The production supervisor is the publisher's representative for overseeing the physical manufacturing of the publication. The printer's representative, as liaison between the production supervisor and the printer's production staff, guides the printing. If color offset lithography is involved, a separator makes color separations, which are actually black-and-white film copies of the original photograph. At this point the photograph is put aside and used thereafter for reference. These color separations, each exposed through a differently colored filter, are records of the three primary colors of light, plus black, which existed in the color transparency.

Next, an extremely fine dot pattern is introduced to each separation by exposure through a fine-mesh screen, because the continuous tones and colors in your photograph cannot be

represented by inks of uniform density. This dot pattern enables the printer to make various areas of a printed image lighter or darker by controlling the size of the dots of color that will carry the printing ink. Larger dots create the effect of richer, more saturated color; smaller dots create paler color. Of course, even the largest dots are invisible to the naked eye.

The half-tone separations go to a plate-maker, who transfers the four screened images to four printing plates by photographic methods. These plates now correspond to the three primary colors, plus black. Finally, a press operator inks the printing press with the proper ink—cyan, magenta, yellow, and black—and controls the transference of ink to paper as each plate makes an impression in register with all others. Almost miraculously, the build-up of tiny dots resembles a work of art.

It is obvious that, with so many hands, opinions, and mechanical steps involved in reproduction, some degree of "interpretation" of a photograph is inevitable.

Color Corrections:
Production Supervisor

Ideally, a production supervisor will compare a color transparency to the actual work of art before separations are made. If there are deficiencies in the transparency, such as slight underexposure or a color cast, the production supervisor will instruct the printer's representative to make corrections when separations are made. This careful step is a fortunate and unusual situation, however; most often, the production supervisor will never see the art and will have only the photograph to use as a guide. Consequently, all steps in reproduction will be tailored to match the transparency. If the transparency is inaccurate, the printed reproduction will not resemble the work of art.

From the color separations, the printer makes proofs that the production supervisor compares to the original art and/or the transparency. If there are flaws, the supervisor describes them to the printer's representative, who makes corrections and prepares another proof for analysis. The number of proofs made before the final press run depends on time and budget. The greatest possible corrections are made during proofing, because the controls available during the actual press run are very limited and expensive.

Color Corrections by the Photographer

The photographer's goal in color-correcting a transparency should be to make its colors match those of a work of art. That can be done by evaluating the color balance of the transparency under standardized conditions in a neutrally colored environment, in the presence of the art. If the transparency's color balance is unacceptably different from the art, the photographer must either reshoot with the appropriate CC filter(s), or pass along the color evaluation to the production specialist.

Illumination, environment, and tools. Since the medium of color-correcting is light, the wisdom of using a standard white source of illumination at all phases of evaluation in both photography and publication should be obvious. The prevalent illumination currently used in transparency illuminators ("light boxes"), viewing booths, and in printing shops throughout much of the world is Daylight 5000K, as supplied by special fluorescent tubes. For best color judgments of transparencies to fit within the dominant system, use one of the more popular light boxes, such as those made by MacBeth or Graphiclite. (Although the logic of having a standard source of illumination is beyond question, for

me, it seems curious that Daylight 5000K fluorescent tubes have become that standard, since neither do they match real daylight in color nor are they commonly used in everyday life by people looking at fine art publications. Because such viewing by the public is done under a wide variety of light sources—in living rooms, offices, buses, etc.—it would seem more sensible to use a standard closer in color [warmer] to real reading conditions than is supplied by the excessively bluish source now used. I can only presume that today's standard is the result of many compromises.)

In correcting transparencies to original works of art, the color temperature of illumination on the art must duplicate that in the light box. If the transparency is lit by 5000K and the painting is lit by conventional 3000K tungsten lights, the viewer's judgment of color will be distorted. Light fixtures with 5000K tubes can be hung in the art storeroom or in one corner of the studio to illuminate the art. All other lights should be turned off, and daylight from windows shut out by shades.

The room for color evaluation should be painted a neutral gray or white, so that no other reflecting colors will falsify the art or disturb the photographer's judgment. The current industry standard suggests that the wall be Gray N/8 in the Munsell Color System.

The only additional tool needed is a full set of CC filters in six colors—see Table 6.3, in chapter 6. Kodak markets a set of cardboard-mounted gels of various density, called a "Color Print Viewing Filter Kit," which uses filters that are slightly different from CC filters. To increase the accuracy of my color correcting, I made my own kit, using three-inch-square CC filters—the same type used over a camera lens—in densities of 0.05 and 0.10. I cut four holes, two-and-a-half

inches square, in each of three cardboards, and taped one filter over each hole, so that each pair of complementary colors was assembled on the same card.

Practicalities. The ideal conditions described above are often unobtainable, even in the most sophisticated studios and institutions. In truth, most color correcting is done by comparing transparencies to art that is illuminated by tungsten lights, or at best, by daylight coming through a window. In most museums, checking transparencies and press proofs against works of art is often done in taxing circumstances, such as in galleries lit by mixed sources or storerooms lit by dim, indirect sources. If you do not have 5000K overhead lights, take the art and the transparency to a window, so that you can make a comparison while both are illuminated by daylight. In a gallery, hold the transparency so that it is illuminated from behind by the same light that illuminates the work of art.

Photographic color theory. Scientists shaping a theory of light as a basis for explaining and controlling photographic phenomena have abstracted white light into six component colors: red, green, blue, cyan, magenta, and yellow. These six colors are divided into two groups of primaries, called *additive* and *subtractive,* and they correspond to the six colors in which CC filters are made. The *additive primaries* are red, green, and blue; the *subtractive primaries* are cyan, magenta, and yellow. Both the origins of these two groups of primaries and their names are beyond the scope of our discussion; indeed, the names can be misleading to photographers just beginning to use CC filters, which are all considered to *subtract* a color from a transparency. Complementary colors in the photographic system are noted by the arrows in the chart in figure 10.1. It is imperative to etch these pairs of colors into your memory,

because they are the basis of an analytical approach to color-correcting. (Readers familiar with the color theory that applies to pigments will notice that neither group of colors corresponds to the primary colors [red, blue, yellow] or the secondary colors [green, orange, purple] used in mixing paint.)

The color wheel. The easiest way to learn the relationships of the six additive and subtractive primary colors is to use a graphic diagram. Plate 1-A is a photographic color wheel, arranged with the additive primaries in an inner circle surrounded by the subtractive primaries in an outer circle. The color wheel demonstrates that *any additive primary is composed of the two subtractive primaries adjacent to it. Likewise, any subtractive primary is composed of the two adjacent additive primaries.* For example, R = M + Y; and Y = R + G. This wheel also shows the complementary relationship between pairs of colors: each subtractive primary is complemented

Fig. 10.1. *The photographic color wheel is arranged with additive primary colors alternating with subtractive primary colors. The complement of each color is located opposite that color on the wheel, as noted by the arrows. Thus, each additive primary is the complement of a subtractive primary — and vice versa. If a transparency has a color cast — red, for example — it can be eliminated when reshooting by using a complementary CC filter over the lens — in this instance, cyan.*

by the opposite additive primary.

People are sometimes surprised to learn that yellow light is composed of red and green light; yet, tests have proven that when a person sees a red and a green spotlight of the appropriate wavelengths and intensities, he will perceive yellow light. To conduct a similar test, place a CC05 R filter and CC05 G filter together on a light box and compare the resulting color to a CC05 Y filter.

When using CC filters for correcting transparencies, beginners usually want to *add* a particular color that seems deficient. This natural tendency must be reversed by evaluating the excessive overall color cast that needs to be *subtracted* from the transparency for a neutral balance throughout the image. Subtraction of an excessive color is done by using a filter whose color is *complementary* to the prevalent color cast.

For example, a blue cast is canceled by using a yellow filter over the lens. Also, the opposite is true. The density of the filter chosen depends on how extreme the color shift is. A moderately blue shift may require a CC 10 Y; an excessive shift might require a CC 20 Y (rare), while a slight but disturbing blue cast would need only a CC 05 Y.

In unusual cases, the aberrant color cast might be a combination of two colors, which would require the use of two CC filters. A yellowish-green cast would call for both a blue *and* a magenta filter. Conversely, a purplish cast (blue plus magenta) would need a yellow filter and a green filter to achieve a neutral color balance.

Any correction requiring two filters should be made with one additive and one subtractive filter. While some particular correction could be made using two filters from the same primary group, it would be an inefficient one, because the same result could be achieved by using one filter from the other primary group.

For example, a color cast that would be eliminated by using one blue and one green filter (two additive primaries) would also be canceled by using one cyan filter, since B + G = C. In addition, no correction of color is possible by adding together two complementary filters of the same density, because they would cancel each other. For these reasons, my homemade "CC filter viewing kit" has pairs of complementary filters mounted on each cardboard: the arrangement precludes my overlaying complementaries when evaluating a transparency. These concepts take some practice to remember, but guidelines in the next section will help to make judging color and choosing the correct CC filter easier.

One other point about CC filters: *they cannot affect only one color or one local area in a transparency.* Since each filter is of uniform density and covers the lens during exposure, *the entire frame or sheet of film will be affected.* In essence, the filter corrects the light that passes through the lens.

Evaluation of transparencies. Throughout evaluation, maintain a viewing distance of a comfortable twelve to eighteen inches, or thirty to forty-five centimeters. Mask your light box with black cardboard to within one inch of the photograph's edge, so that light glows around it. If you butt the mask against the transparency, it will appear correctly exposed, when in fact it may be too dark for proper reproduction.

Now — take a series of three shots you've made whose exposures were bracketed in half-stop increments; line them up in order of density and remove any protective sleeves. Very likely the middle exposure will appear correct, even if wrong, so judge the density carefully. Are important shadow and highlight details represented as tones? If both are not present in any of the shots

simultaneously, the contrast range may be too great, and your lighting will have to be adjusted in a reshoot. (This applies to three-dimensional objects only. The contrast range in flat art can be reduced only by "flashing." See "Contrast Control.") If the exposures are all too dark or all too light, judging both the contrast range of lighting and the color balance will be almost impossible.

Select the best shot, and judge its color balance. Your inclination may be to zero in on one color, exclaiming in disappointment, "The greens are really *sickly*." That may be true, but it doesn't help you find the source of the problem analytically. Instead, look for an overall color that is in *excess*.

If there is a gray scale in the transparency, look at the white and lighter gray steps for a color cast that may be quite faint. If there is no gray scale, or no white or gray background, look at the lighter values within the object for the hint of a color cast. Compare these values to the art, or to the Standard Color Test subjects if shooting a test (see "Shooting for Accurate Color") and judge whether the transparency looks too warm or too cool. Excessive warmth in color means you must subtract red, magenta, or yellow. A predominantly cool cast tells you to subtract blue, cyan, or green.

If, for example, the cast appears warm, close one eye and hold one of the cool-colored filters of 0.05 density a few inches in front of your *open* eye, so that you can see the entire transparency through it. Flick the filter in and out of your line of vision

every few seconds, to assess its effect. Do this in turn with each filter, until you have decided which one best neutralizes the color balance. If none of the three helps, repeat the procedure using densities of 0.10.

At this point, you're very likely to have found the best filter; but if not, try each of the remaining three filters (red, magenta, and yellow) in densities of 0.05. Should you be gripped by total indecision, rest your eyes by looking at a white or gray wall, and relax. Look out a window or take a short break before returning to the problem.

As an alternative method of viewing, hold each filter near the transparency and keep both eyes open. That way, you can compare the effect of two or more filters simultaneously, on a large format transparency. Perhaps two filters in combination are needed, but that test should be used as a last resort, since it complicates matters by adding more possible choices.

Choose the filter you think will work best and reshoot, taking into account the filter factor when calculating exposure. (Use a fresh, clean filter—not the one used for evaluation.) Keep a record of any lighting or exposure change; and process the film immediately. In comparing the new shot with the old, you will notice that the alteration of color balance is slightly greater than you estimated. That always happens, and it must be anticipated when color-correcting.

If the new filtration is close—but

not close enough—try again, with another filter. But don't be finicky; if the color balance is off by a factor of less than 0.05 density, further correction can be done when separations are made.

If, for any reason, you cannot reshoot with new filtration, but you think that the color balance still needs improvement, mark your evaluation on a sticker and attach it to the transparency sleeve for the production specialist to consider. Be clear and brief when marking notes. For example, write, "Looks better when seen through CC 05 B filter." Avoid vague remarks like "Blues are dull and reds are angry," as well as specific instructions, such as "Add 7 percent cyan and reduce red by 3 percent."

Occasionally, you may find that, although a gray scale included in the scene is neutral, the color balance of the art is not correct. If you reshoot with a new filter to correct the art, the gray scale will have a color cast corresponding to the color of filter used. A production specialist looking at the gray scale later might assume that the whole transparency is incorrect, and may undo your correction by telling the printer to alter the whole image's color balance so that the gray scale is neutral. In such situations, leave out the gray scale for the reshoot; otherwise, put a note on the transparency sleeve indicating that you have color-corrected the subject, and that the production specialist can ignore any color tinge apparent in the gray scale.

11
Synthesizing Skills and Vision

THE preceding chapters have been chiefly concerned with technical information and theory, the foundations of photographic craft. The remainder of the book suggests ways to apply knowledge of that information and theory in action, so that the skills of craftsmanship become second nature. Developing skill in any field requires practice, which sometimes means making mistakes and trying again. This is infinitely true of photography; and my belief is that those of us who are serious about making good pictures find our growth as photographers accelerating if we accept mistakes as a natural occurrence in the process of learning. The sooner you master the technical aspects, the sooner your successes will build confidence, speed, and co-ordination—the ingredients of skill. And once you acquire genuine dexterity with the camera, you will be free of worry over the details of craftsmanship, able to concentrate on visualizing a final photograph each time you light a work of art. Important as craft is to good photography, it is merely the skillful use of techniques through which the photographer's vision of a work of art becomes reality, just as accomplished pianistic technique is the mode by which the concert pianist communicates his or her interpretation of a Chopin sonata.

Photographic vision is the ability to anticipate ways in which various means of lighting a work of art will emphasize various of the work's specific superficial or emotional qualities, ways in which the film will record that lighting, and ways in which the final print or reproduction will translate the film image into a photograph of legibility and impact. Such a triumph is not achieved through rote procedure. It requires intelligently integrated forethought, mastery of craft, and awareness, in an easy, focused flow of energy. To me, that process shares an atavistic kinship with the work of alchemy, in the sense that raw film stock becomes a substance transformed, through the application of inspired effort, into useful, evocative images. Whether or not you agree that photography is touched with magic in no way alters the fact that getting predictable results depends upon how well you synthesize practical skills with visualization.

* * * * *

This last portion of the book is divided into two segments: one for *flat art* and one for *three-dimensional art*. Each segment begins with a summary of considerations and procedures for that particular type of work and continues with many illustrative examples, accompanied by descriptions of the way I made them.

The first set of illustrations in each segment deals with "the basics," and includes works typical of most situations that one might encounter. Usually, these were relatively easy to light.

The second set of examples in each segment is somewhat grandly called "Master Class," because these works illustrate rarer problems, requiring either advanced lighting techniques or special equipment.

Basic steps in photographing either flat art or three-dimensional subjects are six: getting instructions, choosing a perspective, preparing a set, lighting the art, computing the exposure, and exposing film. With black-and-white film, processing and printing are additional steps.

First, find out why you are making a shot: is it for records, study, or publication? Is it to show stylistic features, a flaw to be repaired, or the desirability of the art? Is it a shot of the whole object or a detail? Will it be color or black-and-white or both? Knowing these points in advance may help you avoid a reshoot. With the goal in mind, examine the subject and map your approach, imagining the ideal perspective and lighting. These factors, as well as the size of the art, determine the kind of set you will prepare.

Copy sets are for shooting flat art, and can be horizontal, vertical, or inclined. *Floor sets* are for large or heavy objects, such as furniture, or for a high camera angle on smaller objects. *Vertical sets* are for the tops

and bottoms of three-dimensional subjects, for special views of works that cannot be propped safely on a table, and for coins and most jewelry. *Tabletop sets* are for a natural eye-level view of most decorative works, small sculpture, pottery, altar pieces, and so on.

Set construction and lighting are integral processes. If your taste in lighting and your preference for method are similar to mine, you will choose the simplest approach to each subject. After you light the art, all that remains is to compute the exposure and commit the image to film. During exposure, empty your mind of everything but your retinal image of the subject, because if you must later make a black-and-white print or judge a transparency of it, your memory must be accurate.

Photographing Flat Art

Any medium applied to or supported by a two-dimensional surface can be considered flat art. Paintings, drawings, etchings, prints, leaves of books, scrolls, screens, and some textiles fall into this category. Photography of flat works is called *copy work,* and the art is called *the copy.* This class of work gives less scope for personal interpretation than three-dimensional photography, but it demands quite as much technical precision in lighting and camera handling.

Shape and focus. The nature of most flat art requires that an observer look at it from a centered position for an ideal view. Consequently, the camera is nearly always placed in the exact center of the field of view, equidistant from the subject's perimeter. In addition, the film plane and the plane of the art must be precisely parallel. If they are not, the image may not be sharp from edge to edge, and a rectangular work will be rendered trapezoidal. Misshaping of the image is called *keystoning,* a term

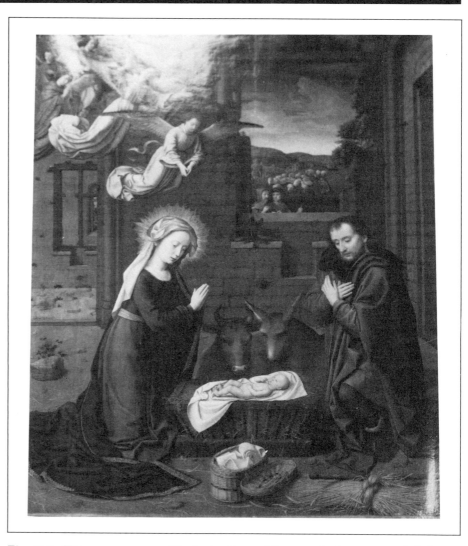

Fig. 11.1. *This manger scene illustrates three of the most bothersome and obvious flaws to avoid in copy work: "keystoning"—shooting a distorted, nonrectangular image caused by the camera being both off-center and not paralled to the art; an out-of-focus image at the top of the painting caused by the camera's film plane and lens plane not being parallel to the art; and glare on the upper left and lower right corners, caused by the lights being too close to the camera axis.*

borrowed from architecture.

Lighting. Except for some textiles, flat art usually creates its own internal sense of light and space through graphic means. Any external light source that is *noticeable* should be avoided. Such sources include *uneven illumination,* caused by improperly balanced photographic lights; *glare,* caused by photographic lights placed too close to the camera axis, and by varnish on paintings applied over heavy impasto or cracks on the surfaces; *reflection,* caused by the shiny parts of a camera and tripod, pale skin and clothing, and light sources behind the camera. Reflections are most troublesome with

varnished dark works and those mounted under glass or plastic.

Only when no distractions occur can the artist's magic lure the observer into dimensions beyond the surface.

Lenses for copying. As discussed earlier, your lens should be corrected for curvature of field, distortion, and chromatic aberration in order to give a sharp image throughout and depict straight lines correctly. Lenses that will do this best are variously known as *macro, process, flat field,* and *apochromat lenses.* A long focal length is desirable in most cases, because it dictates a distant perspective, which minimizes reflections and centering error.

Luminaires for copy. Photographic lights useful for copy works, in order of preference are:

1. *Pan lights:* for all sizes of copy.
2. *Focusing Fresnels:* for small copy and "cross-lighting" large works.
3. *Nooks and broads:* for large copy when used in two groups of two or more lights.
4. *Umbrella-bounced lights:* for use where space is tight.
5. *Undiffused spot/floods:* for emergencies only, since they are difficult to flood evenly and they can "throw" intense heat at the art.

With two 500-watt reflector floods (pan lights), you can evenly illuminate small works up to about three feet square, provided the lights are at least eight feet from the art. Trying to light a larger work will prove fruitless, and you will have to add more lamps on each side of the art. I prefer using two focusing Fresnels for small works, because their beams can be adjusted for matching pools of intensity, and their barndoors eliminate extraneous light from areas outside the copy field, thus reducing lens flare.

Summary of Steps
1. Select a set.
2. Estimate the size of the art.
3. Position the lights.
4. Balance the illumination.
5. Place the art under the light.
6. Set the camera back parallel to the art.
7. Center the camera.
8. Frame the art and focus.
9. Check for problems.
10. Calculate the exposure.
11. Make the exposure.
12. Check the alignment of the camera.

Copy Sets

There are three basic sets for photographing flat art, each corresponding to the direction of the camera axis with respect to the floor.

Horizontal copy sets are used for paintings, screens, and matted drawings, as well as textiles that can be safely hung. The art is either hung on a wall or placed on an easel that is square against the wall, while the camera on a tripod is aimed horizontally at the art.

Vertical copy sets are for matted and loose works on paper, small textiles, and leaves of books. The art is laid on clean background paper or on a low pedestal. Lights are set symmetrically to the sides of the camera, aiming at an angle similar to that described in detail later for a horizontal set. The camera, mounted on a side-arm extension from a tripod, aims downward. Some people feel that hanging a camera over art is foolhardy. Certainly it is dangerous, if you are lax; but, with caution, you can use this set to great advantage. As long as all moveable camera and tripod parts are secured and double-checked, and you move in slow motion, there is no need for distress.

Inclined copy sets are for the faint of heart who don't want to use a vertical set. Large textiles too fragile for wall-hanging can also be placed on an

inclined copy board to permit a greater lens-to-subject distance than would be possible on a vertical set.

Since the relationship between camera, lights, and art is similar in all sets, a description of the horizontal set will illustrate the procedure.

If possible, paint the wall behind the copy non-glossy black or gray. Otherwise, tape a sheet of black seamless paper to the wall, as large as the field "seen" by the lens when the lens shade is in place, to reduce glare. On a permanent copy wall, mark a center line with tape or paint, to indicate the vertical meridian upon which you will center the field of illumination and the art. Such a center line can be any color of medium value, just bright enough to contrast with the wall color. It will show a bit in the photo, but it can be cropped out when printing a black-and-white negative, or masked out of a color transparency in reproduction. Extending this line on the floor, perpendicular to the wall, will help you center the camera.

The Field of Illumination

To assure an even field of illumination, estimate the work's size (or the size of the largest work in a series) and aim for lighting an area about 20 percent larger than that. Smaller works in a series will fit into this field without any further adjustment of lights.

The Standard Copy-Light Set

Deceptively simple in theory, the standard copy-light set is difficult for beginners (and some professionals) to adjust correctly. It consists of an even number of light sources of equal intensity and identical design that are placed symmetrically, at an equal distance to the left and right of the art, so that illumination is uniform over the entire field.

To prevent glare on the art, place the lights at a minimum angle of 45

degrees relative to the lens axis when shooting small copy. For larger works, the lights may have to be as much as 60 degrees to 75 degrees. But if you put them too far toward the plane of the art, their beams will skim the surface, reducing brightness. In addition, illumination will "fall off," meaning that the left and right edges will be brighter than the center. If you cannot move the lights far enough away to prevent glare, try using a longer focal length lens, which may put the camera beyond the path of glare.

Balancing illumination. Imagine that the area to be lit is divided into quarters by a vertical and a horizontal axis. Put two lamps equidistant from the vertical axis, at a height level with the horizontal axis. Turn off all lights except the left copy light; aim that at the copy field and take a reading with an incident meter at the center of the field. Next, turn off this light, and repeat the steps with the other lamp. If the two readings don't match, move the brighter lamp until they do. Now turn on both lamps and meter the perimeter of the field of illumination. This reading should not vary more than one-sixth of a stop; if it does, angle one light to compensate, or move both lamps farther away.

Should two lights be insufficient for even illumination, add one light to each side, but not at the level of the horizontal axis. Instead, place the lights equidistant above and below the horizontal axis, so that each quadrant of the field receives equal illumination. Proceed as before by adjusting one bank of lights at a time.

Occasionally, the standard setup will cause glare on the art's surface, regardless of where you place the direct lights. If the painting is a narrow horizontal, try mounting it on the easel by turning it 90 degrees, so that you compose it as a vertical; that may put the lights far enough away to prevent glare. No one will be the wiser about the way you hung the painting, once the shot is printed with

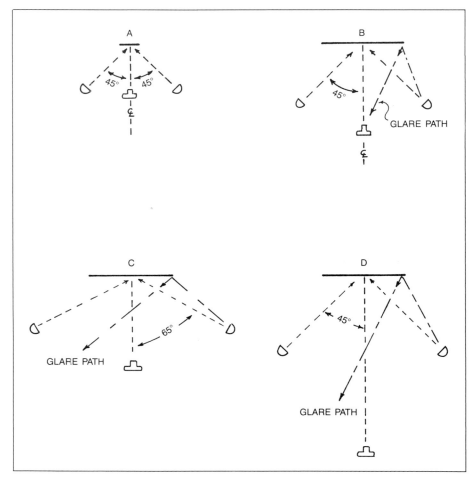

Fig. 11.2. *These sketches illustrate the standard copy light set.* A *is the standard copy light set-up for small originals.*

B *shows what happens when the lights are too close to the optical axis when shooting a large original: glare from the edges of a varnished painting may reflect in the lens.*

C *is one remedy for eliminating glare; when the lights are set 60 to 70 degrees from the optical axis, the glare path misses the lens.*

D *is an alternate solution, using a long focal length lens for a large painting while the lights are set in close. Often, however, glare will still result, so that the lights must be placed at a 60 to 70-degree angle.*

the background cropped out. When this tactic does not work, you may have to hang the painting in the normal way and bounce the lights off the ceiling for an even wash of illumination, with the advantage of a natural "gallery" type of lighting that helps define the art's texture — something not readily possible with the standard two-light setup. However, there are distinct disadvantages to that approach: if the

ceiling is not pure white, there will be a color shift that you must correct with a CC filter, determined by a test; the intensity of illumination will drop, causing a long exposure, with its concomitant problems; and illumination may "fall off" toward the bottom of the art. I use this latter technique regularly with a client whose long triptychs must be lit in a small space; since her ceiling adds a slight yellow cast to the illumination, I

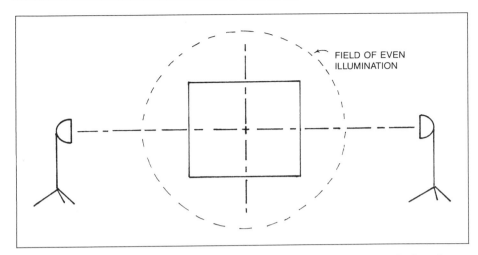

Fig. 11.3. *Here, the point of view from the lens is centered on the vertical and horizontal axes. Two 500-watt pan lights are set equidistant from the vertical axis and aimed inward along the horizontal axis at the center of the field of illumination.*

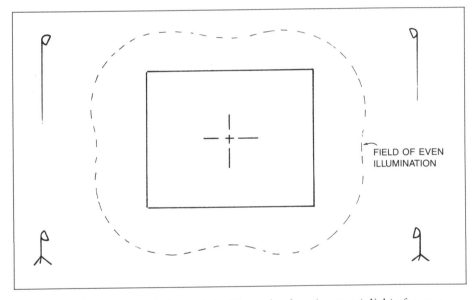

Fig. 11.4. *A large subject to be copied will require four (or more) lights for even illumination. Lights are moved farther away from vertical axis and placed equidistant above and below the horizontal axis.*

add a CC05 Blue filter to the color emulsion's normal filter pack each time I shoot in her loft.

Positioning the Copy

To position the copy for shooting, carefully hang the art on the wall at the center of the field of illumination. If you are using an easel, secure the art with wire looped through the stretcher cross-members or the eye-hooks on the frame and tilt the easel back slightly for safety. Place a gray scale (and color bars, if you use color film) near the copy so that they will be in the photograph and receive full illumination. These are guides for making prints and color separations.

Position of camera to art. To prevent keystoning, make sure that your camera is square with the copy. For horizontal sets, measure the angle of the art's tilt, as it sits on an easel, and transfer that angle to the camera. You can get an angle-finder with a spirit level from a hardware store for a few dollars, or you can use a "torpedo level" and a three-by-six-inch cardboard. Hold or clamp the spirit level in contact with the cardboard and gently place the edge of the cardboard on the frame, stretcher, or edge of the art's surface. Adjust the level until it is vertical. Without disturbing the relationship between the level and the cardboard, carry them to the camera and put the same edge of the cardboard against the camera back. Adjust the tripod head until the spirit bubble indicates that the level is vertical, and the camera back will be parallel to the copy.

Paintings too large for an easel can be set on the floor—which may be a difficult position for lighting them—or they can be placed on low boxes or a riser to elevate them into the field of illumination. In either event, be certain to tilt them against the wall for security.

When shooting downward on book leaves that curl, try wedging the low edge of the book to get the pages parallel to the camera. You can use almost anything that will not harm the book: erasers, wood wedges, etc. You may also need to position a sheet of glass over the page to hold it flat. Use clean, unscratched glass. If reflections are a problem, put black tape over shiny camera parts. With color film, you might want a CC025M filter over the lens to cancel the green cast of glass.

Centering and framing. With the tripod column centered over the axis line marked on the floor, or visually centered on the art, frame a comfortably large image. Too small an image will require a factor of enlargement that makes film grain obvious, while too large an image may

be cut off by slight camera movement while you advance film or insert a holder. Also, 35mm slide mounts might cut off image because of inaccurate viewfinder framing. Vertical centering should be done by raising or lowering the tripod column, *not* by tilting the head, as this will cause keystoning.

If the art is warped or irregularly shaped, it will appear keystoned, no matter how carefully you approach it. Just remember, in *those* situations, that the condition of the object photographed is not your fault. Although you might be able to "correct" its shape with the rear standard of a view camera, you would be making a false document by doing so. However—remember also that if the copy is perfectly flat and rectangular, but your *image* is keystoned, *the camera is not aligned properly,* or the rear standard of your view camera is swung or tilted accidentally.

Focusing. Focus on one edge of the art, then check the opposite edge. If that edge is unsharp, one of three reasons may be the cause:

1. The art may be perfectly flat, but the camera may not be parallel to it.

2. The art may be flat and the camera back may be parallel to it, but the two standards of your view camera are not parallel to each other.

3. The art may be warped. With 35mm cameras, focus in the center of the copy and stop down sufficiently to render both edges sharply. With view cameras, rotate the lens standard around the appropriate axis. With the right optics, you should be able to get all four edges sharp at full aperture. To expose, stop down at least two stops to correct residual aberrations. Using the smallest apertures will magnify diffraction effects, deteriorating the image.

Checking for Problems

Look carefully at the painting by moving in front of the camera so that your head is directly in front of the lens and *you* see what the lens "sees". Is there any glare that obliterates surface detail? If there is, you may have to re-adjust the lights or move the camera farther away. Are there shadows on the art from the picture frame, or from a forgotten stand left in front of a light? Simple errors like these have caused me several re-shoots. Are all the bulbs still burning? In a multiple-light set-up, one burnt-out bulb is easy to overlook.

Exposing the Film

With camera and copy correctly positioned, the art properly centered and framed by the lens, the camera focused, and no extraneous problems detectable, take a final meter reading, double-checking the International Standards Organization Exposure Index setting. When calculating the exposure, don't forget to account for the reflectance of the art—is it predominantly dark or light? Are you using a filter that requires exposure compensation? Must you increase exposure due to bellows extension for a close-up? Is your exposure to be so long that reciprocity characteristics of the film dictate an additional exposure increase? Calculate these factors in a notebook for future reference.

With filters in place, stop down the lens to the taking aperture and look through the camera. Ask yourself, "At the calculated shutter speed and this aperture, would I get the right exposure if my eyes were film?" If you do this *every* time you make a photograph, two things will happen: you will gain a "second vision" capable of anticipating how film responds to light (provided you consistently use one type of film for color and one for black-and-white); and you will become able to judge any flaws in calculations.

Make sure you have loaded your camera or film holder with the proper film. It sounds like an impossible blooper, but many professionals have made what might have been award-winning photographs—with an empty camera.

Finally, tighten all tripod handles and re-check focus. On a small- or medium-format camera, tape the focusing ring in place. On a view camera, lock all controls. If your camera has a mirror lock-up and an eye-piece blind, use them now. If you are using a view camera, cock the shutter, insert the film holder, and pull the slide. With any camera, wait ten seconds after touching the camera to let it settle.

Relax and gently press the cable release for the duration of exposure. During this time, look at the art, try to see it as clearly and objectively as possible. Imagine it as a print, slide, or transparency. If you must print the negative or evaluate the color later, when the art is inaccessible, your memory will have to serve as your source.

Final Checking

After exposing all frames or sheets of film, open the lens aperture and look through the camera. Is it still framed and focused properly? It is surprising how easily a tripod can seemingly slouch, or a lens drift out of focus during exposure.

Flat Art: Illustrations, Basic Class

Routinely, the standard copy set of two or four lights is sufficient for 90 percent of the work of photographing flat art. When the lighting must be altered, the approach is usually obvious and simple. The following photographic examples include tips on exposure, development, and printing for black-and-white film, as well as guides on shooting color.

Following that is the "Master Class" section—photographs illustrating some ways of handling situations in which the standard approach is inadequate.

Figure 11.5

Figure 11.6

Figs. 11.5 and 11.6. *These two works of art are typical of many prints and drawings that are easily shot, using the standard copy set with two lights. The Japanese print (figure 11.5), having a full range of tones, was given normal exposure and development, then printed on contrast Grade 2 paper. As an aid to the darkroom printer, I included the gray scale at right, which gives a clue to the contrast range and density of the negative. At left is a color bar, which, along with the gray scale, is analyzed by the photographer and the production team for color balance. Also visible is black paper, placed over the art's white mat to reduce flare. When using black paper like this, keep it an inch or so from the border of the art, to prevent uneven development of the negative. This phenomenon, called* adjacency

effect, occurs along the sharp line between two large areas of high contrast. Normally, the paper and guides are cropped out for reproduction.

Although works on paper are easily shot in a vertical set, I chose here to use an inclined easel, because this was one of several hundred prints photographed in succession on two formats. With each camera on its own tripod, changing cameras and composing was easy for me and safe for the art.

By comparison, the gem by Man Ray in figure 11.6 is a short-scale subject that contains no gray tones—at least, conceptually speaking. In other words, when we look at an original like this, we can see the paper support

on which the artist drew; however, since we think of the paper as white, we may be tempted to translate it photographically as a toneless value, misleading a viewer. Instead, there should be a faint gray tone that suggests paper. Thus, in a print or reproduction, the drawing paper that served as the artist's basis of space will be "framed" by the white stock of the photo print or book page. The means to achieve this are easier to come by than a clear discussion of the reasons they are used. Give such subjects normal exposure and development, but print them so that a faint tone is barely visible when the print is wet. Judging the density of wet prints is tricky, since all papers "dry down" 2 to 4 percent darker than they appear in the wash.

Figure 11.7

Fig. 11.7. *In photographing print material with fine lines, you might think that you need a high-contrast line film, such as Kodalith. But this approach, as well as printing on high-contrast paper, is usually not necessary or advisable, because the results do not look like the original art. The scene at left, which may depict the way families passed the time on Sunday afternoons before the invention of television, was shot on full-tone pictorial film. Copy lighting, exposure, development, and printing were standard all the way, to retain the subtlety of line and paper tone of the art. This film and technique are applicable to the majority of prints made by engraving, etching, drypoint, pen and ink, or lithography.*

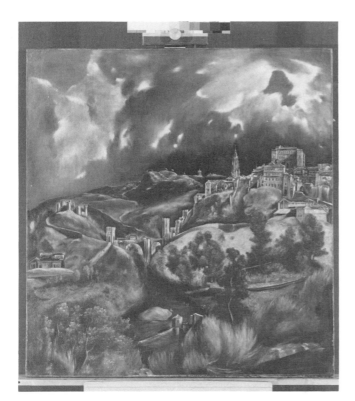

Figure 11.8

Fig. 11.8. *I used a standard four-light copy set to make this black-and-white shot of E1 Greco's* View of Toledo, *which illustrates exposure problems found with many oil paintings. Seeing this work on a museum wall, the casual observer would have little reason to interpret the colors into gray values, but anyone photographing it in black-and-white must be actively aware that that will happen. By comparing the gray scale to the painting, I saw that most colors would translate into very dark tones, causing a loss of shadow detail, unless I increased exposure by about one full stop over the incident meter reading. A reflected meter would also have been fooled, but in an opposite manner—its reading would suggest an increase of two stops over an average subject.*

Since I was using large-format sheet film, I could reduce the development by about 10 percent, to compress the contrast range of the negative, so that it would print on Grade 2 paper. Had I used roll or cassette film, I would not have been able to decrease development without adversely affecting all other frames on the roll. Under those circumstances, I would have printed this image on Grade 1 paper.

A transparency of the same painting (color plate 2) also required a similar increase of exposure; but since underdevelopment was out of the question, there, as was suppression of contrast through printing manipulation, I bracketed exposures in increments of ⅓-stops, to insure that one shot had important tones present at each end of the brightness spectrum.

Figure 11.9

Figure 11.10

Figure 11.11

Figs. 11.9, 11.10, and 11.11. *While most textiles can be lit with direct floodlights or umbrella lights in a standard copy set, some require experimentation in luminaire position to introduce contrast. The floral fabric in the Rose Textile was made in such a way that each change in lighting direction caused a marked change in the tonal relationships of the patterns. Figure 11.9 was lit by one umbrella source, slightly off the lens axis; consequently, as the reflection and intensity of light modulated from top to bottom of the field, the tones reversed. Although this phenomenon is natural, it seems like a mistake unless explained.*

Figure 11.10 was lit by two equidistant focusing Fresnels placed to the left and right of the textile in a standard copy set-up. (Note arrows at bottom of photo.) Because these lights struck the art against the bias, the flowers appear dark against a light background.

The lighting for figure 11.11 was identical to that for figure 11.10, except that the lights were moved 90 degrees, so that they struck the cloth from the top and bottom of the image field. Here the lights are in the same general direction as the bias, and the flower-background tones are automatically reversed.

Choosing the best rendering is a subjective decision, since no one plate is "right." After all, there are no tricks involved here; things appear differently, as light changes. Not to beg the question, I would choose figure 11.10 as most informative of the three, simply because it reproduces more clearly.

Flat Art: Illustrations, Master Class

In those special situations when the standard approach is inadequate, you will have to reach deeper into your bag of tricks to find a solution. The following examples include some ideas about ways to broaden your repertoire and improve your technique in lighting and camera handling.

Figs. 11.12 and 11.13. *Figure 11.12 does not look like a shot of a relief work, but it is. The standard copy lights of equal intensity caused symmetrical shadows from the raised areas, and these shadows look like paint. To improve legibility for figure 11.13, I turned off the copy lights and used a 2-by-2-foot soft light, raised high above the art at camera right. This gentle wash of light, only a couple of feet from the subject plane, caused those raised edges nearest the source to be dazzling white, while the shadows from the protruding mass revealed depth. To minimize fall-off of intensity, I put sheets of white paper at camera left and bottom for fill.*

Figure 11.12

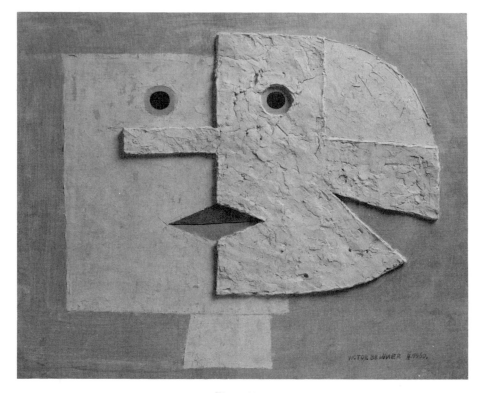

Figure 11.13

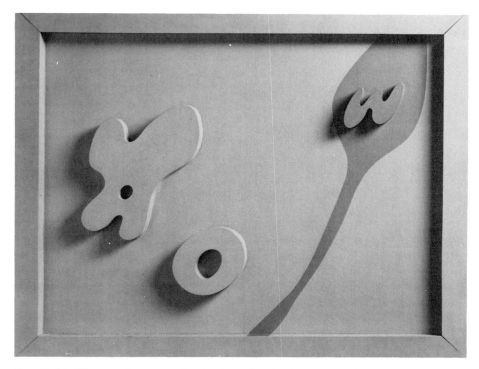

Fig. 11.14. *The wood construction by Jean Arp in figure 11.14 is another example of flat art bordering on being sculpture, like* Expulsion Reintegration *in the two preceding shots. Lighting for the Arp work was identical to that for figure 11.13, but as an added clue to the depth, here, I put the camera off-center. See figure 11.15.*

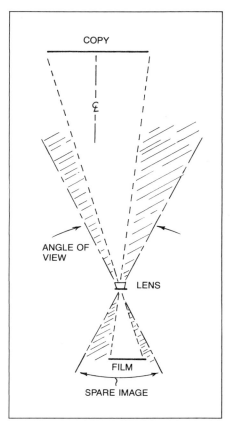

Fig. 11.15. *To prevent keystoning, in figure 11.14, the camera back had to be parallel to the subject. This dictated that I shift the lens standard to the left and downward, to center the art's image on the view camera ground-glass. A lens with a large circle of good definition was essential, here, to avoid poor edge definition, or possible vignetting of the upper and lower right-hand corners. Small- and medium-format cameras require a PC lens (perspective control or shift lens) to shoot off-center without keystoning.*

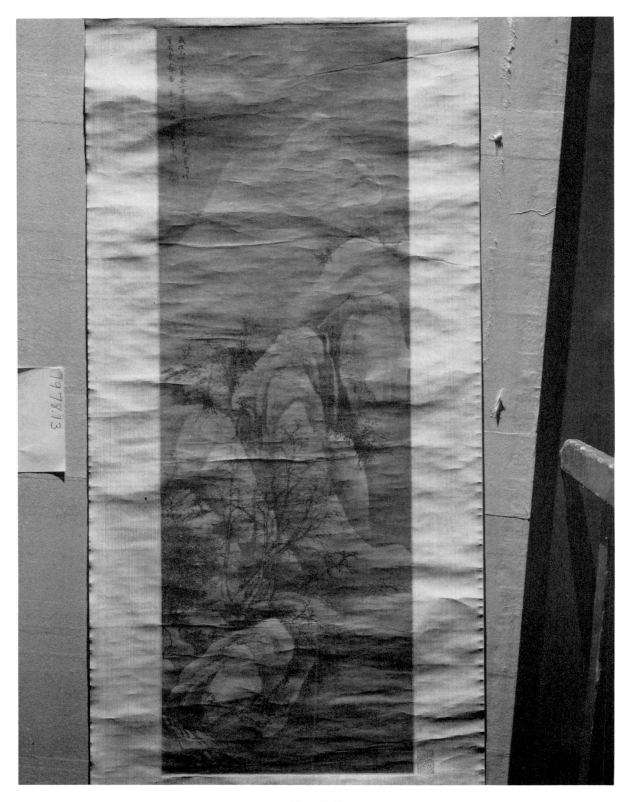

Figure 11.16

Figure 11.17

Figs. 11.16 and 11.17. *The Metropolitan Museum's team for conservation of Far Eastern Art often documents works on silk or paper prior to restoration, to find clues to the extent and position of damage. For the paintings in figures 11.16 and 11.17, I used one focusing Fresnel with barndoors, placed about 80 degrees from the lens axis for raking light.*

Because the 2-by-7-foot painting in figure 11.16 was fragile, the conservators laid it on the floor. To reduce fall-off, I put the luminaire some twenty feet from the upper *end of the painting and aimed the more intense portion of its beam at the* bottom *end. From a ladder, I scanned the reflectance of the border, which is a uniform tone, using a spot meter to detect uneven lighting. Although the 8-by-10-inch camera was mounted high, on a heavy Saltzman stand, I still needed a wide-angle lens. Being of early vintage, this lens suffered from curvature of field; so I focused halfway between the center and one end of the painting, and shot at f/32 for depth of field, to pull in a sharp image across the surface.*

Figure 11.17 is a tiny detail of another painting, lit identically. But the lens used was an apochromat, since the magnification in-camera was about 3X. Any vibration at large magnifications will cause a blurred image, so, in such situations, with tungsten light, I do not use the shutter for exposing. Instead, I turn off all lights, open the shutter (using "Bulb" setting, on a small camera), and flip the luminaire's switch to control the exposure time. The taking aperture here was f/45, which, at this repro ratio, increased depth of field to a whopping quarter-inch (six millimeters).

Fig. 11.18. *Normally, a folding screen is stretched flat, leaned against a wall, and treated as a painting; but for this photograph, the curator wanted the screen standing, zigzag fashion, as it might in situ. Background was a problem, here, because a regular nine-foot width of seamless paper was not large enough for the twelve-foot-long screen. With an assistant's aid, I stood a roll of seamless vertically against the wall at the left side of the subject field and unrolled the paper toward the right side, taping it to the wall as I went. When we reached the right side of the subject field, we cut the paper, laid the roll on the floor—again, unrolling it crosswise to the camera axis—and unrolled enough paper to fill the subject field where the screen would stand. I cut a hole in the floor sheet and threaded the cables for two pan lights, which were to sit on the floor behind the screen, aimed at the background, to give a soft glow around the subject for increased depth and drama. This "utility hole" was near the wall, out of sight of the camera, and allowed the cables to run behind the paper to an outlet. To eliminate a seam where the two sheets of paper overlapped at the wall, we carefully applied double-faced tape. Evenly lit, the screen would have seemed flatter than it appears here, with little clue to its configuration other than the outline. Consequently, I lit three of the panels brighter than the others, using about three times the number of diffused pan lights at camera left as I used at camera right. Because the subject had so much inherent contrast, I had to shoot several tests to gauge the reflectance of the brilliant gold leaf in relation to the dark green leaves and blue irises. After each test negative, I readjusted the lights, to modulate glare, until the balance was right. To keep the glow from the backlights from being too bright and making the screen look radioactive, I double-diffused them with tracing paper.*

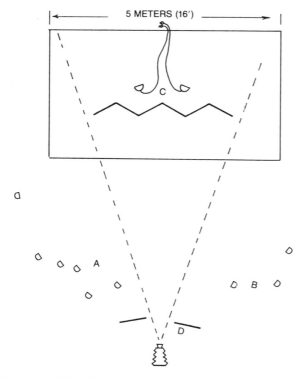

Fig. 11.19. *Plan view of the lighting arrangement for the Japanese screen of irises (figure 11.18), showing main lights—reflector floods (A) and fill lights (B), with two gobos (D), to left and right of the camera. Two pan lights (C) behind the screen served as background lights.*

Fig. 11.20. *Certain works of art—
paintings with metallic pigment,
illuminated manuscripts, early
American silhouettes with penciled
details—require a faint light placed
near the camera to perk up the
reflective medium when standard copy
lights alone do not show the features
clearly. Ideally, this extra illumination
will be as near the optical axis as
possible, to cause a slight glow
consistently even across the work's
surface, with no harsh glare spots. The
easiest way to accomplish this is to use
a ring-light, which is a special light
source, usually circular, that fits snugly
around the lens. However, ring-lights
are strobe lights, and that means that
the main lights must also be strobes, if
color film is used. For this shot, I used
only tungsten pan lights: two 500-watt
lamps at each side of the set, in
standard configuration, to overpower
the two diffused 250-watt lamps near
the camera—a lighting ratio that
prevented the axis sources from
causing an unholy glare. For most
works of this nature, the main lights
should be about five stops brighter
than the axis light, a ratio that can be
determined by metering each group of
lights independently.*

*When using a view camera with axis
lighting, try setting the camera back
off-center, laterally shifting the lens
while keeping the film standard parallel
to the copy (see figure 11.15) and put
the axis light(s) on one side of the
camera to get the reflective glare even.
If the camera is kept centered on the
art, with lights on either side of it, the
camera's bulk may cause the axis
lighting to have a dark hole in the
center of the copy. To tame and
modulate the axis light further, you
might diffuse it with a sheet of
translucent Plexiglas.*

Fig. 11.21. *Plan view for one method of
lighting a painting set in a deep frame,
so that shadows cast by the frame onto
the art are minimal.*

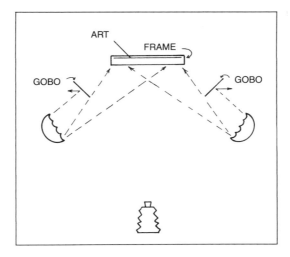

Figure 11.22

Figure 11.24

Figure 11.23

Figs. 11.22, 11.23, and 11.24. *Nearly all paintings arriving at the Metropolitan Museum's photo studio come in unframed, which is a bit of luck for the photographers, since shadows cast by deep frames onto a picture canvas are difficult, if not impossible, to eliminate. One method of lighting framed works for photographing is to set a gobo between each light and the copy, as in figure 11.21. Any luminaires will work, but umbrellas are easier to use than others. Since the left source illuminates the work's right half, and the right source illuminates the left half, you must check evenness of lighting at all corners carefully with either an incident meter, or a reflective meter aimed at a gray card placed near the copy. With the baffles set about halfway between the sources and the art, there will be no shadow from either the gobos or the frame.*

 The Gaddi painting in figures 11.22, 11.23, and 11.24 illustrates a similar technique of cross-lighting: the painting was set deep within a massive frame liberally decorated with gold leaf. Because the eight-foot-long work straddled half the studio, the acute angle between the lights and the art created glare, as well as frame shadows. My unorthodox set-up consisted initially of one 1500-watt focusing Fresnel with barndoors at each side of the subject. The light at camera left illuminated the painting's right half, and the light at camera right illuminated the painting's left half. After checking each light's intensity independently, I exposed one negative to each source and processed the films together, to eliminate development variation in contrast and density. Sandwiching the two films in register near a light box, I saw that the two patterns of illumination overlapped at the Madonna, making her brighter than her fellow saints. I feathered one barndoor leaf, to smooth the light, and then switched on two large "scoops" hung from the ceiling to give the entire work an even wash of soft light that defined the frame and its depth. Lastly, I laid a strip of white paper on the floor for fill, to prevent fall-off at the bottom of the painting. Figure 11.24 shows the final lighting.

Photographing Three-dimensional Art

Choosing a Perspective

Owing to the enormous diversity in types of objects that qualify as art, I can give only the broadest outlines for picking a point of view for photographing three-dimensional art. For clarification, there are common terms used to describe the relative positions of subject, lights, and the camera. Perspectives on three-dimensional objects representing human figures, as well as some other kinds of art, are attributed "proper" aspects. *Proper left,* for example, refers to the *object's left side*—not to that side of the object which is on *your* left as you face it. If you get instructions to shoot an object "turned left," find out exactly what is meant.

Standard as these terms are in "artspeak," I've elected to describe lighting arrangements in the following section *according to the subject space as seen from the camera. For example, a light placed outside the left edge of the image frame is said to be "camera left."* Other terms include the *camera axis,* also called the optical or lens axis, which is an imaginary line extending from the film toward the subject as sighted through the lens; the *subject plane,* extending through the subject at a position parallel to the film plane; and *eye-level camera position,* which describes a horizontal camera that is usually focused on a tabletop set.

The majority of perspectives will suggest themselves through common sense, and in those situations where there is doubt, pick the one that clearly shows the work's characteristic form for quick identification of its species. Once this becomes obvious to your viewer, the work's unique qualities can emerge through your lighting. You would show a teapot, for instance, at eye level in profile if only

one view is needed; that perspective shows the shape of the pot, the spout, and the handle, as well as the way they are connected.

Certain objects, such as architectural elements and altar sculpture, are often seen *in situ* from a low perspective, suggesting a similar camera position. Decorative objects often look best when seen from eye level or slightly higher, although a *very* high angle may cause some subjects to appear small and squat.

When no one point of view rivets your attention, walk around the subject, considering it from all angles, while looking for interesting lines, informative contours, and legibility. Watch for optical confusion caused by overlapping parts or shadows as you formulate your shot while the object sits under your mainlight at its tentative position (see "Lighting a Three-Dimensional Work," below). Try to find a dynamic equilibrium between sense and imagery by appraising the art, as both an object to be realistically documented and as a pattern of abstract graphic shapes within a frame; when appropriate, regard the subject and its camera image in terms of beauty. (Before I became a photogapher, I assumed that *all* art is beautiful.)

Composition and Framing

There is no reason to get high-flown in discussing the composition of a single work of art; in most situations, you will simply center your subject in the frame and balance the tonal values of the background, the shadows cast by the art, and the tones of the subject itself. The process is integral with choosing a perspective and lighting the art. Composition of a group of objects, however, is another matter. Dictating the arrangement of several components in a "pretty pattern" is the requisite of legibility of form for

accurate identification of the individual objects. Usually, each work must stand clear of its neighbor, to preserve clarity of outline; but sometimes you can overlap objects slightly, to unify an assortment of otherwise fragmentary, disparate objects that cause a viewer's eye to wander aimlessly around the photograph. Since tangent outlines can be quite disturbing to some

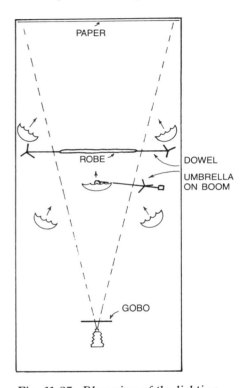

Fig. 11.25. *Plan view of the lighting arrangement for Manchu Dynasty court robe of the Empress Dowager T'zu Hsi, above. (See Plate 18 for the photograph in color.) Set-up included five Tota-lights in umbrellas, a long focal length lens, and a gobo. Two Tota-lights were stationed in front of the subject, one on either side; a third was centered on a boom above the robe; two behind the subject plane lighted the paper background. The gobo—black cardboard suspended between two stands—kept the light beams from shining in the lens, where they might cause flare or "ghost" images on film.*

viewers, either separate or overlap two objects to maintain a soothing image. In general, place the largest or optically heaviest work near the center of the frame, to maintain a stable shot whose optical center of gravity cohesively binds all parts by pulling them inward. After all, you are trying to present the art with a minimum of distracting photographic virtuosity or peculiarity.

Framing a shot is important, because if the subject(s) crowd the borders, a number of problems can occur: a sculptural head in profile will seem claustrophobic if its nose is crammed into the frame; the camera may shift as you advance film, causing the subject to be cropped off; uneven development or mechanical damage along the film edge may be so close to the subject that it cannot be cropped out in printing. But the chief reason to leave a generous space around a three-dimensional object is to allow a graphic designer sufficient

scope to crop to the best proportions for a layout. This presupposes that background paper fills the frame, of course. Loss of quality due to a slightly small image of a work is negligible, as long as the image is not

minuscule. Exceptions to the above include slides not intended for publication and flat art that will be cropped to its rectangular edges. With these subjects, the art can be made fairly large in the frame.

Figure 11.27

Figure 11.28

Figure 11.29

Figure 11.30

Figs. 11.27, 11.28, 11.29, and 11.30. *Lighting experiment, four views: When is a white object gray? When it is lighted properly, to show form in a photograph. The white teacup and saucer in the four photos here were lighted in different ways, with a large soft light, to dramatize changes in legibility and separation from the background. Figure 11.27 was photographed using a front-light; figure 11.28, with a top-light; figure 11.29, with a sidelight from three-quarter elevation; figure 11.30, also using a sidelight from three-quarter elevation, but on a gray background.*

Fig. 11.26. *Lighting sculpture: eight basic camera angles can be used for photographing a representational sculpture, but seldom are more than two or three used for primary documentation. These are the front view, three-quarter front, and profile.*

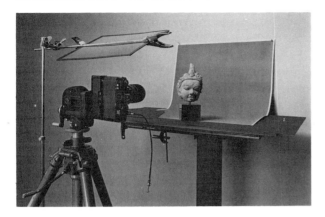

Figure 11.31

Figure 11.32

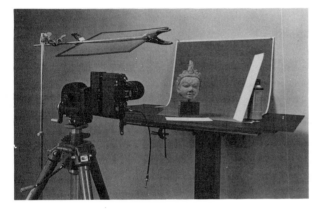

Figure 11.33

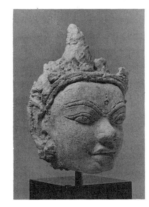

Figure 11.34

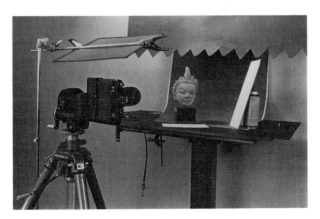

Figure 11.35

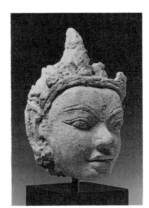

Figure 11.36

Figs. 11.31, 11.32, 11.33, 11.34, 11.35, and 11.36. *These three pairs of photos show the basic steps in lighting a work in a tabletop set. For figure 11.31, I covered a pedestal with black paper, to control the lighting, and pinned a sheet of Coloraid paper to the homosote wall, letting the paper sweep over the pedestal in a gentle curve. After putting the art on the paper, I chose a point of view, set the camera with its zoom lens at that position, and framed the subject. While moving the main light around the subject, searching for characteristic modeling of the head, I decided that toplight would be best, and attached the single Tota light to a boom (not shown). The card on the clamp blocks light from the lens, as the vestigial lens shade for the zoom was insufficient. Figure 11.32 shows the head from the camera's position. Here, the overall effect is passable, but the chin and proper left cheek are too dark, and the contrast range is too great to record all important tones on film. Figure 11.33: I added two white card reflectors, whose effect is apparent in figure 11.34. Still, the image lacks depth and impact. To separate the head further from the background and cause it to seemingly emerge toward the viewer, I darkened the background at the top of the image field by lowering a large black card gobo behind the subject plane. This gobo, taped to another boom cropped out here, was cut to a jagged edge, which helps feather the shadow thrown on the background. The final lighting appears in figure 11.36.*

Lighting a Three-Dimensional Work

Our perception of three-dimensional space is based largely on only a few factors: binocular vision, the comparison of the relative sizes of known objects, the overlapping of objects at different distances, the relationship of object positions to the ground, desaturation of color caused by haze on distant objects, and recognizable form caused by the modeling of light.

Most of these visual clues for interpreting the world are not available for deciphering space and depth in planar photographs of art: camera vision is *monocular*; if only one object is photographed, comparison of relative sizes and the overlapping of objects are both impossible; works placed in a formless environment cannot easily be related to an indefinite ground that has no horizon line; and haze in a studio is seldom present. That leaves the graphic modeling of light— chiaroscuro—as the main tool for conveying form and depth.

The easiest way to introduce chiaroscuro is to choose a fairly bright, large source as a main light and experiment by placing it about 45 degrees from the camera axis and aiming it down at the subject at 45 degrees. Compare this effect with that obtained by moving the light to the other side of the axis. Then try toplighting, with the source (on a boom) just in front of the subject plane, as well as sidelighting with the source near the subject plane but lowered to the subject's level. While playing the critic, visualize the image, with all important information and the emotional content intact. Perhaps the source is too far from the art, causing sharp shadows; when moved closer, the light will seem softer, but intensity may fall off across the subject. If that happens, try a larger, but not necessarily brighter, light

source from farther away. Once the main light is set, add or subtract light as needed to reveal information without destroying the mood. If you add a secondary luminaire, test the effect of each source independently.

How much fill do you need? I should guess that, in general, you will need more than appears necessary to your eye, because the photographic process tends to compress the tonal range, causing loss of highlight and shadow detail. If that answer is begging the question, try analyzing your lighting ratio, comparing the brightness of the main light to the fill. For example, a 500-watt lamp on the left of the subject and a 250-watt lamp on the right will create a ratio of 2:1. Boost the left wattage to 1,000 watts, and the ratio becomes, mathematically, 4:1; but the effect on exposure may be different from what that implies, because the main light is now only *two stops* brighter than the fill. Increase the main light to 2,000 watts, and the ratio is 8:1—three stops brighter than the fill. Following the rule of thumb, you should aim for a maximum ratio of 8:1 for black-and-white, and a ratio of 3:1 for color film.

However, that approach only appraises the light *falling on* the subject and sometimes has little bearing on the amount of light *reflecting toward the lens* from each part of the subject. Since it is reflected light that you are photographing, back up your visual judgment by using a reflective-reading meter to compare lighting ratios on the highlight and fill sides of the subject when possible. You can use your 35mm camera's TTL meter by coming in very close to the subject, or use a 1-degree spot meter from a distance.

You may find that—because of the particular reflectance of a subject, its contours, its shape, its color contrast, etc.—your lighting ratio can be much higher or lower than the guideline.

Check your progress often by moving in front of the camera and putting your head in front of the lens, verifying the scene the lens frames; at the final stages, look through the camera. Often a minor shift in the main light is necessary after secondary sources for fill have been set, but don't drive yourself crazy by constantly moving the lights, because that will change the balance. At some point, perfectionism must yield to a commitment by your reaching a decision.

If there is one rule I observe in lighting, it is this: *Use as few primary sources as possible and fill shadows with reflectors, rather than with luminaires.* That way, the contrast range is easier to control, fewer harsh shadows are cast on the background (shadows are graphic elements), and the lighting looks more natural. Of course, many situations require several sources: large furniture, group shots, rooms, tent sets, and so on. Used deftly, however, even many sources can create an image in which the lighting does not shout for attention.

My philosophy in lighting is simply to create an environment appropriate to each work of art. If the spirit of a work can emerge, to reveal itself through a dynamically lit form, then the lighting becomes a context for the art, and not just some bright stuff aimed at the art to get a sterile record.

Separating Subject and Background

In lighting an object, you may work hard to get the important features clear and the mood just right, only to discover that a portion of the subject's outline blends with the background, making them indistinguishable. A slight adjustment of the light or a reflector may correct the flaw, but that often upsets the balance.

As an exercise, try lighting a white object on a white background, using

one source at several positions. (The prints in Plate 9 look like an exercise, but were, in fact, an actual job.) Expose film at each source position and make prints. Continuing the practice, add a white card for fill; that may make it easier to get both separation and a better rendering of the subject. A variant on the exercise is to shoot a white, a medium-toned, and a dark object, each, in turn, on a white, a gray, and a black background (for a total of nine shots). Note the way the mood changes as you discover the most effective method of showing each work while making a clean separation of outline. If you continue to work with different types of sources, you will quickly build a repertoire capable of solving many problems.

You can alter the tonal contrast between the edge of an object and the background by adding or subtracting light from either. I start by picking a paper whose tone I predict will make separation easy—within the context of the environmental atmosphere I want to create—and concentrate on lighting the art while watching separation out of the corner of my eye. Once the art looks right, I add or, more often, subtract light from the background, as needed; also, varying the distance between the object and the sweep of paper sometimes helps.

As a final check, I stop down the aperture halfway and look through the camera. This introduces a "squint" to my vision equivalent to the way the film will see the image, so that faint tonal distinctions that might merge in the final print become obvious.

You will note further along in the three-dimensional examples that I sometimes flirt with subtle tonal separation, rather than always boldly making the object tone stand out at every point of its outline. This personal stylistic quirk has cost me a reshoot more than once. My advice is

to omit that sort of play at finesse until you have mastered separation the easy and obvious way.

Record photographs are normally shot using a white or a pale gray background, but you might get clarity easier, with light-toned subjects, by using a dark-toned paper. For beginners shooting black-and-white film, a colorless paper will be less confusing than a colored one. Of course, if you set up a color-film shot on colored paper, and then must also shoot the same set-up with black-and-white film, you can keep the same paper, as long as there is ample separation; if there is not, change the paper. For example, a bronze sculpture shot on blue paper will stand out because of *color contrast;* but in black-and-white, the color of the bronze metal and the paper *tones* may be identical.

Color backgrounds. Selecting the appropriate color of background for each object is a complex process and—a potential point of controversy between you and many viewers who see your photos. It's a curious truth, but the wide range of colors available never seems to be quite wide enough for finding the perfect photographic background. And, to complicate matters, background colors rarely record on film exactly the way they appear to the eye.

Many curators I work with feel that, for certain subjects, *any* color in the background is wrong, as it jars the viewer's attention, alters the emotional impact of the subject, and warps the historical context of the art. That point is hard to argue with. Many subjects simply look better against white or gray, choices that eliminate problems of "color contamination" caused by reflection of the background color into the art's surface. On the other hand, certain subjects beg for a color to augment or enliven the image. Of course, editors and publishers of art books like a

sprinkling of vivid and varied colors throughout book pages, to help attract the attention of buyers browsing in shops. But even there your sense of theatrics must be restrained by a rational allegiance to the subject you are working with and to what you believe was the artist's intent.

As subjective as the process may seem, there are empirical factors you can learn as aids in choosing colors—factors based on the rich and intensive studies of color made by scientists and artists throughout history. For example, in addition to the emotional effects that background color may have on the art, there are unavoidable *physiological* changes that occur in our perception of a work, caused by the phenomenon of *simultaneous contrast.* According to Johannes Itten, a pioneer color theorist, when we look at any color, our eyes spontaneously generate its complementary color, and our apprehension of the original is profoundly altered. Itten writes:

> The simultaneous effect occurs not only between a gray and a strong chromatic color, but also between any two colors that are not precisely complementary. Each of the two will tend to shift the other towards its own complement, and generally both will lose some of their intrinsic character and become tinged with new effects. Under these conditions, colors give an appearance of dynamic activity. Their stability is disturbed, and they are set in changeable oscillation. They lose their objective character and move in an individual field of action of an unreal kind, as if in a new dimension. Color is as if dematerialized. The principle that the *agent* of a color sensation does not always agree with its *effect* is fully operative (italics mine).[1]

Although Itten claims that the effects of simultaneous contrast cannot be photographed, it seems logical to assume that a color photo will create its own set of color

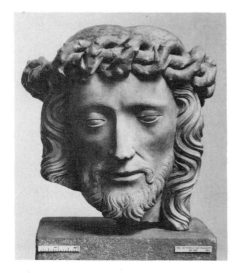

Figure 11.37

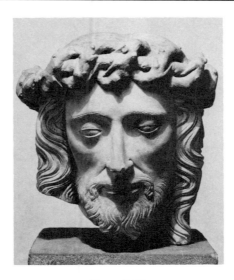

Figure 11.38

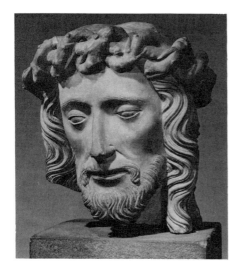

Figure 11.39

Figs. 11.37, 11.38, and 11.39. *These photographs show three images of the same head, shot at time intervals of several years apart, by different photographers. They show changing styles in lighting that affect the mood of the work. Figure 11.37 was made in 1932; figure 11.38, in 1945, by Charles Sheeler; figure 11.39, in 1958. Note the differences in main light position, lighting contrast ratio, and separation of object and background.*

effects, caused by the interplay between art and background. Clearly, choice of background color is vital in conveying an accurate photographic impression of a work. If you are serious about gaining insight and mastery over your craft, experiment with various backgrounds for each of several subjects, and keep your slides on file for reference.

Learn by Study

When I first became interested in photography, I scoured magazines, looking at photos and clipping the ones I liked for my files. By analyzing a wide range of images—still-life subjects, fashion, portraiture, and illustration—I found that photography began to lose some of its magic, but I gained an understanding of studio technique.

You can amplify your repertoire by playing a game when researching other photographers' work: which format was used? What lens? What film—fast or slow? Where was the main light set? What was it— umbrella, tent, soft light? Where was the fill? Was it enough, or too much? Is the overall mood soft, harsh, bland, exciting, depressive, upbeat, cool or hot? Are the angle of view and the lighting appropriate? Eventually, you may find that, when you look at a photograph, you will see much more than just what is inside the frame.

Three-dimensional Art: Illustrations, Basic Class

The following examples were shot using only one light source and a card or two for fill. Progressing from set-ups using the inexpensive pan light to those with spotlights, on to umbrella lights, and finally to soft lights, the examples show the variety of media you can shoot with simple tools.

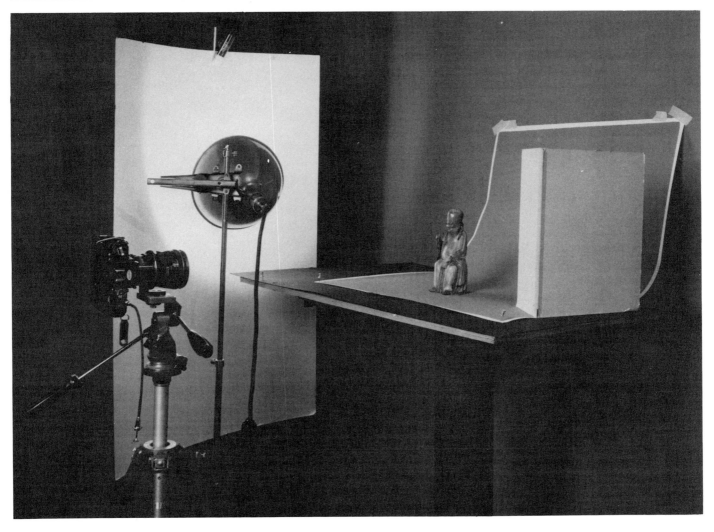

Figure 11.40

Figs. 11.40 and 11.41. *Before you spend a chunk of cash on a sophisticated new luminaire, remember what tremendous things can be done with cheap equipment and a little work. The faithful pan light may not give the most sumptuous quality or be the easiest source to control, but as figure 11.40 shows, it can get you through a lot of film successfully. Reflecting off a white card, pan light illumination was ideal for this ivory statuette when augmented by a small white reflector at camera right. This no-frills approach may cause trouble with color film, however, because reflected light sometimes has a slight yellow cast that may require a CC05 Blue filter over the lens.*

Figure 11.41

Fig. 11.42. *Since the mannequin and her garment were of secondary importance to the pendant being displayed here, I concentrated on presenting the pendant as dramatically as possible while maintaining legibility. I hung a large white card at camera left and bounced a pan light off it, for a broad, directional glow. The reflection of this card is visible as a faint, jagged line along the mannequin's right cheek and neck; the tiny glare spots on her forehead and neck, however, were not from my light, but from another photographer's set, some thirty feet behind my camera.*

Illumination on the pendant required delicate modulation to make it glow as silver and reflect a faint gray tone to represent concavity and surface texture. I accomplished this by watching the effect of moving the light around the card with one hand and twisting the card with the other. The lack of distinct tonal separation between garment and background was a purposeful decision, made to heighten the viewer's attention on the pendant through contrast with its surroundings. Seemingly unimportant, the exact outline of the shoulders was left to the viewer's imagination.

Figs. 11.43, 11.44, 11.45, and 11.46. *Ideally, the lights for each work of art to be photographed should be tailor-made, taking into account the object's medium, the main contours that give legibility, and the important details. In the workaday world, however, small sacrifices in quality must sometimes be made, simply to save time. To minimize such sacrifices, when a series of objects of similar size or similar media must be quickly photographed, you can group the objects according to the basic lighting formulas appropriate to each category. Then, within the basic formula, minor but significant variations in lighting can be made to enhance specific qualities or details of each work of art.*

The coin in figure 11.44 and the cameo of Alexander the Great in figure 11.43 were lighted with a low, raking pan light some three feet from the object at the upper left subject field. Diffusion for the cameo was through a 4 x 8-inch (10 x 20-centimeter) piece of tracing paper propped on the background near the art with two clothespins; by raising or lowering the light or by moving the diffuser toward or away from the subject, I could vary the lighting effect. Fill light on Alexander's face came from a tiny silver card at camera right; unfortunately, however, its use caused a loss of contrast in the helmet, as well. A better print here would have been "burned in" at the helmet. Tonal separation at the cameo's lower rim could have been increased with a reflector, too, but not without destroying form in the face on the shield.

For the coin, I used the pan light raw, filling in the shadows very slightly with a white card.

By comparison, figures 11.45 and 11.46 were lighted by top-light (see figure 11.47). The broad, soft illumination was created by stretching heavy frosted acetate over a 3 x 4-foot (90 x 120-centimeter) frame of small pine planks and aiming a Tota-light through the frame. The necklace in

Figure 11.43

Figure 11.44

Figure 11.45

Figure 11.46

figure 11.45, arranged to show details of the locket and clasp, could not be lighted to reveal the stone's carving at this angle, so a second view (not shown) was needed. White cards at the sides and bottom of the subject field provided minimal fill on the shiny metal, but I left some black areas to give form. The iconographic carvings

and glyphs on the intaglio, figure 11.46, stand out clearly, but with this type of lighting, there is some question as to whether they are raised reliefs or incisions. Without dodging the issue, I think that it really doesn't matter, so long as a caption tells the method of surface carving, because I don't know of any better way to light such stones.

Fig. 11.47. *Elevation side view of the lighting set-up for the coin, intaglios, and cameo in figures 11.43–11.46. Each work of art, A, was laid on a small piece of background paper, and shot from above. B, a diffuser of tracing paper, and C, a white card reflector, were used with D, a single pan light for the cameo and coin photos. C was also used in conjunction with the Tota light, E, aimed through an acetate diffuser in a frame, F, for the intaglio and necklace shots. G, a bellows on a 35mm SLR, allowed the lensboard to be swung, so that imaginary planes extending from the film plane, the lens, and the art coincide at a common point, H, thus bringing the surface of the art in sharp focus at a wide aperture, in accordance with the Scheimpflug principle (see Appendix 2).*

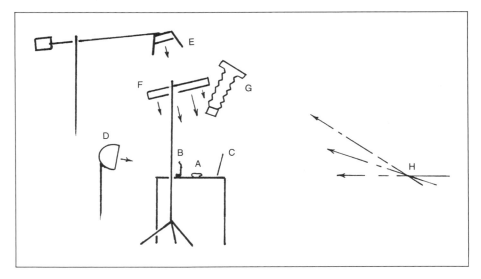

Figure 11.47

Fig. 11.48. *When aesthetic or historical considerations present a strong argument, I try to shape the lighting to support the concept underlying the art. Architect Josef Hoffman, a leader in the "rectilinear modernism" movement, applied his design principles to objects as diverse as towering buildings and unusual miniatures—such as the desk set, shown here. To mimic the midmorning sun on skyscrapers, I used one focusing Fresnel as a three-quarter backlight, for maximum chiseling on the set when seen from a moderately low three-quarter perspective. Fill for the frontal planes came from a shiny silver card—which, serendipitously, gave the mother-of-pearl its characteristic luminescence. Another small silver card, taped to a mini-boom and suspended over the set, reflected light onto the flat black-leather pad, to bring up its texture. For the exposure reading, I put the incident meter near the set and angled its integrating sphere away from the spotlight, to insure an exposure that favored the shadow side and caused the "searing sunlight" effect. To keep the model's*

Figure 11.48

"towers" vertical, with no convergence, I set the view-camera's back vertically and centered the image by lowering the lens-board. Then, by swinging the front standard around its vertical axis, I moved the plane of critical focus, to slice through the middle of the set's long dimension. That done—and the Scheimpflug Condition being satisfied—I could get adequate depth of field at a larger aperture than with the camera in its normal configuration.

Figure 11.49

Figure 11.50

Figs. 11.49 and 11.50. *To photograph this Greek medallion, I used a vertical set with the medallion lying on a sheet of Color-Aid paper, which minimizes texture at high magnification. Figure 11.49 shows the effect of the single undiffused 750-watt Lowel spotlight placed about five feet from the subject. I next assembled a mini-boom from a PIC No. 224 stand, to hold a sheet of*

100 percent cotton rag tracing paper, such as K & E's Albanene, for a pure white diffuser. For shadow fill, I propped up three 6 x 10-inch (15 x 25-centimeter) white cards at the top, left, and bottom of the subject field, to light the shot in figure 11.50. Contrast, with this set-up, is variable over a wide range of ratios. The light can be "spotted," for an intense beam; or it

can be flooded, for softer light. Raising or lowering the light by a few inches or rolling it around for a three-quarter or full, raking top-light also changes modeling and contrast. Likewise, changing the distance and height of both the tracing paper and the cardboards modulates chiaroscuro. A similar technique is shown below, for another object.

Fig. 11.51. *Plan view of the lighting arrangement for photographing the eighth-century Olmec jade mask shown in full color in Plate 15. As seen from the lens, the mask, A, seems to hover in space, as it was propped by a felt-covered brick, B, that sat on black background paper, C, that lay on the floor. A 1500-watt focusing Fresnel lit the face through a sheet of tracing paper on a mini-boom, E, while a gobo, D, kept light off the background. Matte silver cards, F, placed around the sides and bottom of the subject accented facial features and its outline.*

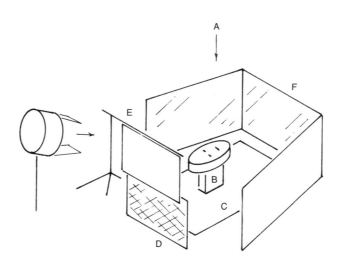

Fig. 11.52. *I chose a low three-quarter view of this terra-cotta head, both to show the facial contours and the flowing cowl and to capture the subject's remarkably mature expression of self-awareness and outward interest. The Tota-light/umbrella, usually a moderately soft source, was on the right, behind the subject plane, to give a relatively harsh, oblique illumination for improved modeling. Any glancing blow of light, coming from behind the subject plane as a "kicker," will approach glare intensity as seen from the lens, unless an intense fill from the front offsets it. To preserve drama, I used minimal fill here, in the form of a matte silver card at camera left, for an approximate ratio of eight parts main light to one part fill. Such a high ratio is more appropriate for an interpretive statement than as a straight document. To keep film grain minimal for this 35mm shot, I used fine-grain Panatomic-X, processed in Microdol-X developer. Although this chemical reduces granularity, it causes a slight loss in resolution, contrast, and film speed.*

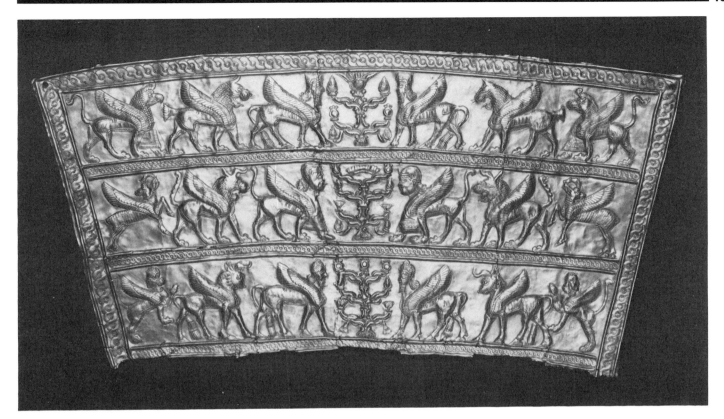

Fig. 11.53. *The repoussé gold pectoral shown here—probably worn by a king from the Near East—was shot in a vertical set, but the camera was inclined slightly, to allow proper positioning of the large umbrella light (see diagram, figure 11.54). Recalling the basic bank shot in billiards, note that the angle of incidence of part of the light equals the angle of reflection into the lens, creating a glare on the smooth gold field that sets off the figures in relief. Three small white cards at the sides and bottom of the subject field provided fill, augmented, over the set, by a 24 x 30-inch (60 x 75-centimeter) white card with a hole in its center for the lens to look through. Part of the umbrella light spilled onto these white cards, to boost their effect. A lens of fairly long focal length (240mm) was needed, to minimize distortion of the pectoral and to get the card over the lens high enough to catch some light. A reflective meter reading of such a bright subject may tend to produce*
underexposure, while an incident reading may cause overexposure. Double-check by reading the reflection off a gray card of about 18 percent reflectance and bracket more toward the smaller apertures than toward the larger ones.*

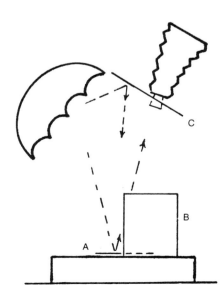

Fig. 11.54. *Elevation side view of the lighting set-up for the chased gold pectoral in figure 11.53. The art (A) receives both direct light from the umbrella source and reflected light from the white cards (B and C). Card C has a small hole for the lens to look through.*

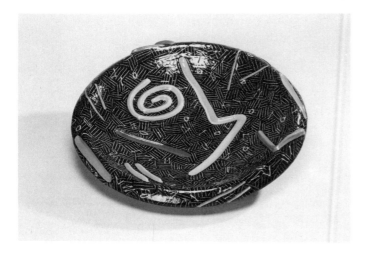

Figure 11.55

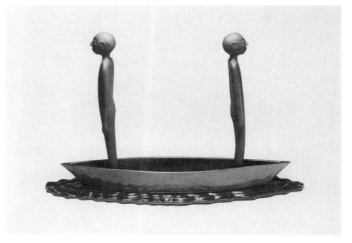

Figure 11.56

Figs. 11.55, 11.56, and 11.57. *Contemporary crafts are often made in diverse materials and shapes that challenge a photographer's wits in lighting and composition. Both the glazed earthenware plate and the glass bowl shown here were so shiny that when the mainlight was in certain positions, it caused a large glare area over key areas of the objects. The chosen mainlight position was a compromise between maximum legibility from chiaroscuro and minimum obscuration from glare. For the ceramic figures, I chose a camera angle low enough to emphasize the tension between the two people, but high enough to show the boat.*

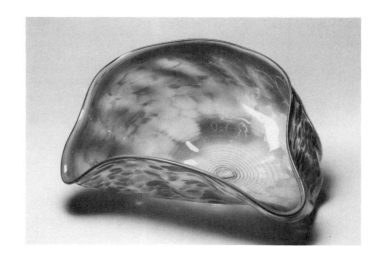

Figure 11.57

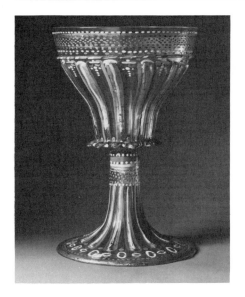

Figure 11.58

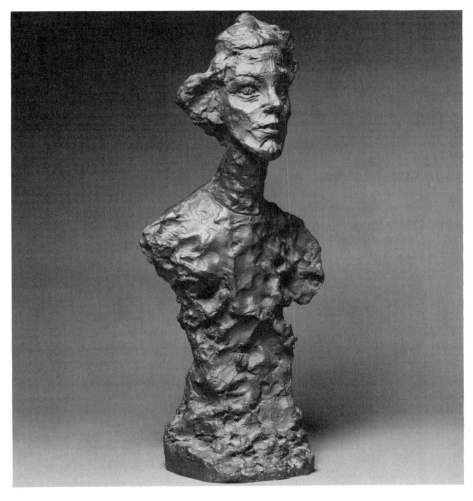

Figure 11.59

Figs. 11.58 and 11.59. *A painted Venetian glass and Alberto Giacometti's bronze* Anna *are reproduced together here to show graphically that quite diverse objects can be photographed with a single lighting arrangement. For both objects, the light source was a 2 x 2-foot (60 x 60-centimeter) soft-light placed camera left at about 45 degrees relative to the lens axis at a height slightly above the subject. A similar effect could have been achieved by aiming a focusing spotlight at a large white card, but the spill on the background would have been much harder to control. By modulating this background illumination across the subject field, I was able to put dark background behind light subject values and put light background behind darker subject values. Modulation was achieved,* after *I had set the main light and fill card, by hanging a black gobo from a small boom and angling it over each subject to block light from the paper. Note the reversal of the painted dots near the rim of the glass, as the light changes from a direct source on the left to a reflected one on the right. What you see is an interesting optical effect that would occur naturally if you saw this glass on a table between two windows in a Venetian parlor.*

Working with the Giacometti bronze afforded one of those rarified moments in photographing an expressive sculpture in which I felt free—even compelled—to infuse the image with my personal response, within the context of accuracy. Without personal interpretation at such times, a photographer is merely making sterile documents, void of sensitivity, of meaning, of life. After all, if a chunk of metal like this is so valuable, so unique, so moving, to so many people, why not *make its image singular, as well?* Anna's *mood seemed at once proud and mysterious, tentatively poised on the brink between revelation and silence. Whether this was Giacometti's intention or simply my own projection, I cannot say, because at the time I was operating less in a sphere of conceptuality and self-analysis than in a mode molded by visual perception, technical priorities, gut feeling, and deadlines. Because of the poor tonal response of the film to dark values, I moved the white card fill quite close to Anna. Even so, the contrast was so great that the negative had to be printed on Grade No. 1 paper to maintain shadow detail. A reflective meter reading here indicated an exposure that favored shadow detail, burning out the brighter values, so I reduced exposure by about one stop. Conversely, an incident reading, favoring highlight detail, would have caused gross underexposure.*

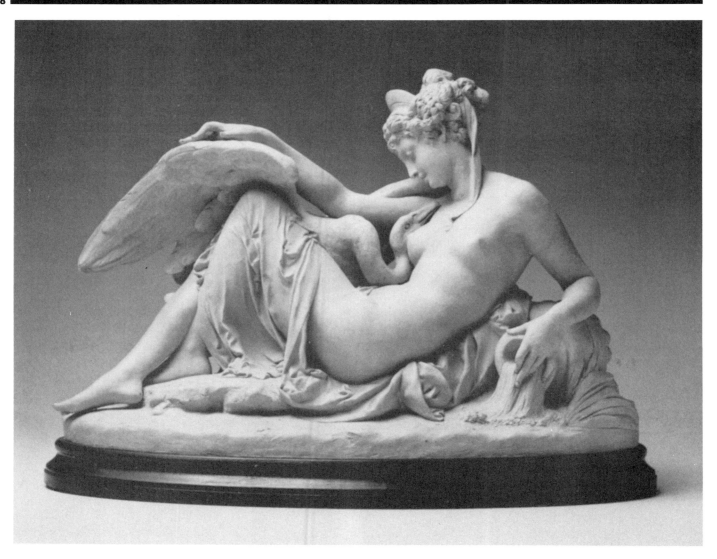

Fig. 11.60. *Once in a while, a work of art comes along that seems to light itself. This voluptuous terra-cotta of* Leda and the Swan *fairly beckoned for the soft glow of a broad top-light. The soft-light kit I used is from Larson (called a Soffbox), and is attached to one focusing spot made by Lowel. The Soffbox is intended for electronic flash heads, but can be used with a hot tungsten source if the wattage is low and if you keep a wary eye on it. The Soffbox was brought low to yield a diffuse light on the object without spilling onto the upper background. The contrast and modeling was controlled by adjusting the spot/flood control, and by moving the light back and forth along the lens axis until the right effect appeared. Knowing when the "right effect" appears is something not easily learned. Perhaps it grows out of intuition, and intuition is largely a matter of experience born of trial and error. The right effect is usually easy to* recognize, *however, when you know your medium and can relate to a fine work of art. A matte surface sheet of beige Formica was the background for photographing Leda. Being light-toned, it reflected top-light back into the shadow areas for ample fill in most places. The only additional fill was a white card, placed camera right, to even the tones from elbow to toe.*

Figs. 11.61 and 11.62. *An exceptional pleasure to photograph, the Stradivarius violin, below, was very fragile, requiring special attention for its support. Although the partial views of the instrument are shown here vertically, I shot it as it lay horizontally, on a table with a weighted towel stretched taut over the body, to hold the violin securely (see diagram, figure 11.63). Since the assignment required a* pure profile of the neck of the violin for stylistic comparison, I obtained permission to de-tune the instrument's pegs, so that they would not jut out and interrupt the sensuous line of the head. Lighting for the graphic shape and wood tone, I used a soft light near the subject plane, to emphasize roundness, and did not fill shadows at all. An umbrella light would have had a similar effect. The exposure reading, taken with an incident meter, was increased by two-and-a-half stops, to account for the light-absorbing thirst of the dark wood and the somewhat oblique angle of the light. All values subsequently "moved up" the exposure scale: deeply toned wood became lighter, medium-toned strings became pale gray, and the towel (included here for demonstration) became pure white. This put all important tones within the film's contrast range, while insignificant tones were sacrified to black or white. One flaw that I could have avoided is that the backgrounds in the two photographs do not match, because of the slight difference in the angle of the light relative to the background. Matched background tones in a series of shots of the same object is a desirable goal, but one that is, of course, subordinate to getting matched tones in the object itself. When it is necessary to make several details of an object that are at the same magnification, frame and focus on the largest one first, tape the lens barrel's focusing ring, and shoot subsequent details by moving the entire camera back and forth on its tripod to focus. Later, when you print the negatives, keep the enlarger at a constant focus and all images will be at the same magnification.*

Figure 11.61

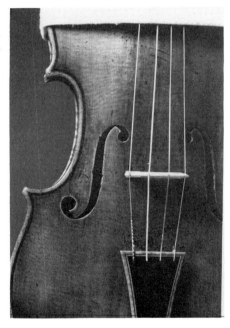

Figure 11.62

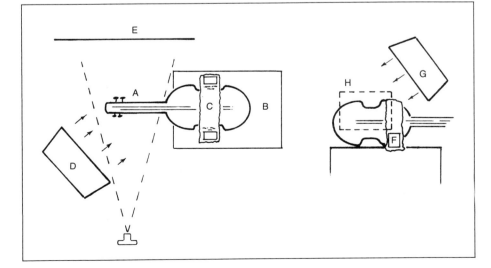

Figure 11.63

Fig. 11.63. *At left, a plan view of the lighting for figure 11.61. The violin neck (A) is the subject, framed by the lens as the instrument rests on a table (B). The violin is held in place by towel (C), kept taut by metal weights at each end. Soft-light (D) is at camera left; the background (E) is about three feet behind the subject.*

At right: a frontal profile view of the lighting for figure 11.62. The iron weight (F) holds the towel supporting the violin, the soft-light (G) is at camera right—duplicating the lighting direction for the neck when both photos are viewed vertically—while dotted line (H) shows the cropping of the lens image.

Three-dimensional Art: Illustrations, Master Class

The next section contains photographs of objects that either were unusual, or required special sets or multiple lights. For many examples, I have included two or more shots of an object, to compare the effects obtained by using different lights; some negatives I shot for my own edification, on the job, when I was unsure of the balance of all lights combined. This kind of "homework" takes time, but I suggest that any good photographer can be the better for it.

For example, I used two umbrellas and a small silver card to shoot the porcelain group in figures 11.65-11.67, placing each light high and near the subject plane for maximum chiaroscuro. The "white" medium can be shown clearly only by making it gray in the photo. I first tried one light with a card fill, but the card's reflectance was insufficient to brighten the shadow side.

Figs. 11.64A and 11.64B.
Photographing this four-thousand-year-old Chinese vessel, known affectionately by some Met staff members as The Football, *presented difficult choices: should it be lighted dramatically or normally? Should I use a pale background or a dark one?*

I selected an eye-level perspective to reveal the naive but balanced profile, which carries a sense of pleasing inevitability, and hoisted a 2 x 3-foot soft light by Chimera above and almost in line with the subject plane, shading the background with a gobo baffle taped to a boom. To me, the translucent glare tells of the tactile nature of the subject without obliterating pertinent information. I let the vessel's lower portion go dark, as it seemed apparent that the incisions were uniform over the entire surface. The curator requesting the photograph disagreed, however, and ordered a reshoot.

Figure 11.64A

Figure 11.64B

In the second version, I put the vessel on a white background for high separation of outline, and lit more fully with three diffused pan lights and a white reflector—the dull center reflection. In the first version, an attempt at dramatization overshot the mark. Perhaps a solution midway between the two would transmit the necessary curatorial information while lifting the image out of the realm of the mundane.

Figure 11.65

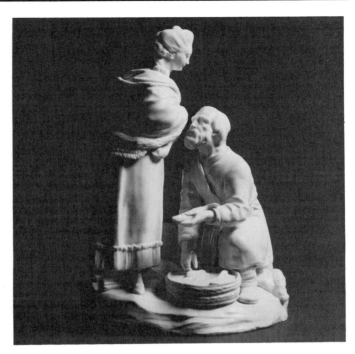

Figure 11.66

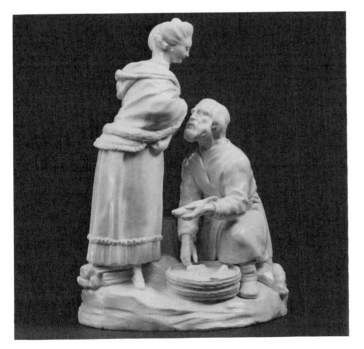

Figure 11.67

Figs. 11.65, 11.66, and 11.67. *In this lighting experiment, the porcelain figures were illuminated by two soft lights, with one placed on each side of the subject at a three-quarter elevation. The three successive illustrations show the effect of each light independently, then together. Highlights on the woman's skirt and the man's right shoulder were created by a 3 x 6-inch shiny silver card, placed camera left, behind the subject plane.*

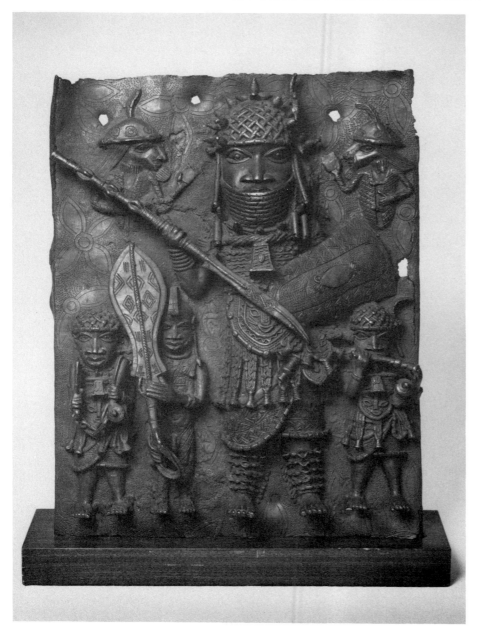

Fig. 11.68. *This heavy bronze plaque, typical of artifacts from the West African Benin culture from the fourteenth century to the nineteenth, required, first, a raking light strong enough to model the high-relief figures; and, second, a fill light bright enough to open the shadows and cause faint glare on the "pinwheel" decoration. Larger and more complex plaques than this one may need up to four umbrellas and one or two dinkies, to skim the surface of isolated areas for additional contrast, but this relatively simple one required only two umbrellas.*

From camera left, at a point some three feet above the lens and two feet forward of the subject plane, I directed the 1000-watt umbrella main light, carefully placing its "hot spot" at the lower right corner, to equalize fall-off from upper left to lower right. Behind me and at camera right I put a weaker 500-watt umbrella fill light, being sure not to cast the camera's shadow onto the object. My choice of white seamless paper for background was a poor one. Due to the long exposure necessary for the very dark bronze, the background areas in the negative were so dense that they required a burning-in time of nearly 8X over the base exposure for the object, in order to get this faint tone, which gives the art a "place" to exist. Had I used a medium-gray paper, it would have automatically registered as the pale gray you see here.

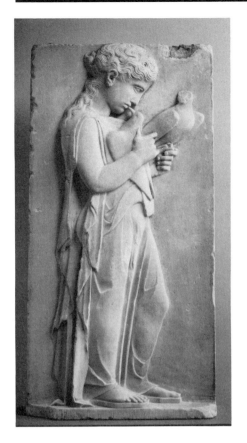

Fig. 11.69. *A straightforward, technically correct approach in lighting this eloquent fifth-century* B.C. *grave stele from the Aegean isle of Paros would have been sufficient to show its style and condition, but I was moved by the tenderness of the scene to try to emphasize the artist's feelings.*

A raking light was needed, to model the relief, so I mounted one Tota-light with umbrella on a stand and moved it around the subject to find the best position. Both the mood and the definition improved, as the light came from the upper right, near the subject plane; but since the single light created fall-off, I added a second umbrella source, from a point alongside the girl's waist, to illuminate her legs. This lower, second light filled in the shadows on the face too much, so I put a gobo above that second umbrella, to block its illumination on the upper torso and head. Now the effect was right—but the shadows were too dense. By adding a third, weaker umbrella source near the lens axis but behind the camera at its left, I opened the shadows to a tolerable contrast ratio, compared to the highlights. Now the effect was that of a single light source, when in fact there were three.

Notice that the lighting, exposure, and printing have been calculated to shift the bulk of tones from pale to medium gray, to introduce chiaroscuro again. This is a technique and an effect also needed to illustrate shiny metallic objects (see Plate 3). So how do we differentiate photographically between metal and stone if they have the same tone? Apart from experience, which suggests that coffeepot shapes are seldom marble, and that gravestones are rarely silver, we intimate materials by showing texture *through using very good lenses and fine-grain film to record nuances of lighting.*

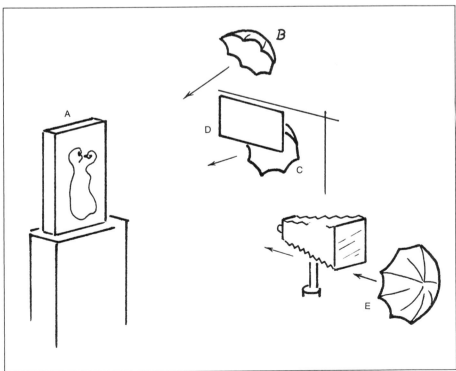

Fig. 11.70. *Isometric view of the set-up for the marble girl with pigeons in figure 11.69:* A, *the subject, lighted by main and lower umbrella lights* B *and* C *and weak fill light* E. *A black card gobo* (D) *blocks illumination from the lower umbrella, so that it does not spill onto the head and upper torso.*

Figure 11.71

Figure 11.72

Figs. 11.71 and 11.72. *Remember the restaurant place mats that had a scene of a barnyard where all sorts of crazy things were going on, and the headline challenged you to* Find What's Wrong With This Picture? *You can play a similar game with photographs, investigating the following: What kind of light was used? How many? Where were they? What focal length lens was used? How could the photos be improved?*

For Nevelson's "Rainforest," I used existing gallery lights, exposing for four times longer than the incident meter reading to compensate for the extreme darkness of the black "trees." Usually, existing lights in galleries are too "spotty" for photography, causing extreme contrast, and must be supplemented or supplanted by your own lights. Here, I chose a camera position to show separation between sculptural elements, avoiding confusion. I used a 150mm lens, a "normal" focal length, on the 4x5" format (comparable to a 50mm lens on 35mm format), because space was cramped. Fortunately, this gave a perspective an ideal viewer might choose to see the work.

For Israel's still life, I used one strobe softbox, with a white card fill. Such high contrast subjects as this normally want a full light with more open shadows, but using more fill here would have made the eggs look like discs. The mainlight was flagged to keep the light gray background a medium tone, so that both the light and dark areas would separate. I used a 210mm lens on the 4x5" format, slightly longer than normal, to preclude foreshortening.

Fig. 11.73. *Works of art such as jewelry, tools, and lace, with small but important negative spaces, require a shadowless background to keep those spaces open and legible. You can accomplish this by using nonglare glass propped above paper, to allow light under the subject; or you can use an illuminated box covered with glass or plastic for even better control of lighting ratios, as I did for the primitive wooden mask shown here. Such a setup is also useful for fragments that do not have proper stands and for those works with distracting stands that you want to eliminate from photographs of the art.*

Normally, art on a light box is shot from directly overhead, for a frontal view; here, however the assignment called for a three-quarter view to show the mask's depth and open mouth. To achieve that, I moved the camera to the side *of the light box, but still above it, turned the camera to a* horizontal *position, and composed. You can move an object in any position to shoot it, so long as it is correctly framed, and no one will be on to your tricks, since they will automatically turn the print to orient the object normally.*

Lighting from above was by two Tota-lights with their umbrellas set side by side for a broad main light, while fill, from camera left, came from shiny silver cards and the backlight of the box. Note how the umbrella lights cause a mild glare on the metal nose and lip, cluing the viewer that those features are a distinctly different medium from the wood. Having a rheostat on the light box gave me the flexibility to adjust its intensity for leaving a soft main light shadow on the background for the impression of a wall behind the mask.

Figure 11.74

Figure 11.75

Figure 11.76

Figs. 11.74, 11.75, and 11.76. *These three photographs of a glass goblet (A, in figure 11.77) were made on an acrylic table (B). The first image was made using only the three lights (C) placed under and behind the table. Although the object's shape is clearly rendered against a clean background, the inscription disappears. The second image was made using only two snooted dinkies on a boom (D). Although the inscription is clear, the shape is not. The third image shows the combination of all sources, balanced for the best compromise. If your budget is limited, you can make a suitable set for photographing glass by draping a piece of heavy frosted acetate over a sheet of thick glass supported by two horses. Or just use white seamless on a large table, allowing plenty of space between the art and the back sweep, and aim one or two spotlights at the background behind the object to get a backlight.*

Figure 11.77

Fig. 11.77. *Side elevation of the acrylic table and lighting for the etched glass goblet in the three photos above. Subject (A), on acrylic table/backdrop B, is lighted from below and behind by three 500-watt Tota-lights, from above and in front by two dinkies with slender snoots (D).*

Figure 11.78

Figs. 11.78 and 11.79. *One of these two versions of a Mary Frank sculpture was used for a poster for a human rights organization. For both shots, one strobe head was aimed through a small (20 x 28") softbox, with minimal fill from a white card. I shot two versions to offer the artist a choice, as each version had distinct merits in terms of mood and impact, using a dark background to emphasize despair. Plenty of background was left around the subject to allow the poster designer ample latitude in cropping and placing type. When type is to be surprinted over a background, the tonality should be either darker than a 75% gray or lighter than a 10% gray for legibility.*

Figure 11.79

Figure 11.80

Figure 11.81

Figs. 11.80 and 11.81. *Although just one view of this unique bronze was requested by the curator, I made a second view as an experiment. The first photo (figure 11.80), passable either as a record document or as a "beauty shot," was a three-quarter perspective lighted by a wash of three umbrella lights set in a vertical line at camera right, just in front of the subject plane. Fill light was supplied by one umbrella, high, at camera left, behind the subject plane, as a "kicker," to emphasize volume. While a white background paper would have facilitated separation of outline, it would also have made the subject seem heavier than it appears here; in spite of the dangers to separation, I chose a dark gray that helped the work emerge from the field and soar.*

For figure 11.81, I turned the sculpture for a frontal view (it could have been the back, since the object was symmetrical), and lit it with only two umbrellas, at camera left, set high and in line with the subject plane. No fill or reflectors were used, so that shadow areas are dense blacks. It may be argued that the second version is misleading, because its lack of textural information causes the sculpture to appear to be painted black, in significant parts, and I would agree wholeheartedly that that is a valid argument. The curator for whom the photographs were made, however, preferred this second, more dramatic version.

Fig. 11.82. *Juxtaposed to the bronze sculpture of unusual texture in figures 11.80 and 11.81 is this work in bronze, whose highly polished surface is typical of many bronzes throughout the ages. You might think that polarized light and a lens polarizer would reduce the glare enough for most tones to reproduce in a print as lustrous grays; but—speaking from hapless experience—I can say that that approach is rarely worth the long, complex effort. I find a much better method is to use broad, soft, indirect sources of illumination, such as pan lights or spotlights bounced off white cards or sheets of paper. Carefully placed, these lights will define major planes and contours without undue contrast.*

For this statue, entitled The Freedman, *I chose a low perspective, to emphasize the tension born of self-preservation: the man was all sleek muscle, poised to bolt at the first faint, distant bark of a bloodhound in pursuit, and I planned the lighting to evoke empathy from the viewer.*

By reflecting two spotlights off two 3 x 4-foot sheets of paper—one each at camera left and camera right—I created relatively diffuse highlights on the important muscles, while preserving legibility of the slave's expression. Two small silver cards—about 8 inches square, attached to mini-booms on swivel clamps—reflected light onto the chest and into the inner thigh for further definition. From behind the camera, I raised high a snooted spotlight, aimed it over the slave's head at the white wall above the gray background paper, and created a bright spot of light that reflected down onto the right arm, shoulder, and cheek for a "rim-light" that separated the sculpture from its surroundings. The bellows type of lens shade had to be augmented by a gobo on a stand near the lens, to prevent this reflection from causing lens flare. Exposure for this dark object was increased by two stops over the incident meter reading; the print, however, was a bit on the pale side, to preserve shadow detail in reproduction.

Fig. 11.83. *Usually, chairs can be shot in three-quarter perspective from a slightly high elevation, for record purposes; but for this Danish Modern subject, I chose a low frontal perspective, to emphasize the simplicity of design elements, which incorporate joinery methods as ornament. Note that the lens position allowed a sliver of light between the front and rear rungs, for clarity.*

The full, buoyant light came from no less than five Tota-lights with umbrellas, placed to give a symmetrical, virtually shadowless atmosphere. Two lights were set just forward of the subject plane and aimed at the chair from a height of seven feet, while two more umbrellas at the same height were three feet behind the subject plane, but aimed at the background. The fifth umbrella was boom-mounted, suspended exactly over the center of the chair for additional modeling. Of course, some light from the three forward luminaires spilled onto the background, some eight feet away from the subject, insuring a pure white environment. Shiny silver cards near the floor—left and right, for glare on the legs—completed the lighting.

With this set-up, a reflective meter reading of the entire subject field would have misled me toward underexposure, unless I had multiplied the exposure time by a factor of four or five, or opened the aperture by two or two-and-a-half stops; this new setting would have been the same as reading directly off a gray card at the chair.

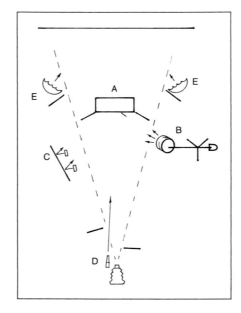

Fig. 11.84. *Plan view of the lighting arrangement for the English cabinet, Plate 19 in the color section. Main light for the subject (A) was direct 1500-watt focusing Fresnel (B) on a boom with fill light from two Tota-lights (C) aimed at sheets of reflective paper. Two additional Totas with umbrellas (E) were aimed at the background, for uniform surround. Snooted dinky (D), at camera left, added light needed to show clear detail of cabinet interior.*

Figure 11.85

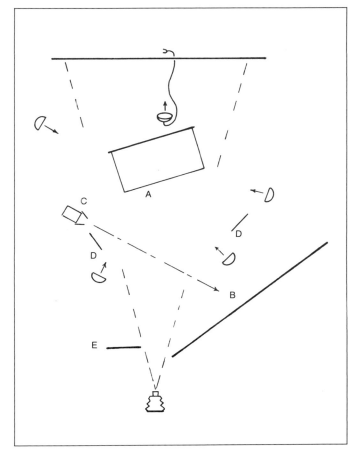

Figure 11.86

Fig. 11.85. *The reflective plane surfaces of mirrors and silver platters invariably reflect the camera when photographed head-on. Angling the subject away from the lens axis will allow you to control reflections so that the surface still looks reflective without distractions. That is what I did for the washstand above; but to be sure that the photograph conveyed the idea of* mirror *to the viewer, I created a modulated tone across the reflection, lighted so that the beveled edges of the mirror were obvious.*

First, I hung a 9 x 9-foot sheet of gray seamless paper between two stands, at camera right, so that the mirror was filled with seamless reflection as seen from the lens. Then I aimed a 750-watt Fresnel at the paper,

angling its narrowed barndoors for the rakish bright tone. Experimentation with two or three white cards on stands at different places around the subject allowed me to stress the reflections of the beveled edges. The light on the washstand itself was virtually omnidirectional. In addition to the permanent overhead scoops for general illumination, I added diffused pan lights, aimed at the subject from camera right and left, as well as from left three-quarter rear, for extra gleam on the branchlike contours. As with the Japanese screen (figure 11.19), one pan light behind the object added depth and glow for drama.

A minor flaw is the lack of tonal distinction between the washstand counter and the background. Since I

had previously lit for an Ektachrome and there had been sufficient contrast between the white marble and the sand-colored paper, I overlooked the problem when shooting in black-and-white. A minor adjustment of lighting ratios in that area would have made the edge separate from the paper.

Fig. 11.86. *Plan view of the lighting set-up used for the mirrored washstand (figure 11.85). Subject's mirror (A) reflected seamless paper (B), which was given a modulated streak of light from a 750-watt Fresnel with barndoors (C). White cards on stands (D) helped stress reflections of mirror's beveled edges, as gobo (E) prevented lens flare.*

Figure 11.87

Figure 11.88

Figs. 11.87 and 11.88. *The photographs of these two Buddhas illustrate radically different approaches to lighting similar life-sized objects. The Chinese Qyon-yin seated on a lion (figure 11.87) was the first object I photographed at the Met; being unsure of the equipment and the prevailing aesthetic temperament, I fell back on an "acceptable" solution, one carried over from my experience in commercial catalogue work.*

Suspended from the ceiling was a movable bank-light whose full wash of light I adjusted to give adequate—but not especially provocative—modeling of the Buddha's facial features and garment folds. However, white card reflectors near the base would have filled in shadows for less fall-off. The background light was a diffused Fresnel whose beam was constricted to an oval shape by cardboard taped to the snoot. Even though the "halo" light enhanced drama, the effect now seems perhaps a bit overplayed.

Three years later, I shot the gilt meditating Buddha in figure 11.88, in a more subtle style, calculated to reveal the massive composure of the subject. Yet, as celestial as I might make the image, it still had to serve as a condition document and an accurate translation of the artist's masterful carving.

Breaking the rules for lighting procedure, I first set the "hair-light," which came from above and slightly behind the head, in order to strike a tone of ethereality and mystery. For increased intensity, this light consisted of two Totas piggybacked into one umbrella on a boom, and from its position, illumination rim-lit the mandorla and defined the left ear, shoulder, and lap. At this point, I had a partial silhouette; so, to bring back the Buddha to recognition, I put two more Totas in two umbrellas at camera left, just forward of the subject plane, for filling in the mandorla and torso. The position of these main lights was critical, so as neither to overwhelm the top-light nor to underlight the important detail. Finally, I set a weak umbrella light just above the camera, aiming its beam along the lens axis for further fill without creating a shadow on the background.

For both these photos, the objects were set about twelve feet from the background, so that I could independently control light on the art and on the paper. Ah, the joys of a large studio!

Figure 11.89

Figure 11.90

Fig. 11.89. *Fortuitous as it may seem, beautiful existing light can impose restrictions. The light from the skylight in Bryan Hunt's studio, shown here, is ideal for photography—at the right time of day, if the weather cooperates. The shooting of a series of wall-mounted "Airships" beneath this skylight was delayed by one week because of weather; once we started, we had to work fast to get uniformity of mood in a three-hour time "window." For the color versions of the series (not shown), I used a series 81B light-balancing filter with daylight color film to absorb excess blue. Selection of the correct filter is virtually impossible without using a color temperature meter—and sometimes a color meter only gets you within a few winks of the right filtration. The framing of the Airship was chosen to show its scale and the suggested position of mounting in relation to the floor.*

Fig. 11.90. *This elegant and humorous work by Steve Keister was mounted high on a wall in a gallery, but the existing spotlights did it little justice for a catalog image. I mounted a Dynalite strobe head in an umbrella and hoisted it on an extension pole atop a heavy stand to get the mainlight high. Fill light came from near the camera, in an identical strobe head/umbrella, whose power was about one-third the mainlight. Too much fill would have made more, confusing shadows. Strobe light was chosen over tungsten because the gallery had a huge skylight whose daylight would have played havoc with the color balance of tungsten film for the slides also made (not shown).*

Figure 11.91

Figs. 11.91 and 11.92. *Showing your own art is a milestone in any artist's career. Apart from the personal reasons to document exhibitions carefully, there are curatorial and historical reasons to do so. Thorough documentation of an installation calls for* overlapping *multiple views of each room of an exhibition. If structural elements block some views, as seen here, you may have to take five or six shots of the room. This same shot also shows the relationship of several galleries, each of which was documented in four to six views. The narrow cropping is the result of using a 6 x 12cm rollfilm back on a 4 x 5" view camera, an ideal format for many gallery views.*

In the second shot of a gallery at the American Craft Museum, the point of view shows the relationship among the many objects and vitrines. The 4 x 5" format included more art than the 6 x 12cm format. Lighting for both photographs came from existing ceiling spots.

Figure 11.92

Figure 11.93

Figure 11.94

Figs. 11.93 and 11.94. *In contrast to most installation photographs, which document the position of discrete works in a gallery, these two images are, in a sense, all that is left of the works. "Contingent Realms," an exhibition at a branch gallery of the Whitney Museum of American Art, had the relationship of the works to their surroundings as a principal theme. Once removed from the galleries, the objects were no longer the same. Because many objects included light sources, exposures were checked on Polaroid film.*

Borofsky's Running People *literally disappeared after its exhibition in the Whitney Museum cafe, when the wall was repainted. Consequently, several views were made, some with chairs and tables, and some without. I chose this particular view because it was the precise position from which the composition could be seen integrally, as the figures ran across three walls. Because the existing ceiling lights were spotty in intensity, I added three Tota-light in umbrellas from camera left.*

APPENDIX 1:
Setting Up Shop

The checklist below outlines basic camera equipment for each format that you need to start shooting, plus suggested minimum lighting gear for copy and three-dimensional work.

The Bare Bones

35mm Camera Equipment
SLR camera with TTL meter and manual-exposure mode
Grid-pattern focusing screen
Cable release
50mm macro lens
Lens shade
Polarizer
Tripod (4 to 5 pounds)

Medium-Format Camera Equipment
SLR camera
Waist-level finder *or* Prism finder with TTL meter
Hand-held meter (if needed)
Grid-pattern focusing screen
80mm or 90mm standard lens
or
100mm or 140mm macro lens
Lens shade
Polarizer
Cable release
Tripod, medium-duty (5 to 6 pounds)

View Camera (4 x 5) Equipment
4 x 5 monorail camera with long bellows (16″/400mm OK; 22″/550mm preferred)
Grid-pattern ground-glass, plus spare 180mm Apochromat lens *or* 180mm wide-field plasmat lens (with shutter) (210mm OK if bellows allows 1:1 reproduction ratio)
Cable release
Compendium lens shade
5 to 10 film holders
Focusing cloth
4X magnifying loupe
Torpedo spirit level
Measuring tape
Tripod, medium-duty (7 to 10 pounds)

View Camera (8 x 10) Equipment
8 x 10 monorail camera
Long bellows *or* extension bellows with center standard (24″/610mm OK; 32″/835mm preferred)
305mm Apochromat lens (for closeup copying and small objects) *or* 360mm wide-field plasmat (for three-dimensional work)
Tripod, heavy-duty (10 to 15 pounds)
All others same as 4 x 5 view camera.

Lighting Equipment

For Three-dimensional Objects (Minimum Illumination) 1 18-inch reflector flood (pan light), 500 to 1,000 watts
or
1 high-intensity spot with umbrella, 500 to 1,000 watts
and
1 10-inch pan light, 250 to 500 watts
1 dinky Fresnel, 200 watts

For Paintings
4 pan lights, 250 to 500 watts
or
4 high-intensity floods, 500 watts

For Ultra-Compact Location
Autostrobe mounted on camera hotshoe, with variable beam angle

For Support
Snoots and barndoors as needed
4 8-foot folding stands
2 PIC stands (#224)
2 Double-swivel clamps (Fisher Scientific)
1 15-foot 12-gauge extension cable with spider box
2 25-foot 12-gauge extension cables with single outlet
Spare bulbs
Adapter plugs (3-prong to 2-prong)

Miscellaneous Equipment (for Lighting Three-dimensional Objects)
Pedestal and/or table
Backgrounds:
 Seamless
 Coloraid or Pantone
 Glass (frosted and clear to 20 x 24″)
 Frosted acetate
Assorted white, black, and silver cardboards in various sizes
Tracing paper
Mat knife and single-edge razors
Scissors
Permanent dulling spray for silver cards (*not for use on art!*)
Spring clamps
Clothespins
Pushpins
Beeswax
Plasticene eraser
Masking tape (1-inch width)
Black photo tape (1-inch width)
White tape (1-inch width)
Small wedges
Iron weights (up to 1″ x 4″ x 6″) for propping objects
Equipment cases for location shooting
5-foot ladder
Wooden shipping crate (to stand on) **187**

APPENDIX 2:

View Camera Movements

THE diagrams in figure A2.1, reprinted courtesy of Calumet Photographic, Inc., show the rudiments of view camera movements. For more complete information, see related books in the suggested-reading list.

Setting up a View Camera for Flat Art

1. Adjust the two standards so that they are parallel and zeroed, with the len's optical axis centered on the ground-glass.

2. Adjust the gross image size by moving the tripod to and fro.

3. Adjust the gross focus by racking the *rear* standard forward or backward.

4. Fine-tune the image size by racking the *front* standard forward or backward.

5. Fine-tune the focus using the *rear* standard.

6. Fine-tune the composition of the subject by using the rise, fall, or lateral shift, as in diagrams 5 and 6. Keep the rear standard parallel to the major plane of the art, to prevent keystoning.

7. Proceed with lighting and exposing.

Setting up a View Camera for Three-dimensional Art

To set up a view camera for photographing three-dimensional art, follow the above procedure but, in addition to that, select a lens whose focal length will give you the best image size when the camera is at your chosen perspective. If a major change in image size is needed, switch lenses. Then go on as above.

Under special three-dimensional circumstances, you will want to shift the plane of critical focus in subject space to a position that is not parallel to the film standard, to get a particular subject plane in *sharper* focus than would be possible through stopping down alone. To illustrate this principle, a brief comment about the view camera's front standard tilt movement, which is a vertical rotation of the lensboard around a horizontal axis, may be helpful.

Suppose your subject is a table whose top you wish to get in focus from front to back while the camera is looking downward at a 45-degree perspective. With the standards in their normal, parallel position (diagram 7-A), the plane of focus slices through the top at a 45-degree angle, midway toward the back of the table. At minimum aperture, the extreme near and far edges will not be sharp. To solve the problem, now imagine that the subject plane, line *A-B* in diagram 8, extends beneath your tripod, and that the film plane, line *A-C*, extends downward to meet plane *A-B*. Next, tilt the lensboard so that, were its plane *A-D* extended as well, it would intersect the other two planes at a *common* point, (*A*). What you have done is shift the plane of critical focus to coincide with the tabletop. In a nutshell, this procedure is the notorious *Scheimpflug Condition* satisfied.

It's a good idea to remember several points, here. First, the depth of field acquired through stopping down will now surround the new plane of focus—the tabletop; consequently, it will be impossible to render the table legs sharply all the way to their feet.

Second, a tilt or swing of the camera back in this or *any* situation will change the *shape* of the subject and will affect the plane of focus as well. If, after setting the lensboard tilt correctly, you then want to tilt the back, for any reason, you must readjust the lensboard tilt.

Third, by tilting the lensboard, you will have moved the lens's optical axis away from its centered position on the ground-glass, possibly causing the film to become vignetted—or at least unsharp at the lower corners—due to the projected cone of light being too small to cover the film. (See Appendix 3 for clarification of optical behavior with view camera lenses.) To avoid that third problem in the present example, first *lower* the lensboard before you compose the image or play with the tilt. This new position will not make the image circle any larger, but it will keep the projected circle of good definition more or less centered on the film after the front standard is tilted.

To understand the swing

View Camera movements and how they work

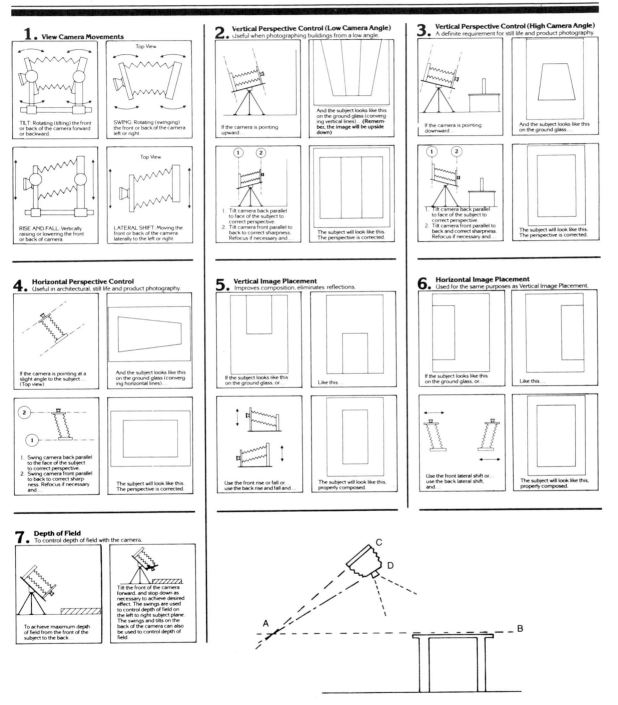

1. View Camera Movements

Top View

TILT: Rotating (tilting) the front or back of the camera forward or backward.

SWING: Rotating (swinging) the front or back of the camera left or right.

Top View

RISE AND FALL: Vertically raising or lowering the front or back of camera.

LATERAL SHIFT: Moving the front or back of the camera laterally to the left or right.

2. Vertical Perspective Control (Low Camera Angle)
Useful when photographing buildings from a low angle.

If the camera is pointing upward...

And the subject looks like this on the ground glass (converging vertical lines)... (Remember, the image will be upside down)

1. Tilt camera back parallel to face of the subject to correct perspective.
2. Tilt camera front parallel to back to correct sharpness. Refocus if necessary and...

The subject will look like this. The perspective is corrected.

3. Vertical Perspective Control (High Camera Angle)
A definite requirement for still life and product photography.

If the camera is pointing downward...

And the subject looks like this on the ground glass...

1. Tilt camera back parallel to face of the subject to correct perspective.
2. Tilt camera front parallel to back and correct sharpness. Refocus if necessary and...

The subject will look like this. The perspective is corrected.

4. Horizontal Perspective Control
Useful in architectural, still life and product photography.

If the camera is pointing at a slight angle to the subject... (Top view)

And the subject looks like this on the ground glass (converging horizontal lines)...

1. Swing camera back parallel to the face of the subject to correct perspective.
2. Swing camera front parallel to back to correct sharpness. Refocus if necessary and...

The subject will look like this. The perspective is corrected.

5. Vertical Image Placement
Improves composition, eliminates reflections.

If the subject looks like this on the ground glass, or...

Like this...

Use the front rise or fall or... use the back rise and fall and...

The subject will look like this, properly composed.

6. Horizontal Image Placement
Used for the same purposes as Vertical Image Placement.

If the subject looks like this on the ground glass, or...

Like this...

Use the front lateral shift or... use the back lateral shift, and...

The subject will look like this, properly composed.

7. Depth of Field
To control depth of field with the camera.

To achieve maximum depth of field from the front of the subject to the back...

Tilt the front of the camera forward, and stop down as necessary to achieve desired effect. The swings are used to control depth of field on the left to right subject plane. The swings and tilts on the back of the camera can also be used to control depth of field.

Fig. A2.1. *The Scheimpflug principle is satisfied when the three planes, A-B, A-C, and A-D, coincide at a common focus. A-B is the plane of the art, A-C is the plane of the film, and A-D is the plane of the lensboard, adjusted through tilting. In this configuration, plane A-B is rendered sharply even at a wide aperture.*

movement, which is a horizontal rotation of the standard around a vertical axis, imagine the camera in diagram 8 to be a plan view as the camera is set up to shoot a *low* three-quarter view of the table, and follow the same principles as above.

Occasionally, you may need to both tilt and swing (especially if you have been working too many late nights), as you would if you were shooting the table from a *high* three-quarter camera position. To avoid making dozens of movements that may twist the camera around on itself and shoot under your armpit, simply make your first movement—swing or tilt—for the longest subject plane, in order to satisfy the Scheimpflug Principle, and then make the other movement for the shorter plane. Then you may have to make two or three small adjustments in shift, rise, or fall, to recompose.

By using the swing and/or tilt, you can usually create a new depth-of-field zone around the subject's principle planes so that the important parts will be sharp at an aperture close to the critical mid-range of settings. This not only keeps resolution high, but also reduces the exposure time to minimize shifts in contrast and color balance.

APPENDIX 3:
Lenses for View Cameras

ONE distinction of a view camera lens is its extra-large cone of projected light inside the camera, which gives the disc-shaped image at the film plane a very big *circle of good definition*. This is necessary, because—as discussed in Appendix 2—moving the standards of a view camera by tilting, shifting, or swinging will cause the film gate to move either laterally, vertically, or diagonally (or a combination of directions) within the circle of good definition. If that circle is small, your image controls will be restricted, and much of your camera's versatility—for which you paid dearly—will be wasted.

The manufacturer's specification sheet for each lens lists the diameter of that lens's circle at infinity focus when the aperture is f/16 or f/22, because the circle's size increases with stopping down. If the diameter is considerably greater than the diagonal of your format, you can use this lens for some pretty dynamic Scheimpflug gymnastics while keeping the film gate within the circle's perimeter. Another bit of related information listed is the lens's *angular covering power*, a measurement in degrees of the cone of projected light. The larger this value for a given focal length, the larger the circle of good definition. Also, this value is a convenient way to classify lenses within each focal length category (see below).

Some manufacturers—confusingly—call angular covering power the *picture angle* or the *angle of view*. Since I have used the latter term to describe the lens's angular view on the subject field *outside* the camera—an angle determined in part by the film gate's dimensions—I'll reserve the terms *angular covering power* and *angular coverage* for the *inside* of the camera. (See figure A3.1)

When do you need a lens with great covering power? You need it when shooting objects and architectural views that require a wide-angle lens to be shifted off-axis to prevent convergent verticals. You also need it when shooting a three-quarter view of a table, or when the camera is pointing downward at a 45 degree angle at a group of objects, and the tilt or swing movements are used with a normal or long-focal length lens. You do *not* necessarily need great covering power when photographing most flat art. In fact, big angular coverage can be a

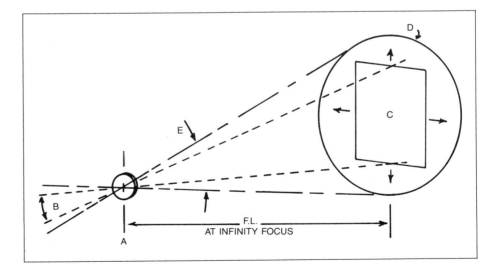

Fig. A3.1. *Schematic for a lens that has considerable covering power at infinity focus. Lens (A) has an angle of view (B) that is determined by the film gate (C), in relation to the focal length of the lens (f.l.). The film gate has leeway to move laterally and vertically within the circle of good definition (D), which is determined by the lens's angular covering power (E).*

disadvantage, when you don't need it, because it costs more to buy, and it produces a useless reserve of non-image-forming light scattering in the bellows that can lower image contrast.

Once in a while, you may encounter a situation in which the best focal length lens for your chosen perspective does not have enough covering power to allow the necessary tilts and swings. If you can sacrifice your point of view and move back a bit, you can use the next longer focal length, which will give you a larger image circle at the same magnification—even though the new lens's angular coverage is identical to the first.

Used Lenses

You can save money by buying used view camera lenses, an especially smart move if you seldom need them. Photographic flea markets and used equipment stores have many used lenses, some of which could date back to your grandparents' days, so you had better know what you're looking for. First, you should visit a reputable dealer and discuss your needs. Avoid used lenses with dents and scratches, as well as those that sound like a maraca when you shake them, because of loose elements. Then rent a candidate for a weekend and shoot tests.

Test a lens by using it as you normally would. In addition, tape a newspaper flat on a wall, carefully set the camera parallel to it, and expose several negatives to tungsten light at different shutter speeds and apertures: wide open, stopped-down halfway, and stopped-down all the way. Then repeat the newspaper test at life-size magnification. Keep notes by writing your exposures somewhere in the field of view. Comparing these negatives should tell you if the lens is sharp at various apertures and magnifications (all the way to the corners), and if the shutter is working

at different speeds. Once you find a good lens, insist on at least a 30-day warranty, in case you've overlooked something amiss.

Guide to Lenses

The following discussion mentions lenses both in and out of production. Two United States firms, Brooks and Burke & James, are now defunct, but they made serviceable, inexpensive lenses. Currently, Fuji is not imported into the U.S., probably because of marketing problems, which may have developed because of uneven quality. Caltar lenses, the brand name manufactured by Calumet Photographic, are currently made by Rodenstock and boast better than average quality at moderate cost. However, Caltar lenses are limited in model types. Nikon, Rodenstock, and Schneider now have the lion's share of the U.S. market—and for good reason. For critical color work when using different focal lengths, stick to one manufacturer and you'll avoid the headache of remembering to change filters when you change lenses.

Trying to compare certain equivalent lens designs among manufacturers can lead to confusion, because information from periodicals, dealers, and even manufacturers' sales representatives is often contradictory. Consequently, the following categories are general and contain appraisals of characteristics that could be refuted by other sources.

Normal and Long-focus Lenses: Standard Commercial (Tessar Type)

The angular coverage of the fabled Tessar type lens is a moderate 50-60 degrees, but resolution is very good. Because it has only a few elements, image contrast is excellent. Since these lenses are not, as a rule, suitable for critical close-up work, you should use this type of lens for medium-sized tabletop and larger works. Tessars are lightweight,

making them ideal for outdoor work. Few models are in current production. Models include: Burke & James Acutar, Schneider Xenar and Zeiss Tessar (all discontinued); and the Nikkor-M Series. The latter is often categorized as a process lens, but it is actually computed to work best at infinity.

Wide-field Commercial (Plasmat Type)

The term "wide-field" refers to the angular covering "field," or power, inside the camera—not the angle of view on the subject side of the lens. Depending on the model, angular coverage of the Plasmat type ranges from about 65 degrees to an impressive 80 degrees, producing a large image circle. It boasts very fine resolution and image contrast, and since performance is better at medium and close range than at infinity, this type of lens is suitable for tabletop and larger works where reproduction ratios in cameras range between 1:10 and 1:3. Recent models give a very flat field with little distortion, characteristics suitable for copy work where ultimate quality is not necessary. Certain models use special glasses and designs, and are confusingly given the prefix "Apo-," although they are not useful in situations that are the domain of the traditional *apo* (short for *apochromat*) lens. Models include: Calumet Caltar II; Goerz Dagor (discontinued); Nikon Nikkor-W Series; Rodenstock Sironar-N and Apo-Sironar; Schneider Symmar and Symmar-S (both discontinued); and Schneider Apo-Symmar and Super-Symmar High-Modulation.

Process and Apo Lenses

Although there are minor differences among them, *process, apo, copy, flat field,* and *macro lenses* are similar enough that they can be discussed together. They all have negligible distortion, meaning that the

straight edges of paintings do not become warped on film. They are all ideal for high reproduction ratios in the ranges between 1:4 and 4:1. The traditional four-element, air-spaced, symmetrical process lens and *apo* lens focus all three primary colors at the same plane for critical color work, and are generally computed to work best at exactly life-size magnification. (One exception is the shutter-mounted Rodenstock Apo-Ronar, computed at 1:3.) The circle of good definition is quite small, which is really no problem when used for high magnification. The maximum aperture is a dim $f/8$ or $f/11$, but there is no focus shift as they are stopped down, meaning that they can, in a pinch, be used near maximum aperture. The newer four-element, three-group design and the six-element design have larger maximum apertures and greater covering power. These latter lenses, though expensive, are useful for copying both small, flat art and three-dimensional work. Models include: Brooks Apo-Computar, Goerz Red-Dot Artar, and Schneider Repro-Claron (all discontinued); Nikon Nikkor-AM Series (uses special glass); Rodenstock Apo-Ronar and Macro Sironar; and Schneider G-Claron (a wide-field design) and Macro-Symmar High Modulation.

Wide-angle Lenses and Center Filters

To be truly useful for architectural and interior photography, a wide-angle lens should be free from flare, distortion, and curvature of field and have even illumination across the image field. This is a big wish list. Older designs suffered from many of these flaws: the lens had to be scrupulously shaded from extraneous light, or the image was flared; straight lines could become bowed; images at the film's corners were not sharp at large apertures; and the image was brighter in the center than at the edges. Also, because older wide-angle lenses were symmetrical, they had to be focused two-thirds the way between the camera and the distant object, then stopped down completely, to let depth of field bring that distant object into sharper focus than if the lens had been focused precisely on the object!

Recent strides have overcome most of these problems, but at a price. Still, wide-angle lenses suffer somewhat from fall-off of illumination on the film, because the film's corners are considerably farther from the aperture than the center. The solution is to use a special graduated, colorless filter that is denser at the center than at the corners. Because each wide-angle lens requires its own graduated filter, arming yourself for a battery of lenses is costly. Only the perfectionist who frequently shoots wide-angle work need apply. Wide-angle lens models include: Calumet Caltar (discontinued) and Caltar II; Goerz Wide-angle Dagor (discontinued); Nikon Nikkor-SW Series; Rodenstock Grandagon; and Schneider Angulon (discontinued) and Super-Angulon.

Telephoto Lenses

Until now, I have called all lenses with longer-than-normal focal lengths "telephotos," for the sake of simplicity. Actually, a true telephoto lens *magnifies* the image within the lens barrel to reduce the distance between the rear element and the film. The reduction in the *physical* length, while maintaining a long *effective* focal length, also reduces weight, making the telephoto design sensible for small-format cameras and technical ("field") cameras, which have short bellows.

Telephoto lenses for the 4 x 5" format (there are none for 8 x 10" format) are very expensive. Instead of a telephoto lens, use a lens of conventional design, perhaps a Tessar or Plasmat, that has a focal length greater than the diagonal of your format.

APPENDIX 4:
Equipment: A Buyer's Guide

35mm SLR Cameras

THE Big Five camera manufacturers—Canon, Minolta, Nikon, Olympus, and Pentax—are so called because they dominate sales in the 35mm camera market. Each offers from three to eight models with various features, designed not so much to fulfill specific user needs as to create demand at different price levels. While we in the marketplace may feel manipulated by such tactics, we can find comfort in knowing that camera prices have not escalated very fast and that we get a lot of technology for our money. Since the making and marketing of cameras is a rapidly changing field, with models being upgraded or phased out frequently, the following commentary is general.

Your camera dollars should get you three things: reliability, features, and your choice of a wide range of accessories and lenses. Even if you do not need many extras, the presence of a total system insures that future design changes will be integrated in such a way not to render your purchase obsolete soon. Durable parts, fine machining and assembly, efficient seals against dust, and a hefty chassis are the hallmarks of the pro's camera body, with all Leicas, the Canon NEW F1, the Nikon F3, and the Pentax LX being superior in these respects. However, many other models from these manufacturers and other companies offer very good workmanship and ease of operation at less cost, even if they are more prone to failure caused by impact damage and plain old hard work.

For the greatest pictorial control, you need a camera that has a manual exposure mode that allows bracketing exposures by means of the aperture. Most mid-priced bodies do that, although their advertising may accent automation. Fully automatic non-manual cameras can only give you approximate exposures. Those models utilizing "off-the-film" metering cells may have the edge over prism-mounted cells where accuracy of exposure is concerned; but if you bracket by small increments, anyway, the point is moot. Yet the former design is quite accurate when using a dedicated flash, which is a marvel of technology that reduces mistakes in camera settings. Very few cameras now have a mechanical shutter, one that is not battery-dependent. The Nikon FM2 and the Pentax MX are notable examples of bodies whose mechanical shutters are more dependable than the delicate and improperly protected electronic shutter microprocessors common to most low- and medium-priced cameras.

Some brands, such as Nikon and Contax/Yashica, offer a secondary line of inexpensive lenses whose optical quality may be better than their construction. Autofocus lenses for our work are a definite waste of money.

Leica lenses are legendary, and so are their prices; but while that brand's quality of materials and assembly are unsurpassed, I cannot discriminate between a shot made with a Leica camera and one made with a Canon, Nikon, or Zeiss (Contax).

That price will be your basic guideline in selection is certain; but within your budget, there will be one camera that stands out as the most comfortable to hold and see through. While the shape and size of all cameras (except the Rollei) are similar, the position of the controls on different brands of cameras will affect their convenience for you. For example, most cameras have the shutter speed dial at the right of the prism, on top of the body, but Contax puts the dial on the left end of the body, where the ASA dial is usually situated. Olympus mounts the shutter dial around the bayonet mount for the lens, where the aperture ring usually sits; as a result, the Olympus aperture ring is set on the front of each lens. These configurations are indeed unique, but they work as well as the standard design. According to your preference, they may seem either perverse or ideal.

The list below omits Fujica, Konica, Mamiya, Ricoh, Rollei, and Yashica, simply because these brands do not offer the flexibility or the options of others; if one of them is to your taste, be happy with it!

Recommendations for 35mm SLR Cameras

Maker	Model	Price Range
Canon	NEW F1	High
Canon	AE-1	Medium
Contax	RTS II	High
Leica	R3	Very high
Minolta	X570	Medium
Minolta	X370	Low
Nikon	F3	High
Nikon	FM2	Medium
Olympus	OM2n	Medium
Olympus	OM1n	Low
Pentax	LX	High
Pentax	MX	Medium

Medium-Format SLR Cameras

A move to medium-format SLR cameras represents a substantial investment, since the medium-format camera is professional equipment built for heavy use. Most cameras are modular systems, with the four main components designed and sold as separate units for interchangeability. An exception is the Pentax 6 x 7, which looks like an overgrown 35mm SLR.

To start as inexpensively as possible, you need a camera body, one lens, a waist-level finder (which gives an upright but reversed image), and a film back for 120 size film that yields from ten to sixteen exposures per roll, depending on the particular format—6 x 4.5cm, 6 x 6cm, or 6 x 7cm. For more flexibility, some brands allow substitution of a 220 back, or insert, for doubling the number of frames per roll, or the adaptation of 35mm or 70mm backs for those films. To get a normal, unreversed image, you must buy an expensive prism finder. Some finders have a built-in light meter, while others allow automatic exposure control—options that quickly escalate costs. The shutters of most brands are not in the bodies, but in each lens, which allows flash synchronization at all shutter speeds—a wasted expense, if you use tungsten light sources. Another expense may be a high service bill for

shutter repair, if you own several lenses; but if such a camera has other features you like, you may be justified in purchasing it. Conversely, those cameras with a focal plane shutter in the body can use shutterless lenses that cost less, focus closer, and have larger maximum apertures than shuttered lenses. Currently, Hasselblad offers two basic cameras, one using a series of mechanically shuttered lenses and one using nonshuttered optics. Both are superb machines, and although they are not quite on a par with the electronic sophistication of the recent Mamiya RZ67, the Hasselblad was NASA's choice to take to the moon. (In fact, one that drifted out of the space capsule's door is in earth-orbit, right now!)

If you already have a view camera, you can ease into medium format by buying rollfilm backs that fit onto your view camera. This method saves a lot of money and takes advantage of the view camera's optical controls. You will probably need one or two additional lenses in the focal length range of 90mm to 135mm. Your view camera's standards must be designed to move freely with such lenses, and perhaps accept a wide-angle "bag" bellows, in order to allow the lenses to focus properly (see below, under *View Cameras*). Calumet makes a 6 x 7cm rollfilm back that inserts under the camera's springback like a cut film holder. More expensive, but better machined, are rollfilm backs by Horseman, available in 6 x 7cm, 6 x 9cm, and 6 x 12cm sizes, which require removal of the ground glass from the camera after you compose.

View Cameras

Before proceeding, you should review the basic information on view cameras found on pages 28–29.

To simplify the process of selecting a view camera, you should try to project your work flow for the upcoming years. If you think your needs will stabilize at a low rate of work, you don't have to invest in a super camera system. A simple model that has a fixed bellows, a fixed-length monorail, and limited swings and tilts should be adequate. With the money you save, you can buy a second lens. If you can see yourself commanding a busy studio, shooting large-format daily, the appropriate choice is a more

Recommendations for Medium-Format SLR Cameras

Format	Maker	Model	Price Range
6 x 4.5cm	Mamiya	M645-1000S	Low
6 x 4.5cm	Bronica	ETRSi	Low
6 x 6cm	Bronica	SQA	Medium
6 x 6cm	Hasselblad	Classic	High
6 x 6cm	Hasselblad	503CX	High
6 x 7cm	Mamiya	RB67 Pro-S	Medium
6 x 7cm	Mamiya	RZ67	High
6 x 7cm	Pentax	6 x 7 System	Low
6 x 8cm	Fuji	GX680 Pro	High

sophisticated, heavier-duty model that has interchangeable bellows and extension rails for long-focus lenses and closeups, and perhaps both base and axial tilts.

Also, anticipate the amount of location work you'll be doing. The lighter models are appropriate for this, perhaps even a flatbed type. Most photographers prefer the monorail type because of the full range of standards movements (rise and fall, tilts, swings and shifts) and more interchangeability of parts for different jobs.

Wide-angle lenses require the standards to be very close together in order to focus on infinity. Two problems arise: First, the standard bellows may not collapse enough to focus, so you would need a "bag" bellows and, of course, the ability to swap bellows. Second, the standards on some cameras are so constructed that, even with a bag bellows, you cannot take advantage of shift and swing movements. One remedy is to use a recessed lensboard, which gets the two standards apart, but also requires tiny fingers and a dental mirror for setting apertures. Another solution is to make sure that the camera you buy will function without a recessed lensboard (the Sinar comes to mind). A third remedy is to buy a "wide-angle" camera, designed specifically for wide-angle lenses.

The tilt design is important to consider. *Base* tilts pivot the standards at the juncture of the standard mount with the rail. Each time a standard is tilted, the image shape and focus is drastically altered, requiring several extra steps in refining the composition and focus. *Axial* tilts pivot the standards along an axis running horizontally through the standard, and are much easier to use. A further distinction of axial tilts separates those that merely swivel around an axis in the *groundglass*, which is preferable. Those cameras

Recommendations for View Cameras:

Monorail Type

Maker	Model	Price Range	Remarks
Calumet	45N	Very Low	Special package, with lens; good for beginners.
Calumet	45NX	Very Low	45N plus interchangeable bellows; revolving groundglass.
Calumet	45W	Low	Wide-angle lenses only.
Calumet	810N	Medium	Basic 8 x 10″, similar to 45N. Note: All Calumet models have a 1-year warranty; many accessories interchangeable with Cambo.
Cambo	Legend	Medium	Geared controls; axial tilts only; good for medium-duty.
Cambo	Legend PC	Medium	Legend plus base tilts.
Cambo	Master	Medium	L-shaped standards; axial tilts only; smooth, geared controls.
Cambo	Master PC	High	Master plus base tilts. Note: all Cambo models have a 5-year warranty; there are 8 x 10″ versions of Legend and Legend PC.
Horseman	LB	Medium	L-shaped standards; axial tilts; DOF scale; 450mm fixed rail.
Horseman	LS	High	LB plus geared controls and base tilts; rail expands to 720mm.
Horseman	LX	High	Heavy-duty version of LS; 2-point focus; very smooth. Note: there are 8 x 10″ versions of all Horseman models.
Sinar	F1 and F2	High	Manual controls; accepts fabled Sinar shutter and extensive accessories; base tilts.
Sinar	C and P2	Very High	Self-locking geared controls; assymetrical axial and base tilts.

Flatbed Types (Field Cameras)

Maker	Model	Price Range	Remarks
Calumet	XM	Low	Lightweight; fixed 300mm bellows (limited extension); no shift; rise and fall front standard only; tilt and swing both standards; 8 x 10″ version available.
Zone VI	4 x 5	Medium	Interchangeable 550mm bellows; front standard shift; rise and fall, swings, axial and base tilts on both standards; 8 x 10″ version available. Note: Zone VI cameras are similar to legendary Deardorff, now discontinued.

with both base and axial tilts give more versatility than either design alone, but they cost more. A rather odd-looking but ingenious design pioneered by Horseman and now available in both the Cambo Master series and the Linhof is the L-shaped standard. This refined mechanism allows axial tilts *and* axial swings, further speeding operation—and with one hand. Sinar revolutionized view camera design with the *asymmetrical axis* tilt and swing, which saves even more time when setting up shots. Now that Sinar's patent has expired on this feature, several other manufacturers offer the asymmetrical

axis on certain models.

Some models now include as standard equipment a depth of field calculator, built into the focusing knob. It allows you to find the precise plane of focus, and the minimum aperture to use, which will get your subject in focus from the nearest to the farthest points.

When shopping, don't be lulled into thinking you can save money by getting the cheapest model of a particular system, because lenses and expensive accessories may multiply the basic camera cost tenfold. Yet you need not be embarrassed or frustrated by using a modest outfit;

with careful technique and superior optics, you will be able to make shots indistinguishable from those made by a ten-thousand-dollar system. Justification for an expensive setup comes only from the work flow.

Because of current marketing practices by camera distributors, nearly every small photo shop has some view camera stock that may or may not be thoroughly understood by salespeople. You will gain quicker insight into this complex field by finding a view camera specialty shop that will continue to service your needs in the future.

APPENDIX 5:

Exposure Compensation for Close-ups and Reciprocity Departure

Close-Ups

Theory

WHEN a conventional lens for any format is focused for a close-up shot, it must be extended away from the film plane. If the focused object is nearer than ten times the focal length of the lens, a substantial loss of light occurs at the film. Unless you make additional exposure compensation, the film will be underexposed. However, no compensation is necessary under the following conditions:

1. When using a camera with a TTL meter.
2. When using a supplementary close-up lens that attaches to the front of a conventional lens.
3. When using a zoom lens with a "macro" range.
4. When using a lens (e.g., Canon 200mm f/4 Macro) incorporating differential focusing for close-ups (*some* compensation needed).

Table A5.1 is a guide for finding exposure compensation for extension of nine popular focal lengths of lenses. Compensation is in quarter-stop increments up to a reproduction ratio of 1:1 (life-size image), and in half-stop increments up to 3:1 for several of the middle focal lengths. Reproduction ratios greater than 1:1 are impractical with very short and very long focal lengths. All values are rounded off to facilitate use.

Practice

Make an exposure reading in the usual way, with a hand-held meter, and choose an appropriate aperture/shutter speed combination. Using a metric scale, next measure the lens extension, which is roughly the distance from the center of the lens to the film plane. In the table, look at the horizontal column, "Lens Focal Length," and find the value nearest the focal length of your lens. In the vertical column beneath that focal length, find the value nearest the lens extension just measured. Read horizontally to the columns "Aperture" and "Time". You can use either of these values to adjust your

Table A5.1
Exposure Compensation Guide

Lens Focal Length (mm)	50	100	150	180	210	240	305	360	450	Open Aperture this Amount	(or) Multiply Time by this Factor	Repro Ratio— Image:Subject
	55	110	170	200	230	270	340	400	500	+¼ stop	1.2	1:10
	60	120	185	220	250	290	370	440	550	+½ stop	1.4	1:6
	65	130	200	240	275	310	400	480	600	+¾ stop	1.8	1:3
	70	140	215	260	300	340	430	520	650	+1 stop	2.2	1:2
	80	155	240	280	330	380	480	570	700	+1¼ stops	2.5	1:1.75
	90	170	260	310	360	410	530	620	800	+1½ stops	2.8	1:1.5
	95	185	280	335	390	445	570	670	850	+1¾ stops	3.3	1:1.25
	100	200	300	360	420	480	610	720	900	+2 stops	4.0	1:1
Lens Extension (mm)		250	370	440	510	580	740	880		+2½ stops	6.0	1.5:1
		300	450	540	630	720	900	1080		+3 stops	9.0	2:1
			520	620	720	820	1040			+3½ stops	12.0	2.5:1
			600	720	840	950				+4 stops	16.0	3:1

base aperture/shutter speed combination.

Example No. 1: 100mm lens
 Base exposure: ¼ sec. @ f/16
 Lens extension: 120mm
 Aperture adjustment: + ½ stop
 New exposure: ¼ sec. @ f/11½

Example No. 2: 240mm lens
 Base exposure: 5 sec. @ f/45
 Lens extension: 440mm
 Shutter adjustment: 3.3 x
 5 = 16.5
 New exposure: 16.5 sec. @
 f/45

In example No. 1, adjustment was made by opening the aperture, while in No. 2, it was made by lengthening shutter duration. When your exposures are shorter than four seconds, compensate by opening the aperture, to keep shutter times accurate. When your subject depth requires a small aperture to maintain depth of field, you may prefer to increase the time, unless doing so makes an uncomfortably long exposure.

Note that when any lens is extended by about half its focal length, the reproduction ratio is 1:2, and the aperture compensation is one stop. When the extension is exactly *double* the focal length, the reproduction ratio is exactly 1:1, and compensation is two stops. Also, at 1:1 reproduction ratio, the distance from the lens to the subject is exactly *double* the focal length. In other words, any lens (except a telephoto design) focusing a life-size image is precisely half-way between the subject and the film—knowledge that can save you time in setting up a 1:1 shot.

Reciprocity Departure

With tungsten studio lighting, illumination at the film plane is often so weak that shutter speeds are longer than those for which films are designed. Especially when you use a view camera, there are several factors—low lighting levels, dark subjects, small apertures, and long lens extensions—that combine to cause exposure times that exceed even the one you chose for the Standard Color Test.

With certain tungsten-balanced color films—some of which have been manufactured since the mid-1970s— you will have to compensate for reciprocity departure if your base exposure plus lens extension factor yields an exposure time longer than about three seconds. If you don't, your film will be underexposed. Table A5.2 provides compensation adjustments for these films. It can be used with fair accuracy for many black-and-white materials, including Polaroid Type 52 and Type 54. If you're not sure which color films require compensation, refer to the data packed with the film. Eastman Kodak gives "Supplementary Information" on the data sheet packed with their Professional color films, which includes various "Effective Speeds" and "Correcting Filters" for different exposure times.

Newer films, manufactured since the late 1980s, usually do *not* show a loss in Effective Speed until the exposure is 30 seconds or even 100

Table A5.2
Compensation Guide for Reciprocity

Uncorrected Time	Use this Adjusted Time	or	Open Aperture by this Amount	Reduce B&W Development (only with adjusted time— not aperture)
2 sec.	2½ sec.			
3	4		+ ¼ stop	
4	5½			
5	7			
6	9		+ ½ stop	Minus 5%
7	11			
8	13			
9	15		+ ¾ stop	
10	17			
11	19			
12	22			
13	25		+ 1 stop	Minus 10%
14	28			
15	31			
16	34			
17	37			
18	40			
19	43		+ 1¼ stops	
20	48			
25	70 (1:10)		+ 1½ stops	Minus 15%
30	90 (1:30)			
35	110 (1:50)			
40	135 (2:15)		+ 1¾ stops	
50	180 (3:00)			
60 (1:00)	240 (4:00)		+ 2 stops	
70 (1:10)	310 (5:10)			
80 (1:20)	380 (6:20)			Minus 20%
90 (1:30)	450 (7:30)		+ 2½ stops	

seconds. With these films, you can ignore adding exposure compensation. But if the data sheet shows a loss in Effective Speed at 5 seconds and longer, you can use Table A5.2 as a starting point. Kodak's data sheet information in the column "Correcting Filters for Reciprocity and/or Balance" is usually *not* helpful because it is based on Kodak's "system" of lights, lenses, and their own lab in Rochester, New York. It may be true that compensating filtration is necessary, but you would have found that out when you made a Standard Color Test. In all events, keep your meter set at the exposure index normally used for your current emulsion. Do not re-rate for a lower Exposure Index, as is suggested by the Effective Speed data; doing so in addition to using the table will only compound compensation. Use this table *after* calculations accounting for any lens extension or filter factors.

If you want to figure the times for a three-sheet set of exposures, first choose the uncorrected times as the upper and lower limits of the bracket, and then use the corrected times in the adjacent column of Table A5.2.

With daylight-balanced color films shot with electronic flash, no compensation is necessary, except in the unusual circumstance of using *multiple flash*. You would use multiple flash either when you need a small aperture, or have a long bellows extension, or use a polarizer, *and* your flash system is underpowered. Suppose you want to use $f/45$ for sufficient depth of field. But your meter says you can only get to $f/22$; the compensation for bellows extension eats up another stop, bringing you to $f/16$. If you set your aperture to $f/45$ anyway, you can get the equivalent exposure of $f/16$ by using multiple "pops" of the flash.

1 pop = $f/16$ (the calculated exposure)
2 pops = $f/22$
4 pops = $f/32$
8 pops = $f/45$ (your new exposure)

In theory, you could then bracket exposures by using 6, 8, and 12 pops, or you could use 8 pops and bracket with the aperture by half-stops. Either method requires that you turn off all lights in the room, including your modeling lamps, and keep the shutter open using the "Time" or "Bulb" setting. Or you can use a self-cocking shutter, such as the Sinar, and keep all the lights on.

Trouble comes when the number of flash "pops" exceeds about three. With most color and black-and-white films, you will need to open the aperture to compensate for underexposure. (Compensation by adding more pops is not recommended . . . you will go blind or crazy—or both—from all the flashes!) In addition, there may be a slight color shift, which will only be found by shooting more tests. Table A5.3 is a guide for compensation for multiple electronic flashes.

Table A5.3
Compensation Guide for Multiple Electronic Flashes

Calculated Pops	Open Aperture by this Amount
1	0
2	0
4	1/3
8	1/2
16	2/3

Suggested Reading

Adams, Ansel. *The New Ansel Adams Photography Series, Vol. I: The Camera.* Robert Baker, ed. Boston: Bulfinch Press, 1980.

————. *The New Ansel Adams Photography Series, Vol. II: The Negative.* Robert Baker, ed. Boston: Bulfinch Press, 1981.

————. *The New Ansel Adams Photography Series, Vol.· III: The Print.* Robert Baker, ed. Boston: Bulfinch Press, 1983.

This is an enlightening and detailed account of the techniques and perceptions behind the work of a master. Covering a wide range of topics, the information ranges from the basic to the sophisticated.

The Joy of Photography: A Guide to the Tools and Techniques of Better Photography. Eastman Kodak Company, ed. Reading, MA: Addison-Wesley, 1983, Rev. ed. 1991.

A general but thorough introduction to photography, with more than 20 million copies sold.

Publications from Eastman Kodak Company (a number of these titles are inexpensive booklets):

Black-and-White Darkroom Techniques (KW-15)

Building a Home Darkroom (KW-14)

Conservation of Photographs (F-40)

Copying and Duplicating in Black-and-White and Color (M-1)

Infrared Photography (N-17)

Kodak Filters for Scientific and Technical Uses (B-3)

Kodak Master Photoguide (AR-21)

Photographing with Automatic Cameras (KW-11)

Photography with Large-Format Cameras (0-18)

Photolab Design (K-13)

Professional Photographic Techniques (O-16)

Safe Handling of Photographic Chemicals (J-4)

Storage and Care of Kodak Color Materials (E-30)

Ericksenn, Lief. *Medium Format Photography.* New York: Amphoto, 1991.

A user's guide to medium format equipment, with applications.

Image. ————. New York: Amphoto, 1988.

Complete information on designing effective pictures, including demonstrations and self-assignments.

Light. Michael Freeman, ed. New York: Amphoto, 1988.

How to use light—natural, available, and photographic—from the most basic principles to the most advanced techniques.

Freeman, Michael. *The Photographer's Studio Manual.* New York: Amphoto, Rev. ed. 1991.

Presents ideas for designing a home studio as well as a professional setup, then explores the relationship of technique to final effect from classic to novel shots.

Garrett, John. *The Art of Black and White Photography.* New York: Amphoto, 1990.

Provides critical details for creating unforgettable pictures in this popular medium.

Hawken, William R. *Close-up Photography.* New York: Curtin and London, 1982.

A brief guide that removes the mystery from the principles of close-up photography, without the usual parade of explicit medical examples.

Ittens, Johannes. *The Elements of Color.* Faber Birren, Ed. New York: Van Nostrand Reinhold, 1970.

Jacobs, Jr., Lou. *Available Light Photography: How to Shoot Without Flash in All Kinds of Light.* New York: Amphoto, 1991.

Includes information on exposure, lens and film choices, and special effects.

Joel, Seth. *Photographing Still Life.* New York: Amphoto, 1990.

Teaches how to capture still lifes effectively to achieve success in commercial photography; includes innovative techniques for shooting art and jewelry, as well as many other subjects.

Kerr, Norman. *Technique of Photographic Lighting.* New York: Amphoto, 1982.

Deals with everything from what light is to how to control it.

Langford, Michael J. *The Camera Book*. New York: Amphoto, 1985.

Explains how to get the most out of camera equipment, using every format.

Marx, Kathryn. *Photography for the Art Market*. New York: Amphoto, 1988.

How to market your work in the flourishing fine art field. Each market is defined—prints, posters, greeting cards, calendar art, and fine art books—along with prices, what buyers are looking for, and rights and reproduction.

Meehan, Joe. *The Complete Book of Photographic Lenses: How to Select and Use Optics for Every Format*. New York: Amphoto, 1991.

Surveys the pros and cons of every kind of photographic lens, from closeup and enlarging to telephoto and wide-angle lenses.

Neubart, Jack. *The Photographer's Guide to Exposure*. New York: Amphoto, 1988.

This complete course in exposure tools and techniques discusses equipment, defines terms, explains different types of film and filters, and covers specific problems in photographing a wide range of subjects.

Peterson, Bryan. *Understanding Exposure: How to Shoot Great Photographs*. New York: Amphoto, 1990.

Shows how to combine aperture, shutter speed, and film speed to make better photographs.

Picker, Fred. *The Zone VI Workshop*. New York: Amphoto, 1978.

The arcane zone system of exposure and contrast control in black-and-white work is described in the clearest terms possible by this meticulous, accomplished photographer.

Schaub, George. *The Amphoto Book of Film: 1992 Edition*. New York: Amphoto, 1991.

An essential resource, this annual is full of vital information on all the most current film specifications.

———. *Black-and-White Printing: A Practical Guide to Effective Darkroom Techniques*. New York: Amphoto, 1991.

A step-by-step course that covers every aspect of printing black-and-white photographs, from setting up a home darkroom to developing the most effective printing techniques for individual purposes.

———. *Using Your Camera: A Basic Guide to 35mm Photography*. New York: Amphoto, 1990.

A clearcut guide written specifically for people who want to go beyond the camera manual.

Shaman, Harvey. *The View Camera*. New York: Amphoto, Rev. ed. 1991.

General principles and step-by-step procedures of view camera handling are logically presented in this self-teaching manual.

Simmons, Steve. *Using the View Camera*. New York: Amphoto, 1987, Rev. ed. 1992.

A creative/technical guide to large-format photography.

Smith, Bill. *Designing A Photograph*. New York: Amphoto, 1985.

Striking visual exercises teach how to design and organize photographs.

Wilhelm, Henry. *The Permanence and Care of Color Photographs: Prints, Negatives, Slides, and Motion Pictures*. (With contributing author Carol Brower.) Grinnell, IA: Preservation Publishing Company, 1991.

Information and suggestions for choosing and using photographic materials, based on extensive accelerated aging tests.

Illustrations: Acknowledgments and Credits

Photo Credits
All photographs are by the author, with the exception of three individuals who photographed figures 11.37, 11.38, and 11.39. Figure 11.38 was made by Charles Sheeler. The names of the two people who made figures 11.37 and 11.39 have been lost in what Marcel Duchamp called "the purgatory of art history."

Color

Plate 1 *(B)*. *Standing Ganesha*. Sculpture: calcareous sandstone; height, 17¼ inches (43.8 centimeters). Cambodian, pre-Angkor Period, ca. late 7th/early 8th century.
Metropolitan Museum of Art: Rogers, Louis V. Bell, and Fletcher Funds, 1982. (1982.220.7)

Plate 2. *View of Toledo*, by El Greco (1541–1614). Painting: oil on canvas; 47¾ inches by 42¾ inches (121.3 by 108.6 centimeters). Spanish.
Metropolitan Museum of Art: Bequest of Mrs. H. O. Havemeyer, 1929. The H. O. Havemeyer Collection. (1929.100.6)

Plate 3. *Bust of Sasanian King, Shapur II (?)*. Metalwork: silver; height, 15⅝ inches (38.7 centimeters); width, 9¹⁄₁₆ inches; thickness, 7⅛ inches. Iranian, ca. 4th century A.D.
Metropolitan Museum of Art: Fletcher Fund, 1965. (65.126)

Plate 4. *Madonna and Child*, by Francia (Francesco di Marco di Giacomo Raibolini) (ca. 1450–ca. 1517–18). Painting: oil on wood; height, 24 inches, width 18⅛ inches (61 centimeters by 46 centimeters). Italian, 15th–16th century.
Metropolitan Museum of Art: Gift of Lewis C. Ledyard, III, Mrs. Victor Onet, and Mrs. T. F. Turner, in memory of Lewis C. Ledyard, 1982. (1982.448)

Plate 5 *(A and B)*. *Sunflowers*, by Vincent van Gogh (1853–1890). Painting: oil on canvas; height, 17 inches, width 24 inches (43.2 centimeters by 61 centimeters). Dutch, late 19th century.
Metropolitan Museum of Art: Rogers Fund, 1949. (49.41)

Plate 6 *(A and B)*. *Emergence in Polychrome*, by Dominick Labino (1910–). Glass: height, about 7 inches (17.5 centimeters). American, 20th century.
Metropolitan Museum of Art: Gift of Mr. and Mrs. Dominick Labino, 1977. (1977.473)

Plate 6 *(C)*. *Taking on Wet Provisions*, by Winslow Homer (1836–1910). Painting: watercolor. American, 19th–20th century.
Metropolitan Museum of Art: Amelia B. Lazarus Fund, 1910. (10.228.11)

Plate 7. *Tiffany Glass Group*, by Louis Comfort Tiffany. Favrile glass: vases, Art Nouveau style. American: New York City, late 19th–early 20th century.
Metropolitan Museum of Art: Gift of H. O. Havemeyer, 1896 (96.17.46); Gift of Louis Comfort Tiffany Foundation, 1951 (51.121.17); Anonymous Gift, 1955 (55.213.12 and 55.213.27).

Plate 8 *(A, B, C, D, E, F, G, H)*. *Leda and the Swan*, by Jacques Sarrazin (1592–1660). Sculpture: marble; height, 62 inches (157 centimeters). French, ca. 1640–1650.
Metropolitan Museum of Art: Purchase, C. Michael Paul Gift; Bequest of Mary Cushing Fosburgh, and Gift of Irwin Untermeyer, by exchange, 1980. (1980.5)

Plate 9 *(A, B, C, D, E, F)*. *Head from a Statue: King Aye (?)*. Sculpture: red granite; height, about 12 inches (30.5 centimeters). Egyptian: Thebes, Dynasty XII, ca. 1450 B.C.
Metropolitan Museum of Art: Museum Excavations, 1922–1923; Rogers Fund, 1923. (23.3.170)

Plate 10. *Patchwork Quilt*, made by Pocahontas Sells. Textiles: cotton scraps; 64 inches by 80 inches (162.5 centimeters by 203.2 centimeters). American, ca. 1955.
Private collection.

Plate 11. *Tibetan jewelry*, by unknown artists.
Private collection.

Plate 12. *Fragment of Royal Head*. Sculpture: individuated limestone, approximately human life-size. Egyptian, Dynasty XVIII, reign of Akhenaton, ca. 1379–1362 B.C.
Metropolitan Museum of Art, Gift of Edward S. Harkness, 1926. (26.7.1395)

Plate 13. Left to right: Evening dress of gold silk satin reversing to green crepe. French, ca. 1933. Designed by Vionnet. Gift of Mr. and Mrs. Charles Abrams, 1978 (1978.29.2ab). Evening dress of silver lame and gray tulle. French, 1938. Designed by Vionnet. Gift of Mrs. Harrison Williams, Lady Mendl, and Mrs. Ector Munn, 1946. (CI 46.4.24ab).
Both dresses: Metropolitan Museum of Art.

Plate 14 *(A and B)*. *Untitled*, 1974, by Lenore Tawney. Linen, manuscript paper, Liquitex, buttons; 26 by 60 inches (66.0 by 152.4 centimeters).
Collection American Craft Museum, New York. Gift of the artist, 1976. Donated by the American Craft Council, 1990.

Plate 14 *(C and D)*. *Goose Beak Pitcher*, 1990, by Dante Marioni. Blown glass. 27 by 8 by 6 inches (68.6 by 20.3 by 15.2 centimeters).
Collection of the artist.

Plate 15. *Jade Mask*. Sculpture: jade; height, 6¾ inches (17.2 centimeters). American: Mexico, Olmec, 10th–8th centuries B.C.
Metropolitan Museum of Art: The Michael C. Rockefeller Memorial Collection, Bequest of Alice K. Bache, 1977. (1977.187.33)

Plate 16 *(A)*. *Collections*, 1985, by Lisa Dinhofer. Painting: oil on canvas. 52 by 52 inches (132.1 by 132.1 centimeters).
Mutual of New York Corporate Collection. Courtesy the artist.

Plate 16 *(B)*. *The Subway*, 1950, by George Tooker. Painting: egg tempera on composition board. 18⅛ by 36⅛ inches (46.0 by 91.7 centimeters).
Collection Whitney Museum of American Art. Purchase, with funds from the Juliana Force Purchase Award 50.23.

Plate 17 *(A)*. *Femali*, 1989, by Keke Cribbs. Sculpture: glass, wood, paint, copper; 50 by 9 by 6 inches (127.0 by 22.9 by 15.2 centimeters).
Collection American Craft Museum, New York. Gift of Edwin and Nancy Marks.

Plate 17 *(B)*. *Couple*, by Dorothy Dehner. Sculpture: corten steel.
Courtesy Twining Gallery, New York.

Plate 18. *Court Robe of the Empress Dowager T'zu Hsi*. Textile: embroidered; in colors and gold, phoenix design partly in silk, embroidered. Chinese, 19th century.
Metropolitan Museum of Art: Gift of Mrs. William H. Bliss, 1927. (27.33)

Plate 19. *Cabinet on Stand*. Furniture: deal, oak; marquetry of walnut and holly; height, 62¾ inches, width, 45¾ inches. English.
Metropolitan Museum of Art: Bequest of Marion E. Cohn, 1966. (66.64.15)

Plate 20. *Red, Yellow, Blue*, 1986, by Mel

Kendrick. Painted wood.
Private collection.

Plate 21 (A, B, C, D). The Michael C. Rockefeller Wing of Primitive Art.
The Metropolitan Museum of Art.

Plate 22. *Early/Later: Selected Works from the Permanent Collection of the Whitney Museum of American Art.*
(March 26, 1990–March, 1991) at Whitney Museum of American Art at Equitable Center.

Black and White

Figs. 4.8, 4.9, and 4.10. *Virgin of the Immaculate Conception,* by Wenzel Neu (1708–1774). Ceramic: Hard-paste porcelain; height, 14½ inches (36.3 centimeters). German: Fulda, ca. 1781.
Metropolitan Museum of Art: The Jack and Belle Linsky Collection, 1982. (1982.60.182)

Figs. 4.14, 4.15, 4.16, and 4.17. *Pianoforte,* by Bartolomeo Cristofori. Italian: Florence, 1720.
Metropolitan Museum of Art: The Crosby Brown Collection of Musical Instruments, 1889. (89.4.1219)

Figs. 5.1, 5.2, 5.3, and 5.4. *Pantaloon.* Ceramic: hard-paste porcelain; height, 9 inches (22.8 centimeters). German: Hochst, ca. 1750–1753.
Metropolitan Museum of Art: The Jack and Belle Linsky Collection, 1982. (1982.60.226)

Figs. 6.1, 6.2. *Black-Figure Amphora with Chariot Scene.*
The Collection of Nicholas S. Zoullas.

Figs. 7.1, 7.4, and 7.7. *The Lighthouse at Two Lights,* by Edward Hopper. Painting: oil on canvas (1929); 29½ inches by 43¼ inches (74.9 centimeters by 109.9 centimeters).
Metropolitan Museum of Art: Hugo Kastor Fund, 1962. (62.95)

Figs. 7.2, 7.5, and 7.8. *Black Abstraction,* by Georgia O'Keeffe. Painting: oil on canvas; 30 inches by 40½ inches (76.2 centimeters by 102.2 centimeters).
Metropolitan Museum of Art: The Alfred Stieglitz Collection, 1949. (69.278.2)

Figs. 7.3, 7.6, and 7.9. *Untitled Work* by Morris Louis. Painting: magna on canvas (1960); 105 inches by 202 inches (266.7 centimeters by 513.1 centimeters).
The Muriel Kallis Steinberg Newman Collection.

Figs. 8.4, 8.5. *Janus Headdress.* Wood, basketry, human hair, cloth, pigment, clay; height, 13 inches (33 centimeters). Nigeria: Igala, 19th–20th century.
Metropolitan Museum of Art: Gift of Dr. Robert Portman, 1980. (1980.550)

Figs. 8.6, 8.7, and 8.8. *Seated Figure,* by Henry Moore. Statue: cast concrete; height, about 14 inches (35. 5 centimeters).
Private collection.

Figs. 8.9, 8.10. *Returning Fishermen,* by T'ang Ti (1296–1364). Hanging scroll: ink and light color on silk; height, 52¾ inches; width, 34 inches (134 centimeters by 86.3 centimeters). Chinese, Yuan Dynasty, ca. 1342.
Metropolitan Museum of Art: Purchase, 1973, Bequest of Joseph H. Durkee, by exchange. (1973.121.5)

Fig. 9.1. Gallery of Greek Art.
Metropolitan Museum of Art.

Fig. 9.2. *Hatshepsut. Represented as a King.* Statuary: red granite; height, about 9.5 feet (290 centimeters). Egyptian, Dynasty XVIII (1490–1480 B.C.).
Metropolitan Museum of Art: Rogers Fund, 1928. (28.3.18)

Figs. 9.4, 9.5. *Triumph of Dionysos and the Seasons Sarcophagus.* Phrygian marble; length 7 feet, 1 inch (216 centimeters). Roman, A.D. 220–235.
Metropolitan Museum of Art: Purchase, Joseph Pulitzer Bequest, 1955. (55.1.5)

Figs. 9.6, 9.7. *Outer Coffin of Henettawy.* Wood. Egyptian: Thebes, Dynasty XXI.
Metropolitan Museum of Art: Rogers Fund 1925. (25.3.182)

Figs. 9.8, 9.9, and 9.10. Pennsylvania German Room from Lancaster County, Pennsylvania, 1791.
Metropolitan Museum of Art.

Fig. 11.1. *Saints Jerome and Vincent,* by Gerard David (active by 1484, d. 1523). Painting (wing of triptych): tempera and oil on canvas, transferred from wood; height, 35¼ inches; width, 12⅜ inches (89.6 centimeters by 31.4 centimeters). Flemish, 15th–16th century.
Metropolitan Museum of Art: The Jules Bache Collection, 1949. (49.7.20b)

Fig. 11.5. *Amagoi Komachi,* by Hosoda Yeishi (1756–1829). Print; 15¼ inches by 10¼ inches (38.7 centimeters by 26 centimeters). Japanese, ca. 1791.
Metropolitan Museum of Art: Rogers Fund, 1936. (JP 2420)

Fig. 11.6. *Cliche verre,* by Man Ray. Print (1923); 15⅝ inches by 10¾ inches (39.4 centimeters by 27.3 centimeters). American, 20th century.
Metropolitan Museum of Art: John B. Turner Fund, 1967. (67.765.4)

Fig. 11.8. *View of Toledo,* by El Greco (1541–1614). Painting: oil on canvas; 47¾ inches by 42¾ inches (121.3 centimeters by 108.6 centimeters). Spanish.
Metropolitan Museum of Art: Bequest of Mrs. H. O. Havemeyer, 1929. The H. O. Havemeyer Collection. (1929.100. 6)

Figs. 11.9, 11.10, and 11.11. *Length of Woven Silk.* English, mid-18th century.
Metropolitan Museum of Art: Rogers Fund and funds from various donors, 1982. (1982.178.2)

Figs. 11.12, 11.13. *Expulsion Reintegration,* by Victor Brauner. Painting: oil relief on wood; height, 18 inches; width, 21½ inches (45.7 centimeters by 54.6 centimeters). Roumanian, 1960.
Metropolitan Museum of Art: Gift of Sylvia de Cuevas, 1981. (1981.496)

Fig. 11.14. *Torso, Navel, Man with a Mustache,* by Jean (Hans) Arp. Painting: oil relief on wood (1930).
The Muriel Kallis Steinberg Newman Collection.

Fig. 11.16. *Snow Cleaning,* by Wang Hui. Hanging scroll: ink and color on paper; height, 43⅝ inches (1.1 meter). Chinese, Ch'ing Dynasty, 1669.
Metropolitan Museum of Art: Gift of Mr. and Mrs. Earl Morse, in honor of Professor Wen Fong, 1978. (1978.13)

Fig. 11.17. *Japanese Painting.* Height 78½ inches; width, 10¾ inches (199.4 centimeters by 27.3 centimeters). Late 17th century, Genroku Period.
Metropolitan Museum of Art: Rogers Fund, 1912. (12.134.12)

Fig. 11.18. *Irises and Bridge,* by Korin (1658–1716). Six-panel screen (one of a pair): paint on paper; height 70½ inches; length, 146¼ inches (170.1 centimeters by 371.5 centimeters). Japanese.
Metropolitan Museum of Art: Louis E. McBurney Gift Fund, 1953. (53.7.1)

Fig. 11.20. Title page from album compiled for Shah Jahan: inscriptions and rosette. Painting: colors and gilt on paper; height 15³⁄₁₆ inches, width, 10⁷⁄₁₆ inches. Islamic; Indian, Mughal. 17th century, Period of Shah Jahan, 1628–1658.
Metropolitan Museum of Art: Purchase, Rogers Fund and the Kevorkian Foundation Gift, 1955. (55.121.10.39)

Figs. 11.22, 11.23, and 11.24. *Madonna and Child Enthroned with Saints,* by Taddeo Gaddi (active by 1334, d. 1366). Altarpiece, originally a polyptych of five panels: tempera on wood, gold ground; overall, 43¼ inches by 90⅛ inches (109.8 centimeters by 228.9 centimeters).
Metropolitan Museum of Art: Rogers Fund, 1910. (10.97)

Figs. 11.27, 11.28, 11.29, and 11.30. *Cup and Saucer.* Ceramic: white molded ware, soft-paste porcelain. French, St. Cloud (1712–1762).
Metropolitan Museum of Art: Gift of Mrs. Morris Hawkes, 1924. (24.214.8,9)

Figs. 11.31, 11.32, 11.33, 11.34, 11.35, and 11.36. *Head of a Deity (Bodhisattva?).* Stucco; height of head, 7½ inches (19.1 centimeters). Thailand: Mon Style, ca. 8th century.
Metropolitan Museum of Art: Purchase, Lita Annenberg Hazen Charitable Trust Gift, in honor of Cynthia Hazen and Leon Bernard Polsky, 1982. (1982.214)

Figs. 11.37, 11.38, and 11.39. *Head of Christ, Crowned with Thorns.* Sculpture: limestone, polychromed; height, 10½ inches (26.6 centimeters). French, Champagne, 15th century.
Metropolitan Museum of Art: The Cloisters Collection, 1925. (25.120.219)

Figs. 11.40, 11.41. *Figure of God of Longevity.* Statuette: ivory; height, with stand, 9¾ inches (24.77 centimeters). Chinese, 16th century.
Metropolitan Museum of Art: Bequest of Rosina H. Hoppin, 1965. (65.86.135ab)

Fig. 11.42. *Necklace.* Silver: diameter, 5¾ inches (14.6 centimeters). South American.
The Muriel Kallis Steinberg Newman Collection.

Figs. 11.43, 11.44, 11.45, and 11.46. *Cameo of Alexander; Metal Coin; Pendant with Intaglio and Chain; Intaglio.* Sizes indicated by metric scale in each photograph.
Private Collection.

Fig. 11.48. *Desk Set,* by Josef Hoffman. Lapidary work: mother-of-pearl, ebony, leather, and silver; greatest height: 4¼ inches (10.8 centimeters). Austrian, Wiener Werkstatte, ca. 1911.
Metropolitan Museum of Art: Purchase, Anonymous Gift, 1977. (1977.72.1-5)

Figs. 11.49, 11.50. *Emblema, with Relief of Scylla Hurling a Boulder.* Silver, parcel gilt: diameter, 4⅛ inches (10.7 centimeters). Greek (Tarentine), early 3rd century B.C.
Metropolitan Museum of Art: Purchase, Classical Purchase and Rogers Funds, and Anonymous, Norbert Schimmel, Mr. and Mrs. Martin Fried, Mr. and Mrs. Thomas A. Spears, Walter Bareiss and Mr. and Mrs. Howard J. Barnet Gifts, 1981. (1981.11.22)

Fig. 11.52. *Bust of Baby.* Terra-cotta.
Private Collection.

Fig. 11.53. *Plaque with Fantastic Creatures.* Metalwork: gold; 8½ inches by 10½ inches (21.6 centimeters by 26.7 centimeters). Iranian, 7th century B.C.
Metropolitan Museum of Art: Ann and George Blumenthal Fund and Harris Brisbane Dick Fund, 1954, and Rogers Fund, 1962. (54.3.5) and (62.78.1)

Fig. 11.55. *Plate,* 1988, by John Donoghue. Ceramic: earthenware; 3 by 20 inches (7.6 by 50.8 centimeters).
Collection of Philip Morris Companies Incorporated.

Fig. 11.56. *Persimmon Macchia,* by Dale Chihuly. Glass (hot worked); 10 by 21 by 19 inches (25.4 by 53.3 by 48.3 centimeters). 1986.
Collection of Philip Morris Companies, Incorporated.

Fig. 11.57. *Trust,* by Nancy Carman. Ceramic, glazed; 15 by 23 by 7 inches (38.1 by 58.4 by 17.8 centimeters). 1989.
Collection of Philip Morris Companies, Incorporated.

Fig. 11.58. *Standing Cup.* Glass: enameled and gilded; height, 11 ½ inches (30 centimeters). Italian, Venice, ca. 1530.
Metropolitan Museum of Art: The Jack and Belle Linsky Collection, 1982. (1982.60.130)

Fig. 11.59. *Annette VI,* by Alberto Giacometti. Sculpture: bronze; height 25⅞

inches (65.7 centimeters).
Jointly owned by the Metropolitan Museum of Art and Mr. and Mrs. Joseph Zimmerman, 1981. (1981.491)

Fig. 11.60. *Leda and the Swan,* by Louis-Robert Carrier-Belleuse. Sculpture: cast terra-cotta; height, 14½ inches (36.8 centimeters). French, 19th–20th century.
Metropolitan Museum of Art: Purchase, Rogers Fund and Mr. and Mrs. Claus von Bulow Gift, 1980. (1980.123)

Figs. 11.61, 11.62. *Violin: Long Pattern,* by Antonius Stradivarius. Pine, curly maple, ebony, pearwood; length 23¼ inches (59 centimeters). Italian, 1691.
Metropolitan Museum of Art: Gift of George Gould, 1955. (55.86a)

Figs. 11.64A, 11.64B. *Flask* (Ts'an-Chien Hu). Ceramic: burnished earthenware; height, 10¾ inches (27.3 centimeters). Chinese, late Eastern Chou-Western Han Dynasty, ca. 3rd–1st century B.C.
Metropolitan Museum of Art: Gift of Mrs. Richard E. Linburn, 1981. (1981.466)

Figs. 11.65, 11.66, and 11.67. *Fisherman.* Ceramic: hard-paste porcelain; height, 9 inches (22.7 centimeters). German.
Metropolitan Museum of Art: The Jack and Belle Linsky Collection, 1982. (1982.60.174)

Fig. 11.68. *Bronze Plaque.* Height, about 15 inches (38 centimeters). African, Benin.
Private Collection.

Fig. 11.69. *Grave Relief: Girl with Pigeons.* Sculpture: marble; height, 34 inches (84.6 centimeters). Greek, Island of Paros, ca. 455–450 B.C.
Metropolitan Museum of Art: Fletcher Fund, 1927. (27.45)

Fig. 11.71. *Rainforest,* 1982, by Louise Nevelson. Sculpture: painted wood; 84 by 72 by 48 inches (213.4 by 182.9 by 122.0 centimeters).
Collection Whitney Museum of American Art.

Fig. 11.72. *Still Life from MPI Studio,* by Margaret P. Israel.
Courtesy Twining Gallery, New York.

Fig. 11.73. *Mask.* Wood, brass sheets, metal pins; length, 18 inches (946 centimeters). African, Mali, Bamana, 19th–20th century.
Metropolitan Museum of Art: Gift of Mr. and Mrs. J. Gordon Douglas III, 1981. (1981.138.2)

Figs. 11.74, 11.75, and 11.76. *Goblet,* attributed to H. Schwinger. Glass; height, 14 inches (35.5 centimeters). German, Nuremberg, 18th century.
Metropolitan Museum of Art: Gift of Dr. Eugene Grabscheid, 1982. (1982.97.15)

Figs. 11.78, 11.79. *Untitled Sculpture,* 1988, by Mary Frank.
Courtesy the artist.

Figs. 11.80, 11.81. *Column of Peace,* by Antoine Pevsner. Sculpture: bronze; height, 53

inches (134.6 centimeters). French, 1954.
Metropolitan Museum of Art: Gift of Alex Hillman Family Foundation, in memory of Richard Alan Hillman, 1981. (1981.326)

Fig. 11.82. *The Freedman,* by J. Q. A. Ward. Sculpture: bronze; height 19½ inches (49 centimeters). American, 1863.
American Academy of Arts and Letters.

Fig. 11.83. *Chair.* Designer: Hans J. Wegner. Maker: Johannes Hansen. Walnut, canework, and mahogany; height, 29¾ inches (75.6 centimeters). Danish, 20th century.
Metropolitan Museum of Art: Edward C. Moore, Jr., Gift Fund, 1961. (61.7.45)

Fig. 11.85. *Dressing Table-Sink,* by Louis Majorelle. Honduras mahogany, Macassar ebony, gilt bronze, mirror glass, marble, ceramic; height, 86⅜ inches (219.3 centimeters). French, Nancy, 1900–1910.
Metropolitan Museum of Art: Gift of the Sydney and Frances Lewis Foundation, 1979. (1979.4)

Fig. 11. 87. *Bodhisattva Kuan-Yin (Avalokitesvara).* Sculpture: wood with color and gilt on gesso; height, 59¾ inches (152.2 centimeters). Chinese, Ming Dynasty, ca. 1600.
Metropolitan Museum of Art: Purchase, 1976, Laurance S. Rockefeller Gift. (1976.326)

Fig. 11.88. *Statue of Amida Buddha.* Sculpture: carved wood; height, about 5 feet (150 centimeters). Japanese, Kamakura Period, ca. 1250.
Metropolitan Museum of Art: Rogers Fund, 1919. (19.140)

Fig. 11.89. *Airship,* 1986, by Bryan Hunt.
Courtesy the artist.

Fig. 11.90. *Flight II,* 1987, by Steve Keister. Spandex, epoxy paint, epoxy resin, fiberglass, bondo, found objects; 57 by 50 by 34 inches (144.8 by 127.0 by 86.4 centimeters).
Courtesy the artist.

Fig. 11.91. *Master Drawings from the Ian Woodner Family Collection,* (1990) at the Metropolitan Museum of Art.

Fig. 11.92. *Scandinavian Craft Today,* (1988) at the American Craft Museum, New York.
Exhibition organized by the Nordic Council of Ministers and Tokyo's Seibo Museum of Art.

Fig. 11.93. *Contingent Realms: Four Contemporary Sculptors* (September 27 through December 8, 1990) at Whitney Museum of American Art at Equitable Center.

Fig. 11.94. *Running People at 2,616,216,* 1989, by Jonathon Borofsky. Painting: latex paint on wall.
Installation view at Whitney Museum of American Art, collection of Whitney Museum of American Art. Purchase, with funds from the Painting and Sculpture Committee 84.43.

Fig. A2.1. *View Camera Movements.* Reproduced from the catalog of Calumet Photographic, Bensenville, Illinois.

Index